the photoshop elements 2020 book

for digital photographers

Scott Kelby

D1594874

MANAGING EDITOR
Kim Doty

COPY EDITOR
Cindy Snyder

ART DIRECTOR
Jessica Maldonado

PHOTOGRAPHY BY
Scott Kelby

EXECUTIVE EDITOR/
NEW RIDERS
Laura Norman

Published by
New Riders

Composed in Myriad Pro and Helvetica by Kelby Media Group, Inc.

Trademarks
All terms mentioned in this book that are known to be trademarks or service marks have been appropriately capitalized. New Riders cannot attest to the accuracy of this information. Use of a term in this book should not be regarded as affecting the validity of any trademark or service mark.

Photoshop Elements is a registered trademark of Adobe Systems, Inc.
Windows is a registered trademark of Microsoft Corporation.
Macintosh is a registered trademark of Apple Inc.

Warning and Disclaimer
This book is designed to provide information about Photoshop Elements for digital photographers. Every effort has been made to make this book as complete and as accurate as possible, but no warranty of fitness is implied.

The information is provided on an as-is basis. The authors and New Riders shall have neither the liability nor responsibility to any person or entity with respect to any loss or damages arising from the information contained in this book or from the use of the discs, electronic files, or programs that may accompany it.

THIS PRODUCT IS NOT ENDORSED OR SPONSORED BY ADOBE SYSTEMS INCORPORATED, PUBLISHER OF ADOBE PHOTOSHOP ELEMENTS 2020.

ISBN 13: 978-0-13-530101-2
ISBN 10: 0-13-530101-7

1 2019

www.kelbyone.com
www.newriders.com

*This book is dedicated to
my friend and colleague
Larry Becker. I consider myself
very fortunate to get to work
with you, one of the most
talented, genuine, funny, and
hard-working folks in our industry.
Most of all, I'm honored to be
able to call you my friend.*

ACKNOWLEDGMENTS

I've been writing books for 23 years now, and I still find that the thing that's the hardest for me to write in any book is the acknowledgments. It also, hands down, takes me longer than any other pages in the book. For me, I think the reason I take these acknowledgments so seriously is because it's when I get to put down on paper how truly grateful I am to be surrounded by such great friends, an incredible book team, and a family that truly makes my life a joy. That's why it's so hard. I also know why it takes so long—you type a lot slower with tears in your eyes.

To my remarkable wife, Kalebra: We've been married 30 years now, and you still continue to amaze me, and everyone around you. I've never met anyone more compassionate, more loving, more hilarious, and more genuinely beautiful, and I'm so blessed to be going through life with you, to have you as the mother of my children, my business partner, my private pilot, Chinese translator, and best friend. You truly are the type of woman love songs are written for, and as anyone who knows me will tell you, I am, without a doubt, the luckiest man alive to have you for my wife.

To my son, Jordan: It's every dad's dream to have a relationship with his son like I have with you, and I'm so proud of the bright, caring, creative man you've become. I can't wait to see the amazing things life has in store for you, and I just want you to know that watching you grow into the person you are is one of my life's greatest joys.

To my precious little girl, Kira: You have been blessed in a very special way, because you are a little clone of your mom, which is the most wonderful thing I could have possibly wished for you. I see all her gifts reflected in your eyes, and you're now getting to the age where you're starting to realize how blessed you are to have Kalebra as your mom. One day—just like Jordan—you will realize it on an entirely different level, and then you'll know what an incredible gift God has blessed you with in her.

To my big brother Jeff, who has always been, and will always be, a hero to me. So much of who I am, and where I am, is because of your influence, guidance, caring, and love as I was growing up. Thank you for teaching me to always take the high road, for always knowing the right thing to say at the right time, and for having so much of our dad in you.

I'm incredibly fortunate to have the production of my books handled in-house by two extraordinary people, whose talent, passion, and work ethic are an inspiration to everyone around them—my editor Kim Doty and book designer Jessica Maldonado. I don't know how I'd ever get a book done without this dream team of creatives. They keep me on track, calm, and smiling with their 100% can-do attitudes and the talent and drive to pull it off. I'm also very grateful to still have the wonderful Cindy Snyder working on my books, even though we don't get to see her every day (but, we all miss seeing her—especially around birthdays [inside joke]). I feel so blessed to have this incredible team behind me, and I couldn't be more proud of what you have accomplished, and what you continue to do every single day. Thank you.

Thanks so much to my friend and colleague Erik Kuna, for all his support, ideas, brainstorming sessions, dedication, and spirit. Also, thanks for going shooting with me in sometimes less-than-ideal conditions, and for co-hosting *The Grid* with me. You are an awesome person and a very smart and talented one at that.

Thanks and a hug to my dear friend and business partner Jean A. Kendra. Thanks for putting up with me all these years, and for your support for all my crazy ideas. It really means a lot.

A big thanks to my assistant Jeanne Jilleba, who generally herds me like sheep to keep me focused and on track so I have time to write books, spend time with my family, and have a life outside of work.

Thanks to my publishing editor Laura Norman, and the team at Peachpit and New Riders, whose commitment to producing great books has done the brand proud. Thanks for all your support and patience (ahem) over these many years. We appreciate it more than you know.

Thanks to my friends at Adobe: Bryan O'Neil Hughes, Mala Sharma, Terry White, Julieanne Kost, Tom Hogarty, Scott Morris, Sharad Mangalick, Russell Preston Brown, Jeff Tranberry, Bryan Lamkin, and the amazing engineering team at Adobe (I don't know how you all do it).

I owe a debt of gratitude to, and will never forget: Barbara Rice, Jill Nakashima, Nancy Aldrich-Ruenzel, Sara Jane Todd, Rye Livingston, Addy Roff, Jennifer Stern, Winston Hendrickson, Deb Whitman, Kevin Connor, John Nack, John Loiacono, Cari Gushiken, Jim Heiser, and Karen Gauthier.

I want to thank all the gifted photographers who've taught me so much over the years, including: Moose Peterson, Joe McNally, Anne Cahill, Dave Black, Lindsay Adler, Jay Maisel, Tim Wallace, Rick Sammon, Frank Doorhof, David Ziser, Helene Glassman, Mimo Meidany, Peter Hurley, and Jim DiVitale.

Thanks to my mentors, whose wisdom and whip-cracking have helped me immeasurably, including John Graden, Jack Lee, Dave Gales, Judy Farmer, and Douglas Poole.

Most importantly, I want to thank God, and His Son Jesus Christ, for leading me to the woman of my dreams, for blessing us with two amazing children, for allowing me to make a living doing something I truly love, for always being there when I need Him, for blessing me with a wonderful, fulfilling, and happy life, and such a warm, loving family to share it with.

OTHER BOOKS BY SCOTT KELBY

The Adobe Photoshop Lightroom Classic Book for Digital Photographers

The Adobe Photoshop CC Book for Digital Photographers

Photoshop for Lightroom Users

How Do I Do That In Photoshop?

How Do I Do That In Lightroom?

Professional Portrait Retouching Techniques for Photographers Using Photoshop

The Digital Photography Book, parts 1, 2, 3, 4, and 5

The Best of The Digital Photography Book Series

Light It, Shoot It, Retouch It

The Landscape Photography Book

The Natural Light Portrait Book

The Flash Book

It's a Jesus Thing: The Book for Wanna Be-lievers

ABOUT THE AUTHOR

Scott Kelby

Scott is President and CEO of KelbyOne, an online educational community for photographers. He is Editor, Publisher, and co-founder of *Photoshop User* magazine; Editor of *Lightroom Magazine*; host of *The Grid*, the influential live weekly talk show for photographers; and is founder of the annual Scott Kelby's Worldwide Photo Walk™.

Scott is a photographer, designer, and award-winning author of more than 90 books, including *The Landscape Photography Book*; *The Flash Book*; *Light It, Shoot It, Retouch It*; *The Adobe Photoshop CC Book for Digital Photographers*; *Photoshop for Lightroom Users*; *How Do I Do that In Lightroom?*; *The Natural Light Portrait Book*; and his landmark *Digital Photography Book* series. The first book in this series, *The Digital Photography Book*, part 1, has become the #1 top-selling book ever on digital photography.

His books have been translated into dozens of different languages, including Chinese, Russian, Spanish, Korean, Polish, Taiwanese, French, German, Italian, Japanese, Hebrew, Dutch, Swedish, Turkish, and Portuguese, among many others. He is recipient of the prestigious ASP International Award, presented annually by the American Society of Photographers for "…contributions in a special or significant way to the ideals of Professional Photography as an art and a science" and the HIPA Special award, presented for his contributions to photography education worldwide.

Scott is Conference Technical Chair for the annual Photoshop World Conference and a frequent speaker at conferences and trade shows around the world. He is featured in a series of online learning courses at KelbyOne.com and has been training Photoshop users and photographers since 1993.

CONTENTS

CONTENTS

Chapter 3

Beyond the Reach
Camera Raw—Beyond the Basics

77

Chapter 4

Scream of the Crop
How to Resize and Crop Photos

107

CONTENTS

CONTENTS

It's really important to me that you get a lot out of reading this book, and one way I can help is to get you to read these ten quick things about the book that you'll wish later you knew now. For example, it's here that I tell you about where to download something important, and if you skip over this, eventually you'll send me an email asking where it is, but by then you'll be really aggravated, and well…it's gonna get ugly. We can skip all that (and more), if you take two minutes now to read these ten quick things. I promise to make it worth your while.

Ten Things You'll Wish You Had Known Before Reading This Book

(1) You don't have to read this book in order.

You can treat this as a "jump-in-anywhere" book, because I didn't write it as a "build-on-what-you-learned-in-Chapter-1" type of book. For example, if you just bought this book, and you want to learn how to convert an image to black and white, you can just turn to Chapter 10, find that technique, and you'll be able to follow along and do it immediately, because I walk you through each step. So, if you're a more advanced Elements user, don't let it throw you that I say stuff like, "Go under the Image menu, under Adjust Color, and choose Levels," rather than just saying, "Open Levels." I did that so everybody could follow along no matter where they are in the Elements experience.

(2) Not everything about Elements is in this book.

I tried hard not to make this a giant encyclopedia of Elements features. So, I didn't include tutorials on every feature in Elements. Instead, it's more like a recipe book—you can flip through it and pick out the things that you want to do to your photos and follow the steps to get there. Basically, I just focused on the most important, most asked-about, and most useful things for digital photographers. In short—it's the funk and not the junk.

Continued

(3) Practice along with some of the same photos I used here in the book.

As you're going through the book, and you come to a technique like "Adding Contrast and Drama to Cloudy Skies," you might not have a cloudy sky image hanging around. I made most of the images used in the techniques available for you to download, so you can follow along with them. You can find them at **http://kelbyone.com/books/elements2020** (see, this is one of those things I was talking about that you'd miss if you skipped this and went right to Chapter 1).

(4) Photography is evolving, Elements is evolving, and this book has to, too.

The photographer's Elements workflow has evolved greatly over time, and in this current version of the book you'll wind up doing a lot of your processing and editing in Adobe Camera Raw (whether you shoot in RAW, JPEG, or TIFF—it works for all three). That's because for years now, Adobe has been adding a lot of Elements' new features for photography directly to Camera Raw itself. Since today's photography workflow in Elements is based around Camera Raw, not surprisingly we have a couple chapters just dedicated to working in Camera Raw, and I wanted you to know that up front. (After all, you don't want to buy an outdated Elements book that used a 2008 workflow, you want one for today's workflow.) This affects other old-school features like Elements' Levels feature, which was actually in the original version of Photoshop 1.0 (released back in 1990) and has hardly changed much since. Today we really don't use Levels as often; we use the Exposure, Whites, and Blacks controls found in Camera Raw instead. Just thought you should know this up front.

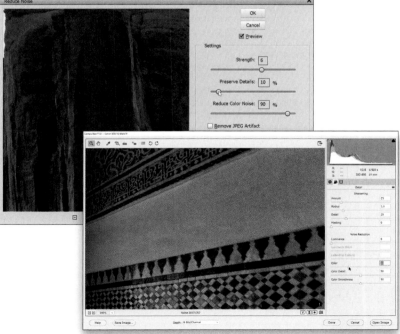

(5) The intro pages at the beginning of each chapter are not what they seem.

The chapter introductions are designed to give you a quick mental break between chapters, and honestly, they have little to do with what's in the chapter. In fact, they have little to do with anything, but writing these quirky chapter intros has become kind of a tradition in all my books, so if you're one of those really "serious" types, I'm begging you, skip them and just go right into the chapter because they'll just get on your nerves. However, the short intros at the beginning of each individual project, up at the top of the page, are usually pretty important. If you skip over them, you might wind up missing stuff that isn't mentioned in the technique itself. So, if you find yourself working on a technique, and you're thinking to your-self, "Why are we doing this?" it's probably because you skipped over that intro. So, just make sure you read it first, and then go to Step One. It'll make a difference—I promise.

(6) There are things in Elements 2020 and in Camera Raw that do the exact same thing.

For example, there's a way to reduce noise in a photo in Camera Raw and there's a way to do it in the Elements Editor, as well. And, they look almost identical. What this means to you is that some things are covered twice in the book. As you go through the book, and you start to think, "This sounds familiar," now you know why. By the way, in my own workflow, if I can do the exact same task in Camera Raw or the Editor, I always choose to do it in Camera Raw, because it's faster (there are no progress bars in Camera Raw) and it's non-destructive (so I can always change my mind later).

Continued

(7) I included my Elements 2020 workflow, but don't read it yet.

At the end of Chapter 12, I included a special tutorial detailing my own Elements 2020 workflow. But, please don't read it until you've read the rest of the book, because it assumes that you've read everything else in the book already, and understand the basic concepts, so it doesn't spell everything out (or it would be one really, really long drawn-out tutorial).

(8) What new stuff is in this book?

Elements 2020 is a pretty good upgrade for photographers, and thankfully Adobe continued with their tradition of taking some of the coolest features from the full-blown version of Photoshop and bringing them over to Elements (but usually in a much more refined or easier-to-use way, so it feels right at home here in Elements). One of the features they brought over in this update is the Select Subject selection feature from Photoshop. They added some new guided edits, along with some useful updates in the Organizer—things like being able to use Smart Tags and facial recognition on your videos. And, of course, all the cool new stuff is covered here in the book.

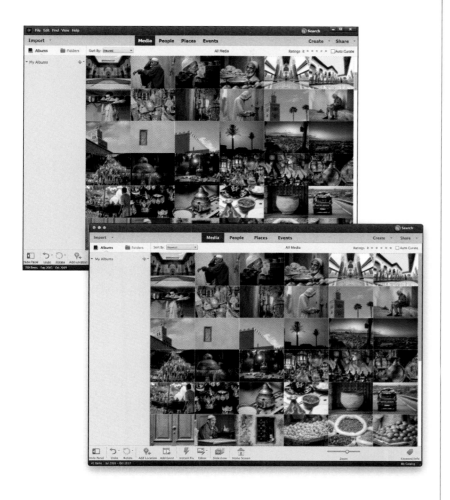

(9) This book is for Windows and Mac users.

Elements 2020 is available for both Win--dows and Macintosh platforms, and the two versions are nearly identical. However, there are three keys on the Mac keyboard that have different names from the same keys on a PC keyboard, but don't worry, I give you both the Windows and Mac shortcuts every time I mention a short-cut (which I do a lot). Also, the Editor in Elements 2020 is the same on both platforms, but the Organizer (where we sort and organize our images) was only made available on the Mac starting with Elements 9. As a result, there are some Organizer functions that still aren't avail-able on the Mac yet, and I've noted it in the book wherever this is the case.

(10) Elements has a Home Screen.

The Home Screen appears when you launch Elements and you can get to it at anytime by clicking the Home Screen button in the taskbar at the bottom of either the Editor or the Organizer. It's kinda mis-named, as it really should be called the "I need some ideas of what to do" screen, but that's too many letters, so they went with Home Screen. It's a bunch of little cards, letting you know what's new in this latest version (feature-wise), it gives you some ideas of things you can do in Elements, there's some inspirational stuff there and some how-tos, and well…you're not going to spend much time here because you're about to become an Elements shark. But, I thought I'd at least let you know up front that: (a) it's there, (b) you prob-ably won't need it for anything, but (c) in case you're curious, you can check it out. Okay, time to get to work—turn the page and let's rock this thing!

Location: Koutoubia Mosque, Marrakesh, Morocco | Exposure: 1/1600 sec | Focal Length: 102mm | Aperture Value: *f*/4.5

The Organizer
managing photos using the organizer

I know what you're probably thinking: "Scott, I thought that it was your tradition to name your chapter titles after a song, movie title, or TV show, yet this is named exactly what the chapter is about—the Organizer. I'm a bit disappointed." Okay, while I do name my chapters after one of those (a song, TV show, or movie title), I do try to choose a name that is still at least somewhat relevant to the content of the chapter, and believe it or not, when I typed "Organizer" into the iTunes Store search field, not only did I find a song named "Organizer" (by rapper Chubb Rock), but I actually found a song named "The Organizer" (by Chris Murray). Chubb's "Organizer" has an old-school feel to it, so I totally dug it (ain't no school like the old school), and while it would make a solid title for this chapter, it's just not as perfect a title as "The Organizer," so I went with that. I will tell you that I made the mistake of listening to the free iTunes preview of "The Organizer," and I have to say, it was startlingly bad. I feel terrible saying this, but it sounds like a sound track from a silent movie performed on someone's home organ and recorded on a 1970s cassette recorder designed strictly for spoken-word recordings. Again, I feel bad about this harsh critique, because I'm sure Mr. Murray is a nice man, and judging strictly by the style of music being played, Mr. Murray was probably a war hero, maybe defending us from the Brits at the Battle of Fort Ticonderoga, because he has to be at least a couple of hundred years old. It's music your great grandparents would listen to and complain that it's too "old-fashioned" for them. It's music to churn butter by and would be a welcome distraction as background music while driving that wagon train out West over the Allegheny Mountains and along the Santa Fe Trail, until the wagon master would finally bring the wagons to a halt and yell, "Would someone please turn off that awful organ music?!" At which point, one of the pioneers would yell back, "What's an organ?" Ah, it was a simpler time then.

Importing
Your Photos

One of the major goals of Adobe Photoshop Elements is simply to make your life easier and the Photo Downloader is there to help do just that. Adobe has not only made the process of getting your photos from your digital camera into the Elements Organizer much easier, they also included some automation to make the task faster. Why? So you can get back to shooting faster. Here's how to import your photos and take advantage of this automation:

Step One:
When you attach a memory card reader to your computer (or attach your camera directly using a USB cable), the Elements Organizer – Photo Downloader standard dialog appears onscreen (if you have it set that way; by the way, it will also download photos from your mobile phone). The first thing it does is it searches the card for photos, and then it tells you how many photos it has found, and how much memory (hard disk space) those photos represent.

TIP: Import in Bulk
If you have a lot of images on your computer that you'd like to import into the Organizer, there's a feature in Elements that lets you easily import a large number of images at once. Just go under the File menu, under Get Photos and Videos, and choose **In Bulk.**

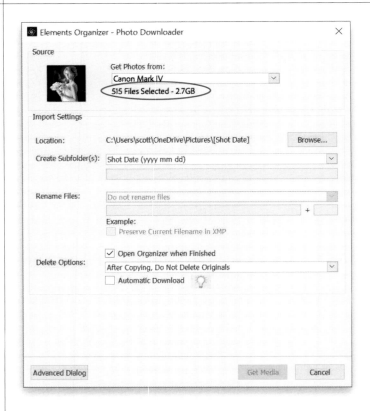

Step Two:
The Import Settings section is where you decide how the photos are imported. You get to choose where (on your hard disk) they'll be saved to, and you can choose to create subfolders with photos sorted by a custom name, today's date, when they were shot, and a host of attributes you can choose from the Create Subfolder(s) pop-up menu (as shown here).

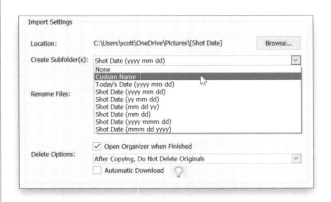

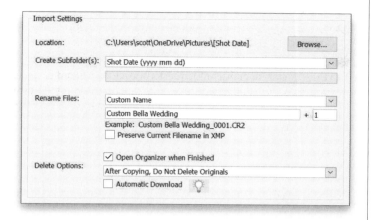

Step Three:

If you want to rename files as they're imported, you can do that in the next field down. You can use the built-in naming conventions, but I recommend choosing **Custom Name** from the Rename Files pop-up menu, so you can enter a name that makes sense to you. You can also choose to have the date the photo was shot appear before your custom name. Choosing Custom Name reveals a text field under the Rename Files pop-up menu where you can type your new name (you get a preview of how it will look). By the way, it automatically appends a four-digit number starting with 0001 at the end of your filename to keep each photo from having the same name.

TIP: Storing the Original Name

If you're fanatical (or required by your job) and want to store the original filename, turn on the Preserve Current Filename in XMP checkbox and your original filename will be stored in the photo's metadata.

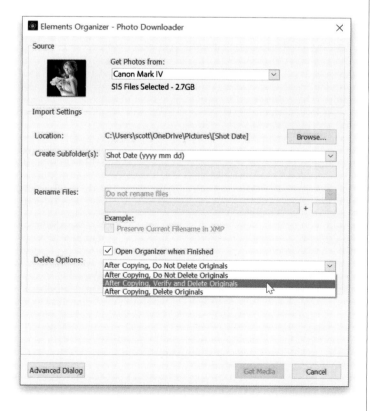

Step Four:

The last setting here is Delete Options. Basically, it's this: do you want the photos deleted off your memory card after import, or do you want to leave the originals on the card? What's the right choice? There is no right choice—it's up to you. If you have only one memory card, and it's full, and you want to keep shooting, well… the decision is pretty much made for you. You'll need to delete the photos to keep shooting. If you've got other cards, you might want to leave the originals on the card until you can make a secure backup of your photos, then erase the card later.

Continued

Step Five:

Beneath the Delete Options pop-up menu is the Automatic Download check-box (this feature is currently only available in the PC version of Elements 2020) and this lets you skip the Photo Downloader. When you plug in a memory card reader, or camera, it downloads your photos using your default preferences, with no input from you (well, except it asks whether you want to erase the original photos on the card or not). To set up these preferences, go under the Organizer's Edit menu, under Preferences, and choose **Camera or Card Reader** to bring up the dialog you see here.

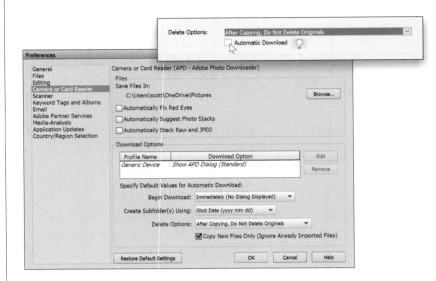

TIP: Auto-Import with Watched Folders

You can set up folders for Elements to "watch" (choose **Watch Folders**, under the File menu), and any images you save in these folders will automatically be imported. You can now even set up Cloud folders, like Dropbox, Google Drive, iCloud (for iPhone users) and OneDrive for auto-import.

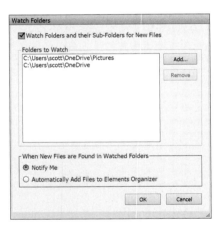

Step Six:

Here is where you decide what happens when you turn on the Automatic Download checkbox in the Photo Downloader. You get to choose a default location to save your photos (like your Pictures folder), and whether you want it to automatically fix any photos that it detects have red eye. You can also choose to have it automatically suggest photo stacks (it groups photos it thinks belong together), or automatically stack images shot in both RAW and JPEG. You can have settings for specific cameras or card readers (if you want separate settings for your mobile phone, or a particular camera). At the bottom, you've got some other options (when to begin the downloading, if you're going to have subfolders, and your delete options). Click OK when the preferences are set the way you want them.

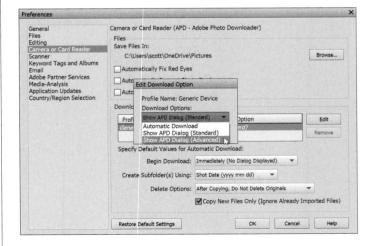

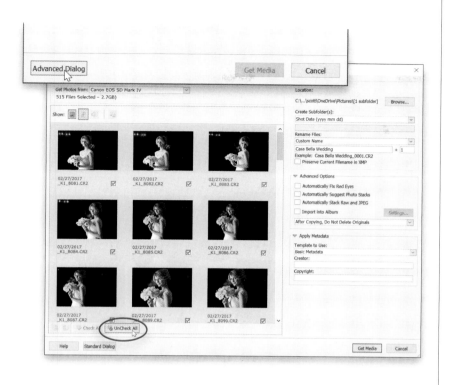

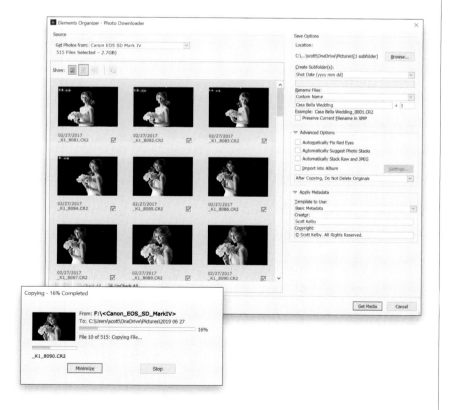

Step Seven:

Okay, back to the Photo Downloader. Now, at this point, all the photos on the card will be imported, but if you want to import just a few selected photos, then you'll need to click on the Advanced Dialog button at the bottom-left corner of the dialog (shown at the top). That expands the dialog and displays thumbnails of all the photos on the card. By default, every photo has a checkbox turned on below it, indicating that every photo will be imported. If you just want some of these photos imported, then you'll need to click the UnCheck All button at the bottom left of your thumbnails. This turns off all the photos' checkboxes, which enables you to then go and turn on the checkboxes below only the photos you actually want imported.

Step Eight:

When you look at the right side of the dialog, you'll see some familiar Save Options (the subfolder choice, renaming files), and in the Advanced Options section, you'll see choices to automatically fix red eyes, suggest photo stacks, stack images shot in both RAW and JPEG, import into an album, and delete options. Another nice feature is the ability to embed metadata (like your name and your copyright info) directly into the digital file, just like your camera embeds information into your digital camera images. So, just type in your name and your copyright info, and these are embedded into each photo automatically as they're imported. This is a good thing. When you click Get Media, your photos are imported (well, at least the photos with a checkmark under them). If you want to ignore these advanced features and just use the standard dialog, click on the Standard Dialog button.

Backing Up Your Photos to a Hard Drive

When you think about backing up, I'd like you to consider this: it's not a matter of *if* your hard drive will crash, it's a matter of *when*. I've personally had new and old computers crash. So many times that now I'm totally paranoid about it. Sorry, but it's a harsh fact of computer life. You can protect yourself, though, by backing up your entire catalog to an external hard drive, and/or using an online backup, so your photos are protected in an off-site location. So even if your hard drive dies or your computer is lost, stolen, damaged in a fire, flood, or hurricane, you can retrieve your images.

Step One:
To back up your catalog to an external hard drive, you simply go under the Organizer's File menu and choose **Back-up Catalog** (as shown here).

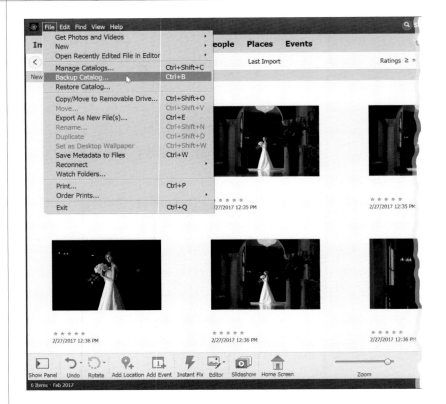

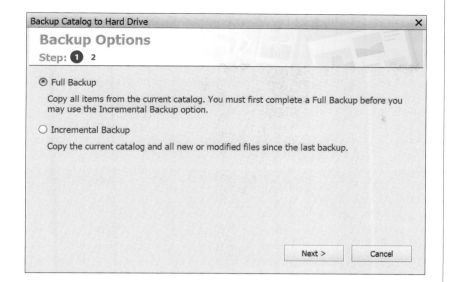

Step Two:
This brings up a dialog where you decide whether to do a Full Backup (you choose this the first time you back up your catalog), or an Incremental Backup (which is what you'll choose after your first backup, as it only backs up the files that have changed since your last backup, which is a big time saver). In this case, since this is your first time, choose Full Backup (as shown here), then click the Next button.

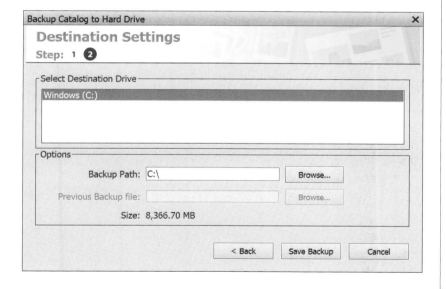

Step Three:
When you click Next, the Destination Settings screen appears, which is basically where you tell Elements to back up your stuff to—just choose your external hard drive from the list and click the Save Backup button.

Importing Photos from Your Scanner

If you're reading this and thinking: "But this is supposed to be a book for digital photographers. Why is he talking about scanning?" Then ask yourself this: "Do I have any older photos lying around that I wish were on my computer?" If the answer is "Yes," then this tutorial is for you. We'll take a quick look at importing scanned images into the Organizer.

Step One:
In the Elements Organizer, go under the File menu, under Get Photos and Videos, and choose **From Scanner**. By the way, in the Organizer, you can also use the shortcut **Ctrl-U** to import photos from your scanner or click on Import just below the menu bar and choose **From Scanner**. (*Note:* This feature is currently only available in the PC version of Elements 2020.)

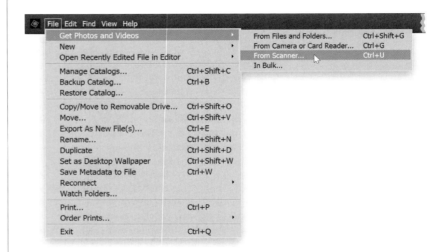

Step Two:
Once the Get Photos from Scanner dialog is open, choose your scanner from the Scanner pop-up menu. Choose a high Quality setting (I generally choose the highest quality, unless the photo is for an email to my insurance company for a claim—then I'm not as concerned), then click OK to bring in the scanned photo. See? Pretty straightforward stuff.

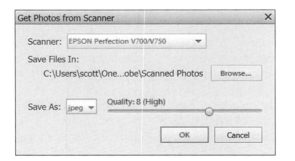

We all have our personal preferences. Some people like to cram as many photos onscreen at once as they can, while others like to see the photos in the Organizer's Media Browser at the largest view possible. Luckily, you have total control over the size they're displayed at.

Changing the Size of Your Photo Thumbnails

Step One:
The size of your thumbnails is controlled by a slider below the right side of the Media Browser. Click-and-drag the Zoom slider to the right to make them bigger and to the left to make them smaller.

TIP: Jumping Up a Size
To jump up one size at a time, click on a thumbnail, then press-and-hold the **Ctrl (Mac: Command) key** and press the **+** (plus sign) **key**. To go down in size, press **Ctrl--** (minus sign; **Mac: Command--**).

Step Two:
To jump to the largest possible view, just double-click on your thumbnail. At this large view, you can enter a caption directly below the photo by clicking on the placeholder text (which reads "Click here to add caption") and typing in your caption. (*Note:* If you don't see this text, go under the View menu and choose **Details**.) Press **Esc** to return to the grid view, or click on the Grid button in the top left of the Media Browser.

Seeing Full-Screen Previews

If you like seeing a super-big view of your photos, then use Elements' Full Screen view. It shows you a huge preview of a selected thumbnail without having to leave the Organizer. Here's how:

Step One:
To see a full-screen preview of your currently selected photo(s), go under the View menu, and choose **Full Screen** (or press **F11 [Mac: Command-F11]**).

Step Two:
This brings you into Full Screen view, and your photo should appear large onscreen with everything else black around it. This is really a way to launch into a slide show, but if you don't do anything here, you're simply just viewing your photos in a larger view. If you want to return to the Media Browser, press the **Esc key** on your keyboard. But wait, there's more.

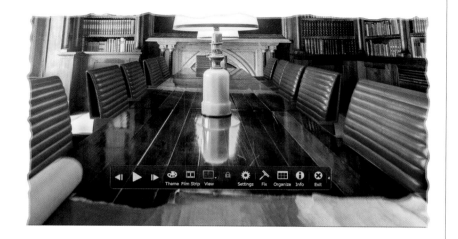

Step Three:
Once your photo(s) appears full screen, there's a control palette at the bottom of the screen where you can control your viewing options—click the Play button to start moving through your photos and click the Pause button to stop. You can also click the Right Arrow and Left Arrow buttons to view the next or previous photo.

Step Four:
One more thing: Try clicking the Toggle Film Strip button on the control palette (or just press **Ctrl-F [Mac: Command-F]**). This opens a filmstrip view of your photos on the bottom of the screen. So you don't necessarily have to click the Right Arrow button or press the Right Arrow key a bunch of times to get to a photo that's 25 photos into your list. You can just scroll the filmstrip until you see it and click on it. Nifty, huh?

Sorting Photos by Date and Viewing Filenames

When photos are imported into the Organizer, the Organizer automatically sorts them by date. How does it know on which dates the photos were taken? The time and date are embedded into the photo by your digital camera at the moment the photo is taken (this info is called EXIF data). The Organizer reads this info and then sorts your photos automatically by date, putting the newest ones on top. You can change that, though, and you can choose whether or not to view your filenames.

Step One:

By default, the newest photos are displayed first, so basically, your last photo shoot will be the first photos in the Organizer. You can see the exact date and time each photograph was taken by going under the View menu, and choosing **Details**. If you want to see the filenames, then under the View menu, choose **File Names**, as well.

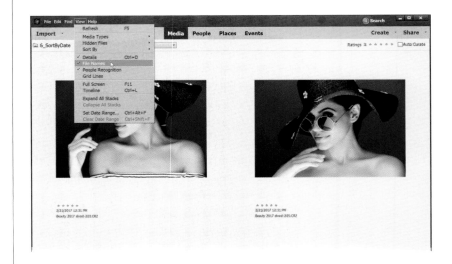

Step Two:

If you'd prefer to see your photos in reverse order (the oldest photos up top), then choose **Oldest** from the Sort By pop-up menu above the top left of the Media Browser. There you have it!

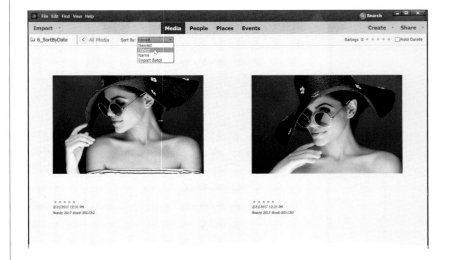

Let's say you travel between time zones and you import a bunch of photos. Well, they're all going to show up with the date and time that was set in your camera from your home location, not where you traveled. No sweat, though. If you ever want to change them to account for the time zone changes (or any other date/time you'd like), Elements has a way.

Change the Time & Date of Your Photos (Great, If You Travel)

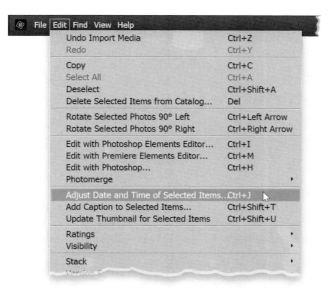

Step One:
First, select all the photos you want to set the time and date for by Ctrl-clicking (Mac: Command-clicking) on each image (or Shift-clicking on the first and last images if they are contiguous) in the Media Browser. Then, go under the Organizer's Edit menu and choose **Adjust Date and Time of Selected Items** (or press **Ctrl-J [Mac: Command-J]**).

Step Two:
This brings up a dialog asking how you want to handle the date and time for these photos. For this example, select Shift by Set Number of Hours (Time Zone Adjust) and click OK.

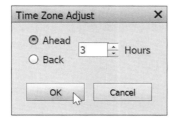

Step Three:
This brings up the Time Zone Adjust dialog, where you just choose whether you want to move the time ahead or back, and by how many hours. When you're done, click OK and the date/time for the photos will be changed.

Finding Photos Fast by Their Month & Year

By default, the Organizer sorts your photos by date and time, with the most recent photos appearing at the top. You know and I know that it's hard to always remember when you took some of your favorite photos, though. With the Timeline, you can at least get pretty close. Let's say you're trying to find photos you took in Lisbon in fall 2017. You may not remember exactly whether it was October or November, but by moving a slider you can find them really fast.

Step One:
First things first: You need to display the Timeline to use it. Go under the View menu and choose Timeline (or just press **Ctrl-L [Mac: Command-L]**). It'll appear right above the Media Browser. We're going to assume you're trying to find photos you took in Lisbon in fall 2017 (as mentioned above). You see those bars along the Timeline that look like the little bar charts from Microsoft Excel? Well, the higher the bar, the more photos that appear in that month. So click on any month in 2017 and the photos taken in that month will appear in the Media Browser. As you slide your cursor to the left (or right), you'll see each month's name appear. When you move to October, photos taken in October 2017 will appear. Take a quick look to see if any of those photos are the ones from that trip. If they're not in October, scroll on the Timeline to November, and those photos will be visible.

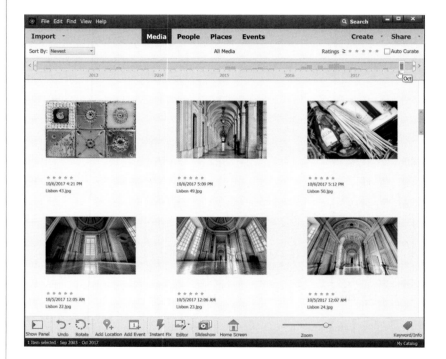

The way we search through a huge library of photos and videos and have a chance of actually finding the ones we're looking for is by applying keywords (search terms) to each photo, and now video (new in Elements 2020). The downside of all this is the time it takes to keyword thousands of photos and videos. Luckily, that whole process is a lot easier thanks to Smart Tags, where Elements does the keywording for you automatically, and Enhanced Search, which takes the power of those tags and helps you find the images or videos you're looking for fast.

Smart Tags and Enhanced Searching

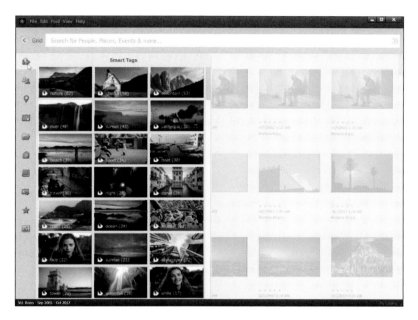

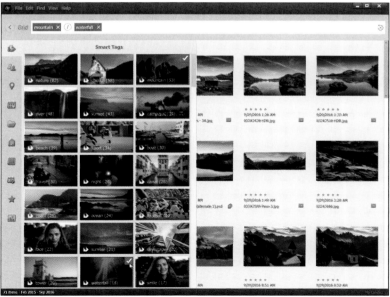

Step One:
In the top-right corner of the Organizer, click on Search. This brings up a Search window, and you'll see icons on the left representing things you can search for. The first icon at the top is the Smart Tags icon. Click on it and the Smart Tags panel pops out (as seen here), where you'll see thumbnails with the names of each Smart Tag that Elements automatically applied to your images and videos (you don't have to do anything to start this automatic smart tagging, it's turned on by default), along with how many images and videos are tagged with each Smart Tag.

Step Two:
To see the images that have a particular Smart Tag applied to them, just click on the thumbnail and they appear in the Search window (behind the side panel). For example, here, I clicked on the Smart Tag "mountain," and instantly all the images that Elements automatically tagged with the keyword mountain now appear. Now, let's expand our search: if you tap on the thumbnail for "waterfall," it shows you all the images with "waterfall" and "mountain" applied as keywords. If you look at the search field at the top of the screen, you'll see "mountain / waterfall" (that's your current search string). The cool (and powerful) thing is that you can keep adding more (or fewer) search terms (Smart Tags) just by clicking on those thumbnails, or click on the "x" to the right of a Smart Tag in the search field to remove it from your search.

Continued

Step Three:

Now, if there's a particular image or video that has a Smart Tag that either you don't want applied, or it's just wrong, you can remove it by clicking on it, then clicking the Back arrow button in the top left to go back to the Media Browser. Then, Right-click on the photo and, under **Remove Smart Tag**, you'll see a list of Smart Tags applied to the image. Choose the one you want to remove, and it's gone. If you want to turn off this automatic Smart Tagging altogether, go to the Organizer's Preferences **(Ctrl-K [Mac: Command-K])**, click on Media-Analysis on the left, and turn off the Images and/or Videos checkboxes under Automatically Analyze Media. That turns off the automatic tagging. (By the way, any tags it applied before you turned this off will still be there. This just turns off the feature going forward.)

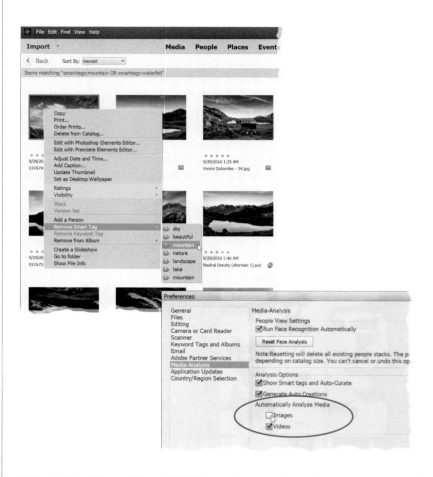

Step Four:

So, the first icon at the top left is for seeing the Smart Tags that Elements added, but you can also see some other preset categories by moving your cursor over the other icons. When you do, it displays photos tagged with those categories, and you can add them to your search, just like you would with Smart Tags. There are icons for People, Places, Date, Folders, Keywords (ones you assigned to photos yourself), Albums, Events, star ratings, and even different types of media (photos, audio files, videos, and projects. Whew!). Here, I moved my cursor over the Places icon and you can see the places that I added photos to (we'll look at Places, as well as some of these other categories, later in this chapter). (*Note:* If you want to go "old school," you can type in search terms in the search field up top—just put a + [plus sign; for "and"] or / [forward slash; for "or"] between each search term.)

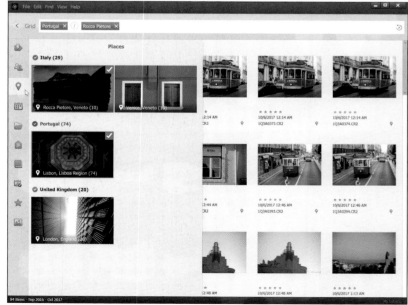

The real power of the Organizer appears when you assign tags (keywords) to your photos. This simple step makes finding the exact photos you want very fast and very easy. We just looked at the new Smart Tags feature, but you can also add keyword tags to your images manually. The first step is to decide whether you can use the pre-made tags that Adobe puts there for you or whether you need to create your own. In this situation, you're going to create your own custom tags.

Tagging Your Photos (with Keyword Tags)

Step One:
Start by finding the Tags palette in the Organizer (it's on the right side of the window). Adobe's default set of keyword tag categories will appear in a vertical list. Now, there are a few different ways to tag photos, so let's take a look at them all. In the end, they all do the same thing, just in a different way.

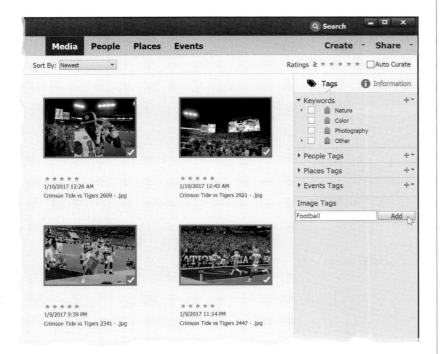

Step Two: The Really Easy Way
Let's start by tagging the really easy way. Type a tag name in the Add Custom Keywords text field at the top of the Image Tags palette (right below the Tags palette). Then in the Media Browser, click on the photo (Ctrl-click [Mac: Command-click] to select multiple photos) you want to assign this tag to and click the Add button to the right of the text field. The tag will automatically be created and applied to the selected photo(s).

TIP: Use an Existing Keyword Tag
Since the Image Tags text field dynamically displays existing keyword tags (in a pop-up menu) based on the letters you type, you can use it to assign an existing keyword tag to your photos instead of creating a brand new one.

Continued

Step Three: The More Customized and Visual Way

The thing about Step Two is that it automatically creates your tag in the Other category. As you start tagging, you may want to categorize your tags and even create your own categories. So, let's start by creating a custom category (in this case, we're going to create a category for college football shots). Click on the Create New Keyword Tag button (the little green plus sign) at the top right of the Tags palette and choose **New Category** from the pop-up menu. This brings up the Create Category dialog. Type in a name for your category (I typed "College Football"). Now choose an icon from the Category Icon list and then click OK. (The icon choices are all pretty lame, so we'll just choose the icon that looks like a ball here.)

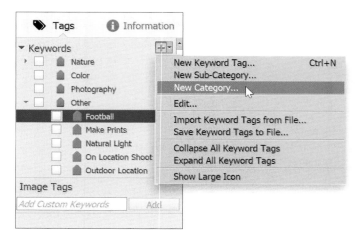

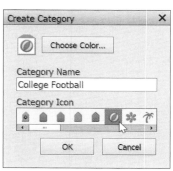

Step Four:

To create your own custom tag within your new category, click on the Create New Keyword Tag button again and choose **New Keyword Tag**. This brings up the Create Keyword Tag dialog. Choose College Football from the Category pop-up menu (if it's not already chosen), then in the Name field, type in a name for your new tag (here I entered "National Championship"). If you want to add additional notes about the photos, you can add them in the Note field, and you can choose a photo as an icon by clicking the Edit Icon button. Now click OK to create your tag.

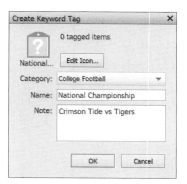

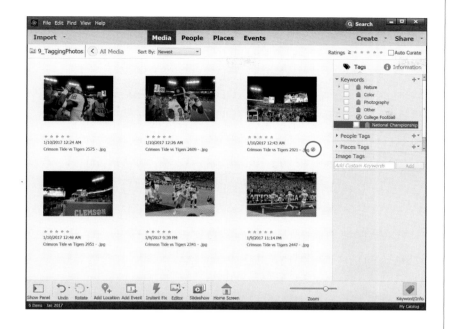

Step Five:
Next, you'll assign this tag to all the photos from this shoot. In the Media Browser, scroll to the photos from that shoot. We'll start by tagging just one photo, so click on your new tag that appears in your Keywords list in the Tags palette and drag-and-drop that tag onto any one of the photos. That photo is now "tagged" and you'll see a small tag icon appear below the right side of the photo's thumbnail.

Step Six:
So at this point, we've only tagged one photo from this shoot. Drag-and-drop that same tag onto three more photos from the shoot, so a total of four photos are tagged. Now, in the Tags palette, click in the box to the left of the tag, and just those photos with that tag appear in the Media Browser. To see all your photos again, click in the box again.

TIP: Using Your Touchscreen
Back in Elements 15, they gave us touch-screen capabilities. So, if you have a touchscreen computer, you can just tap on your screen to do lots of things in the Organizer, like editing, sorting, and tagging.

Tagging Multiple Photos

Okay, if you had to tag any more than a few photos, you've probably realized that dragging-and-dropping the tag onto each photo is a pain in the neck. If you had a whole photo shoot, that process would take forever and you'd probably be getting ready to send Adobe (or me for even showing you this feature) a nasty email. You'll be happy to know there are faster ways than this one-tag-at-a-time method. For example…

Step One:
To tag all the photos from your shoot at the same time, try this: First, click on any photo from the shoot. Then press-and-hold the Ctrl (Mac: Command) key and click on other photos from that particular shoot. As you click on them, they'll become selected (each selected photo will have a blue stroke around it). Or, if all the photos are contiguous, click on the first image in the series, press-and-hold the Shift key, and then click on the last image in the series to select them all.

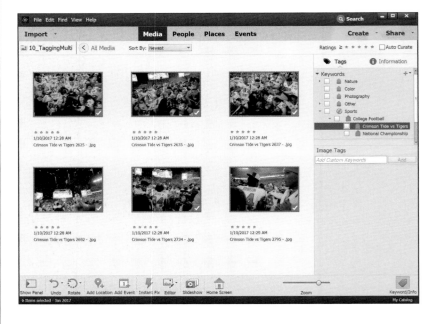

Step Two:
Now, drag-and-drop your chosen tag onto any one of those selected photos, and all of the selected photos will have that tag (here, I created a new Sports category, then made College Football a sub-category within it, and then added a Crimson Tide vs Tigers keyword tag). If you want to see just the photos from that shoot, click in the box to the left of that tag in the Tags palette and only photos with that tag will appear. By the way, if you decide you want to remove a tag from a photo, just Right-click on the tag icon below the photo and from the pop-up menu that appears, choose **Remove Keyword Tag**. If you have more than one tag applied, you can choose which tag you want removed by Right-clicking on its icon.

Okay, what if you want to assign a keyword tag to a photo, but you also want to assign other keyword tags (perhaps an "Upload to Website" tag and a "Make Prints" tag) to that photo, as well? Here's how:

Assigning Multiple Tags to One Photo

Step One:
To assign multiple tags at once, first, of course, you have to create the tags you need, so go ahead and create your new tags by clicking on the Create New Keyword Tag button and choosing **New Keyword Tag** from the pop-up menu. Name them "Upload to Website," "Make Prints," and two others specific to this shoot. Now you have four tags you can assign. To assign all four tags at once, just press-and-hold the Ctrl (Mac: Command) key, then in the Tags palette, click on each tag you want to assign (Palm Trees, Make Prints, Upload to Website, and Morocco).

Step Two:
Then, click-and-drag those selected tags, and as you drag, you'll see you're dragging four tag icons as one group. Drop them onto a photo, and all four tags will be applied at once. If you want to apply the tags to more than one photo at a time, first press-and-hold the Ctrl (Mac: Command) key and click on all the photos you want to have all four tags. Then, go to the Tags palette, press-and-hold the Ctrl key again, and click on all the tags you want to apply. Drag those tags onto any one of the selected photos, and all the tags will be applied at once. Cool.

Tagging People in Photos and Videos

You're either going to think this is the coolest, most advanced technology in all of Elements, or you're going to think it's creepy and very Big Brother-ish (from the book by George Orwell, not the TV show). Either way, it's here to help you tag people easier because the Organizer can automatically find photos, and now videos, of people for you—as it has some sort of weird science, facial-recognition software built in (that at one point was developed for the CIA, which is all the more reason it belongs in Elements).

Step One:

Let's say you want to quickly find all the photos of your sister. In the Organizer, at the top, click on People. By default, this shows all the people in your catalog that you haven't tagged with a name, and that are in at least four photos. To see all unnamed people, turn off the Hide Small Stacks checkbox at the top left.

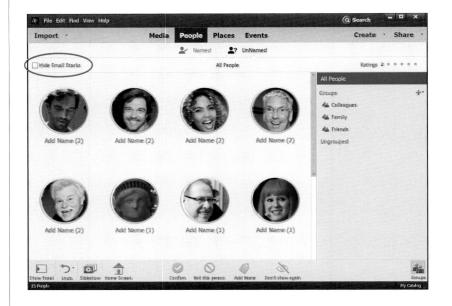

Step Two:

Just click on Add Name beneath one of the image thumbnails, type in a name to tag the photo(s) with, and press Enter (Mac: Return) or click the checkmark. If the keyword doesn't already exist, this will create a new one. If Elements found something that isn't a person in a photo (like the Statue of Liberty at the bottom) or is someone you don't know (like from a travel photo or football game), click on the thumbnail and click the Don't Show Again button in the taskbar at the bottom. The thumbnail will be removed from People view. If multiple images contain the same people, they'll be stacked beneath the thumbnail, and the name you add to the thumbnail will be added to them, as well.

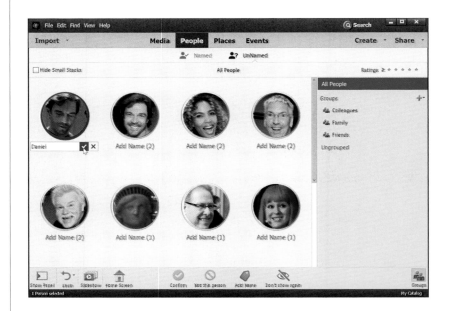

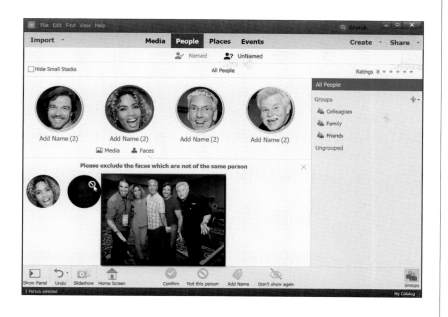

Step Three:

When you hover your cursor over a thumbnail, Media and Faces buttons appear below it. Click on Media to see all the photos that person is in. Click on Faces to see a close-up of the face in each. If you hover your cursor over one of these close-ups, a preview of the entire image appears. If this isn't the right person, you have two options: The first is to click the international symbol for "No!" that appears in the top right of the close-up and it will be removed from the stack. The second is to click on that close-up to select it, click the Add Name button in the taskbar, then add that person's name in the dialog that appears, and they will be removed from the stack. Once you're done removing people that don't match from a stack, add the remaining person's name as we did in Step Two. That will move the entire stack under the Named header.

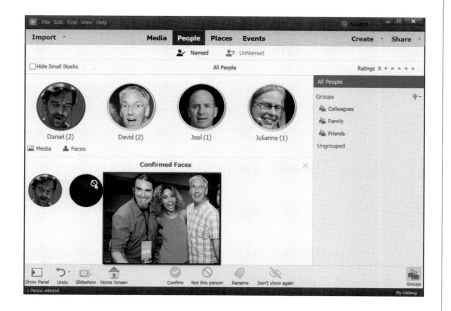

Step Four:

When you finish adding names to your people photos, they will all be stacked by name under the Named header (seen here). If you move your cursor over a stack from left to right (or right to left), it will scroll through the images in the stack, so you don't have to open it to see the rest of the photos in it. If Elements thinks there might be untagged photos of the same person, you'll see an exclamation point in a blue triangle to the left of their name. Click on that triangle to see the faces tagged as that person and the faces Elements thinks could be that person. If it's the same person, click on the checkmark at the top left of the close-up when you move your cursor over it. If it's not, click on the No! symbol. The Groups palette on the right works much like the Tags palette. You can add new groups or use the default ones for Friends and Family. Just drag-and-drop the group name onto the photo stack to add those photos to the group.

Continued

Step Five:

If Elements didn't recognize a face, you can always add it manually. In the Media Browser, double-click on the image with the person you want to tag, then click the Mark Face icon in the bottom taskbar. Click-and-drag the rectangle over the person's face, resize it by dragging any of the corner handles, and then give 'em a name and click the green checkmark.

TIP: Train Elements to Find Faces

The more you tag and the more you use this face tagging technology, the better you train Elements to find faces. Each time you tag faces, it gets more and more accurate.

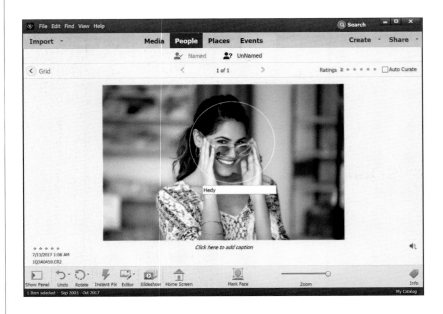

Step Six:

Tagging people in your videos (added in Elements 2020) works the same as tagging them in your photos. Elements searches through your video clips, identifies faces in them, and then puts these videos under the Unnamed header in People view for you. All you have to do is tag those videos with the name of the person it found (after all, it recognizes that there's a face in the video, but it doesn't know if the face is that of Aunt Martha or David Lee Roth—that part you have to help it with). Once you tag those vidoes, they'll appear under the Named header, just like a still image. What's pretty cool about this is that if you click on one of those named thumbnails, a preview pops up (just like with a photo and shown here) and it plays the video from the exact spot where that tagged person appears in the video. How awesome (creepy?) is that!

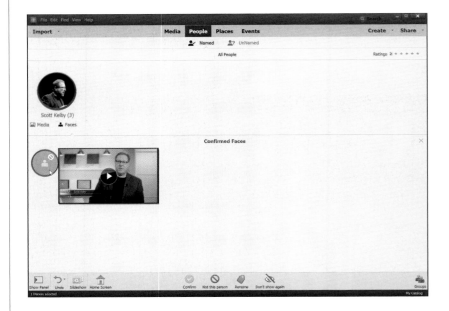

Once you've tagged all your photos, you may want to create a collection of just the best photos (the ones you'll show to your friends, family, or clients). You do that by creating an "album" (which used to be called a collection in earlier versions of Elements). An advantage of albums is that once photos are in an album, you can put the photos in the order you want them to appear (you can't do that with tags). This is especially important when you start creating your own slide shows and web galleries.

Albums: It's How You Put Photos in Order One by One

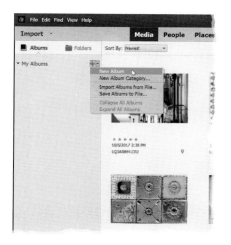

Step One:
To create an album, go to My Albums in the Albums palette on the top-left side of the Organizer (it's below the Import button). You create a new album by clicking on the Create New Album button (the green plus sign), and from the pop-up menu, choosing **New Album**. When the New Album pane appears on the right, enter a name for your album. You can then drag-and-drop images onto the New Album pane to add them to that album, or just click OK and add them after.

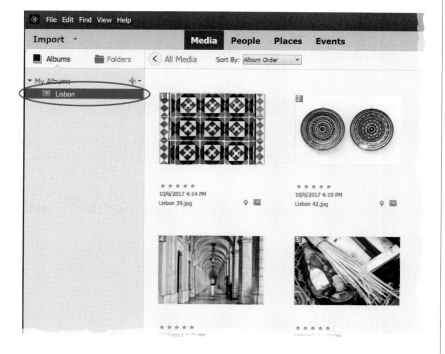

Step Two:
Now that your album has been created, you can either (a) drag the album icon onto the photos you want in your album, or (b) Ctrl-click (Mac: Command-click) on the photos to select them and then drag-and-drop them onto your album icon under My Albums. Either way, the photos will be added to your album. To see just those photos, click on your album name. Now, to put the photos in the order you want, set the Sort By pop-up menu at the top to **Album Order**, then just click on any photo and drag it into position. The Organizer automatically numbers the photos for you in each thumbnail's top-left corner, so it's easy to see what's going on as you click-and-drag. To return to all of your images, click on the All Media button in the top-left corner of the Media Browser.

Choosing Your Own Icons for Keyword Tags

By default, a keyword tag uses the first photo you add to that tag as its icon. Most of the time, these icons are so small that you probably can't tell what the icon represents. That's why you'll probably want to choose your own photo icons instead.

Step One:
It's easier to choose an icon once you've created a keyword tag and tagged a few photos. Once you've done that, Right-click on your tag, and choose **Edit** from the pop-up menu. This brings up the Edit Keyword Tag dialog. In this dialog, click on the Edit Icon button to launch the dialog you see here on the right.

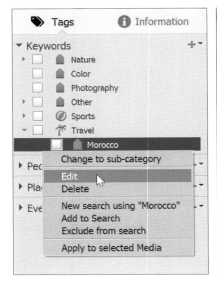

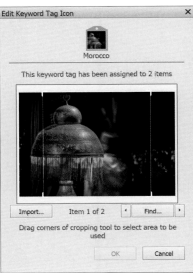

Step Two:
You'll see the first photo you tagged with this keyword in the preview window (this is why it's best to edit the icon after you've added tags to the photos). If you don't want to use this first photo, click the arrow buttons under the bottom-right corner of the preview window to scroll through your photos. Once you find the photo you want to use, click-and-drag the little cropping border around (in the preview window) or make it smaller to isolate a part of it. This gives you a better close-up photo that's easier to see as an icon. Then click OK in the open dialogs and that cropped image becomes your icon.

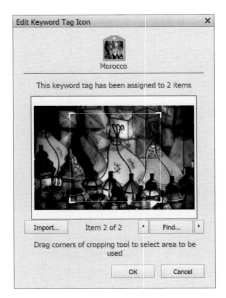

There will be plenty of times when you create a keyword tag or an album and later decide you don't want it anymore. Here's how to get rid of them:

Deleting Keyword Tags or Albums

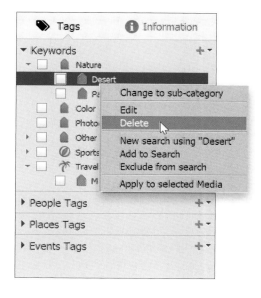

Step One:
To delete a keyword tag or album, Right-click on the keyword tag or album you want to delete in the Tags palette on the right side of the Organizer or under My Albums in the Albums palette on the left, and choose **Delete** from the pop-up menu.

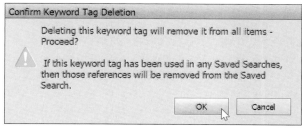

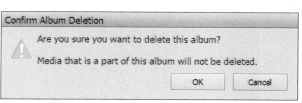

Step Two:
If you're deleting a tag, it brings up a warning dialog letting you know that deleting the tag will remove it from all your photos and Saved Searches. If you want to remove that tag, click OK. If you're deleting an album, it asks if you're sure you want to delete the album. Click OK and it's gone. However, it does not delete these photos from your main catalog—it just deletes that album.

Seeing Your Photo's Metadata (EXIF Info)

When you take a photo with a digital camera, a host of information about that photo is embedded into the photo by the camera itself. It contains just about everything, including the make and model of the camera that took the photo, the exact time the photo was taken, what the f-stop setting was, what the focal length of the lens was, and whether or not the flash fired when you took the shot. You can view all this info (called Exchangeable Image File [EXIF] data—also known as metadata) from right within the Organizer. Here's how:

Step One:

To view a photo's EXIF data, click on the image in the Media Browser and then click on Information in the top right of the Organizer (if you don't see it, click on the Keyword/Info icon on the right side of the taskbar at the bottom of the window) to open the palette.

TIP: Information Palette Shortcut

You can also press **Alt-Enter (Mac: Option-Return)** to open/close the palette.

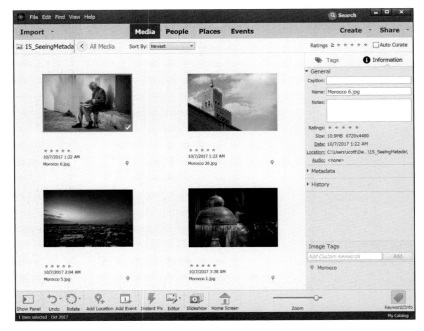

Step Two:

When the Information palette appears, you'll see a General section, a Metadata section, and a History section. Click on Metadata to expand the section. This shows an abbreviated version of the photo's EXIF data (basically, the make, model, ISO, exposure, shutter speed, f-stop, aperture, focal length of the lens, and the status of the flash). Of course, the camera embeds much more info than this. To see the full EXIF data, click on the Complete button (the right of the two buttons) to the right of the word "Metadata," and you'll get more information on this file than you'd probably ever want to know.

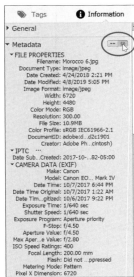

As soon as you press the shutter button, your digital camera automatically embeds information into your photos. But you can also add your own info if you want. This includes simple things like a photo caption (that can appear onscreen when you display your photos in a slide show), or notes for your personal use, either of which can be used to help you search for photos later, or you can add copyright and contact info.

Adding Your Own Info to Photos

Step One:
First, click on the photo in the Media Browser that you want to add your own info to, and then click on Information in the top right of the Organizer (or you can use the keyboard shortcut **Alt-Enter [Mac: Option-Return]**).

Step Two:
In the Information palette, you'll see General, Metadata, and History sections. By default, the General section is selected. In this section, the first field is for adding a caption (I know, that's pretty self-explanatory), and then the photo's filename appears below that. It's the third field down—Notes—where you add your own personal notes about the photo.

Continued

Step Three:

To add your copyright and contact info to your photos, you'll have to select multiple photos, so Ctrl-click (Mac: Command-click) on the photos you want to add this info to, and then click on Information on the right. In the palette, you'll see the number of photos you've selected, as well as an Edit IPTC Information button. Click that button.

Step Four:

This brings up the Edit IPTC Information dialog (shown here). You'll see several IPTC metadata categories on the left-hand side. In the fields below each category, simply type in the information that you'd like to add to your photos (in the example shown here, I just added my basic copyright info in the IPTC Status section). Click Save, and that info will be added to all your selected photos.

TIP: Remove Metadata

There's a Remove IPTC Metadata button at the bottom left of the dialog that lets you delete your metadata. This can be useful if you don't want those metadata-creepers looking at your camera settings like aperture, shutter speed, or even the make/model of your camera.

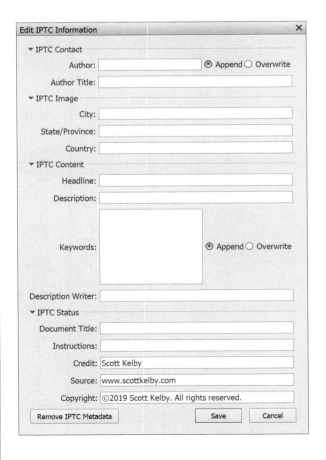

Aside from actually doing things to fix your photos, finding them will be the most common task you do in Elements. If you've tagged them, then it's easy to find groups of photos. But finding just one photo can be a little harder (not really too hard, though). You first have to narrow the number of photos to a small group. Then you'll look through that group until you find the one you want. I know, it sounds complicated but it's really not. Here are the most popular searching methods:

Finding Photos

From the Timeline:
We saw this one earlier. The Timeline (from the View menu, choose **Timeline** to see it), which is a horizontal bar across the top of the Media Browser, shows you all the photos in your catalog. Months and years are represented along the Timeline. The years are visible below the Timeline; the small bars above the Timeline are individual months. If there is no bar visible, there are no photos stored in that month. A short bar means just a few photos were taken that month; a tall bar means lots of photos. If you hover your cursor over a bar, the month it represents will appear. To see the photos taken in that month, click on the bar and only those photos will be displayed in the Media Browser. Once you've clicked on a month, you can click-and-drag the locator bar to the right or left to display different months.

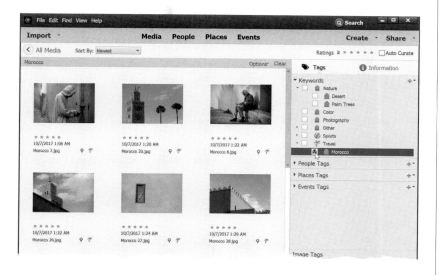

Using Keyword Tags:
If there's a particular shot you're looking for, and you've tagged all your shots with custom tags, then just go to the Tags palette and click in the box to the left of that tag. Now only shots with that tag will appear in the Media Browser.

Continued

By Details (Metadata):

If you want to do a search with more options to really narrow down the results, then go under the Organizer's Find menu and choose **By Details (Metadata)**. In the resulting dialog, you pick your search criteria from pop-up menus, and you can add as many different lines of criteria as you'd like by clicking on the + (plus sign) button on the far-right side of each criteria line. Here, I started by clicking the Any One of the Following Search Criteria [OR] radio button. Then, I searched for the keyword Morocco, but added more criteria, so it only searches for my 5-star images taken with my Canon Mark IV. You can also save this search by turning on the Save this Search Criteria as Saved Search check-box at the bottom and giving the search a name. To use a saved search again, go under the Find menu, choose **By Saved Searches**, and then choose your saved criteria from the Saved Searches dialog.

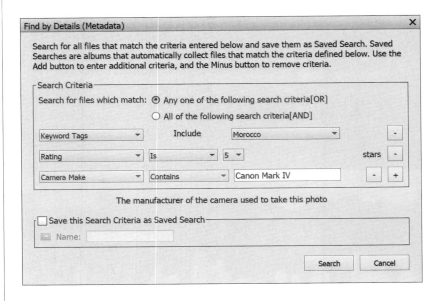

By Caption or Note:

If you've added personal notes within tags or you've added captions to individual photos, you can search those fields to help you narrow your search. Just go under the Organizer's Find menu and choose **By Caption or Note**. Then, in the resulting dialog, enter the word(s) that you think may appear in the photo's caption or note, and click OK. Only photos that have that word in a caption or note will appear in the Media Browser.

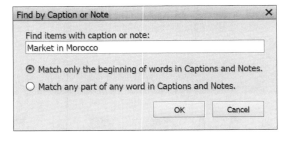

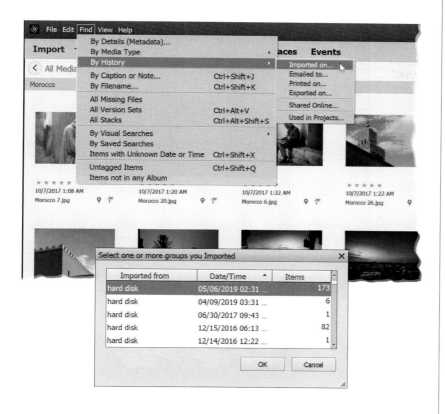

By History:

The Organizer keeps track of when you imported each photo and when you last shared it (via email, print, webpage, etc.), so if you can remember any of those dates, you're in luck. Just go under the Organizer's Find menu, under **By History**, and choose which attribute you want to search under in the submenu. (*Note:* Some of the options shown here are currently not available in the Elements 2020 version for the Mac.) A dialog with a list of names or locations and dates will appear. Click on a date or name, click OK, and only photos that fit that criterion will appear in the Media Browser.

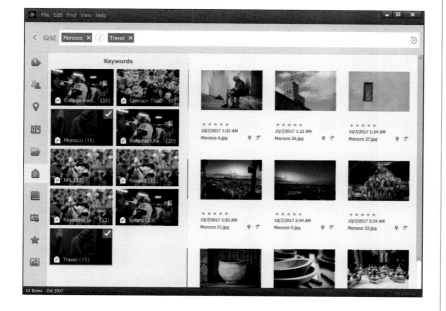

Using the Search Feature:

Elements also has an enhanced Search feature that lets you search for photos by keyword tags, albums, folders, etc. (we looked at this earlier). In fact, it's probably one of the most powerful and easiest ways to search, since you don't have to worry as much about what you're looking for and where to look for it. Just click on Search in the top right of the Organizer window and a bunch of search icons appear on the left. Here, I clicked on the Keywords icon, then clicked on Morocco to find the photos with that keyword. You can click on as many options as you'd like to add them to the search field up top to help narrow down your search (as shown here, where I also clicked on the Travel keyword).

Finding Duplicate Photos

If you're like most photographers out there, when you take a photo of someone (or something), you don't just take one. You take 18 or more. It's totally normal. We figure the more photos we take, the better chance we have that at least one photo will be exactly what we want. The problem comes when we're trying to organize our photos. We tend to build up huge libraries of photos that include a bunch of duplicates. I'm not talking exact filename duplicates (as if we imported the same photo twice), but duplicates in that one photo looks just like another. Well, Elements can help you find them.

Step One:

Let's say you took some vacation photos, and you wanted to quickly sort through them to find the best ones. Chances are you probably shot a bunch of each place you visited to make sure you had at least one good one of each. You only really need one keeper, right? In the Organizer, select the group of photos you want to search through (you can press **Ctrl-A [Mac: Command-A]** to Select All, click on an album, or just Ctrl-click [Mac: Command-click] on as many images as you want to sort through). Then, go under the Find menu, under By Visual Searches, and choose **Duplicate Photos**. Depending on how many photos you're looking through, it can take anywhere from a few seconds for 50 photos to a few minutes for a few thousand.

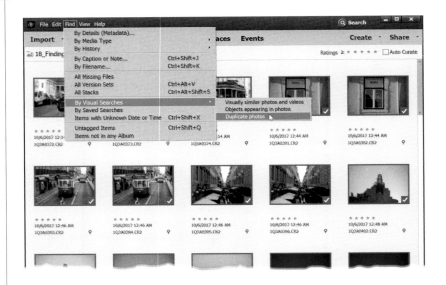

Step Two:

When Elements is done, you'll see the Visual Similarity Photo Search dialog open. Elements will put each series of photos that it finds similar into suggested groups. For me, it was kinda hard to really see what was in each group, because the thumbnails are so small. Since we're going to actually do things with the photos in these series, you may want to increase the size of the thumbnails of the photos using the slider at the top right (circled here).

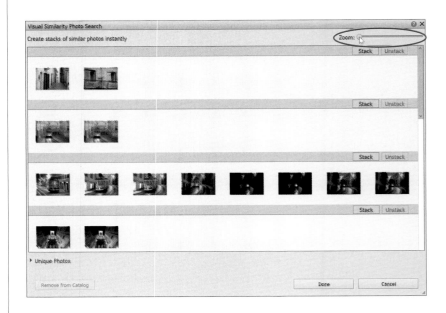

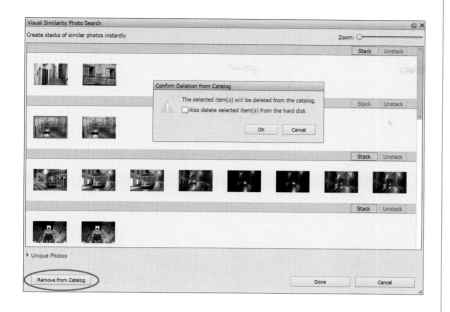

Step Three:

At this point, you've got two choices for what you can do with these suggested duplicate photos: First, you can look through the photos to find the best one from the series (which is why increasing the thumbnail size is helpful here), and then delete the rest, since you'll probably never use them. To do that, simply click on one of the photos (or Ctrl-click to select multiple ones) and click the Remove From Catalog button at the bottom left of the dialog (circled here). If you do that, Elements will give you the option to simply remove the photos from the catalog or remove them from the hard disk, as well. I also remove them from the hard disk altogether, since I don't need them anymore.

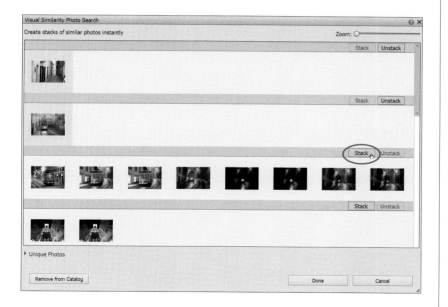

Step Four:

Your other option is to group the series of photos together in a stack. That way, when you're looking at them in the Organizer, you'll have fewer photos to look through since the entire series will be stacked. To stack the photos together, just click the Stack button above the right side of each group. Or, if you only want to stack certain photos from the group together, then select them first, and click the Stack button. When you're done stacking (or removing the photos from the catalog), just click the Done button in the lower-right corner to return to the Organizer.

Creating a Slide Show

If you've ever wanted a quick and easy way to show your photos off on your computer or laptop, then slide shows are one of the best. Add some music, a couple of transitions, and you've got a really nice way to let people sit back and enjoy your work.

Step One:

In the Organizer, Ctrl-click (Mac: Command-click) on the photos you want to display in a slide show, then click on Create in the top right of the window, and choose **Slideshow**.

TIP: Try Some of the Other Organizer Creations

You'll notice that you can create lots of other cools things right from the Organizer's Create menu (like photo books, greeting cards, and even an instant movie). Each option walks you through the process, and it couldn't be easier to create some really fun things with your images.

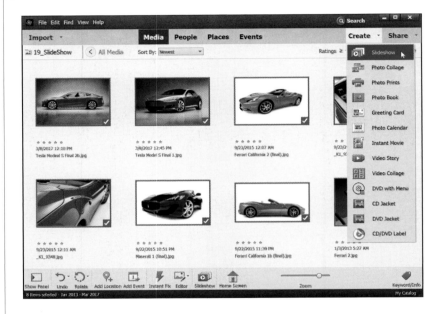

Step Two:

A preview of your slide show will automatically begin generating, and then it will play a preview. Your first choice should be the overall theme you want for the slide show. So, click on the Themes icon on the left side of the window (it's the little palette) to see your choices. Here, I chose Pan & Zoom, but there are a few others you can choose from here.

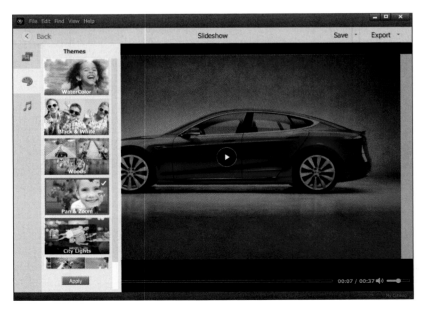

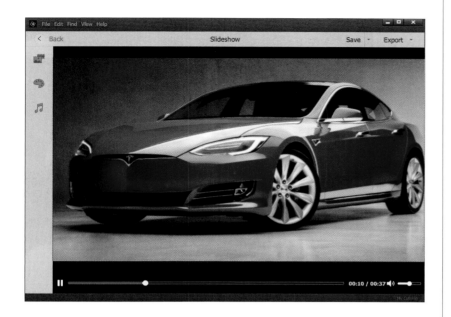

Step Three:

Once you make your choice, click Apply and it will launch you right back into the slide show with the theme you chose. If everything is good and you like the music (I doubt you will), then you could always be done with it and click Save or Export at the top right. But, if you want to customize it a little, then start by clicking on the Audio icon on the left (the music note).

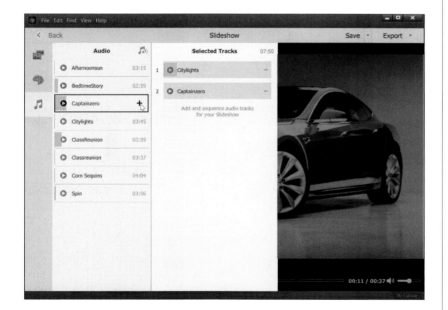

Step Four:

This brings up some options for music that Elements includes. Just click on the play button for each song to hear a preview. If you find one you like, click on the plus sign icon to the right of the song's title to add it to your Selected Tracks list. Once you have a couple songs in your list, you can click-and-drag them in the order you want them to play (if you have a long slide show and want multiple songs to play). To remove a song from the Selected Tracks list, just click on the minus sign icon to the right of the song's name.

Continued

Step Five:

To see a few other options, click on the Media icon on the left (the one with the image and filmstrip). If you've added captions to your photos, turn on the Add Captions checkbox. You can also add text here, if you want to put your name on the slide at the beginning of the slide show or add one to the end, by clicking on the Add Text Slide icon at the top right of the Media options (the second one from the right; be sure to click on the last image in the grid of images first to add an ending slide). A dialog will appear where you can enter a title and subtitle for your slide show, as well as choose a beginning or ending slide (there are different slide options available here for each theme). If you want to add any other images or videos to your slide show, click on the Add Photos and Videos icon at the top right. And, if you want to remove a slide or image from your slide show, just Right-click on it in the grid and choose **Remove**.

Step Six:

Finally, you'll want to save the slide show, so you can get back to it again. To save it in the Organizer, click Save in the top right. If you want to export it to Vimeo or YouTube or just save it as a file on your hard drive that you could send to someone else to view, click on Export.

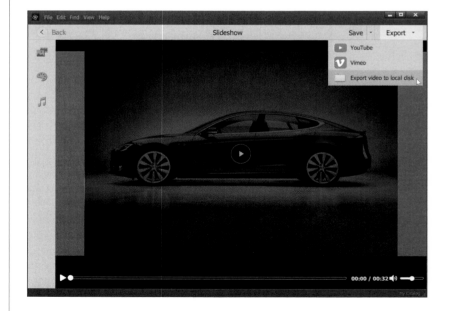

I love stacks, because as much as I try to compare my photos and get rid of the ones that I have duplicates of, I inevitably wind up with several photos that look the same. Well, there's a feature called stacking and it works just like its real-world counterpart does—it stacks several photos on top of each other and you'll just see the top one. So if you have 20 shots of the same scene, you don't have to have all 20 cluttering up your Media Browser. Instead, you can have just one that represents all of them with the other 19 underneath it.

Reducing Clutter by Stacking Your Photos

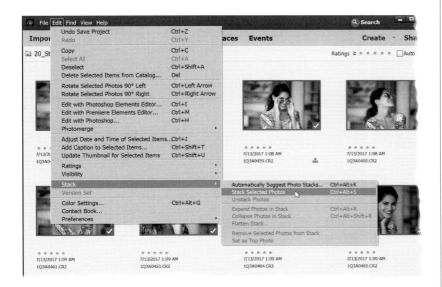

Step One:
With the Organizer open, press-and-hold the Ctrl (Mac: Command) key on your keyboard and click on all the photos you want to add to your stack (or if the images are contiguous, simply click on the first image in the series, press-and-hold the Shift key, and click on the last image in the series). Once they're all selected, go under the Organizer's Edit menu, under Stack, and choose **Stack Selected Photos**, or press **Ctrl-Alt-S (Mac: Command-Alt-S)**.

Step Two:
No dialog appears, it just happens—your other photos now are stacked behind the first photo you selected (think of it as multiple layers, and on each layer is a photo, stacked one on top of another). You'll know a photo thumbnail contains a stack because a Stack icon (which looks like a little stack of paper) will appear in the upper-right corner of your photo. You'll also see a right-facing arrow to the right of the image thumbnail.

Continued

Step Three:

Once your photos are stacked, you can view these photos at any time by clicking on the photo with the Stack icon, and then going under the Edit menu, under Stack, and choosing **Expand Photos in Stack**, or just clicking on the right-facing arrow to the right of the image thumbnail. This is like doing a Find, where all the photos in your stack will appear in the Media Browser within a gray shaded area so you can see them without unstacking them. Then, to collapse the stack, just click on the left-facing arrow that appears to the right of the last image thumbnail in the stack.

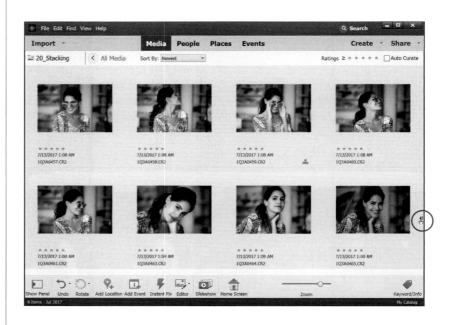

Step Four:

If you do want to unstack the photos, select the photo with the Stack icon in the Media Browser, then go under the Edit menu, under Stack, and choose **Unstack Photos**. If you decide you don't want to keep any of the photos in your stack, select the photo with the Stack icon in the Media Browser, go back under the Edit menu, under Stack, and choose **Flatten Stack**. It's like flattening your layers—all that's left is that first photo. However, when you choose to flatten, you will have the choice of deleting the photos from your hard disk or not.

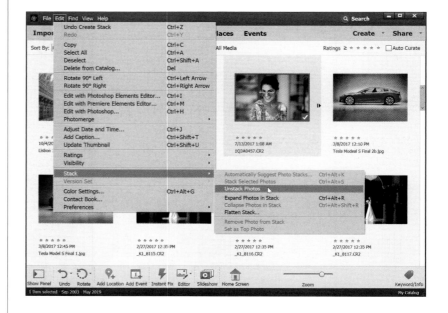

Places in the Organizer is a way to view your photos based on where they were taken. It works great if you use your cell phone to take a lot of photos (which many people do nowadays), because your phone typically embeds location info right into the photo. But it doesn't stop there. If you have a photo that doesn't have the location info in it, it's really simple to add it after the fact, so you can see all your photos on a map.

Places: Viewing Your Photos on a Map

Step One:
In the Organizer, click on Places at the top of the window to switch to the Map view of your photos. In this example, I already have photos with location info in them, so if I click on Pinned at the top of the window, Elements shows where they were taken on the map.

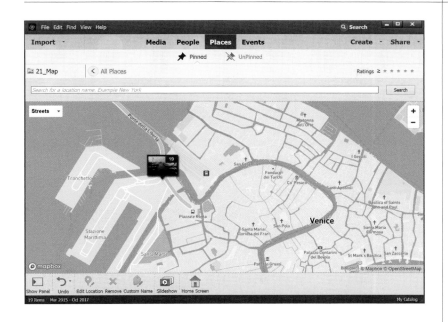

Step Two:
As you look at the map, you'll see exactly how many photos were taken in each location. If you double-click on one of the locations on the map, Elements will automatically show those photos in the Media Browser.

Continued

Step Three:

This is a really good way to create an album based on places you've visited, because Elements does a lot of the work for you. Just click on a location on the map and all of the photos will appear. Then, click on the Create New Album button (the green plus sign) at the top left of the window (if you don't see My Albums, click on the Show Panel icon at the bottom left of the window), choose **New Album**, give it a descriptive name, and you're ready to go.

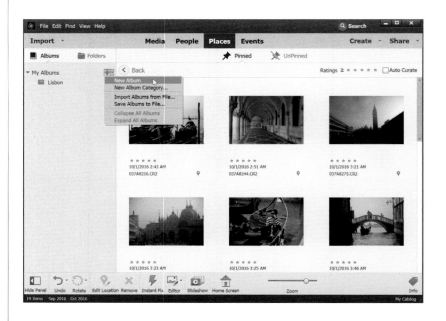

Step Four:

But what happens if you have photos without location or GPS info in them? Just click on Unpinned at the top of the window. That opens the panel on the left, where you'll see all your photos with no GPS info associated with them grouped by date range. Click on the last image within a group to see the images in that group.

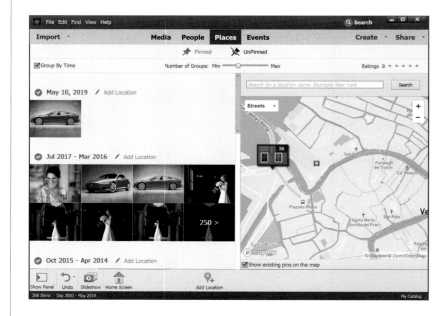

Step Five:

To associate a photo with a place, you can do one of two things: First, you could just drag-and-drop the photo from the panel onto the map to add it to a location (or Ctrl-click [Mac: Command-click] on several photos to select them, then drag-and-drop all of them onto the map at once). When it appears on the map, just click the little green checkmark to confirm that that is indeed where you want it to go.

Step Six:

If you can't find the exact location on the map, then try searching for it. Select the photos you're going to add to that location, then type in the location in the Search for a Location field above the map, and click the Search button. Depending on how specific you are in your location, you may get one or more suggestions that pop down from the search field. If so, just click on the correct one, and the location will show up on the map, with Elements asking if you want to place those photos in that location. Just click that little green checkmark to associate your selected photos with that location. You gotta love this stuff, huh?

TIP: Locations Stay with Your Images

What's really cool is that if you have GPS info associated with your photos, any time you share them on places like Flickr (or any other photo sharing service that supports GPS info), your locations will automatically travel along with your images, so you won't have to add the locations again on each site.

Sharing Your Photos

Elements gives you a number of ways to easily share your photos to places like Flickr and Twitter—you can even upload a video to YouTube right from the Organizer. Here, we'll look at how to email your photos.

Step One:
Before you do anything, you have to set up Elements to work with your email. So, first go under the Edit (Mac: Elements) menu, under Preferences, and choose **Email**. In the Email preferences, click on the New button, give this email profile a descriptive name, and then choose whichever email provider you use from the Service Provider pop-up menu. Click OK.

Step Two:
From there, add your email address, your name, and the password for that email account, and then click the Validate button to confirm that Elements will work with your email account. When you're done, you can click OK at the bottom right to close the Preferences dialog.

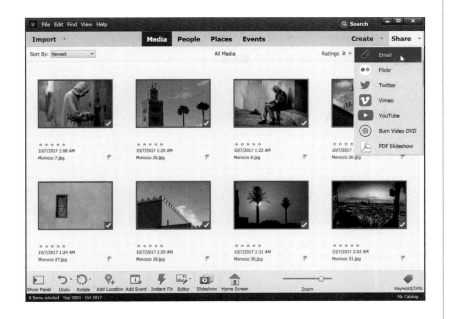

Step Three:

Now, just select the photos in the Organizer that you want to email, then click on Share (in the top right of the window), and choose **Email** (you'll use this Share menu to share your images to places like Flickr, Twitter, etc., as well, and it'll walk you through the process just like it does with Email).

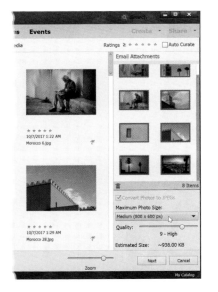 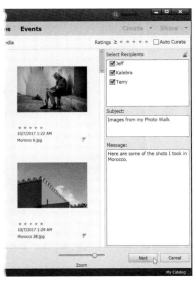

Step Four:

In the Email Attachments palette, choose a preset for the size you want the photos resized to (I usually go with Medium). Click Next, select the recipients (click on the little person icon to the right to add them), and then enter a subject line and any message you want included. Finally, click Next and your photos will automatically be resized (not the originals, though) and emailed off to your friends and family.

Location: Library of Congress, Washington, DC | Exposure: 1/10 sec | Focal Length: 11mm | Aperture Value: ƒ/11

Raw and Un-Kutt
the essentials of camera raw

Okay, just a friendly heads up: I wouldn't even attempt to read this chapter intro until you read #5 of the "Nine Things You'll Wish You Had Known..." right before Chapter 1. If you skipped it (and we both know you did), jump back to page xv, read it, then come right back. I'll hold your place—go ahead [gently taps fingers on desk]. That was pretty quick. Did you just skim it? You did, didn't you? Hey, this is imperceptibly important stuff, so please go back and read it again carefully. I'll wait. (No worries, I'm still on hold with Verizon tech support.) Well, if you're back here, you know what you're in for, so now the onus is on you (ewwww, you have an onus!). This chapter on the essentials of Camera Raw is named after the album *Raw and Un-Kutt* by rapper Kutt Calhoun. I wasn't familiar with his work, so I played a preview of one of his tracks (I think it was called "Naked [Boom, Boom, Boom]," which coincidentally was almost the name of this chapter before I even heard of that song). Anyway, whoa Nelly! He certainly seems very upset about something. But I digress. Before we get too deep into this, I'm going to call Adobe out on something. You know that little knobby thing on the Camera Raw

sliders that you click on and drag? Some folks call it a "nub" or "knob" or whatever, but it has no official name, and personally, I feel this is a travesty. Everything, and I mean everything, in Elements has an official name that a group of perpendicular engineers literally argued to death blows over, except this one nebulous nubby thing. That's when it hit me, this nubby thing's name is up for grabs! Like an undiscovered planet or a new perfume (Splendifiquois, the new fragrance from L'Oréal). But I knew I would have to come up with a name that isn't already used for anything, and that's not as easy as it sounds, because a lot of things in life already have names. Then it hit me: there is one totally made-up word that has no actual meaning, yet is an important part of the American rock vernacular—pompitous. Check this out: "Click on the Highlights pompitous and drag it over to +0.25." It sounds so legit! Yes, it shall be pompitous from now on. So let it be known; so let it be done. And remember, it was I, "Maurice," who came up with this. (Well..."some people call me Maurice. 'Cause I speak of the pompitous of love.") Dang, this word works for anything! (Stop bragging, you sound so pompitous).

Opening Your Photos into Camera Raw

Although Adobe Camera Raw was created to process photos taken in your camera's RAW format, it's not just for RAW photos, because you can process your JPEG, TIFF, and PSD photos in Camera Raw, as well. So even though your JPEG, TIFF, and PSD photos won't have all of the advantages of RAW photos, at least you'll have all of the intuitive controls Camera Raw brings to the table.

Step One:

We'll start with the simplest thing first: opening a RAW photo from the Organizer. If you click on a RAW photo to select it in the Organizer, then click on the down-facing arrow to the right of the Editor icon (on the taskbar at the bottom of the window) and choose **Photo Editor** from the pop-up menu, it automatically takes the photo over to the Elements Editor and opens it in Camera Raw.

Step Two:

To open more than one RAW photo at a time, go to the Organizer, Ctrl-click (Mac: Command-click) on all the photos you want to open, then choose an option from the Editor icon's pop-up menu (as shown here, or just press **Ctrl-I [Mac: Command-I]**). It follows the same scheme—it takes them over to the Editor and opens them in Camera Raw. On the left side of the Camera Raw dialog, you can see a filmstrip with all of the photos you selected. (*Note:* By default, you'll also see the filmstrip appear on the left when you open a single image. I prefer to close it, though, when working on a single image, so that my image takes up more of the window. You can close it by double-clicking on the right edge of the filmstrip.)

Step Three:

Okay, so opening RAW photos is pretty much a no-brainer, but what if you want to open a JPEG, TIFF, or PSD in Camera Raw? Go under the Editor's File menu and choose **Open in Camera Raw**. In the Open dialog, navigate to the photo you want to open, click on it, and click Open.

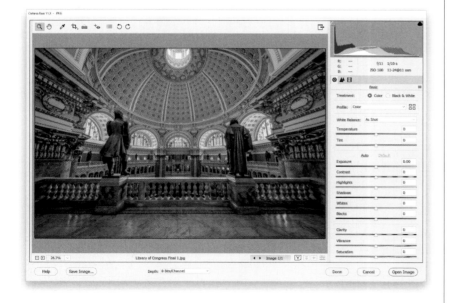

Step Four:

When you click the Open button, that JPEG, TIFF, or PSD is opened in the Camera Raw interface, as shown here (notice how JPEG appears up in the title bar, just to the right of Camera Raw 11.3?). *Note:* When you make adjustments to a JPEG, TIFF, or PSD in Camera Raw and you click either the Open Image button (to open the adjusted photo in Elements) or the Done button (to save the edits you made in Camera Raw), unlike when editing RAW photos, you are now actually affecting the pixels of the original photo. Of course, there is a Cancel button in Camera Raw and even if you open the photo in Elements, if you don't save your changes, the original photo remains untouched. Also, if you have a layered PSD file open in Camera Raw and you click the Open Image button, Elements will flatten your layers as it opens the photo.

My Camera Raw Editing Cheat Sheet

Here's a quick look at the sliders in Camera Raw's Basic panel (this isn't "official"—it's just how I think of them). By the way, although Adobe named this the "Basic" panel, I think it may be the most misnamed feature in all of Camera Raw. It should have been called the "Essentials" panel, since this is precisely where you'll spend most of your time editing images. Also, something handy to know: dragging any of the sliders to the right brightens or increases its effect; dragging to the left darkens or decreases its effect.

Apply a RAW Profile:
From the Profile pop-up menu, you can choose the overall "look" you want to apply to your RAW photo. Do you want a flat, untouched starting point, or something a bit more colorful and contrasty?

Automatic Toning:
If you're not sure where to start, try clicking the much improved Auto button, which automatically tries to balance out the tones in an image for you. It's low risk—if you don't like the results, just press **Ctrl-Z (Mac: Command-Z)** to Undo the Auto adjustment.

Brightening or Darkening:
I use these three sliders together: First, I set the white and black points to expand the image's tonal range (see page 65 for how Camera Raw can do this for you automatically), and after that, if the image looks a little too bright or a little too dark, I tweak the overall brightness by dragging the Exposure slider to the left to darken or to the right to brighten.

Fixing Problems:
If there are exposure problems (often caused by the limitations of our camera's sensors), one or both of these sliders will usually provide the fix. I use the Highlights slider when the brightest areas of my photo are too bright (or the sky is way too bright), and the Shadows slider opens up dark areas in your photo and makes things "hidden in the shadows" suddenly appear—great for fixing backlit subjects (see page 72).

Fixing Flat-Looking Photos:

If your photo looks flat and drab, drag the Contrast slider to the right—it makes the brightest parts brighter, the darkest parts darker, and makes your colors punchier.

Enhancing Detail:

Technically, the Clarity slider controls midtone contrast, but what it really does when you drag it to the right is it brings out texture and detail in your photo. It also tends to make your photo a little darker if you apply a lot of it, so you might have to drag the Exposure slider a tad to the right after increasing the amount of Clarity.

Getting Your Color Right:

These two White Balance sliders help you either correct the white balance in your image (i.e., you'd drag the Temperature slider to the right to reduce a blue color cast, or to the left to remove a yellow color cast by adding in some blue), or you'll use these to get creative, like making a slightly yellow sunset a glorious orange, or a drab sky a gorgeous blue.

Making Your Colors More Colorful:

I drag the Vibrance slider to the right when my image needs a color boost (see page 74). You'll notice I didn't mention the Saturation slider. That's because I stopped using it years ago when Vibrance was introduced. Now, I only use the Saturation slider (dragging it to the left) if I want to wash out or remove color altogether. I never drag it to the right. Yeech!

If You Shoot in RAW, You Need to Start Here

In the spring of 2018, Adobe changed the way we process our RAW images (for the better), but it's important to understand what they did (and why they did it), so you can add it to your RAW editing workflow. On these first two pages, I'm going to explain something that will help you really understand why Camera Raw does things a certain way, but to do that we have to start in your camera. If you're shooting in JPEG, you can skip these five pages altogether, and instead, your workflow starts on page 57 (shooting in JPEG is not a bad thing, but what I'm teaching here doesn't apply to JPEG images, so I don't want to waste your time or create confusion).

Step One:

Note: Again, this only applies to you, if you shoot in RAW. If you shoot in JPEG, skip these five pages.

When you shoot in JPEG, your camera automatically applies all sorts of processing adjustments to your JPEG images in-camera—like contrast, vibrance, sharpening, noise reduction, and so on—to make your JPEG image look really good straight out of the camera. That's why JPEG images look so much better out of the camera than RAW images—RAW images don't have any of that stuff applied to them.

Step Two:

Besides JPEGs looking better by default, most cameras allow you to further tweak them by applying camera profiles right in your camera to make even better looking JPEGs. These profiles are named by the subject you're shooting, so for example, if you're shooting a landscape, you'd apply the Landscape camera profile to get more saturated colors, more sharpness, and more contrast. You can take it a step further by choosing Vivid, so your image looks even more colorful. If you're shooting portraits, you can choose the Portrait camera profile and it provides flatter, less contrasty looks and tones that should be more pleasing for skin.

Step Three:

When you switch your camera to shoot in RAW mode, you're telling it, "Turn off the sharpening, the contrast, the vibrance, the noise reduction—turn off all that stuff that's added to make the image look great, and just give me the untouched RAW image, straight out of the camera, so I can add my own sharpening, contrast, and so on, in Camera Raw." This "turn all that in-camera stuff off" for RAW photos also applies to those camera profiles you just learned about. If you applied a Landscape or Portrait camera profile to your RAW photo, since it's RAW, Camera Raw just ignores it (in short, they really only work for JPEG images). The good news is, you can apply these same types of camera profiles in Camera Raw to RAW images. But, the news gets even better (well, not yet, in the step after the next step).

Step Four:

Now, the built-in default Camera Profile that was used to interpret your RAW photo (it was found in the Camera Calibration panel, as seen here) was "Adobe Standard." But, Adobe recommended that you start by choosing Camera Standard to see how that looked.

Continued

Step Five:

So, for 12+ years, I've been telling photographers that they could have a better starting place than Adobe Standard by applying one of Adobe's camera profiles hidden in the Camera Calibration panel (well, they were there in earlier versions of Camera Raw anyway). They could choose Camera Standard or Camera Landscape or Camera Vivid (depending on their camera), and their RAW image would then look more like the JPEG preview—with more contrast, more color, and a more JPEG-looking starting place for processing their RAW images. Well, in the spring of 2018, Adobe released a replacement for Adobe Standard, called "Adobe Color" (which is the new default RAW image look for Camera Raw). This is such a better starting place, as Adobe Color gives your RAW image a more pleasing overall color with added warmth, contrast, and vibrance. Plus, Adobe moved the Profile options to the top of the Basic panel (as seen here). You don't have to do anything to use the Adobe Color profile—it's added by default. But, the even better news is you now have more choices—more potential starting places that you might want to consider.

Step Six:

For example, from the Profile pop-up menu, choose the Adobe Landscape profile and it will look better for most landscape images (I think it looks even better than the in-camera profiles), and some images will look even better with Adobe Vivid applied. You won't know until you try 'em out. While Adobe added the Adobe RAW profiles as Favorites in the Profile pop-up menu, you can find others by choosing **Browse** (as shown here). You can also click the little icon with four squares just to the right of the Profile pop-up menu—either one will bring up the Profile Browser (seen in the next step).

Step Seven:

In the Profile Browser, under Adobe Raw, you'll find the new RAW profiles. The thumbnails here give you a preview of how your image would look if you chose one of those profiles. Even better, if you hover your cursor over one of them, you get a full-size preview of how that profile would look on your image. Incredibly helpful. Here, I chose the Adobe Vivid profile, and look at how much better the After image on the right looks already (you can see a split-screen before and after like this by pressing the letter **Q**. More about this on page 61). It made my starting place that much better!

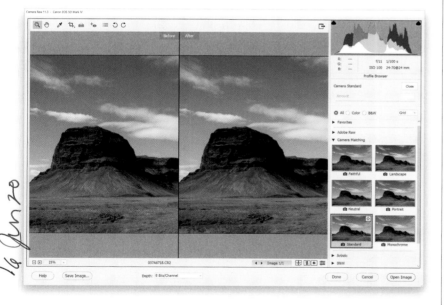

Step Eight:

Besides Adobe's new and improved RAW camera profiles, you still have access to the camera profile choices from earlier versions of Camera Raw, found under Camera Matching. They're named Camera Matching because these are the same profiles you could have applied in your camera if you were shooting in JPEG mode (the list will look somewhat different depending on your camera make). These old camera profiles are there in case you wanted to work on a RAW image you previously edited in an older version of Camera Raw where you had applied one of those older profiles without it being automatically changed to a new profile. That being said, I wouldn't recommend applying these old Camera Matching profiles to new photos you're editing in Camera Raw—they're not nearly as good as the new ones—but if you have bad taste in editing, at least you know they're there.

JRVLS
105 3 STORE
JAMESTOWN

Continued

Step Nine:
If you want, you can change the thumbnail options in the Profile Browser. The standard view is called "Grid," which is what you see here on the left. Or, you can choose **List** from the pop-up menu near the top right (as shown here, on the right) to see just a text-only list.

The default: Grid

List view (text only)

Step 10:
To save a profile as a Favorite (so it appears in the Profile pop-up menu—no more scrolling through panels, digging for profiles), move your cursor over the profile thumbnail you want to save and click the star icon that appears in the upper-right corner (as shown here, left). Now that profile will appear in the Profile pop-up menu (as seen here, at right) when the Profile Browser is hidden, and also under Favorites when it's open (just click on the star icon again to remove it from the Favorites). There is a Monochrome choice in both the Adobe Raw and Camera Matching profile sets, and we'll cover that when we look at converting to black and white in Camera Raw in Chapter 3. Lastly, you'll notice that below the Camera Matching profiles there are even more profiles. Those are actually creative effects you can apply to get certain "looks" (kind of like presets, but better). They're pretty awesome (and you can also add these to your Favorites if you find you use some of them often).

I start editing my photos by setting the white balance first. I do this for two reasons: (1) Changing the white balance affects the overall exposure of your image big time (take a look at the histogram while you drag the Temperture slider back and fourth a few times, and you'll see what a huge effect white balance has on your exposure). And, (2) I find it hard to make reasonable decisions about my exposure if the color is so off it's distracting. I find that when the color looks right, my exposure decisions are better. But hey, that's just me. Or is it?

Setting the White Balance

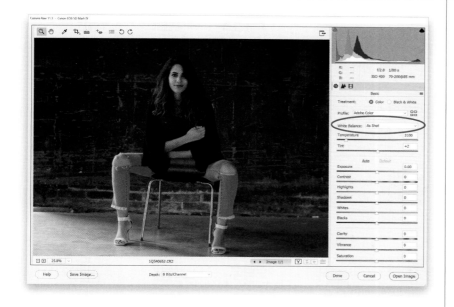

Step One:
The White Balance controls are found near the top of Camera Raw's Basic panel. Your photo reflects whichever white balance you had selected in your camera, so that's why the White Balance pop-up menu is set to "As Shot"—you're seeing the white balance "as it was shot," which in this case, is way too blue (I had been shooting under fluorescent lights earlier, then wound up shooting in this natural light setting and forgot to change my white balance to match the lighting conditions). There are three ways to set the white balance in Camera Raw, and I'm going to show all three, but I use the third way most of the time because it's just so fast and easy. Still, it's important to know all three methods because you might prefer one of the other methods for certain types of photos.

Step Two:
First, you can try the built-in White Balance presets. If you shot in RAW, you can choose the same white balance presets (seen here on the left) you could have chosen in your camera from the White Balance pop-up menu. If you shot in JPEG mode, you only get one preset, Auto (seen here on the right), because your white balance choice was already embedded in the file by your camera. You can still change the white balance for JPEG images, but you'll have to use the next two methods instead. *Note:* If your list looks different than mine here on the left, it's because you're using a differ-ent make/model of camera. The White Balance pop-up menu is based on which camera brand you shot with.

WB presets if you shot in RAW

WB presets if you shot in JPEG

Continued

Step Three:

In our photo in Step One, the overall tone is really blue, so it definitely needs a white balance adjustment. (*Note:* If you want to follow along using this same image, you're welcome to download it from the book's companion webpage, mentioned in the book's introduction.) I usually start by choosing Auto from the White Balance pop-up menu to see how that looks (as you can see here, it's much better all around. In person, her skin has a warmer tone, but the Auto preset is actually a little too warm [yellow]). Go ahead and try the next three presets, but—spoiler alert—Daylight will be a bit warmer, with Cloudy and Shade being progressively warmer still (you'll see how much warmer Cloudy and Shade make her skin tone, as well as the whole photo). You can skip Tungsten and Fluorescent— they're going to be way crazy blue (I accidentally had my white balance set to Fluorescent). By the way, the last preset isn't really a preset—Custom just means you're going to set the white balance manually instead of using a preset.

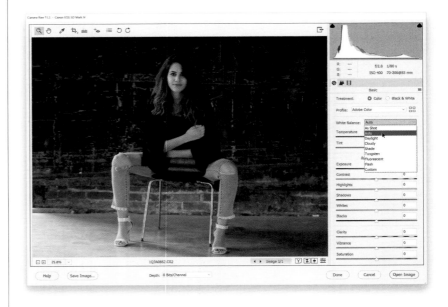

Step Four:

If you go through the White Balance presets and none look right to you (or if you shot in JPEG, so your only choice was Auto, and it didn't look right), then move on to Method #2: choose a preset that is the closest to being right (in this case, it was Auto), then drag the Temperture and Tint sliders (found right below the pop-up menu) to tweak the color to your liking. Take a look at those two sliders. If I wanted more blue in this photo, which way would I drag the Temperture slider? Right—those color bars behind the sliders are a huge help. In this case, I think her skin is too yellow, so I dragged the Temperture slider away from the yellow side and more toward blue, looking at the image while I dragged. I didn't have to drag it very far and now it looks pretty good overall.

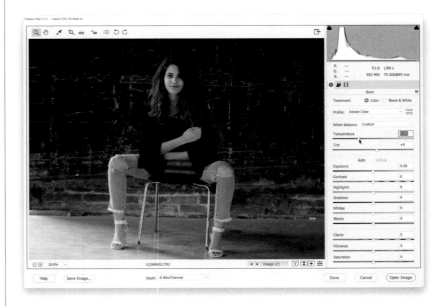

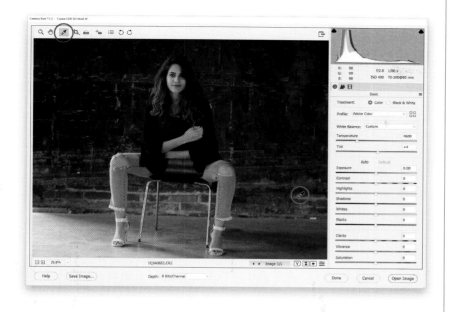

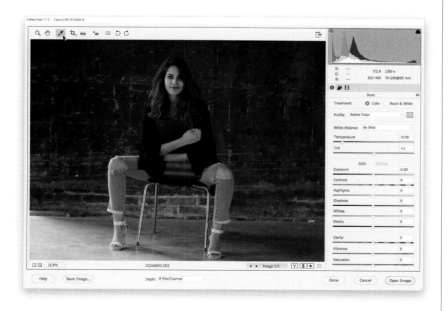

Step Five:

Method #3 is my favorite way to set white balance and is the one I use the most: the White Balance tool (it's that huge eyedropper on the left side of the toolbar at the top of the window, or just press I on your keyboard to get to it). It couldn't be easier to use—simply take the tool and click on an area in your image that should be a light-to-medium gray. Not white (that's for setting the white balance for video cameras)—gray! If there's no gray in the photo, look for an area that's kind of a neutral color, like a tan, ivory, taupe, or beige. Boom. Done. Now, the nice thing about this tool is this: if you don't like how the white balance looks where you clicked, just click somewhere else until it looks good to you. So, go back to the White Balance preset pop-up menu, choose As Shot, then get the White Balance tool and click it on an area that is supposed to be either gray or neutral (the floor or the lighter areas of that background should do).

Step Six:

What happens if you click in the wrong spot? Trust me, you'll know. If it happens (and it will), don't sweat it—just click somewhere else, even trying a place you wouldn't think would give you an accurate white balance. Now, although this can give you a perfectly accurate white balance, it doesn't mean that it will look good (for example, people usually look better with a slightly warm white balance). White balance is a creative decision, and the most important thing is that your photo looks good to you. So don't get caught up in that "I don't like the way the white balance looks, but I know it's accurate" thing that sucks some people in—set your white balance so it looks right to you. It's your photo, so make it look its best. Accurate is not another word for good. Okay, I'm off the soapbox, and it's time for a tip: Want to quickly reset your white balance to the As Shot setting? Just double-click on the White Balance tool up in the toolbar (as shown here).

Continued

Step Seven:

One last thing: once you have the White Balance tool, if you Right-click within your photo, a White Balance preset pop-up menu appears under your cursor (as shown here), so you can quickly choose a preset.

TIP: For Creative White Balance, Use the Temp/Tint Sliders

Here we learned how to get an accurate white balance because our subject is a person and we want their skin tone to look normal. However, there are times, like when we're doing landscape photos, when we might want to get creative and choose a white balance that makes the image look awesome, rather than accurate. In those cases, I drag the Temperture and Tint sliders until I see something I like.

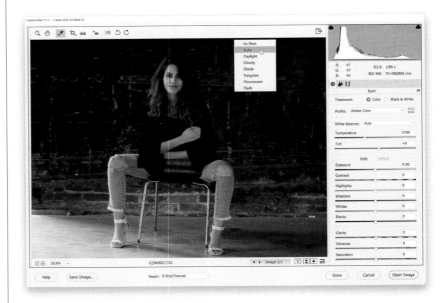

Step Eight:

Here's a before/after so you can see what a difference setting a proper white balance makes (by the way, you can see a quick before/after of your white balance edit by pressing **P** on your keyboard to toggle the Preview on/off).

TIP: Using a Gray Card

To help you find that neutral light gray color in your images, we've included an 18% gray card for you in the back of this book (it's perforated so you can tear it out). Just put this card into your scene (or have your subject hold it), take the shot, and when you open the image in Camera Raw, click the White Balance tool on the card to instantly set your white balance. Now, apply that same white balance to all the other shots taken under that same light (more on how to do that coming up in the next chapter).

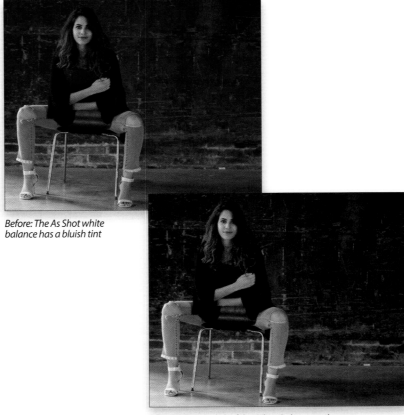

Before: The As Shot white balance has a bluish tint

After: With one click of the White Balance tool, everything comes together

In earlier versions of Camera Raw, its ability to show you a before/after preview of your changes was clunky at best, and totally confusing at worst, mostly because toggling on/off the Preview checkbox didn't show you a full before/after of your image, it only turned on/off the changes you made in the current panel. Luckily, they borrowed a feature from Lightroom and gave us before/after previews that have a lot of options and make sense.

Seeing a Before/After in Camera Raw

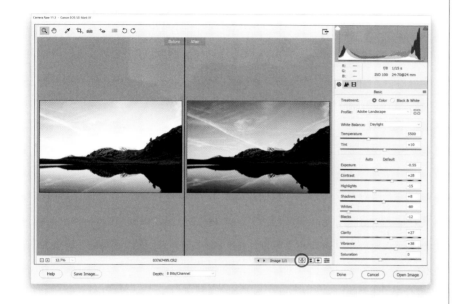

Step One:
If you've made some adjustments, and want to see what your image looked like before you made them (the "before" image), just press the **P** key on your keyboard. This is probably the Before view I use the most in my own workflow. To return to your After image, press P again. If you'd like to see a side-by-side Before/After view, either click on the Before/After preview icon (circled here in red) or press the **Q** key to get the view you see here, with the Before image on the left, and the After image, with the tweaks you applied (here, I made some basic adjustments), on the right. *Note:* Each time you press Q, it toggles to a different preview view.

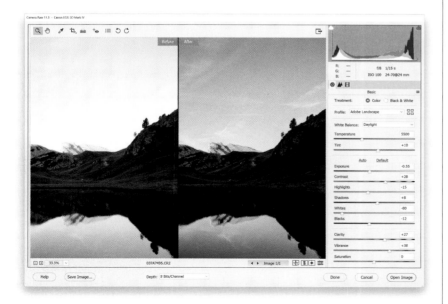

Step Two:
One thing I don't like about this side-by-side view is that while it works great on tall, vertical images, for wide orientation images like this, the previews are really small. Luckily, you can fix that: once you're in this view, just press **Ctrl-+** (plus sign; **Mac: Command-+**) to zoom in on your image like you see here. Each time you press that shortcut, it zooms in tighter. Once you're zoomed in tight, you can reposition your image by simply clicking on either image (your cursor changes to the Hand tool) and dragging the image any way you want. To zoom back out, press **Ctrl--** (minus sign; **Mac: Command--**) until you're zoomed out enough.

Continued

Step Three:

Another preview option is a split-screen that shows the left half of the image as the Before and the right half as the After (as seen here). Once you're in this mode, you can literally swap sides, so the After is on the left and the Before is on the right (so instead of a Before/After, you have an After/Before). To do that, click on the icon to the right of the Before/After icon (it's shown circled in red here, at the bottom) below the bottom-right corner of your image preview, and it swaps the two. If you click the next icon to the right of it, it copies the current settings to the Before image. The final icon (on the far right), lets you toggle on/off the changes made in just the current panel (like the old way previews worked in Camera Raw). By the way, if you click-and-hold on the first icon (the one that looks like the letter "Y"), a pop-up menu appears (seen here) that lets you choose the different before/after previews by name.

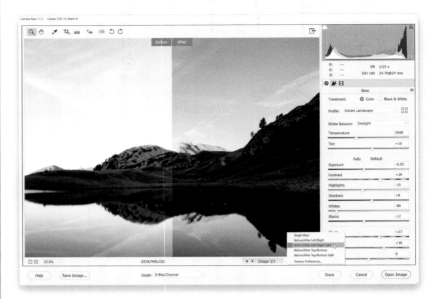

Step Four:

If you press Q again, it toggles you to the Before/After Top/Bottom preview (as seen here). If you press Q one last time, you get a top/bottom split view. Anyway, besides all this, you have a reasonable amount of control over how all this is displayed by going to that pop-up menu we saw back in Step Three and choosing **Preview Preferences** to bring up the dialog you see here below. The first column lets you hide (by turning off the checkboxes of) any of the preview modes you don't care about (I only use the left/right side-by-side myself). In the second column, you get to choose whether you want to see a solid line divider between your before/after previews, and if you want to see the words Before and After onscreen.

If you're not quite comfortable with manually adjusting each image, Camera Raw does come with a one-click Auto function, which takes a stab at correcting the overall exposure of your image (including contrast, highlights, shadows, etc.), and at this point in Camera Raw's evolution, it's really not that bad. If you like the results, you can set up Camera Raw's preferences so every photo, upon opening in Camera Raw, will be auto-adjusted using that same feature. You also have the option to add individual Auto corrections, and we'll take a look at how to do that, too.

Letting Camera Raw Auto-Correct Your Photos

Step One:
The Auto function is a one-click fix (or at least, a good starting place) and the worse your photo looks at the start, the better job it seems to do. It uses this AI and machine learning, called "Adobe Sensei," and by golly, it ain't bad! Here's an under-exposed, dull, flat-looking original RAW image. Click the Auto button once (it's in the Basic panel, right above Expsoure), and Camera Raw quickly analyzes the image and applies what it thinks is the proper correction for this photo. It only moves the sliders it thinks are needed to make the image look decent (the obvious ones, like Exposure, Contrast, Shadows, and the other stuff in this section of the Basic panel, but it'll also adjust Vibrance and Saturation. At this point, though, it does not adjust the Clarity amount).

Step Two:
Just one click and look at how much better the image looks. Compare the slider settings now versus the previous step. Also, I find that if you apply the Auto correction and it looks a little funky, it's because sometimes it applies too much of the Shadows slider and lowers the Contrast too much. So, just lower the Shadows amount a bit, and increase the Contrast amount a bit, and then see how that looks (but, again, only do this if the Auto results look funky). By the way, if you don't like the results from the Auto correction button, no harm done, just press **Ctrl-Z (Mac: Command-Z)** to undo it.

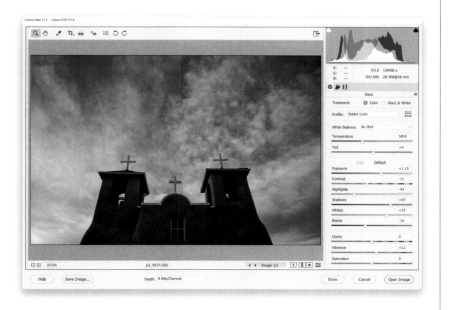

Continued

Step Three:

You can set up Camera Raw so it automatically performs Auto adjustments each time you open a photo—just click on the Preferences icon up in Camera Raw's toolbar (it's the third icon from the right, and when the dialog appears, turn on the Apply Auto Tone and Color Adjustments checkbox (shown circled here), then click OK. Now Camera Raw will evaluate each image and try to correct it. If you don't like its auto corrections, then you can just click on the Default button, which appears to the right of the Auto button (the Auto button will be grayed out because it has already been applied).

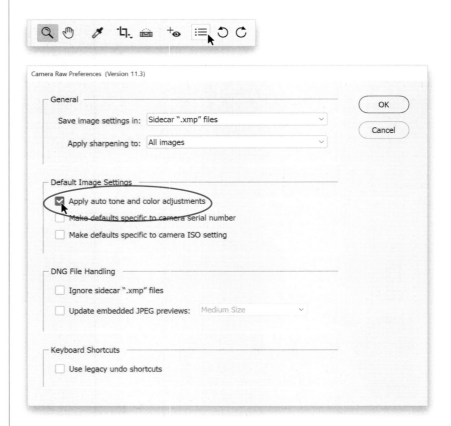

One way to get the most out of your image editing is to expand the tonal range of your photo by setting your white point and black point (this is something regular Photoshop users have done for many years using Photoshop's Levels control). We do this using the Whites and Blacks sliders or you can have Camera Raw do it for you automatically (you just need to know the secret handshake). We increase the whites as far as we can without clipping the highlights, and increase the blacks as far as we can without clipping the deepest shadows too much (although I personally don't mind a little shadow clipping), which expands the tonal range big time.

Expanding Your Tonal Range by Setting Your White and Black Points

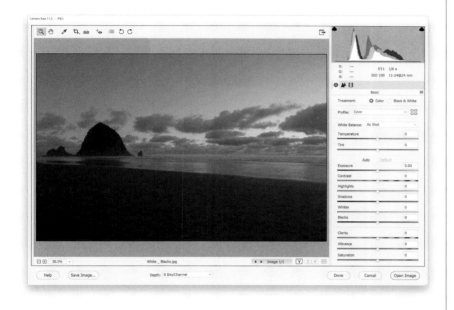

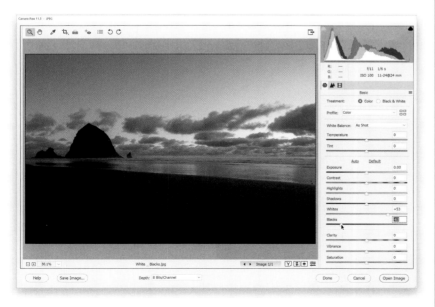

Step One:
Here's the original image and you can see it looks pretty flat. I use the technique you're about to learn (which expands the image's tonal range) on pretty much every image, but this is another technique where the worse the original looks, the more dramatic the results. There are two ways to do it: Camera Raw can do this for you by expanding the amount of whites in the image to as bright as they can get without damaging your highlights, and increasing the amount of blacks until the dark areas are nearly solid black, but it stops short so you still have some detail. Yup, it'll do all that automatically. Or, you can do it yourself (I never do it the manual way—I always let Camera Raw set it for me).

Step Two:
Here's how to have Camera Raw automatically set your white and black points, expanding your tonal range, near the start of your editing process (it's simple): Just press-and-hold the Shift key, then double-click directly on the Whites slider knob in the Basic panel. That sets your white point. Now, Shift-double-click on the Blacks slider knob (as shown here), and it automatically sets your black point. That's it. It's that easy, and that's how I do it in my own workflow (but I add one extra thing, which you'll learn after the next page). By the way, if you Shift-double-click on either one and it barely moves or doesn't move at all, that means your original capture already pretty much has its tonal range expanded.

Continued

Step Three:

If, instead, you want to do this process manually, you'll want to make sure you don't "clip" any of your highlights (making them so bright you lose data in the brightest areas of your image, or so dark that parts of the image turn solid black and thus have no detail). Luckily, Camera Raw can warn you using an onscreen clipping warning. Here's how: Press-and-hold the Alt (Mac: Option) key before you drag the Whites slider. This turns the screen solid black (as seen here, at top). As you drag to the right, any areas that start to clip will become visible. If you see red, blue, or yellow, it means you're clipping in just that individual channel (not as big a worry). However, if you see solid white areas, you're clipping in all three channels, and you've gone too far. So, pull it back to the left until those white areas go away. Now, do the same thing with the Blacks slider: press-and-hold the Alt key as you drag to the left, and stop when you see black areas appear, then pull back to the right (as seen here, below, where I backed off, so I'm only really clipping in the blues. I can live with that little bit of clipping).

Step Four:

Here's a before and after where I used the automatic "Shift-double-click the Whites/Shift-double-click the Blacks" method to expand the image's tonal range. There's still work to be done (including what I do on the next page in conjunction with this), which will give me my overall exposure. So, what you're seeing here is not the final product—that's just a double-click on two different sliders. Not bad for a couple of double-clicks, though.

The next thing I fix (after the white balance and setting the white and black points) is the photo's exposure. But, because we've already expanded the image's tonal range, adjusting the Exposure slider is usually just a small tweak—moving it one way or the other to make the midtones a little bit brighter or a little bit darker. If you set the white and black points first, this is almost like fine-tuning the exposure. If you didn't already set them, then this becomes your main exposure adjustment since it controls such a large part of the midtones, including the upper shadow areas and lower highlight areas.

Controlling Overall Brightness (Exposure)

Step One:
Here's our image, and you can see it's way overexposed (there are no lights here, except for those inside the elevator car and the natural light coming in from above—it looks dark and futuristic inside this "cone," in the City of Arts and Sciences complex in Valencia, Spain). To lower the overall brightness of an image, I reach for the Exposure slider in the Basic panel. This is one powerful slider, and it covers a wide range of midtones, lower highlights, and upper shadow areas. So, when I need something a little brighter or darker overall, this is the slider I reach for.

TIP: Get a Larger Image Window
To hide the filmstrip on the left side of the window, just double-click on its right edge to tuck it away and give you a larger image window (as seen below).

Step Two:
To darken the overall brightness of the image, drag the Exposure slider to the left until the exposure looks good to you. Here, I dragged it to the left quite a bit (down to –1.35, so it was nearly a stop-and-a-half overexposed). While I do grab this slider to make the overall image brighter or darker, I think you get better results if you use it in conjunction with setting the white and black points (see the next page).

My Power Trio: Combining Whites + Blacks + Exposure

In my own daily workflow, I combine setting the Whites slider, the Blacks slider, and the Exposure slider to give me my overall exposure, and I think the results are far better. I start by setting the white and black points (well, I let Camera Raw do this for me automatically; see page 65) to expand my tonal range, and then if the image still looks too dark or too bright, I only have to tweak the Exposure amount a little bit, dragging it left (if I think the overall image is still too bright) or right to brighten it.

Step One:

I'm using the same image we used on the previous page, and I did the same thing here that I did there—I saw the image was overexposed (too bright), so I dragged the Exposure slider to the left until the exposure looked right to me (as seen here in the After photo). So, now the baseline exposure is correct, but we can make this image look better (and this is what I do in my own workflow) if instead of grabbing the Exposure slider first, we use it after we have Camera Raw set the Whites and Blacks sliders for us (again, see page 65). That way, those sliders expand the tonal range first, then we can make the final adjustment with the Exposure slider, tweaking it to be darker or lighter with just a small move. I think the result looks much better overall doing it this way.

Step Two:

Here, I used my "Power Trio" technique by first Shift-double-clicking on Whites, and then Shift-double-clicking on Blacks. Then, I took a look at how the overall brightness of the image looked. I felt it needed to be a bit darker overall, so I dragged the Exposure slider to the left. The difference will look more subtle here in a printed version of a screen capture, but when you try it yourself (try it on one of your images, or download this same one), you'll see quite a difference. (By the way, the name "Power Trio" is actually used to describe rock bands that only have drums, bass, and one guitar [no second rhythm guitar or keyboards]. Think bands like ZZ Top, Rush, or Motörhead.)

If I had to point to the biggest problem I see in most people's images (we get hundreds sent to us each month for "Blind Photo Critiques" on our weekly photography talk show, *The Grid*), it's not white balance or exposure problems, it's that their images look flat (they lack contrast, big time). It's the single biggest problem, and yet it's about the easiest to fix (or it can be a bit complex, depending on how far you want to take this). I'll cover a simple method here and a more advanced method in the next chapter.

Adding Contrast (Important Stuff!)

Step One:
Here's our flat, lifeless image. Before we actually apply any contrast (which makes the brightest parts of the image brighter and the darkest parts darker), here's why contrast is so important: when you add contrast, it (a) makes the colors more vibrant, (b) expands the tonal range, and (c) makes the image appear sharper and crisper. That's a lot for just one slider, but that's how powerful it is (in my opinion, perhaps the most underrated slider in Camera Raw).

Step Two:
Here, all I did was drag the Contrast slider to the right (to +85), and look at the difference. It now has all the things I mentioned above: the colors are more vibrant, the tonal range is greater, and the whole image looks sharper and snappier. This is such an important tweak, especially if you shoot in RAW mode, which turns off any contrast settings in your camera (the ones that are applied when you shoot in JPEG mode), so RAW images look less contrasty right out of the camera. Adding that missing contrast back in is pretty important, and it's just one slider. By the way, I never drag it to the left to reduce contrast—I only drag it to the right to increase it.

Dealing with Highlight Problems (Clipping)

One potential problem we have to keep an eye out for is highlight clipping. That's when some of the highlights in an image got so bright (either when you took the shot, or here in Camera Raw when you made it brighter) that there's actually no detail in those parts of the image at all. No pixels whatsoever. Just blank nothingness. This clipping happens in photos of nice cloudy skies, white jerseys on athletes, bright, cloudless skies, and a dozen other places. It happens, and it's our job to fix it so we keep detail throughout our image. Don't worry, the fix is easy.

Step One:

Here's a shot of one of the spiral staircases in the wonderful Tate Britain museum in London. Not only is the staircase fairly white, but I overexposed the image a bit when I shot it. That doesn't necessarily mean we have clipping (see the intro above for what clipping means), but Camera Raw will warn us if we do. Take a look at the triangle up in the top-right corner of the histogram (seen here). That triangle is normally gray, which means everything's okay—no clipping. If you see a color inside that triangle (red, yellow, or blue), that mean the highlights are clipping in just that color channel, which isn't the end of the world. However, if you see that triangle filled with white, then it's clipping the highlights in all your channels, and you'll need to deal with it if it's an area where there's supposed to be detail.

Step Two:

Okay, now we know we have a highlight clipping problem somewhere in our image, but exactly where? To find out, go up to that white triangle and click directly on it (or press the letter **O** on your keyboard). Now, any areas that are clipping in the highlights will appear in bright red (as seen here, where big parts of the stairs and railings are clipping badly). Those areas will have *no* detail whatsoever (no pixels, no nuthin') if we don't do something about it.

Step Three:

Technically, you could just drag the Exposure slider over to the left until all those red clipped warning areas go away (as shown here, where I dragged it to +1.25), but that will affect the overall exposure of the image, making the entire image underexposed (and, in this case, a bit dingy, too). It's like you fixed one problem, but then created another. That's why the Highlights slider is so awesome—it lets you leave the exposure right where it is and it addresses those super-bright clipped areas itself because it just affects the highlights and not the entire exposure. So, reset your Exposure slider to 0 by double-clicking on it.

Step Four:

Let's put the Highlights slider to work. Just drag it to the left until you see the red onscreen clipping warning go away (as shown here, where I dragged it to −36). The warning is still turned on, but dragging the Highlights slider to the left fixed the clipping problem and brought back the missing detail, so now there are no areas that are clipping (expect for that tiny bit in the railing, which is fine).

TIP: This Rocks for Landscapes

The next time you have a blah sky in a landscape or travel shot, drag the Highlights slider all the way to the left to −100. It usually does wonders with skies and clouds, bringing back lots of detail and definition. I use this trick fairly often.

Fixing Backlit Photos and Opening Up Dark Areas

Why do we take so many backlit photos? It's because our eyes are so darn amazing and adjust for such huge differences in tonal range automatically. So, our subject could be totally backlit, but our eyes automatically adjust and everything looks fine to us. The problem is that even the best camera sensors today don't have nearly the range of our eyes, so even though, when we look through our viewfinder, it looks fine to us, when we press the shutter button, the sensor can't handle that much range and we wind up with a backlit photo. Luckily for us, help is just one slider away.

Step One:

Here's the original image and you can see the subject is backlit. While our eyes do an amazing job of adjusting for scenes like this with such a wide range of tones, as soon as we press the shutter button and take the shot, we wind up with a backlit image where our subject is in the shadows (like you see here). As good as today's cameras are (and they are the most amazing they've ever been), they still can't compete with the incredible tonal range of what our eyes can see. So, don't feel bad if you create some backlit shots like this, especially since you're about to learn how easy it is to fix them. (*Note:* You can also fix this problem using the Editor's Shadows/Highlights enhancement [under the Enhance menu], but it's much easier to do it here in Camera Raw.)

Step Two:

Go to the Shadows slider, drag it to the right (I dragged it to +81 here), and as you do, just the shadow areas of your photo are affected. As you can see here, the Shadows slider does an amazing job of opening up those shadows and bringing out detail in the image that was just hidden in the shadows. *Note:* Sometimes, if you really have to drag this slider way over to the right, the image can start to look a little flat. If that happens, just increase the Contrast amount (dragging to the right), until the contrast comes back into the photo. You won't have to do this very often, but at least when it happens, you'll know to add that contrast right back in to balance things out.

If you're looking for the nerdy technical explanation, the Clarity slider adjusts the amount of midtone contrast, but since that's of little help (well, I guess it is to nerds), then here's how I look at it: I drag this slider to the right when I want to enhance any texture or detail in my image. When you apply a lot of Clarity, it almost looks like you've sharpened the image (but, be careful, you can over-apply Clarity—if you start to see halos around objects in your image or your clouds have drop shadows, that's a warning sign you've gone too far).

Clarity: Camera Raw's Detail Enhancer

Step One:

Which kinds of shots work best with Clarity? Usually anything with wood (from churches to old country barns), landscape shots (because they generally have so much detail), cityscapes (buildings love clarity, so does anything glass or metal), or basically anything with lots of intricate detail (even an old man's craggy face looks great with some Clarity). Here's our original image and there's lots of detail we can enhance—everything from the wood grain in the pews to the ornate adornments throughout the tiny chapel. *Note:* I don't add Clarity to photos where you wouldn't want to accentuate detail or texture (like a portrait of a woman, or a mother and baby, or just a newborn).

Step Two:

To add more punch and bring out the texture and detail in our image here, drag the Clarity slider quite a bit to the right. Here, I dragged it to +74, so you can really see the effect—look at the added detail in the wood and the altar. If you start seeing a black glow appear on the edges of objects, you know you've dragged too far. If that happens, just back it off a bit until the glow goes away.

Note: The Clarity slider does have one side effect—it can affect the brightness of the photo; sometimes making it look darker, and other times making parts look too bright. That's easily fixed with the Exposure slider, but I just wanted you to keep an eye out in case that happens.

Making Your Colors More Vibrant

Photos that have rich, vibrant colors definitely have their appeal (that's why professional landscape photographers back in the film days got hooked on Fuji Velvia film and its trademark saturated color). Camera Raw has a Saturation slider for increasing your photo's color saturation, but the problem is it increases all the colors in your photo equally, and…well…let's just say it's not awesome (and that's being kind). That's why I love Camera Raw's Vibrance slider (a great name for it would have been "Smart Saturation"). It lets you boost colors without trashing your photo, and it does it in a very smart way.

Step One:

At the bottom of the Basic panel are two controls that affect the color saturation—one is brilliant; one is…well…crappy. There, I said it. It's crappy. I only use the Saturation slider to reduce color (desaturating), never to boost it because the results are pretty awful (it's a very coarse adjustment where every color in your image gets saturated at the same intensity). This is why I use Vibrance instead—it boosts the vibrance of any dull colors in the image quite a bit. If there are already saturated colors in the image, it tries not to boost them very much at all. Lastly, if your photo has people in it, it uses a special mathematical algorithm to avoid affecting flesh tones, so your people don't look sunburned or weird.

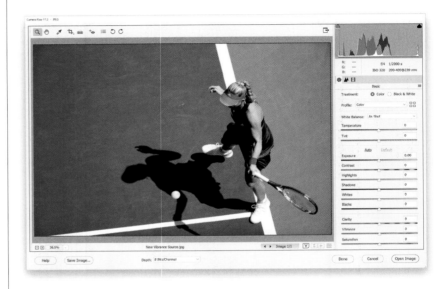

Step Two:

Here's a perfect example. Take a look at our tennis player back in Step One. She's wearing a vibrant red visor and red tennis outfit, but the blue service court areas and the green back court behind the baseline are kind of washed out in the direct sun. If I drag the Vibrance slider over to +67 (like I did here), you can see how much it affected the dull blue and green areas—they're now nice and vibrant. But look at her hat and outfit—they've only been boosted a little because they were already pretty vibrant. Most importantly, compare her skin tone in both image—it's only boosted the tiniest amount because Vibrance protects skin tones wonderfully. It truly is "smart saturation."

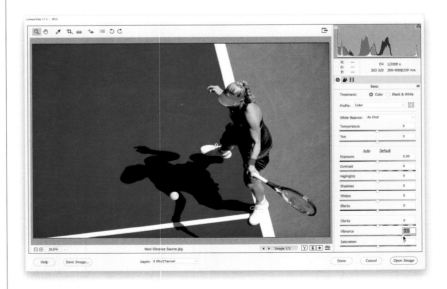

Now that you've learned all that, I wanted to share the order in which I use all those Basic panel sliders (and yes, I pretty much do the same thing every time, in the same order). While there are still things yet to learn, including some other Camera Raw features and special effects and lots of other fun stuff, this is the fundamental image editing I do, and it's often the only editing I do to my image (it just depends on the image). Almost everything else I apply to an image (special effects, or looks) will happen after I'm done with this phase here. I hope you find this helpful.

Putting It All Together (Here's the Order I Use for My Own Editing)

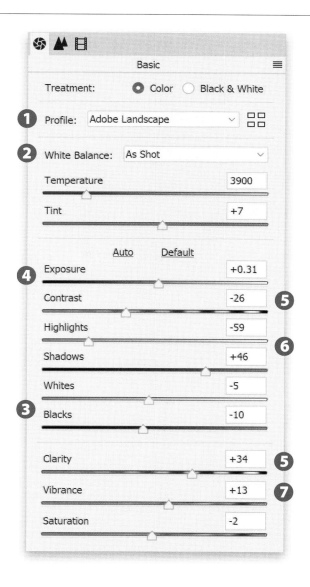

1) I choose my RAW Profile
Adobe Color is pretty good, but if I decide I want more pop, I usually go with Landscape or Vivid as my starting place.

2) I set my white balance
If your color isn't right…it's wrong. I use the White Balance tool (found in the toolbar) most of the time.

3) I have Camera Raw automatically set my white and black points
I expand my overall tonal range by Shift-double-clicking on the Whites slider knob, then on the Blacks slider knob.

4) I tweak the overall brightness
After setting the white and black points, if I feel the image is too dark or too bright, I drag the Exposure slider a bit, until it looks right.

5) I add contrast and clarity
I always add contrast. As for clarity, I only use it if I want to enhance detail.

6) If I have highlight clipping or detail lost in shadows, I fix it now
This is when I would fix any clipping problems or open up the shadows (dragging the Shadows slider to the right) to reveal hidden detail.

7) Boost colors
Between setting my whites and blacks, and adding contrast, my color is usually pretty vibrant, but if for some reason I think it needs more, I increase the Vibrance amount.

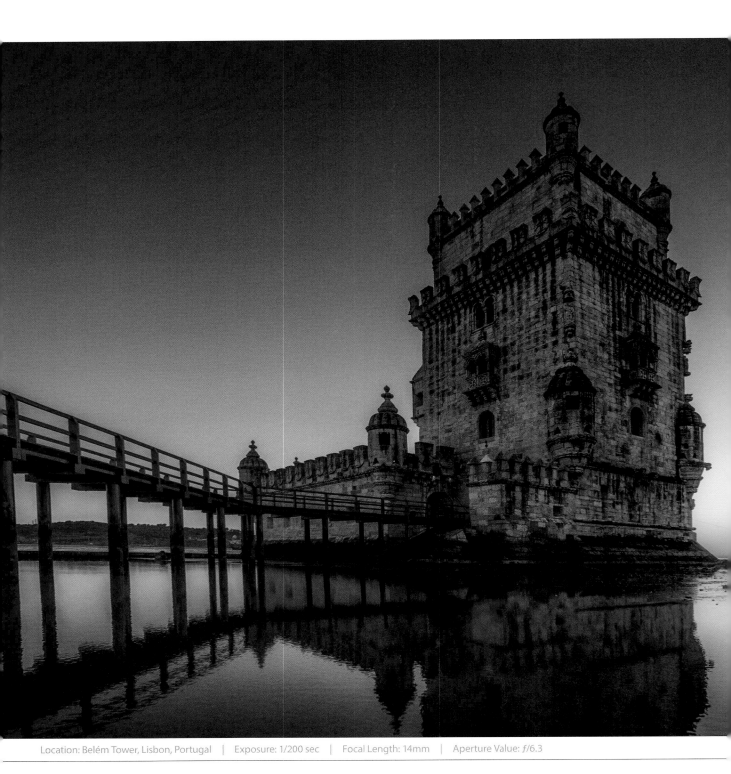

Location: Belém Tower, Lisbon, Portugal | Exposure: 1/200 sec | Focal Length: 14mm | Aperture Value: *f*/6.3

Beyond the Reach
camera raw—beyond the basics

Just so you know, it has been a tradition of mine, going back about 80 books or so, to name each chapter after a movie title, song title, or TV show, and this one is named after a 2014 movie starring Michael Douglas (who plays a "high-rolling corporate shark") and Jeremy Irvine (who plays the other guy), and while I felt this wasn't a bad name for the chapter, I think it may be a pretty bad movie overall. This is based on a review I read from the *New York Daily News'* Joe Neumaier, who wrote: "The title of this turgid chase drama couldn't be more apt; almost everything escapes its aim." This led me to one solid conclusion: do not invite Joe Neumaier to review this, or any of my books, ever, so help me God. First, he used the term "turgid," which quite honestly, I had to Google because I thought it might be another word the Steve Miller Band made up, but it is actually a real word, and according to Google (which is the unequivical bottom line for stuff like this), it means "swollen and distended." Ouch! Joe really didn't like that movie. Now, Michael Douglas (world famous actor who has won not just one, but two Academy Awards), has numerous advantages over me, as someone who is not only not Michael Douglas, but only has one Oscar, and that was for Best Performance by an Actor in a Supporting Role for my screen debut as Armani Yogamat, the Tunisan Roomba salesman, in the critically acclaimed indie film *Eat. Spray. Lunch* (it didn't do the numbers the studio had hoped for, which is why its sequel, *Drink. Spay. Neuter*, went straight to DVD). I was asked to reprise my role as Armani Yogamat for the sequel, but I was already in dress rehearsals for the Broadway musical adaptation of *The Grand Budapest Marriott* and had to pass on the project. Anyway, if Joe can totally carpet bomb a classy high-end thriller from multi-Oscar winner Michael Douglas and that other guy, there's no way I would ever want him reviewing or reading any of my books, or even casually walking past a bookstore in the mall where my books are sold, rented, or shared with other food court employees/actors.

Editing Multiple Photos at Once

One of the coolest things about Camera Raw is the ability to apply changes to one photo, and then have those same changes applied to as many other similar images as you'd like. It's a form of built-in automation, and it can save an incredible amount of time in editing your shoots.

Step One:
Start off in the Organizer by selecting a group of RAW photos that were shot in the same, or very similar, lighting conditions (click on one photo, press-and-hold the Ctrl [Mac: Command] key, and click on the other photos), then open these images in Camera Raw.

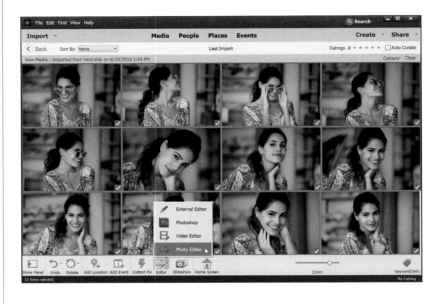

Step Two:
The selected photos will appear along the left side of the Camera Raw window. First, click on the photo you want to edit (this will be your target photo—the one all the adjustments will be based upon), then click the Select All button at the top left of the window to select all the other images (as shown here).

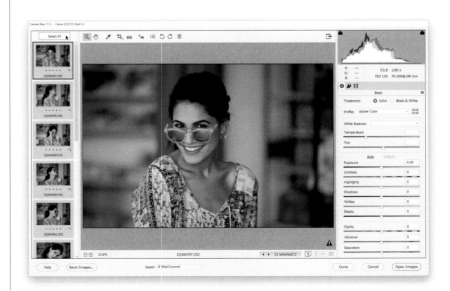

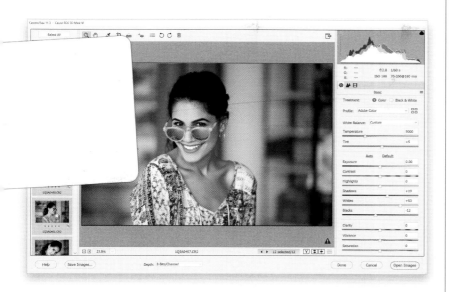

Step Three:
Go ahead and adjust the photo the way you'd like. You can see the settings I used here, for this photo. You'll notice that the changes you make to the photo you selected first are being applied to all the photos in the Camera Raw filmstrip on the left (you can see their thumbnails update as you're making adjustments).

Step Four:
When you're done making adjustments, you have a choice to make: (a) if you click the Open Images button, all of your selected images will open in the Elements Editor (so if you're adjusting 120 images, you might want to give that some thought before clicking the Open Images button), or (b) you can just click the Done button, which applies all your changes to the images without opening them in Elements. So, your changes are applied to all the images, but you won't see those changes until you open the images later (you will, though, see the changes reflected in the Organizer. I usually choose [b] when editing lots of images at once). That's it—how to make changes to one image and have them applied to a bunch of images at the same time.

Sharpening in Camera Raw

In Elements, we have pro-level sharpening within Camera Raw. So when do you sharpen here, and when in Elements? I generally sharpen my photos twice—once here in Camera Raw (called "capture sharpening"), and then once in Elements at the very end of my editing process, right before I save the final image for print or for the web (called "output sharpening"). Here's how to do the capture sharpening part in Camera Raw:

Step One:

When you open a RAW image in Camera Raw, by default it applies a small amount of sharpening to your photo (not the JPEGs, TIFFs, or PSDs—only RAW images). You can adjust this amount (or turn if off altogether, if you like) by clicking on the Detail icon (circled here in red), or using the keyboard shortcut **Ctrl-Alt-2 (Mac: Command-Option-2)**. At the top of this panel is the Sharpening section, where by a quick glance you can see that sharpening has already been applied to your RAW photo. If you don't want any sharpening applied at this stage (it's a personal preference), then simply click-and-drag the Amount slider all the way to the left, to lower the amount of sharpening to 0 (zero), and the sharpening is removed.

Step Two:

If you want to turn off this "automatic-by-default" sharpening (so image sharpening is only applied if you go and manually add it yourself), first set the Sharpening Amount slider to 0 (zero), then go to the Camera Raw flyout menu and choose **Save New Camera Raw Defaults** (as shown here). Now, RAW images taken with that camera will not be automatically sharpened.

Step Three:

Before we charge into sharpening, there's one more thing you'll want to know: if you don't actually want sharpening applied, but you'd still like to see what the sharpened image would look like, you can sharpen just the preview, and not the actual file. Just press **Ctrl-K (Mac: Command-K)** while Camera Raw is open, and in the Camera Raw Preferences dialog, choose **Preview Images Only** from the Apply Sharpening To pop-up menu (as shown here), and then click OK to save this as your default. Now the sharpening only affects the preview you see here in Camera Raw, but when you choose to open the file in Elements, the sharpening is not applied.

Step Four:

This may seem kind of obvious (since it tells you this right at the bottom of the Detail panel, as seen in Step One), but so many people miss this that I feel it's worth repeating: before you do any sharpening, you should view your image at a 100% size view, so you can see the sharpening being applied. A quick way to get to a 100% size view is simply to double-click directly on the Zoom tool (the one that looks like a magnifying glass) up in Camera Raw's toolbar. This zooms you right to 100% (you can choose **Fit in View** from the pop-up menu beneath the bottom left of the preview area to return to the normal view).

Continued

Step Five:

Now that you're at a 100% view, just for kicks, drag the Amount slider way to the right so you can see the sharpening at work. Again, dipping into the realm of the painfully obvious, dragging the Amount slider to the right increases the amount of sharpening. Compare the image shown here with the one in Step Four (where the Sharpening Amount was set to 0), and you can see how much sharper the image now appears, since I dragged it to 100.

TIP: Switch to Full Screen

To have Camera Raw expand to fill your entire screen, click the Full Screen icon at the top right of the preview area (or just press the **F key**).

Step Six:

The next slider down is the Radius slider, which determines how far out the sharpening is applied from the edges being sharpened in your photo. This works pretty much like the Unsharp Mask filter in the Editor. I leave my Radius set at 1 most of the time. I use a Radius of less than 1 if the photo I'm processing is only going to be used on a website, in video editing, or something where it's going to be at a very small size or resolution. I only use a Radius of more than 1 when the image is visibly blurry and needs some "emergency" sharpening, or if it has lots of detail (like this photo, where I pushed the Radius to 1.2). If you decide to increase the Radius amount above 1 (unlike the Unsharp Mask filter, you can only go as high as 3 here), just be careful, because your photo can start to look fake, oversharpened, or even noisy, so be careful out there.

Step Seven:

The next slider down is the Detail slider, which is kind of the "halo avoidance" slider (halos occur when you oversharpen an image and it looks like there's a little halo, or line, traced around your subject or objects in your image, and they look pretty bad). The default setting of 25 is good, but you'd raise the Detail amount (dragging it to the right) when you have shots with lots of tiny important detail, like in landscapes, cityscapes, or the photo here, where I dragged it to 50. Otherwise, I leave it as is. By the way, if you want to see the effect of the Detail slider, make sure you're at a 100% view, then press-and-hold the Alt (Mac: Option) key, and you'll see your preview window turn gray. As you drag the Detail slider to the right, you'll see the edges start to become more pronounced, because the farther you drag to the right, the less protection from halos you get (those edges are those halos starting to appear).

Step Eight:

I'm going to change photos to show you the Masking slider. This one's easier to understand, and for many people, I think it will become invaluable. Here's why: When you apply sharpening, it gets applied to the entire image evenly. But what if you have an image where there are areas you'd like sharpened, but other softer areas that you'd like left alone (like the photo here, where you want to keep her skin soft, but have her eyes, lips, etc., sharpened)? If we weren't in Camera Raw, you could apply the Unsharp Mask filter to a duplicate layer, add a layer mask, and paint away (cover) those softer areas, right? That's kind of what the Masking slider here in Camera Raw does—as you drag it to the right, it reduces the amount of sharpening on non-edge areas. The default Masking setting of 0 (zero) applies sharpening to the entire image. As you drag to the right, the non-edge areas are masked (protected) from being sharpened.

Continued

Step Nine:

All four sliders in the Sharpening section of the Detail panel let you have a live preview of what the sharpening is affecting—just press-and-hold the Alt (Mac: Option) key as you drag; your screen will turn grayscale, and the areas that the slider you're dragging will affect appear as edge areas in the Preview area. This is particularly helpful in understanding the Masking slider, so press-and-hold the Alt key and drag the Masking slider to the right. When Masking is set to 0, the screen turns solid white (because sharpening is being evenly applied to everything). As you drag to the right, in the preview (shown here), the parts that are no longer being sharpened turn black (those areas are masked). Any areas you see in white are the only parts of the photo receiving sharpening (perfect for sharpening women, because it avoids sharpening their skin, but sharpens the things you want sharp, like the eyes, hair, eyebrows, lips, edges of her face, and so on). Below is a before/after of our first shot, with these settings—Amount: 100, Radius: 1, Detail: 60, Masking: 0.

Before

After

This is, hands down, not only one of the most-requested features by photographers, but one of the best since the last Camera Raw upgrade. Now, if you're thinking, "But Scott, didn't Elements and Camera Raw both have built-in noise reduction before?" Yes, yes they did. And did it stink? Yes, yes it did. But, does the current noise reduction rock? Oh yeah! What makes it so amazing is that it removes the noise without greatly reducing the sharpness, detail, and color saturation. Plus, it applies the noise reduction to the RAW image itself (unlike most noise plug-ins).

Reducing Noise in Noisy Photos

Step One:
Open your noisy image in Camera Raw (the Noise Reduction feature works best on RAW images, but you can also use it on JPEGs, TIFFs, or PSDs, as well). The image shown here was shot at a high ISO using a Canon 5D, which didn't do a very good job in this low-light situation, so you can see a lot of color noise (those red, green, and blue spots) and luminance noise (the grainy looking gray spots).

Step Two:
Sometimes it's hard to see the noise until you really zoom in tight, so zoom in to at least 100%, and there it is, lurking in the shadows (that's where noise hangs out the most). Click on the Detail icon (it's the middle icon at the top of the Panel area) to access the Noise Reduction controls. I usually get rid of the color noise first, because that makes it easier to see the luminance noise (which comes next). Here's a good rule of thumb to go by when removing color noise: start with the Color slider over at 0 (as shown here) and then slowly drag it to the right until the moment the color noise is gone. *Note:* A bit of color noise reduction is automatically applied to RAW images—the Color slider is set to 25—but, for JPEGs, TIFFs, or PSDs, the Color slider is set to 0.

Continued

Step Three:

So, click-and-drag the Color slider to the right, but remember, you'll still see some noise (that's the luminance noise, which we'll deal with next). What you're looking for here is just for the red, green, and blue color spots to go away. Chances are that you won't have to drag very far at all—just until that color noise all turns gray. If you have to push the Color slider pretty far to the right, you might start to lose some detail, and in that case, you can drag the Color Detail slider to the right a bit, though honestly, I rarely have to do this for color noise.

Step Four:

Now that the color noise is gone, all that's left is the luminance noise, and you'll want to use a similar process: just drag the Luminance slider to the right, and keep dragging until the visible noise disappears (as seen here). You'll generally have to drag this one farther to the right than you did with the Color slider, but that's normal. There are two things that tend to happen when you have to push this slider really far to the right: you lose sharpness (detail) and contrast. Just increase the Luminance Detail slider if things start to get too soft (but I tend not to drag this one too far), and if things start looking flat, add the missing contrast back in using the Luminance Contrast slider (I don't mind cranking this one up a bit, except when I'm working on a portrait, because the flesh tones start to look icky). You probably won't have to touch either one all that often, but it's nice to know they're there if you need them.

Step Five:

Rather than increasing the Luminance Detail a bunch, I generally bump up the Sharpening Amount at the top of the Detail panel (as shown here), which really helps to bring some of the original sharpness and detail back. Here's the final image, zoomed back out, and you can see the noise has been pretty much eliminated, but even with the default settings (if you're fixing a RAW image), you're usually able to keep a lot of the original sharpness and detail. A zoomed-in before/after of the noise reduction we applied is shown below.

Before

After

Removing Red Eye in Camera Raw

Camera Raw has its own built-in Red Eye Removal tool, and there's a pretty good chance it might actually work. Although, if it were me, I might be more inclined to use the regular Eye tool in Elements itself (see Chapter 7), which actually works fairly well, but if you're charging by the hour, this might be a fun place to start. Here's how to use this tool, which periodically works for some people, somewhere. On occasion. Perhaps.

Step One:
Open a photo in Camera Raw that has the dreaded red eye (like the one shown here). To get the Red Eye Removal tool, you can press the letter **E** or just click on its icon up in Camera Raw's toolbar (as shown here).

KIM DOTY

Step Two:
You'll want to zoom in close enough so you can see the red-eye area pretty easily (as I have here, where I just simply zoomed to 100%, using the zoom level pop-up menu in the bottom-left corner of the Camera Raw window). The way this tool works is pretty simple—you click-and-drag the tool around one eye (as shown here) and as you drag, it makes a box around the eye. That tells Camera Raw where the red eye is located.

Step Three:

When you release the mouse button, theoretically it should snap down right around the pupil, making a perfect selection around the area affected by red eye (as seen here). You'll notice the key word here is "theoretically." If it doesn't work for you, then press **Ctrl-Z (Mac: Command-Z)** to undo that attempt, and try again. Before you do, try to help the tool along by increasing the Pupil Size setting (in the Red Eye Removal panel on the right), as I did here.

Step Four:

Once that eye looks good, go over to the other eye, drag out that selection again (as shown here), and it does the same thing (the before and after are shown below). One last thing: if the pupil looks too gray after being fixed, then drag the Darken amount to the right. Give it a try on a photo of your own. It's possible it might work.

Before

After

The Trick for Expanding the Range of Your Photos

As good as today's digital cameras are, there are still some scenes they can't accurately expose for (like backlit situations, for example). Even though the human eye automatically adjusts for these situations, your camera is either going to give you a perfectly exposed sky with a foreground that's too dark, or vice versa. Well, there's a very cool trick (called double-processing) that lets you create two versions of the same photo (one exposed for the foreground, one exposed for the sky), and then you combine the two to create an image beyond what your camera can capture!

Step One:

Open an image with an exposure problem in Camera Raw. In our example here, the camera properly exposed for the sky in the background, so the buildings and water in the foreground, as well as the mountains are dark. Of course, our goal is to create something our camera can't—a photo where the buildings, water, mountains, and sky are all exposed properly. Plus, by double-processing (editing the same RAW photo twice), we can choose one set of edits for the sky and another for the foreground to create just what we want.

Step Two:

Let's start by making the foreground more visible. Drag the Shadows slider to the right (I dragged it to +43), and then bump up the Exposure slider, as well (here, I dragged it over to +1.60). The buildings and mountains look kind of "flat" contrast-wise, so bump up the Contrast a bit, too (let's go to +26). Lastly, let's crank the Clarity up to around +20, and then make the color more vibrant by increasing the Vibrance to around +22. Now, click the Open Image button to create the first version of your photo.

Step Three:

In the Elements Editor, go under the File menu, choose **Save As**, and rename and save this adjusted image. Then go back under the File menu, and under **Open Recently Edited File**, choose the same photo you just opened. It will reopen in Camera Raw. The next step is to create a second version of this image that exposes for the sky, even though it will make the foreground very dark.

Step Four:

So, first click the Default link to reset the sliders to 0, then drag the Exposure slider to the left (I went to –0.30), and drag the Contrast slider to +20 to help define the clouds. I also dragged the Highlights and Whites sliders to the right to brighten the sky and clouds, and lastly, I increased both the Clarity and Vibrance a bit. Once the sky looks good, click Open Image.

Continued

Step Five:

Now you should have both versions of the image open in the Editor: one exposed for the foreground and one exposed for the sky. (*Note:* This is easier if your windows are floating. So, in Elements' General Preferences, turn on the Allow Floating Documents in Expert Mode checkbox, then under the Window menu, under Images, choose **Float All in Windows**.) Arrange the image windows so you can see both onscreen (with the lighter photo in front). Press **V** to get the Move tool, press-and-hold the Shift key, click on the lighter image, and drag-and-drop it on top of the good sky version. The key to this part is holding down the Shift key while you drag between documents, which perfectly aligns the lighter image (that now appears on its own layer in the Layers palette) with the darker version on the Background layer. (This exact alignment of one identical photo over another is referred to as being "pin-registered.") You can now close the lighter document without saving, as both versions of the image are contained within one document.

Step Six:

You now have two versions of your photo, each on a different layer—the darker sky version on the bottom layer and the brighter one exposed for the foreground on the layer directly on top—and they're perfectly aligned, one on top of the other. This is why we call it "double-processing," because you have two versions of the same image, each processed differently. Now we need to combine these two layers into one image that combines the best of both. We'll combine the images with a layer mask (more on layer masks in Chapter 6), but rather than painstakingly painting it, we can cheat and use the Quick Selection tool **(A)**. So, get it from the Toolbox and paint over the sky, and it selects it for you in just a few seconds (as shown here).

Step Seven:
Press **Ctrl-Shift-I (Mac: Command-Shift-I)** to Inverse your selection, so the foreground is selected. Then, go to the Layers palette and click on the Add Layer Mask icon at the top of the palette (shown circled here in red). This converts your selection into a layer mask, which hides the light sky and reveals the darker sky layer in its place (as seen here). It still needs some tweaking (for sure), but at least now you can see what we're aiming for—the brighter foreground from one layer blended with the darker sky from the other layer.

Step Eight:
Now, you're going to lower the Opacity of this top layer (the brighter foreground layer), so it blends in a little better with the darker sky layer. Here, I've lowered it to 90%, and the colors match much better.

Continued

Step Nine:

Occasionally, you'll have to deal with some common problems after lightening the foreground, like noise, but you can easily fix them in Camera Raw. First, you'll need to flatten the layers by going to the Layers palette and, from the flyout menu at the top right, choose **Flatten Image** to flatten the image down to one layer, and then save it. Then, you can reopen the image in Camera Raw and make any needed corrections. A before/after of our double-processing is shown below.

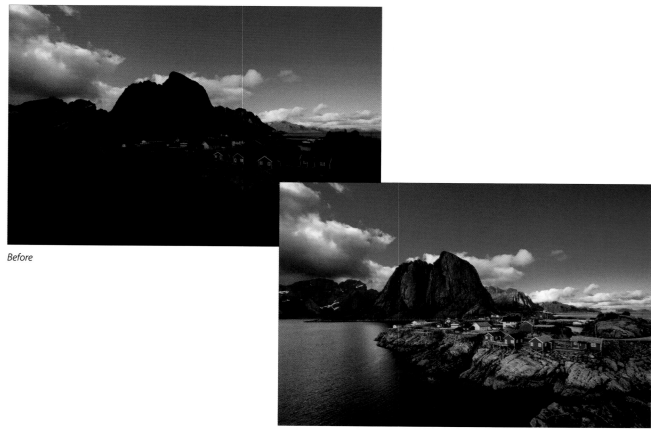

Before

After

One of the easiest ways to make great black-and-white photos (from your color images) is to do your conversion completely within Camera Raw. There are two methods for converting your images from color to black and white, and I'll start with the method that I previously used in Camera Raw. But, the newer method (definitely my preferred method now) gives you more choices, live previews, and, I think, a far better result. Plus, once you've made the conversion, you can use the same techniques you learned in Chapter 2 to really fine-tune your conversion. Here's how it's done:

Black & White Conversions in Camera Raw

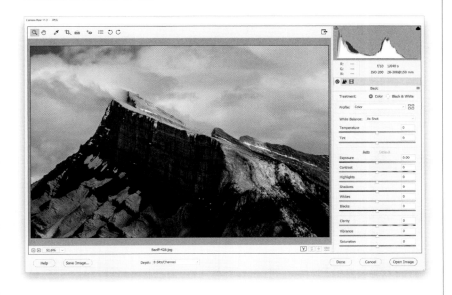

Step One:
Start by opening a photo you want to convert to black and white. We're going to work from the bottom of the Basic panel upward. The first step in converting to black and white is to remove the color from the photo.

TIP: Try the Auto Adjustment
This is one of the rare times I start by clicking the Auto button (you know, the button beneath the Tint slider that looks like a web link), because it usually pumps up the exposure about as high as it can go without too much clipping (if any).

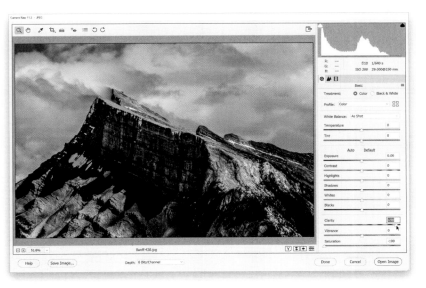

Step Two:
Go to the Saturation slider and drag it all the way to the left. Although this removes all the color, it usually makes for a pretty flat-looking (read as: lame) black-and-white photo. So, go up two sliders to the Clarity slider and drag it over quite a bit to the right to really make the midtones snap (I dragged over to +90).

Continued

Step Three:

Now you're going to add extra contrast by (you guessed it) dragging the Contrast slider to the right until the photo gets really contrasty (as shown here). It's important that you set this slider first—before you set the Blacks slider—or you'll wind up setting the blacks, then adjusting the contrast, and then lowering the Blacks slider back down. That's because what the Contrast slider essentially does is makes the darkest parts of the photo darker and the brightest parts brighter. If the blacks are already very dark, then you add contrast, it makes them too dark, and you wind up backing them off again. So, save yourself the extra step and set the contrast first. After setting the Contrast slider to +65, I then dragged the Blacks slider to –20.

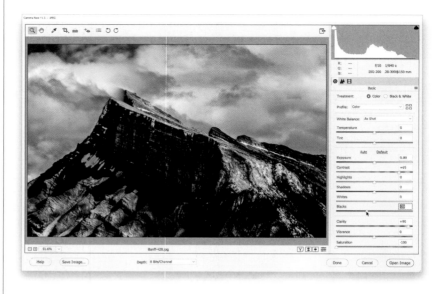

Step Four:

The image is pretty dark, so drag the Highlights slider to the right to lighten those areas (I dragged to +65). To enhance the dramatic look, I also upped the Whites to +26. That's it—one way you can convert to black and white right within Camera Raw. But, there's a better way.

TIP: Change the White Balance

Another thing you might try for RAW images is going through each of the White Balance presets (in the White Balance pop-up menu) to see how they affect your black-and-white photo. You'll be amazed at how this little change can pay off (make sure you try Fluorescent and Tungsten—they often look great in black and white).

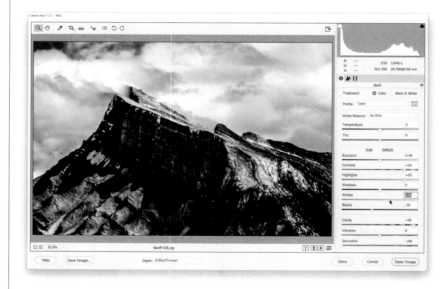

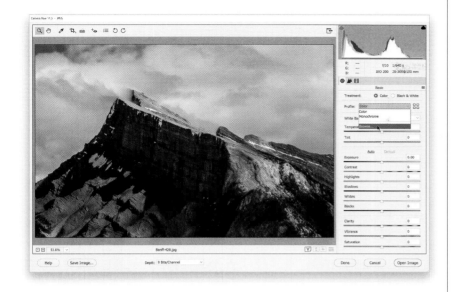

Step Five:
Okay, press-and-hold the Alt (Mac: Option) key and the Cancel button at the bottom right will change to the Reset button. Click on it and let's try the other method. Go to the top of the Basic panel, and from the Profile pop-up menu, choose **Browse** (as shown here). We're going to use a profile to convert to black and white, and we're going to have a lot of choices as to how this conversion happens, and how the final image winds up looking.

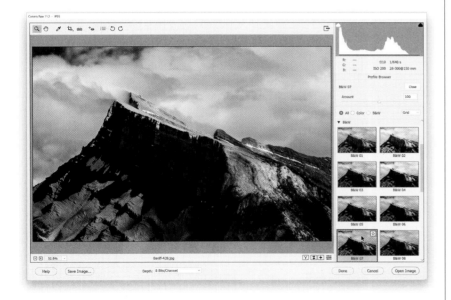

Step Six:
When you choose Browse, it brings up the Profile Browser you see here. Scroll down to the B&W profiles. The awesome thing about these B&W profiles is that they're not presets—they don't move any sliders—so when you find one you like and apply it, you can still tweak the resulting image to your heart's content. It shows you a preview of what each B&W profile looks like right on the thumbnail themselves. To find which one looks best to you, just hover your cursor over each thumbnail and you'll get a live preview right on your image. Here, I moved my cursor over each of the thumbnails to find out which one looked best on this particular image, and, for me, it was B&W 07. So, that's what you're seeing here. Just one click.

Continued

Step Seven:

One of the best things about these profiles (besides the fact that they don't move any sliders when you use them) is that you can control their amounts—if you apply one and the effect is too intense, you can use the Amount slider at the top of the panel to back off the intensity. Or, if you like what you see, you can intensify the profile's effect, so that's what I did here, where I increased the Amount by dragging the slider to the right to 152.

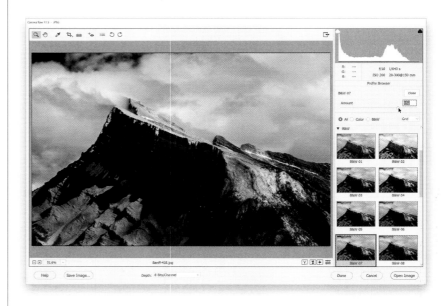

Step Eight:

Since the B&W profiles don't move any sliders, you're free to use them to tweak your image (click the Close button at the top right of the Profile Browser first). That's what I did here, adding a little more Contrast, backing off the Highlights a bit, and opening up the Shadows and the Whites. Lastly, I went to the Detail panel and sharpened the living daylights out of it (which I always do with black-and-white images) by setting the Amount to 90 and the Radius to 1.1.

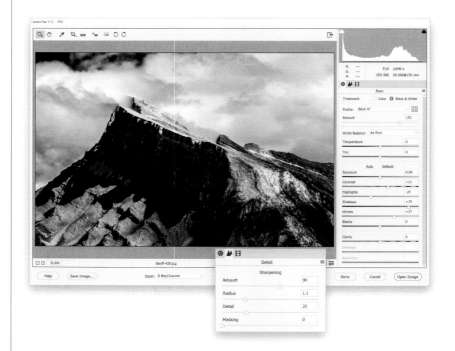

Before

After applying a B&W profile, then cranking up the Amount, and making Basic panel and Detail panel tweaks

Cropping and Straightening

There are some distinct advantages to cropping your photo in Camera Raw, rather than in Elements itself, and perhaps the #1 benefit is that you can return to Camera Raw later and return to the uncropped image. (Here's one difference in how Camera Raw handles RAW photos vs. JPEG, TIFF, and PSD photos: this "return to Camera Raw later and return to the uncropped image" holds true even for them, as long as you haven't overwritten the original JPEG, TIFF, or PSD file. To avoid overwriting, when you save the JPEG, TIFF, or PSD, in Elements, change the filename.)

Step One:

The fourth tool in Camera Raw's toolbar is the Crop tool. By default, it pretty much works like the Crop tool in Elements (you click-and-drag it out around the area you want to keep), but it does offer some features that Elements doesn't—like access to a list of preset cropping ratios. To get them, click-and-hold on the Crop tool and a pop-up menu will appear (as shown here). The Normal setting gives you the standard drag-it-where-you-want-it cropping. However, if you choose one of the cropping presets, then your cropping is constrained to a specific ratio. For example, choose the 2-to-3 ratio, click-and-drag it out, and you'll see that it keeps the same aspect ratio as your original uncropped photo.

Step Two:

Here's the 2-to-3-ratio cropping border dragged out over my image. The area that will be cropped away appears dimmed, and the clear area inside the cropping border is how your final cropped photo will appear. If it's a RAW photo, and you reopen it later and click on the Crop tool, the cropping border will still be visible onscreen, so you can move it, resize it, or remove it altogether by simply pressing the **Esc key** or the **Backspace (Mac: Delete) key** on your keyboard (or by choosing **Clear Crop** from the Crop tool's pop-up menu).

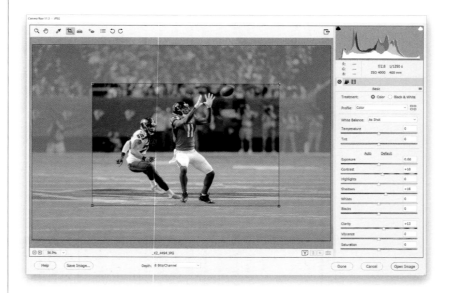

Step Three:

If you want your photo cropped to an aspect ratio that isn't in the presets, like 3 to 5, for example, choose **Custom** from the Crop tool's pop-up menu to bring up the dialog you see here. Just type in your custom size, click OK, and it will now appear in the pop-up menu.

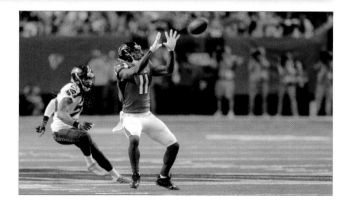

Step Four:

Here, we're going to create a custom crop so our photo winds up having a 3-to-5 aspect ratio, so type in your custom size, click OK, click-and-drag out the cropping border, and the area inside it will be a 3-to-5 ratio. Click on any other tool in the toolbar or press **Enter (Mac: Return)**, and you'll see the final cropped image. Once you click on the Open Image button in Camera Raw, the image is cropped to your specs and opened in the Editor. If, instead, you click on the Done button, Camera Raw closes and your photo is untouched, but it keeps your cropping border in position for the future.

Continued

Step Five:

If you save a cropped JPEG, TIFF, or PSD photo out of Camera Raw (by clicking on the Save Image button on the bottom left of the Camera Raw window), the only option is to save it as a DNG (Digital Negative) file. DNG files open in Camera Raw, so by doing this, you can bring back those cropped areas if you decide to change the crop. Your original JPEG, TIFF, or PSD will also keep the cropping border if you simply click the Done button, or once you open the cropped photo in the Editor, save it from there with a new filename. Just open the original photo in Camera Raw again, and click on the Crop tool to see the border.

Step Six:

If you have a number of similar photos you need to crop the same way, you're going to love this: First, select all the photos you want to crop (either in the Organizer or in the Open dialog), then open them all in Camera Raw. When you open multiple photos, they appear in a vertical filmstrip along the left side of Camera Raw (as shown here). Click on the Select All button (it's above the filmstrip) and then crop the currently selected photo as you'd like. As you apply your cropping, look at the filmstrip and you'll see all the thumbnails update with their new cropping instructions. A tiny Crop icon will also appear in the bottom-left corner of each thumbnail, letting you know that these photos have been cropped in Camera Raw.

Step Seven:

Another form of cropping is actually straightening your photos using the Straighten tool. It's a close cousin of the Crop tool because what it does is essentially rotates your cropping border, so when you open the photo, it's straight. In the Camera Raw toolbar, choose the Straighten tool (it's immediately to the right of the Crop tool). Now, click-and-drag it along the horizon line in your photo (as shown here). When you release the mouse button, a cropping border appears and that border is automatically rotated to the exact amount needed to straighten the photo.

Step Eight:

You won't actually see the rotated photo until you click on another tool (which I've done here) or open it in Elements (which means, if you click Save Image or Done, Camera Raw closes, and the straightening information is saved along with the file. So, if you open this file again in Camera Raw, that straightening crop border will still be in place). If you click Open Image, the photo opens in Elements, but only the area inside the cropping border is visible, and the rest is cropped off. Again, if this is a RAW photo (or you haven't overwritten your JPEG, TIFF, or PSD file), you can always return to Camera Raw and remove this cropping border to get the original uncropped photo back.

TIP: Canceling Your Straightening

If you want to cancel your straightening, just press the **Esc key** on your keyboard, and the straightening border will go away.

Converting RAW Photos to the Adobe DNG Format

You have the option of converting your RAW images from your camera manufacturer's proprietary RAW format to Adobe's open format DNG (Digital Negative) format. DNG was created by Adobe out of concern that one day, one or more manufacturers might abandon their proprietary RAW format, leaving photographers shooting RAW out in the cold. Unfortunately, none of the big three camera manufacturers embraced this DNG format, and even I stopped converting my images a few years ago. However, if you want to convert to DNG, here's how:

Step One:

There are two advantages of the DNG format: (1) DNG files maintain the RAW properties, but are about 20% smaller in file size, and (2) if you need to share an original RAW image file with someone, and you want that file to include any changes you made to it in Camera Raw (including keywords, copyright, metadata, etc.), you don't have to generate a separate XMP sidecar file (a separate text file that stores all that info). With DNG, all that data is backed right into the file itself, so there is no need for a second file. There are disadvantages to DNG, as well, including importing taking longer because your RAW files have to be converted to DNG first. Also, DNGs aren't supported by many other photo applications. Just so you know. However, if you have a RAW image open in Camera Raw that you want to save as an Adobe DNG, click the Save Image button (as shown here) to bring up the Save Options dialog (seen in the next step). *Note:* There's really no advantage to saving TIFF, JPEG, or PSD files as DNGs.

Step Two:

When the Save Options dialog appears, in the middle of the dialog, you'll see the File Extension pop-up menu is set to DNG (shown here). Below that, under Format: Digital Negative, is a set of options for saving your DNGs.

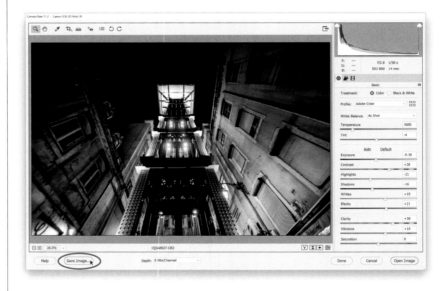

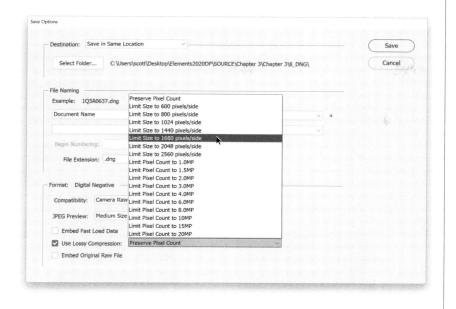

Step Three:
In the Format section is the Embed Fast Load Data checkbox, which uses a smaller embedded RAW preview that makes switching between images faster. Below that is a somewhat controversial option. It uses a JPEG-like lossy compression (meaning there is a loss in quality), but the trade-off (just like in JPEG) is that your file sizes are dramatically smaller (about 25% of the size of a full, uncompressed RAW file). So, if there's a loss of quality, why would you use this? Well, you wouldn't use it for your Picks (the best images from a shoot—ones you might print, or a client might see), but what about the hundreds the client rejected or you don't like? Those might (it's your call) be candidates to be compressed to save drive space. It's something to consider. If you do want to do it, turn on that checkbox, then choose (from its pop-up menu) which option is most important to you: saving the same physical dimensions (pixel size) or file size (megapixels). Once you've made your choices, click Save, and you've got a DNG.

TIP: Setting Your DNG Preferences
With Camera Raw open, press **Ctrl-K (Mac: Command-K)** to bring up Camera Raw's Preferences dialog. There are two preferences in the DNG File Handling section: Choose Ignore Sidecar ".xmp" Files only if you use a different RAW processing application (other than Camera Raw or Lightroom), and you want Camera Raw to ignore any XMP files created by that application. If you turn on the Update Embedded JPEG Previews checkbox (and choose your preferred preview size from the pop-up menu), then any changes you make to the DNG will be applied to the preview, as well.

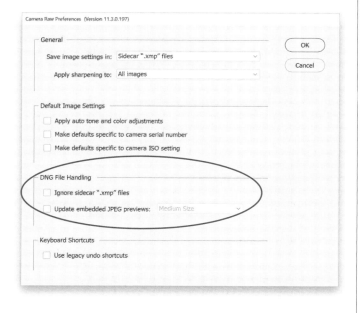

Scream of the Crop
how to resize and crop photos

You know what? If I go to Google or the iTunes Store (two of my most reliable sources for TV show, song, and movie titles), and type in "crop," do you know what I'm going to get? That's right, a bunch of results about corn and wheat. Now, I have to be straight with you—I hate corn. I don't know what it is about corn that I don't like (maybe its red color?), but I just never warmed up to it at all. It's probably because I don't like the smell of corn, and if you think about it, when it comes to which foods we like and which we don't like, we generally don't like any foods that smell bad to us. For example, when was the last time you put a big forkful of food up to your mouth and said, "Wow, this smells horrible!" and you actually ate it? Okay, outside of a fraternity prank, when was the last time? Really? You eat food that stinks? Wow, I never knew that about you. I'm a little surprised frankly, because up to this point, I thought we had kind of a simpatico thing going between us. I write ridiculous stuff, and you don't return the book for a refund, and

you even skip entire chapters just to jump to the next chapter opener. I thought we were buds, but this…this really has me worried. What else haven't you told me? What? No way! Did you get sick? Oh man, that had to be bad. Did you call the cops? Why not? Oh. Then what? No way! What? What? What? Ewwwww! Look, I'm not sure we can go through any more of these chapter intros together. You're pretty messed up, and I'm not sure that reading these is good for you. You seem like you're in kind of a downward spiral. What? No, I am not judging you. Okay, I'm judging you, but no more than anyone else would who knew you did that, which by the way was pretty sick, and yes you should have called the cops, or a lawyer, or a podiatrist, or a taxidermist. So, corn, huh? All that, and you're totally okay with eating corn, even though it smells bad to you. Well, if it's any consolation, I don't eat wheat. I mean, where would you even buy a bushel of wheat? The tack shop? The Purina shop? Subway? Hey, I have a 50% off coupon!

Basic Cropping

After you've sorted your images in the Organizer, one of the first editing tasks you'll probably undertake is cropping a photo. There are a number of different ways to crop a photo in Elements. We'll start with the basic garden-variety options, and then we'll look at some ways to make the task faster and easier.

Step One:
Open the image you want to crop in the Elements Editor, and then press the letter **C** to get the Crop tool (you could always select the tool directly from the Toolbox, but I only recommend doing so if you're charging by the hour).

Step Two:
Click within your photo and drag out a cropping border. By default, you'll see a grid appear within your border. This feature lets you crop photos based on some of the popular composition rules that photographers and designers use. We'll go over this feature more in a moment, so for now click on the None icon in the Grid Overlay section on the right end of the Tool Options Bar. The area to be cropped away will appear dimmed (shaded). You don't have to worry about getting your cropping border right when you first drag it out, because you can edit it by dragging the control handles that appear in each corner and at the center of each side.

TIP: Turn Off the Shading

If you don't like seeing your photo with the cropped-away areas appearing shaded (as in the previous step), you can toggle this shading feature off/on by pressing the **Forward Slash key (/)** on your keyboard. When you press the Forward Slash key, the border remains in place but the shading is turned off.

Step Three:

While you have the cropping border in place, you can rotate the entire border. Just move your cursor outside the border, and your cursor will change into a double-headed arrow. Then, click-and-drag, and the cropping border will rotate in the direction that you drag. (This is a great way to save time if you have a crooked image, because it lets you crop and rotate at the same time.)

Continued

Step Four:

Once you have the cropping border where you want it, click on the green checkmark icon at the bottom corner of your cropping border, or just press the **Enter (Mac: Return) key** on your keyboard. To cancel your crop, click the red international symbol for "No Way!" at the bottom corner of the cropping border, or press the **Esc key** on your keyboard.

Step Five:

Elements includes a feature called Crop Suggestions in both Quick and Expert edit modes. It automatically looks at your photo and gives you a few suggestions for ways to crop it. It's pretty simple to use: just hover your cursor over the different thumbnails to see the suggestions. If you find one you like, click on it to select it. If you like the size, but not the placement, simply click inside the cropping border and drag it where you want it.

Step Six:

Like I mentioned, Elements includes overlay features to help you crop your photos. The one you'll use the most is called the Rule of Thirds (and is the default overlay). It's essentially a trick that photographers sometimes use to create more interesting compositions. Basically, you visually divide the image you see in your camera's viewfinder into thirds, and then you position your horizon so it goes along either the top imaginary horizontal line or the bottom one. Then, you position the subject (or focal point) at the intersections of those lines (as you'll see in the next step). But if you didn't use the rule in the viewfinder, no sweat! You can use this overlay feature to achieve it. There is one other option in the Grid Overlay section: Grid, which is useful for straightening horizons.

Step Seven:
So, click on the Rule of Thirds icon and then click within your photo and drag out a cropping border. When you drag the cropping border onto your image, you'll see the Rule of Thirds overlay appear over your photo. Try to position your image's horizon along one of the horizontal grid lines, and be sure your focal point (the running back, in this case) falls on one of the intersecting points (the top-left intersection, in this example).

Before

After

Auto-Cropping to Standard Sizes

If you're outputting photos for clients, chances are they're going to want them in standard sizes so they can easily find frames to fit. If that's the case, here's how to crop your photos to a predetermined size (like a 5x7", 8x10", etc.):

Step One:

Open an image in the Elements Editor that you want to crop to be a perfect 5x7" for a vertical image, or 7x5" if your image is horizontal. Press **C** to get the Crop tool, then go to the Tool Options Bar and click on the words "No Restriction" in the pop-up menu on the left. From the list of preset crop sizes, choose **5x7 in.** (*Note:* To hide the Rule of Thirds overlay grid, click on the None icon on the right side of the Tool Options Bar.)

TIP: Swapping Fields

The W(idth) and H(eight) fields are populated based on the type of image you open—7x5" for horizontal images and 5x7" for vertical images. If you opened a horizontal image, but your crop is going to be vertical (tall), you'll need to swap the figures in the W and H fields by clicking on the Swaps icon between the fields in the Tool Options Bar (as shown here).

Step Two:
Now click-and-drag the Crop tool over the portion of the photo that you want to be 7x5" (as mentioned on the previous page, if your image is vertical, Elements will automatically adjust your border to 5x7". I made the rulers visible here by pressing **Ctrl-Shift-R [Mac: Command-Shift-R]**). While dragging, you can press-and-hold the Spacebar to adjust the position of your border, if needed.

Step Three:
Once it's set, press **Enter (Mac: Return)** and the area inside your cropping border will become 7x5" (as seen here).

TIP: Crop with an Action
You can also use the Actions palette (found under the Window menu) in Elements to crop your photos. In the palette, they are in the Resize and Crop folder. Simply open the image you want to crop, click on the cropping action you want to run, then click on the Play Selection icon at the top right of the palette, and—BAM!—your image is cropped and ready to go.

Cropping to an Exact Custom Size

Okay, now you know how to crop to Elements' built-in preset sizes, but how do you crop to a nonstandard size—a custom size that you determine? Here's how:

Step One:

Open the photo that you want to crop in the Elements Editor. (I want to crop this image to 8x6".) First, press **C** to get the Crop tool. In the Tool Options Bar, you'll see fields for W(idth) and H(eight). Enter the size you want for the width, followed by the unit of measure you want to use (e.g., enter "in" for inches, "px" for pixels, "cm" for centimeters, "mm" for millimeters, etc.). Next, press the **Tab key** to jump over to the H(eight) field and enter your desired height, again followed by the unit of measure.

Step Two:

Once you've entered these figures in the Tool Options Bar, click within your photo with the Crop tool and drag out a cropping border. (*Note:* To hide the Rule of Thirds overlay grid, click on the None icon on the right side of the Tool Options Bar.) You'll notice that as you drag, the border is constrained to an 8x6" aspect ratio; no matter how large of an area you select within your image, the area within that border will become your specified size. When you release your mouse button, you'll still have the corner handles visible, but if you click-and-drag on a side, it will act like a corner handle to keep your size constrained.

Step Three:

Once your cropping border is onscreen, you can resize it using the corner handles or you can reposition it by moving your cursor inside the border. Your cursor will change to a Move arrow, and you can now click-and-drag the border into place. You can also use the **Arrow keys** on your keyboard for more precise control. When it looks right to you, press **Enter (Mac: Return)** to finalize your crop or click on the checkmark icon at the bottom right of your cropping border. Here, I made the rulers visible **(Ctrl-Shift-R [Mac: Command-Shift-R])** so you could see that the image measures exactly 8x6".

Continued

TIP: Clearing the Fields

Once you've entered a width and height in the Tool Options Bar, those dimensions will remain there. To clear the fields, just choose **No Restriction** from the pop-up menu above the W and H fields. This will clear the fields, and now you can use the Crop tool for freeform cropping (you can drag it in any direction—it's no longer constrained to your specified size).

COOLER TIP:
Changing Dimensions

If you already have a cropping border in place, you can change your dimensions without re-creating the border. All you have to do is enter the new sizes you want in the W and H fields in the Tool Options Bar, and Elements will resize your cropping border.

Before

After

Elements has a cool feature that lets you crop your photo into a pre-designed shape (like putting a wedding photo into a heart shape), but even cooler are the edge effects you can create by using the pre-designed custom edges. Here's how to put this feature to use to add visual interest to your own photos:

Cropping into a Shape

Step One:
In the Elements Editor, open the photo you want to crop into a pre-designed shape, and press the letter **C** until you get the Cookie Cutter tool.

Step Two:
Now, go down to the Tool Options Bar and click on the shape thumbnail. This brings up the Custom Shape Picker, which contains the default set of 30 shapes. To load more shapes, click on the Shapes pop-up menu at the top of the Picker and a list of built-in shape sets will appear. From this list, choose **Crop Shapes** to load the edge-effect shapes, which auto-matically crop away areas outside your custom edges.

Continued

Step Three:

Once you select the custom edge shape you want to use in the Custom Shape Picker, just click-and-drag it over your image to the size you want it. When you release the mouse button, your photo is cropped to fit within the shape. *Note:* I like Crop Shape 10 for something simple, and Crop Shape 20 (which is shown here) for something a little wilder. The key thing here is to experiment and try different crop shapes to find your favorite.

Step Four:

You'll see a bounding box around the shape, which you can use to resize, rotate, or otherwise mess with your shape. To resize your shape while keeping it proportional, press-and-hold the Shift key (or choose Defined Proportions from the pop-up menu to the right of the shape thumbnail in the Tool Options Bar), then click-and-drag a corner handle. To rotate the shape, move your cursor outside the bounding box until your cursor becomes a double-headed arrow, and then click-and-drag. As long as you see that bounding box, you can still edit the shape. When it looks good to you, press **Enter (Mac: Return)** and the parts of your photo outside that shape will be permanently cropped away.

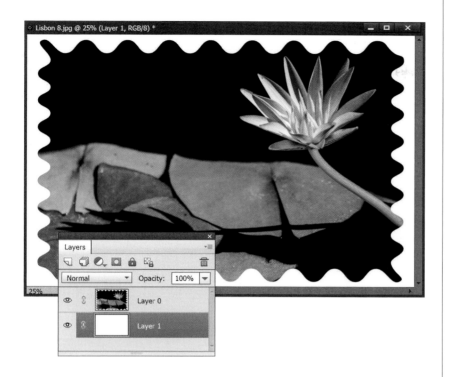

TIP: Tightly Crop Your Image

If you want your image area tightly cropped, so it's the exact size of the shape you drag out, just turn on the Cookie Cutter's Crop checkbox (in the Tool Options Bar) before you drag out your shape. Then, when you press Enter (Mac: Return) to lock in your final shape, Elements will tightly crop the entire image area to the size of your shape. *Note:* The checkerboard pattern you see around the photo is letting you know that the background around the shape is transparent. If you want a white background behind the shape, click on the Create a New Layer icon at the top of the Layers palette, and then drag your new layer below the Shape layer. Press **D**, then **X** to set your Foreground color to white, and press **Alt-Backspace (Mac: Option-Delete)** to fill this layer with white.

Before

After

Fixing Problems with Perspective Crop

This is the tool you reach for when there's something in your image that's at an angle, but you need it to be flat (and you need to crop everything else but that object away). It's a one-trick pony, but when you need it, it really works wonders.

Step One:

Open an image that has something that's angled that you want to be flat. In this case, it's a book sitting on my desk (by the way, this is the Spanish translation of my Lightroom Classic book). Press the letter **C** until you get the Perspective Crop tool (shown selected here in the Tool Options Bar).

Step Two:

Now, click-and drag a cropping border over the object you want flat. It doesn't have to surround the whole object at this point because we're going to adjust it in a second. When you click-and drag, it drags out a visible grid, which is helpful in positioning your crop border (as seen here).

Step Three:

To position the cropping border around the book, just click on the top-right corner handle, and drag it over to the top-right corner of the book. Then, do the same with the top-left and bottom corners—click-and-drag the corner handles to the corners of the book (as shown here). If you need to reposition the grid, just click anywhere inside it and drag it, or use the side handles to resize it. If you're not happy with the grid you created, just hit the **Esc key** on your keyboard and you can take another stab at it.

Step Four:

When it looks good to you, press the **Enter (Mac: Return) key** to apply the crop to your image. It flattens it out like you see here, and crops everything outside that grid away. Again, you're not going to use this technique every day, but when you need it, it works like a charm.

Using the Crop Tool to Add More Canvas Area

I know the heading for this technique doesn't make much sense—"Using the Crop Tool to Add More Canvas Area." How can the Crop tool (which is designed to crop photos to smaller sizes) actually make the canvas area (white space) around your photo larger? That's what I'm going to show you.

Step One:
In the Elements Editor, open the image to which you want to add additional blank canvas area. Press the letter **D** to set your Background color to its default white. If you want to add a different color canvas, click on the Background Color swatch at the bottom of the Toolbox to open the Color Picker, choose whatever color you want the canvas to be, and click ok.

Step Two:
If you're in Maximize Mode or tabbed viewing, press **Ctrl-–** (minus sign; **Mac: Command-–**) to zoom out a bit (so your image doesn't take up your whole screen). If your image window is floating, click-and-drag out the bottom corner of the document window to see the gray desktop area around your image. (To enter Maximize Mode, click the Maximize Mode icon in the top-right corner of the image window. To enter tabbed viewing, go under the Window menu, under Images, and choose **Consolidate All to Tabs**.)

Step Three:
Press the letter **C** to switch to the Crop tool and drag out a cropping border to any random size (it doesn't matter how big or little it is at this point).

Step Four:
Next, grab any one of the side or corner handles and drag outside the image area, out into the gray area that surrounds your image. The cropping border extending outside the image is the area that will be added as white canvas space, so position it where you want to add the blank canvas space.

Step Five:
Now, just press the **Enter (Mac: Return) key** to finalize your crop, and when you do, the area outside your image will become white canvas area.

Auto-Cropping Gang-Scanned Photos

A lot of photographers scan photos using a technique called "gang scanning." That's a fancy name for scanning more than one picture at a time. Scanning three or four photos at once with your scanner saves time, but then you eventually have to separate these photos into individual documents. Here's how to have Elements do that for you automatically:

Step One:
Place the photos you want to "gang scan" on the bed of your flatbed scanner. In the Organizer, you can scan the images by going under the File menu, under Get Photos and Videos, and choosing **From Scanner** (they should appear in one Elements document). In the dialog that appears, select where and at what quality you want to save your scanned document. (*Note:* This feature is currently not available in the Elements 2020 version for the Mac, so you'll need to use your scanner's software.)

Step Two:
Once your images appear in one document in the Editor, go under the Image menu and choose **Divide Scanned Photos**. It will immediately find the edges of the scanned photos, straighten them if necessary, and then put each photo into its own separate document. Once it has "done its thing," you can close the original gang-scanned document, and you'll be left with just the individual documents.

Straightening Photos with the Straighten Tool

In Elements, there's a simple way to straighten photos, but it's knowing how to set the options for the tool that makes your job dramatically easier. Here's how it's done:

Step One:
Open the photo that needs straightening (the photo shown here looks like it's sloping down to the left). Then, choose the Straighten tool from the Toolbox (or just press the **P key**).

TIP: Another Place to Straighten
You can also use the Straighten tool in Quick Mode.

Step Two:
Take the Straighten tool and drag it along an edge in the photo that you think should be perfectly horizontal, like a horizon line (as shown here) or the edge of a building.

Continued

Step Three:

When you release the mouse button, the image is straightened, but as you see here, the straightening created a problem of its own—the photo now has to be cropped again because the edges are showing a white background (as the image was rotated until it was straight). That's where the options (which I mentioned in the intro to this technique) come in. You see, the default setting does just what you see here—it rotates the image and leaves it up to you to crop away the mess. However, Elements can do the work for you (see the next step).

Step Four:

Once you click on the Straighten tool, go down to the Tool Options Bar and click on the Remove Background icon.

Step Five:

Also, there's a feature in Elements that lets you get the best of both worlds. For example, what happens if you straighten the photo and crop away the edges, but a key part of your photo gets cropped away with it? You'd normally be outta luck. Instead, go back to the default Grow or Shrink Canvas icon that we started with. Then turn on the Autofill Edges checkbox to the right. This time, Elements will try to automatically patch those areas that would normally be left white. You'll find it works best on skies and water, and areas with non-essential parts of the photo in them. It's not a gimme and it won't work every time, but it's definitely worth a try.

TIP: Straightening Vertically

In this example, we used the Straighten tool along a horizontal plane, but if you wanted to straighten a photo using a vertical object instead (like a column or light pole), just click-and-drag it vertically along an object and that will do the trick.

If you're more familiar with resizing scanned images, you'll find that resizing images from digital cameras is a bit different, primarily because scanners create high-resolution images (usually 300 ppi or more), but the default setting for most digital cameras usually produces an image that is large in physical dimension, but lower in ppi (usually 72 ppi). The trick is to decrease the physical size of your digital camera image (and increase its resolution) without losing any quality in your photo. Here's the trick:

Resizing Photos

Step One:
Open the digital camera image that you want to resize. Press **Ctrl-Shift-R (Mac: Command-Shift-R)** to make Elements' rulers visible, and then check out the rulers to see the approximate dimensions of your image. As you can see from the rulers in the example here, this photo is around 41x62".

Step Two:
Go under the Image menu, under Resize, and choose **Image Size** to bring up the Image Size dialog. In the Document Size section, the Resolution setting is 72 pixels/inch (ppi). A resolution of 72 ppi is considered low resolution and is ideal for photos that will only be viewed onscreen (such as web graphics, slide shows, etc.). This res is too low, though, to get high-quality results from a color inkjet printer, color laser printer, or for use on a printing press.

Continued

Step Three:

If we plan to output this photo to any printing device, it's pretty clear that we'll need to increase the resolution to get good results. I wish we could just type in the resolution we'd like it to be in the Resolution field (such as 200 or 240 ppi), but unfortunately, this "resampling" makes our low-res photo appear soft (blurry) and pixelated. That's why we need to make sure the Resample Image check-box is turned off (as shown here). That way, when we type in the setting that we need in the Resolution field, Elements automatically adjusts the Width and Height fields for the image in the exact same proportion. As your Width and Height decrease (with Resample Image turned off), your Resolution increases. Best of all, there's absolutely no loss of quality. Pretty cool!

Step Four:

Here I've turned off Resample Image, then I typed 240 in the Resolution field (for output to a color inkjet printer—I know, you probably think you need a lot more resolution, but you don't. In fact, I never print with a resolution higher than 240 ppi). At a resolution of 240 ppi here, I can actually print a photo that is around 18" wide by around 12" high.

Step Five:

Here, I've lowered the Resolution setting to 180 ppi. (Again, you don't need nearly as much resolution as you'd think, but 180 ppi is pretty much as low as you should go when printing to a color inkjet printer.) As you can see, the width of my image is now almost 25" and the height is almost 17." Best of all, we did it without damaging a single pixel, because we were able to turn off Resample Image.

Step Six:

When you click OK, you won't see the image window change at all—it will appear at the exact same size onscreen. But now look at the rulers—you can see that your image's dimensions have changed. Resizing using this technique does three big things: (1) it gets your physical dimensions down to size (the photo now fits on a 16x24" sheet); (2) it increases the resolution enough so you can output this image on a color inkjet printer; and (3) you haven't softened or pixelated the image in any way—the quality remains the same—all because you turned off Resample Image. *Note:* Do not turn off Resample Image for images that you scan on a scanner—they start as high-res images in the first place. Turning off Resample Image is only for photos taken with a digital camera at a low resolution.

Resizing and How to Reach Those Hidden Free Transform Handles

What happens if you drag a large photo onto a smaller photo in Elements? (This happens all the time, especially if you're collaging or combining two or more photos.) You have to resize the photo using Free Transform, right? Right. But here's the catch: when you bring up Free Transform, at least two (or, more likely, all four) of the handles that you need to resize the image are out of reach. You see the center point, but not the handles you need to reach to resize. Here's how to get around that hurdle quickly and easily:

Step One:
Open two different-sized photos in the Elements Editor. Use the Move tool **(V)** to drag-and-drop the larger photo on top of the smaller one (if you're in tabbed viewing, drag one image onto the other image's thumbnail in the Photo Bin). To resize a photo on a layer, press **Ctrl-T (Mac: Command-T)** to bring up the Free Transform command. Next, press-and-hold the Shift key to constrain your proportions (or turn on the Constrain Proportions checkbox in the Tool Options Bar), grab one of the Free Transform corner handles, and (a) drag inward to shrink the photo, or (b) drag outward to increase its size (not more than 20%, to keep from making the photo look soft and pixelated). But wait, there's a problem. The problem is—you can't even see the Free Transform handles in this image.

Step Two:
To instantly have full access to all of Free Transform's handles, just press **Ctrl-0** (zero; **Mac: Command-0**), and Elements will instantly zoom out of your document window and surround your photo with gray desktop, making every handle well within reach. Try it once, and you'll use this trick again and again. *Note:* You must choose Free Transform first for this trick to work.

There is a different set of rules we use for maintaining as much quality as possible when making an image smaller, and there are a couple of different ways to do just that (we'll cover the two main ones here). Luckily, maintaining image quality is much easier when sizing down than when scaling up (in fact, photos often look dramatically better—and sharper—when scaled down, especially if you follow these guidelines).

Making Your Photos Smaller (Downsizing)

Downsizing photos where the resolution is already 300 ppi:

Although earlier we discussed how to change image size if your digital camera gives you 72-ppi images with large physical dimensions (like 24x42" deep), what do you do if your camera gives you 300-ppi images at smaller physical dimensions (like a 10x6" at 300 ppi)? Basically, you turn on Resample Image (in the Image Size dialog—go under the Image menu, under Resize, and choose **Image Size**), then simply type the desired size (in this example, we want a 4x6" final image size), and click OK (don't change the Resolution setting, just click OK). The image will be scaled down to size, and the resolution will remain at 300 ppi. *IMPORTANT:* When you scale down using this method, it's likely that the image will soften a little bit, so after scaling you'll want to apply the Unsharp Mask filter to bring back any sharpness lost in the resizing (look at the sharpening chapter [Chapter 11] to see what settings to use).

Continued

Making one photo smaller without shrinking the whole document:

If you're working with more than one image in the same document, you'll resize a bit differently. To scale down a photo on a layer, first click on that photo's layer in the Layers palette, then press **Ctrl-T (Mac: Command-T)** to bring up Free Transform. Press-and-hold the Shift key to keep the photo proportional (or turn on the Constrain Proportions checkbox in the Tool Options Bar), grab a corner handle, and drag inward. When it looks good to you, press the **Enter (Mac: Return) key**. If the image looks softer after resizing it, apply the Unsharp Mask filter (again, see the sharpening chapter).

Resizing problems when dragging between documents:

This one gets a lot of people, because at first glance it just doesn't make sense. You have two documents, approximately the same size, side-by-side onscreen. But when you drag a 72-ppi photo (of St. Mark's Square, in this case) onto a 300-ppi document (Untitled-1), the photo appears really small. Why is that? Simply put: resolution. Although the documents appear to be the same size, they're not. The tip-off that you're not really seeing them at the same size is found in the title bar of each photo. For instance, the photo of St. Mark's Square is displayed at 100%, but the Untitled-1 document is displayed at only 25%. So, to get more predictable results, make sure both documents are at the same viewing size and resolution (check in the Image Size dialog).

Elements has a pretty slick little utility that lets you take a folder full of images and do any (or all) of the following automatically at one time: (1) rename them; (2) resize them; (3) change their resolution; (4) color correct and sharpen them; and (5) save them in the file format of your choice (JPEG, TIFF, etc.). If you find yourself processing a lot of images, this can save a ton of time. Better yet, since the whole process is automated, you can teach someone else to do the processing for you, like your spouse, your child, a neighbor's child, passersby, local officials, etc.

Automated Saving and Resizing

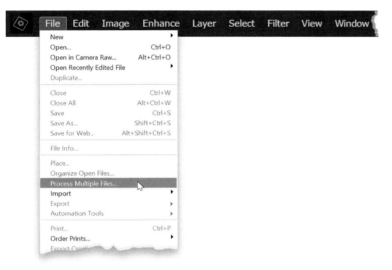

Step One:
In the Elements Editor, go under the File menu and choose **Process Multiple Files**.

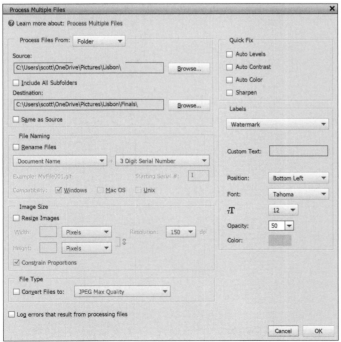

Step Two:
When the Process Multiple Files dialog opens, the first thing you have to do is choose the folder of photos you want to process by clicking on the Browse button in the Source section of the dialog. Then, navigate to the folder you want and click OK (Mac: Choose). If you already have some photos open in Elements, you can choose Opened Files from the Process Files From pop-up menu (or you can choose Import to import files). Then, in the Destination section, you decide whether you want the new copies to be saved in the same folder (by turning on the Same as Source checkbox), or copied into a different folder (in which case, click on the section's Browse button and choose that folder).

Continued

Step Three:

The next section is File Naming. If you want your files automatically renamed when they're processed, turn on the Rename Files checkbox, then in the fields directly below that checkbox, type the name you want these new files to have and choose how you want the numbering to appear after the name (a two-digit number, three-digit, etc.). Then, choose the number with which you want to start numbering images. You'll see a preview of how your file naming will appear just below the document name field (shown circled here).

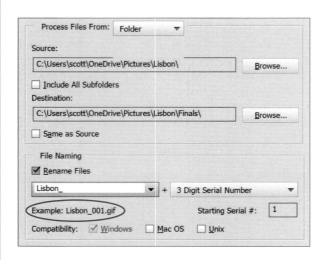

Step Four:

In the Image Size section, you decide if you want to resize the images (by turning on the Resize Images checkbox), and you enter the width and height you want for your finished photos. You can also choose to change the resolution. If you want to change their file type (like from RAW to JPEG Max Quality), you choose that in the bottom section—File Type. Just turn on the Convert Files To checkbox, and then choose your format from the pop-up menu.

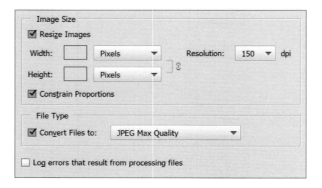

Step Five:

On the top-right side of the dialog, there is a list of Quick Fix cosmetic changes you can make to these photos, as well, including Auto Levels (to adjust the overall color balance and contrast), Auto Contrast (this is kind of lame if you ask me), Auto Color (it's not bad), and Sharpen (it works well). Also on the right is a Labels section, where you can add a custom watermark or a caption to these photos. Now, just click OK and Elements does its thing, totally automated based on the choices you made in this dialog. How cool is that?

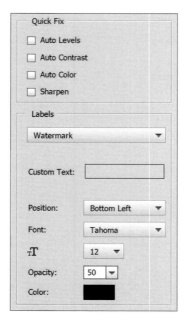

We've all run into situations where our image is a little smaller than the area where we need it to fit. For example, if you resize a digital camera image so it fits within a traditional 8x10" image area, you'll have extra space either above or below your image (or both). That's where the Recompose Tool comes in—it lets you resize one part of your image, while keeping the important parts intact (basically, it analyzes the image and stretches, or shrinks, parts of the image it thinks aren't as important). Here's how to use it:

Resizing Just Parts of Your Image Using the Recompose Tool

Step One:
Create a new document at 8x10" and 240 ppi. Open a digital camera image, get the Move tool **(V)**, and drag-and-drop it onto the new document, then press **Ctrl-T (Mac: Command-T)** to bring up Free Transform. Press-and-hold the Shift key (or turn on the Constrain Proportions checkbox in the Tool Options Bar), then grab a corner point and drag inward to scale the image down, so it fits within the 8x10" area (as shown here on top), and press **Enter (Mac: Return)**. Now, in the image on top, there's white space above and below the photo. If you want it to fill the 8x10" space, you could use Free Transform to stretch the image to do so, but you'd get a stretched version of the camels (seen at bottom). This is where Recompose comes in.

Step Two:
Click on the Recompose tool **(W)** in the Toolbox. The way the tool works is you tell Elements which areas of the photo you want to make sure it preserves and which areas of the photo are okay to remove/squish/expand/get rid of. This is all done using the four tools at the left end of the Tool Options Bar (circled in red here at the bottom).

Continued

Step Three:

Click on the Mark for Protection tool (the brush with the plus sign), and paint some loose squiggly lines over the areas of the photo you want to make sure Elements protects. These are the important areas that you don't want to see transformed in any way (here I painted over the camels, the man, and some of the beach). If you make a mistake and paint on something you didn't want to, just use the tool's corresponding Erase tool to the right of the Mark for Protection tool.

Step Four:

Now you have to tell Elements what parts of the photo are okay to get rid of or stretch out. Click on the Mark for Removal tool in the Tool Options Bar (the brush with the minus sign) and paint some lines over the non-essential areas of the photo. No need to go crazy here, a few quick brush strokes will do just fine.

Step Five:

Click on the top-center handle and drag it upward until it reaches the edge of your document (remember, you already set the document to 8x10). You'll notice that Elements won't stretch the camels now, but rather just the sky. Do the same thing with the bottom-center handle. Drag it downward until it reaches the edge. It may stretch the texture in the area you've selected a little, but it's not anything most people will notice. And if it is, then try going back and adjusting the areas to protect/unprotect and sometimes you'll get better results. In this case, the camels (which are the most important part of the photo) were left alone, and only the sky and some of the beach were stretched to fit the 8x10 print that we'd like to make.

TIP: Use the Preset Pop-Up Menu

The Recompose tool has a preset pop-up menu in the Tool Options Bar with some common print sizes, so when you select one of them, it automatically recomposes your photo to that specific size.

Location: Lisbon, Portugal | Exposure: 1/25 sec | Focal Length: 70mm | Aperture Value: *f*/2.8

Radio Edit
which mode do I use: quick, guided, or expert?

Do you have any idea how many songs are available for download from the iTunes Store that have the phrase "Radio Edit" at the end of their name? Well, let me tell you cowboy, it's plenty. So many, in fact, that I felt totally justified in using it as the title for this chapter on editing your images using one of the four different editing methods you can choose from in Elements. Now, don't let the last part of that sentence fool you, this chapter intro is about to take a left turn, because after I settled on this title, I started thinking, "What actually is a 'radio edit'?" So, I went to Google, and the first search result was (not surprisingly) Wikipedia, which describes it this way: "In music, a radio edit is a modification, typically truncated, to make a song more suitable for airplay, whether it be adjusted for length, profanity, subject matter, instrumentation, or form." It was right then that I realized that I could save a ton of time on writing these chapter intros if I just copied-and-pasted various long sentences, or even entire paragraphs, from Wikipedia into these openers. I could be done in like three minutes (instead of the four to six hours of grueling research and Hemingway-like devotion to making sure each and every word is as if it was hand-crafted by angels—or at the

very least, conceived for a hand-crafted beer). Anyway, did you notice the part of the Wikipedia description that said sometimes these songs are edited for "profanity?" Well, I'm about to share some inside scoop here—the kind of stuff my publisher goes to great lengths to keep hidden deep in the underbelly of the publishing Illuminati underworld, but I think it's time the reading public knew the truth: the version of this book you are reading (and many of my books, in fact) are actually the "paper edit" versions, which have been heavily edited to remove my never-ending stream of profanity that is so vile, so wildly inappropriate that Snoop Dogg himself contacted me via Twitter DM and told me I really needed to tone it down. It was making him, and the rap community in general, uncomfortable. The thing is, I can't teach Elements without dropping a few "unmentionables" here and there, but it's mostly because of my penchant for making sure each of the steps in my tutorial rhyme, and that's hard to do if you can't use naughty words. Here's an example: "Step Three: Open the dialog and start to click. If you don't like it, I'll show you my [redacted by publisher]." See, I was going to say "technique." If you were thinking anything else, you need a "mind edit."

Using Instant Fix to Quickly Edit Your Photos

Before we take a look at the three editing modes in the Editor, I wanted to show you what you can do right in the Organizer. If you want to quickly fix a bunch of photos (okay, "fix" makes it sound like there's something wrong with them, let's use the word "enhance" instead), you can do it all right from within the Organizer itself. Plus, Elements is now touch-enabled, so you can do all your editing right on your screen (if you have a touchscreen computer, of course).

Step One:

In the Organizer, select the photo(s) you want to quickly edit using Instant Fix (click on the first image, then Ctrl-click [Mac: Command-click] on any other images you want to edit), then click on the Instant Fix icon in the taskbar at the bottom of the window. This opens your image(s) in the Instant Fix window. If you selected a bunch of photos, but only want to apply a particular effect to one of them, double-click on that photo and it enters Show One Photo view (as seen here).

Step Two:

There are icons for a number of very common adjustments along the right side of the window. Start by clicking on the Smart Fix icon (it looks like a magic wand) and see if you like the results (it's an automated fix that either does a pretty good job or looks horrible). If you don't like the way it looks, no sweat, just click on Undo in the bottom left. If the problem is your image is too dark (or too light), click on the Light icon (it looks like a sun), and a vertical list of thumbnails appears with your image ranging from darker to lighter. Just drag the slider up/down to choose the one you want (you'll see an instant preview onscreen. I moved it up a bit). If color is the problem, click on the Color icon (the paint palette) instead, and this time the vertical list shows warmer or cooler versions of your image. Again, just drag the slider to the one that looks best to you (as shown here, where I moved it up).

Step Three:

If you click on the Crop tool icon, a bunch of preset cropping sizes pop up—to see how one looks, just click on it. To create your own custom crop, click on the first one, Custom, and then click-and-drag the cropping border that appears over your image right where you want it. When you're done, click on the green checkmark icon. The Crop tool is applied on a one-on-one basis, so it only crops the individual image you're working on right now, not all your selected images. At the bottom is the Clarity icon. Click on it and it brings up another vertical list of image thumbnails (seen here)—dragging the slider up enhances details (which can look good on landscapes and cityscapes, and things like cars, motorcycles, and stuff with lots of detail); dragging it down adds a softening blur kind of effect. A little bit of it can help smooth skin tone; too much and skin can start to look blocky, so be careful about dragging too far in either direction.

Step Four:

The last two adjustments are Red Eye and Effects. Red Eye, obviously, will get rid of any red eye in your image. If all your image problems (brightness, color, etc.) look good, click on the Effects icon (fx) to add some finishing touches, not far from what you'd get using Instagram's built-in filter effects. Again, it's a vertical scrolling list of filter effects, and you'll see things like duotones, cross-processing effects, tints, and color effects. Which one should you choose? Whichever one looks good to you (luckily, there is no International Committee on which one looks good), so pick one, and roll on (here, I chose Lomo). When all your Instant Fixes are done, click on Done in the bottom-right corner and those Instant Fix edits you chose are applied to all your selected photos all at once (they'll have a little icon in the top right of their thumbnails in the Media Browser.

Photo Quick Fix in Quick Mode

Quick edit mode is kinda like a stripped down version of Expert mode. If you're new to Elements, it's not a bad place to start. I'm usually against "quick" modes and "auto-fix" stuff, but the way they've implemented this is actually really nice, and I think it works great for beginners. (*Note:* We'll look at a Quick mode special effect in Chapter 10.)

Step One:

Open a photo and click on Quick at the top of the Editor window. First things first: forget about the left side of the window. The tools in the Toolbox make using Quick mode too much like using Expert mode (but without all of the options that Expert mode has). So, if you find that you need the tools here, you're better off going into Expert mode to do what you need to do.

Step Two:

In the preview area of Quick mode, you can see side-by-side, before-and-after versions of the photo you're correcting (before on the top or left; after on the bottom or right). To see this view, from the View pop-up menu above the top left of the preview area, select **Before & After (Horizontal or Vertical)**. In the Palette Bin on the right side of the window is a group of nested palettes offering tonal and lighting fixes you can apply to your photo. Start with the Smart Fix palette at the top. Click on the Auto button and Smart Fix automatically analyzes the photo and tries to balance the overall tone (adjusting the shadows and highlights), while also fixing any obvious color casts. In a lot of cases, this feature does a surprisingly good job. There's also a slider within the Smart Fix palette that you can use to increase (or decrease) the effect, or you can click on the thumbnails beneath the slider.

Step Three:

If you're not happy with the Smart Fix results, don't try to stack more "fixes" on top of it. Instead, click the Reset Image icon (the curved arrow above a straight line that appears above the top right of the Palette Bin) to reset the photo to how it looked when you first entered Quick mode. Now, let's take a look at each setting individually: First, click on Exposure to open its palette. The Exposure setting is like the heavy hitter—if the whole photo is too dark or too bright, then this is where to go. You'll see its palette also has a slider and thumbnails right below it. They're different ways of doing the same thing. If you like using the thumbnails, just click on the one that looks closest to how bright or dark you'd like your photo to be. As you do that, you'll see the slider move each time. Usually, though, I just drag the slider (as shown here) until I'm happy with the overall exposure.

Step Four:

More often than not, just adjusting the exposure won't fix the whole photo. You'll usually end up in the next palette, which is Lighting. Here you can choose to work on the shadows, midtones, or highlights separately. The Shadows slider is particularly helpful because we tend to lose a lot of detail in the shadows. Drag it to the right a little bit, and watch how it opens up the dark shadow areas in your photo (mainly the detail in the darker areas of the foreground in this photo). The Highlights slider will add some detail back to the sky here, as well. For this one, I increased the Shadows slider to 5, the Midtones slider to 15, and the Highlights slider to 25. I tend to stay away from the Auto Levels and Auto Contrast buttons, because chances are, if Smart Fix didn't work well, then neither will they.

Continued

Step Five:

The next palette down, Color, really has only one setting that I think is worthwhile. You'll see at the top of the palette you can control the Saturation, Hue, and Vibrance. The Saturation adjustment adds or removes color saturation in the whole photo. It's worth trying out and maybe even clicking the Auto button. Sometimes the photo looks good, but most of the time, the Vibrance setting is the most useful here. While Saturation adds color to everything in the photo, Vibrance tends to only add color saturation to the colors that need it, while leaving the other colors alone, so you don't get that fakey look. It's also great on portraits because it tends to leave skin tones alone and only adds color saturation to everything else.

Step Six:

While the Color palette helps us fix the overall color saturation in a photo, the Balance palette right below it helps remove color casts (like when an indoor photo looks really yellow). It's pretty simple to use to control the temperature and the tint in the photo. I'll warn you ahead of time, though, small adjustments here make *big* changes, so be careful. The Temperature adjustment lets you add more blue or more yellow/red to a photo. Basically, adding blue removes yellow and adding more yellow removes blue. Photos taken indoors at night are perfect candidates for this since they tend to look really yellow, so dragging the slider toward blue helps balance (hence the name of this palette) the photo. You can also control the Tint (greens and magentas), but honestly, you won't notice much of a problem there in most cases. But if you do, it works the same—adding more green removes magenta, and adding more magenta removes a greenish color cast.

Step Seven:
The final step here is to sharpen your photo. I always click on the Zoom tool in the Toolbox, and zoom in a little further, so I can see the details. Then, just click the Auto button in the Sharpen palette and watch the results. If the photo isn't sharp enough for you, drag the slider to the right to increase the amount of sharpening. But, be careful, because oversharpening can ruin the photo by becoming too obvious, and it can introduce color shifts and halos around objects.

Step Eight:
There are a couple other things you can do while you're here in Quick mode (basically, think of this as a "one-stop shop" for quickly fixing images). Below the preview area is an icon you can click on to rotate your photo (this photo doesn't need to be rotated, but hey, ya never know). And, I know I told you to forget about the Toolbox on the left, but there is a Crop tool there, so if you need to do a quick crop, you can do it here.

Step Nine:
Okay, so you've color corrected, fixed the contrast, sharpened your image, and even cropped it down to size (if it needed it). So, how do you leave Quick mode and return to Expert mode? Just click on Expert at the top of the window (the same place you went to, to get into Quick mode). It applies all the changes to your photo and returns you to the normal Expert editing mode.

Let Guided Mode Walk You Through It

When you use Guided mode, it walks you through a bunch of popular editing options, like cropping, enhancing colors, retouching, and sharpening. They're kind of like built-in tutorials in Elements—they don't do all of the work for you, they just explain to you what tools you should use and the order in which to use them. However, there are some other options in Guided mode that can be more useful, because they can help you to easily create some special effects, and they added a couple new ones in Elements 2020. (*Note:* We'll look at some of the Guided mode special effects in Chapter 10.)

Step One:

Open a photo and click on Guided at the top of the Editor window. The Guided window has six tabs at the top where you can choose which effect you want to apply to your photo (like the new Pattern Brush option under Fun Edits, which lets you add creative patterns to a photo, or the Perfect Portrait option under Special Edits, which allows you to easily and realistically smooth skin. We'll look at this one in Chapter 7). Click on a tab and it'll give you a before/after example of each effect. (Again, the options here are basically tutorials with guided walkthroughs. They're the kinds of things we cover in this book, so if you weren't reading this book, then that would be a good mode to check out. Since you *are* reading this book, I'd stick with the tutorials you just paid for.)

Step Two:

Many of these effects can be done in Expert mode, but you might have to use a bunch of tools, dialogs, etc. So, if the effect you want is here, it's not a bad place to get to know. Here, we'll look at the new Object Removal option (which you can also easily do in Expert mode using Content-Aware Fill. See Chapter 9 for more on this) in the Basics tab, so click on that option. By the way, the rest of the effects pretty much work exactly the same—remember, this is "Guided" mode, so Elements will walk you through each step.

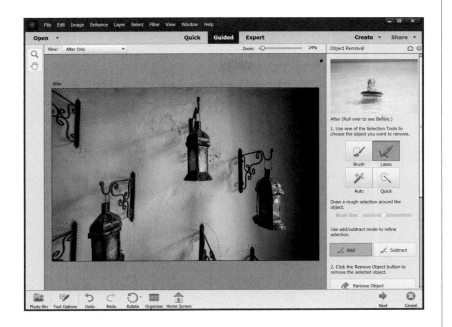

Step Three:

You'll see the Palette Bin appear on the right side of the window, showing all of the settings you have control over for the effect. The first thing you'll want to do for this Guided option is click on one of the Selection Tools, then paint or select the thing(s) you want to remove from your image to select them. Here, I'm using the Lasso tool to select the lantern holders without lanterns on the left and bottom. If you select areas you don't want selected, just click on the Subtract button and remove them from your selection.

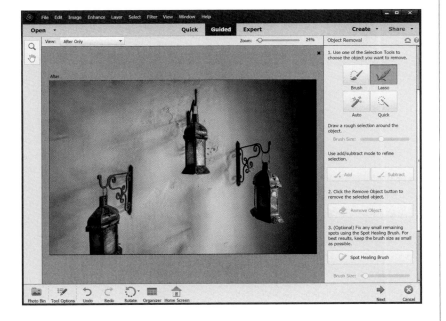

Step Four:

Next, just click on the Remove Object button. A little dialog will appear showing you that it's working to remove the selected objects. Once it's done, they're gone. Easy as that.

Continued

Step Five:

It did a pretty good job here, but if it leaves something behind, just click on either the Spot Healing Brush button or the Clone Stamp Tool button to remove it. Here, I used the Spot Healing Brush to remove a few shadows that were left behind (you can see them in Step Four) by just painting right over them. If what was left behind is near something that you wanted to keep, use the Clone Stamp Tool, but you'll need to Alt-click (Mac: Option-click) to sample a clean nearby area first before painting over what you want to remove.

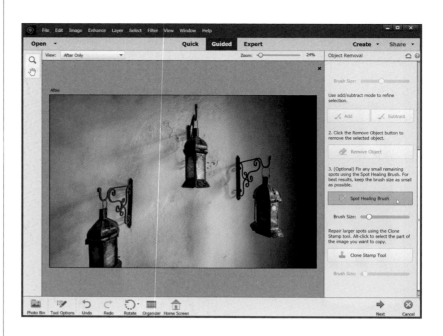

Step Six:

When you're ready, click the Next button at the bottom right. Here, you'll choose what you want to do next with your image—save it, continue editing it, or share it to Flickr or Twitter (if you choose to share it to one of these sites, Elements will ask you for authorization first). So, just click on your choice and you're done. Here, we'll choose to continue editing in Expert mode.

Step Seven:

When the image opens in Expert mode, take a look in the Layers palette, and you'll see Elements has added a layer here. Since the whole effect is layer based, you can always use a layer mask (we'll look at these in Chapter 6) to add something back in or delete the layer with the removed objects altogether. A before and after is shown below.

Before

After

A Quick Look at Expert Mode (It's Not Just for Experts!)

Okay, I know the third editing mode is called "Expert" mode, but don't let the name fool you—it's not just for experts. In fact, most of what you'll do in this book is done in Expert mode because, let's face it, that's where all the cool stuff is. You go into Expert mode when you want to do things like retouching photos, or adding text, or modifying just a specific portion of a photo, because it's got a ton of features like layers, layer masks (which are covered in Chapter 6), and much more. So, get it out of your mind that Expert mode is just for experts. It's for you, even if you're not a seasoned pro at Elements.

Step One:
Open an image and then click on Expert at the top of the Editor window, which will take you into the full Elements Editor (if you're not already there) with all the bells and whistles. By the way, if you were to go into Expert mode after applying a Guided edit, you'd actually see all the layers and effects that Elements has applied.

Step Two:
Over on the left side of the window, one of the first things you'll notice is that there are a bunch of tools in the Toolbox. These tools are broken up into categories: View, Select, Enhance, Draw, Modify, and Color. As a photographer using Elements (which I assume you are, since you bought this book), you won't use the Draw tools much (except for the Brush tool) and you won't use the Modify tools much either (except for cropping and straightening). But, you'll use the Select and Enhance tools plenty.

Step Three:

Go ahead and click on one of the tools in the Toolbox. It can be any tool, so just click around a few times and then look at the bottom of the window beneath the preview area. You'll see a context-sensitive Tool Options Bar appear for each tool (here, I clicked on the Quick Selection tool). Since most tools have different settings, you'll notice it changes based on which tool you click on. This is a really important area, so make sure you get accustomed to it. (*Note:* To hide/show the Tool Options Bar, press **F5**.)

TIP: Getting to Tools Quickly

If you're going to be using Expert mode a lot, then it's a good idea to get used to the keyboard shortcuts for the most commonly used tools. If you hover your cursor over each tool in the Toolbox, you'll see a tool tip appear with the name of the tool followed by its one-letter keyboard shortcut.

Continued

Step Four:

Now look over at the bottom-right of the window. There are six icons there. Click on the Layers icon to open/close the Layers palette on the right side of the window. Layers are one of the key elements to working inside of Expert mode and there's actually a whole chapter devoted to them (Chapter 6). For now, just know that you should probably keep that palette open all the time, since you'll be using it a lot.

Step Five:

Click on the More icon to access some of the other palettes. As for the other icons, you (as a photographer, at least) probably won't use them as much.

TIP: Undock the Layers Palette
To undock the Layers palette from the right side of the window, choose **Custom Workspace** from the More icon's pop-up menu, then click on the Layers palette's tab and drag it out of the nested palettes. This will minimize the size of the palette, giving you more room in your work area. To hide the other palettes, choose Close Tab Group from the active palette's flyout menu (click on the down-facing triangle and lines icon at the top right of the palette).

Step Six:
Finally, don't forget the menu bar at the very top of the window. That's the launch pad for a lot of the things we'll do in the book. So, for example, if you read "Go to the Layer menu," that means to go to the Layer menu up in the menu bar. And, if you read something like "Go to the Layers palette," that means to go to the palette we just talked about in Step Four.

Location: Rockefeller Center, New York, New York | Exposure: 1/50 sec | Focal Length: 14mm | Aperture Value: ƒ/5.6

Layers of Light
working with layers

I only found one movie that would work here, *Layer Cake*, and I used that one already in a previous edition of this book, so I can't go to that well again, so I'm going with the well-named album *Layers of Light* by Nils Landgren and Esbjörn Svensson. I don't always do this, but I took a few minutes to listen to some of their album. It's rare that I find an album that doesn't have the Explicit Lyrics warning on every single song, so that was a good start. I listened to the first few tracks in the iTunes Store, which included "Song from the Valley," "Calling the Goats," and "Kauk" (don't pronounce that last one out loud), but by far their most popular song (according to iTunes anyway) is the first one. I gave it a listen, and I thought, as a fellow musician and piano player myself, that I might offer my own brief review here in the book, rather than on iTunes. It's because I want to speak from the heart, and to the artists directly, which I feel is much more meaningful than speaking to the general public, who are simply wondering if they should plunk down the $8.99 for the album. I think it's more personal to address the artists themselves. I picture us meeting at sunset in a small cafe in Sweden,

where we would share a nice glass of 2010 Francois LeClerc Gevrey Chambertin Burgundy. With the crackling from a roaring fire, and the muted chatter from the other guests enjoying the sunset on a crisp fall night as our background, I would let Nils and Esbjörn know how much I feel they need to sell their gear. All of it. Immediately. The instruments, all their recording gear, that piano—every lick of it—and never play another note again. It was that bad. I want to let them know it sounded like a cat was walking across their piano, playing random notes, while someone boiled a live lobster nearby, as plates came crashing off the walls. I would tell them to destroy any tapes, copies of the albums, and any trace that might lead anyone back to their "music" because… well…okay, I can't keep this up. Their album was actually pretty great. Really great, in fact, but you have to admit, I had you going there for a second. Rest assured, in reality, their songs are beautiful. Now, come and join me as I raise a glass to Nils and Esbjörn, as I toast the name of their third track so loudly in the cafe that the manager comes over and asks me to leave.

Layer Basics

This tutorial is only meant for those of you who don't really understand why you would use layers. If you already know why layers are important, then skip this and go straight to the next one, where we dive right into building things with layers. So, let's talk a little bit about layers and how they're the foundation of everything you do in Elements. Think of it this way: you'd never dream of drawing on a printed photograph with a black marker and then expect to go back and erase that drawing, would you? Well, that's exactly what you're doing if you don't use layers in Elements and you work on the original image.

Step One:
Picture this: you're holding a printed photo (we're using one of Corey here, but it can be any printed photo). The point is, imagine you set that photo down on the desk, grabbed a black marker, and started drawing on it—fake eyebrows, a mustache, and maybe even a funny beard.

BRAD MOORE

Step Two:
Now, what would happen if you grabbed a damp towel and tried to erase what you just drew? One of two things would most likely happen: (a) you would start to erase the drawing marks, but you'd probably start to ruin the photo under them, as well, or (b) you wouldn't be able to erase anything (if you used a permanent marker) and you'd be stuck with a pretty funny-looking photo.

BRAD MOORE

BRAD MOORE

Step Three:
Let's take this example one step further. Back up to the point where you have a photo that you want to draw over. This time, though, you also have a sheet of transparent plastic.

BRAD MOORE

Step Four:
Now when you place the photo down on the desk and get ready to draw, you place the transparent sheet of plastic over it. Just like before, imagine taking a black marker and drawing over the photo. However, unlike before, you're not drawing directly on the photo itself—instead, you're drawing on the transparent plastic. It looks the same, though, right?

Continued

Step Five:

After you see the final result, you'll probably decide that Corey looks much better without a mustache and beard. Once again, try erasing what you just drew with that damp cloth. Now it's a breeze. Or, if you're unhappy with the entire project, then just toss the transparent sheet of plastic into the garbage and start over again. By using that transparent sheet of plastic, you've gained a tremendous amount of flexibility.

BRAD MOORE

Step Six:

Okay, enough imagining. I promise we'll actually be using Elements for the rest of the chapter. Go ahead and open a photo in the Editor by clicking on the File menu and choosing **Open** (or just press **Ctrl-O [Mac: Command-O]**). Navigate to the photo you want (or just use the photo of Corey), click on it, and click Open. Now you'll see the photo, but more importantly, notice the Layers palette (if you don't see it, just go under the Window menu and choose **Layers**). You should notice that there's only one layer in the Layers palette—it's called Background.

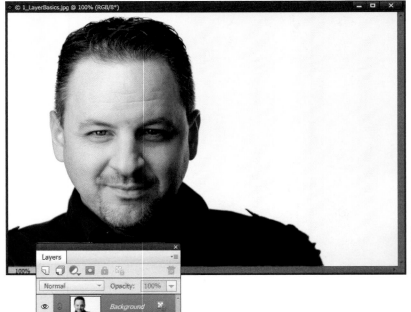

PETER HURLEY

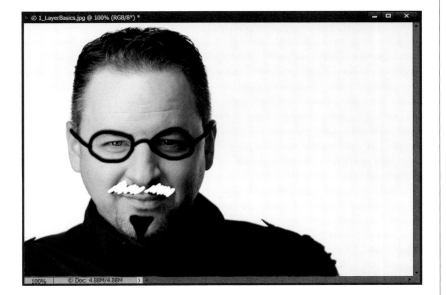

Step Seven:
Select the Brush tool from the Toolbox (or just press **B**), then click on the Brush thumbnail down in the Tool Options Bar to open the Brush Picker, and select a small, hard-edged brush. Press the letter **D** to set your Foreground color to black and start painting on the photo. Have at it—a funny face with glasses, a mustache, whatever you want!

Step Eight:
After you're done painting on the photo, you'll inevitably think it looked much better before the vandalism (sorry, I meant to say artwork). So, select the Eraser tool **(E)** from the Toolbox and try to erase those brush strokes away. See what happens? Not only do you erase away the black brush strokes, but the underlying photo is erased, as well (you see white here because my Background color is set to white). Not good, but as you can imagine, there's a better way to do this. Go ahead and close this image, but make sure you don't save the changes.

Continued

Step Nine:

Let's bring this example back around to the photo with the transparent sheet of plastic. Remember how well it worked to isolate our drawing on the transparent sheet of plastic? Well, layers give us the same benefit. Open a new image (or use the same one of Corey) and click on the Create a New Layer icon at the top of the Layers palette (circled in red here). You'll see a new layer, named Layer 1, now appears on top of the Background layer. This new layer is just like that transparent sheet of plastic.

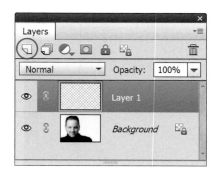

Step 10:

Press B to select the Brush tool again, and then click once on Layer 1 in the Layers palette to make sure it's selected. (*Note:* You've got to click on a layer to select it in the Layers palette. If you don't, then you may be working on the wrong layer. Always look for the layer that is highlighted in color. That is the current or active layer and the one that you'll be editing.) Now, start painting on it just like before. Everything should look and act exactly the same.

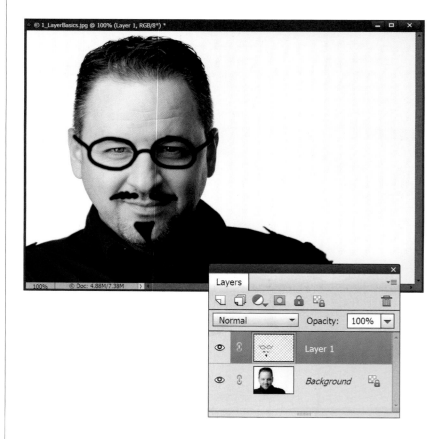

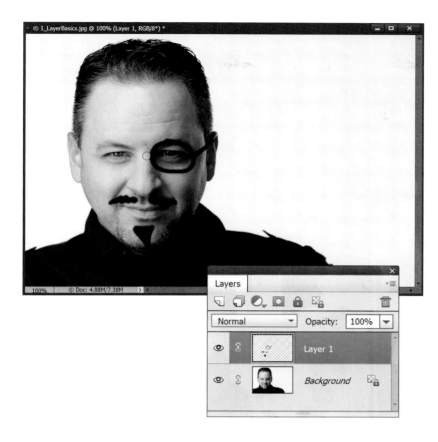

Step 11:
Finally, to bring this example back around full circle, select the Eraser tool again and erase away any of those brush strokes. You'll see that you can easily erase them without affecting the original photo. That's because you created your changes on a separate, blank layer on top of the photo. You never touched the original photo, just the layer on top of it.

There you have it my friends—the totally basic introduction to layers. Don't forget to stop by the website (mentioned in the book's introduction) to download the images to follow along with. Now, roll your sleeves up and get ready—we've got some really cool stuff ahead.

Using Multiple Layers

The main idea behind this tutorial is to use multiple images and get used to the way layer stacking works. Working with one image is great, but you'll get an even better understanding of layers when you start bringing multiple images into one Elements document. There are going to be plenty of times where you want to take a layer from one image and add it into another image you're working on. A great example would be blending multiple photos together to create some type of collage.

Step One:

First off, open the photos that you'd like to combine into one image. Click on the File menu and choose **Open**. Then navigate to each photo and click Open. Here, we're going to combine three images, so I've opened all three and can see them in my workspace. *Note:* To float all three image windows, press **Ctrl-K (Mac: Command-K)** to open the General Preferences, and turn on the Allow Floating Documents in Expert Mode checkbox. Then, in the Window menu, go under Images, and choose **Float All in Windows**.

©ADOBE STOCK/DETAUFIG

Step Two:

Now let's create a brand new document to hold what we're about to create. Go under the File menu, under New, and choose **Blank File**. For this example, we're going to create a small football flyer. I want my new document to be 7" tall by 5" wide, so from the Document Type pop-up menu, choose **Photo**, then from the Size pop-up menu, choose **Portrait, 5x7**. Since we're just displaying this onscreen, change the resolution to 180 ppi. If we were going to print this, we'd probably use something like 240 ppi. Click OK to create the new blank document.

Step Three:

We need to get the photos into the new blank document now. There are a couple ways to do this and each have their place. First, let's try the one I use the most—copy-and-paste: Click on the photo of the football players to bring it to the front and make it the active document. Go under the Select menu and choose **All** to select the entire image. Copy this selection by going under the Edit menu and choosing **Copy**. Now, click over to the blank document and paste the copied photo into it by going under the Edit menu and choosing **Paste**. By the way, we're not going to use the Edit menu for these anymore. The keyboard shortcuts for Copy and Paste are **Ctrl-C (Mac: Command-C)** and **Ctrl-V (Mac: Command-V)**, respectively, and they work a lot faster.

Continued

Step Four:

Right after you paste the image, you should see a new layer called Layer 1 appear in the Layers palette right above the Background layer. By default, Elements automatically creates a new layer whenever you paste something into an image. This is a good thing, because it forces us to work on multiple layers. Now, select the Move tool from the Toolbox (or just press **V**), click on the pasted image, and drag it so the football players are in the top left of the document.

Step Five:

Let's bring another photo into the new document. Before, we used copy-and-paste, but there's another way: you can also click-and-drag images into other documents. Position the new document window and the other photo of the helmet so you can see both of them. Click once on the new photo to make it the active document, and with the Move tool, click-and-hold on the helmet photo, and drag it over into the new document (that's why you need to be able to see both of them).

Step Six:

Once your cursor is over the new document, release the mouse button and this photo will appear as a new layer at the top of the layer stack. Use the Move tool to drag it so the helmet is toward the right side of the document. Close the original photos of the football players and the helmet. We don't need them open anymore because we've copied their contents into layers in our new document. (The layers in our new image are not connected to their originals. No matter what you do here, you won't affect the originals.)

TIP: Hide a Layer

You can hide a layer altogether by clicking on the little Eye icon to the left of the layer's thumbnail in the Layers palette.

Step Seven:

Now we're going to blend these layers together, so press-and-hold the Alt (Mac: Option) key and click on the Add Layer Mask icon at the top of the Layers palette. This hides the top helmet layer behind a black layer mask. (*Note:* We're going to look at layer masks more later in this chapter.) Get the Brush tool **(B)** from the Toolbox, then in the Tool Options Bar, click on the Brush thumbnail to open the Brush Picker, and choose a soft-edged brush. Set the Size to something large (like 175 pixels).

Continued

Step Eight:

With your Foreground color set to white, and Layer 2's layer mask active, start painting on the right side of the photo to reveal the image hidden by the mask (as shown here). This makes the two photos blend together. Press the **Left Bracket key** to decrease the size of your brush if you need to reveal a smaller area. And, if you make a mistake and reveal too much of the top layer, just press the **X key** to switch your Foreground color to black and paint away those areas to hide them again.

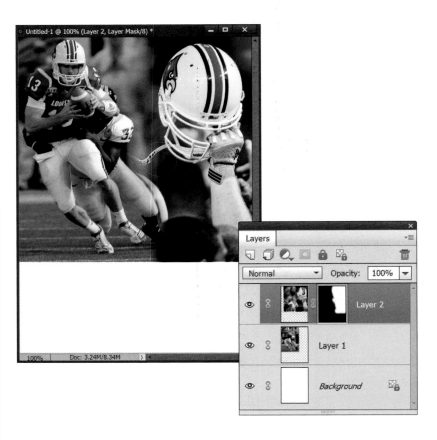

Step Nine:

Finally, let's bring in a finishing logo. Open the image that has the graphics and logo that you want to add. So far, we've been opening JPEG images and dragging them in, but you can just as easily open other types of files, too, including Photoshop (PSD) files. Here, I've got a PSD file that has a logo on its own layer.

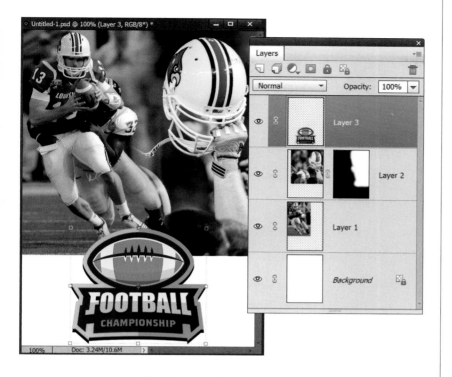

Step 10:

Go back to your new image and make sure the top layer in your Layers palette (Layer 2) is active (this is important, because when you bring the logo over to this document, it will appear above whichever layer is active in your Layers palette. So, save time by clicking on the layer you want it to appear above). Now, click-and-drag (or copy-and-paste) the logo from the other image into your new image. It'll appear at the very top of the layer stack, ready to be positioned where you need it. Here, I moved it to the bottom of the image. In the final image below, I ended up making the helmet image larger by using Free Transform **(Ctrl-T [Mac: Command-T])**. We'll look at resizing layers this way more in this chapter.

If you think you know layers pretty well now, this tutorial will show you more. Trust me. We're going to build a project—a big project, I know—and along the way, we're going to see all the things in the Layers palette that help you work better. We'll look at moving multiple layers at the same time, linking layers, resizing layers, aligning layers, merging and flattening, and even which features in the Layers palette are worth using and which ones actually hold you up. We'll also see how to get around that dreaded locked Background layer, so you can actually do something with it. By the time you're done with this one, you will be a layers pro.

Everything Else About Layers

Step One:

In this tutorial, we're going to create a wedding album page. Start by opening the main image that will be the background of the page. Here, I'm using a texture I downloaded from Fotolia.com (which is now Adobe Stock). You can find a ton of them just by searching for the word "texture."

Step Two:

Before we move on, I've got to share this tip with you (you're seriously going to love me for this one): Ever thought the thumbnails in the Layers palette were too small? Well, you can change them. Every palette has a flyout menu associated with it, and the Layers palette is no different. Click on the little icon with the down-facing arrow and four lines next to it at the top right of the palette. Choose **Panel Options** from this flyout menu, select the largest thumbnail option by clicking on its radio button in the dialog, and then click OK. Now, just sit back and revel in the seemingly inhuman-sized (not really) Layers palette thumbnails.

Step Three:

Notice how the name of the bottom layer in the Layers palette is always "Background"? If you haven't already, you will undoubtedly come to hate that Background layer, because you simply can't do certain things to it. You can't move it with the Move tool and you can't change its position in the layer stacking order, either. Well I'm here to tell you that you can change all that. Make the Background layer a regular layer by just double-clicking on the word Background and clicking OK in the New Layer dialog. Now it's a regular layer. Sweet, huh?

Step Four:

Next, we're going to spice up the background texture a little by adding some depth to it. Since the texture layer isn't the Background layer anymore, we can actually add a layer below it. You could always click on the Create a New Layer icon at the top of the palette to create a new layer on top of the texture layer and then click-and-drag it beneath it, but there's a shortcut: press-and-hold the Ctrl (Mac: Command) key and click on the Create a New Layer icon, and the new layer will automatically be added below the currently selected layer.

Continued

Step Five:

Click on the small Eye icon to the left of the texture layer's thumbnail to hide that layer and, with the new blank layer you just added at the bottom active (highlighted), add a white-to-black radial gradient. To do this, select the Gradient tool from the Toolbox **(G)**, click on the down-facing arrow to the right of the Gradient thumbnail in the Tool Options Bar, and choose the Black, White gradient from the Gradient Picker (the third gradient from the left in the top row). Now, click on the Radial Gradient icon (it's the second icon to the right of the Mode pop-up menu), turn on the Reverse checkbox (also in the Tool Options Bar), then starting in the center of your document, just drag from left to right to add a gradient to the bottom layer.

Step Six:

Next, we're going to use the gradient to give our background texture some depth and dimension. Click on the texture layer's Eye icon again to make it visible. We just added a gradient, but we don't see it anymore because the texture layer now hides it. The Opacity setting, though, will let us blend the two together. So, click on the top texture layer to make it active and then move your cursor over the word "Opacity" in the top right of the Layers palette. You'll see two little arrows appear on either side of the hand cursor. If you click-and-drag your cursor to the left, you'll decrease the Opacity setting, allowing you to see through the texture to the gradient below. Here, I set the Opacity to 92%.

Step Seven:

Open the photos that are going to be included on the album page. (*Note:* This is easiest if you turn on the Allow Floating Documents in Expert Mode checkbox in Elements' General Preferences. Then, you can click on the Layout icon at the bottom of the window and choose **All Floating**.) Here, I'm going to use three wedding photos. Let's start with the vertical photo of the bride and groom. Position the photo so you can see both it and the texture (album) image. With the Move tool **(V)**, click-and-hold on the photo, then drag it into your album image, and place it toward the left. As you can see, it happens to pretty much fit right in and is a good size for what we're looking for. That's not always the case, though, so read on to the next step.

Step Eight:

Let's move on to the next photo. I know that I want two small square photos toward the right of this layout, and just by looking at this image of the bride and groom, you can tell it's not going to work, because it's not square. So, instead of bringing the entire photo in, let's just take a selection. Grab the Rectangular Marquee tool **(M)**, press-and-hold the Shift key (which keeps your selection square), and make a square selection over the area you want (if it's not in the right place at first, simply click-and-drag inside the selection to move it). Now, press **Ctrl-C (Mac: Command-C)** to Copy and then click on the album image and press **Ctrl-V (Mac: Command-V)** to Paste that selected area into the album layout. You'll see only the selected part of the photo is placed and it's on its own layer.

Continued

Step Nine:

We got lucky with the first photo of the bride and groom—it was the exact size we wanted. But, I'll be the first to tell you that it will never happen again. More often than not, you'll have to resize the images you add. In this case, the second photo of the couple is still too big. The best way to resize precisely is to press **Ctrl-T (Mac: Command-T)** to go into Free Transform, click on the Scale icon near the left end of the Tool Options Bar, and then enter the exact width and height settings you want. In this case, enter 275 px for the W(idth) setting and 275 px for the H(eight) setting. Don't forget to actually type the "px" (for pixels) after 275 or bad things will happen. Press **Enter (Mac: Return)** when you're done.

Step 10:

Now we need to bring the third photo into the wedding album image. Make a square selection of only the part of the photo where you can see the couple's rings, then copy-and-paste the selection into the wedding album image, just like we did with the last one. Resize it just like in the previous step, so it's exactly 275x275 px in size. Finally, use the Move tool to position it somewhere below the other one (no need to be exact, because we'll take care of aligning them in the next step).

Step 11:

As you can see, the two small photos we just added to the album image probably aren't perfectly aligned. We could try to precisely align each one of them with the Move tool, but it's way too hard to really be exact when you're just eyeballing it. Instead, let's use the Align Layers options. First, we need to select the layers we want to align in the Layers palette. So, click on one of the small photo layers in the Layers palette and then Ctrl-click (Mac: Command-click) on the other small photo layer to select multiple layers. You'll be able to tell that both are selected because they'll be highlighted with a color (the layers not selected will not be highlighted).

Step 12:

Now, you need to tell Elements where to align the layers. First, press **Ctrl-A (Mac: Command-A)** to select the whole canvas, so Elements sees a selection edge around the entire album image. Then, with the Move tool still selected, you'll see some Align choices in the middle of the Tool Options Bar. Click on the Right icon to align the selected layers to the right side of the selection. This pushes the two photos up against the right edge of the album image. It's automatic, so there's no manual effort required on your part.

Continued

Step 13:

Remember how you selected the two photo layers back in Step 11? Let's say you decide you want to move those two smaller photos somewhere else in the album image. Since they're both still selected, there's a temporary link between the two layers and any moves you make will affect both at the same time. Press **Ctrl-D (Mac: Command-D)** to remove your selection from the entire image, and then, using the Move tool, click-and-drag one of the photos toward the left, so it's not right up against the right edge of the image (I like this placement better actually). The other photo will follow right along. When you're done, just click on one of the layers in the Layers palette to deselect the other.

Step 14:

If you want to create a more permanent connection between the two layers, so that every time you move one of them, the other follows, Elements lets you create a link between them that lasts even after you click on another layer to do something else. To create this link, select both of the smaller photo layers, just like we did before. Then, click on the Link Layers icon at the left of either layer (next to the Eye icon and circled here). Now, click on one of the layers, so only that one is active, and then use the Move tool to move one photo, and both of them will move together. With this permanent link, from now on, you'll only have to select one layer to move and the other(s) will follow.

Step 15:

Let's take a break from copying, pasting, and moving for a minute. As your Layers palette starts growing, you should name your layers to keep things organized. Just double-click on a layer name in the Layers palette, the name will highlight, and you can then type a new name (as seen here for the three photo layers).

TIP: Keep Your Layer Stack Organized

To help organize your layer stack and keep it uncluttered, you can create layer groups. Just Ctrl-click (Mac: Command-click) on the layers you want to put into a group, and then click on the Create a New Group icon at the top of the Layers palette. You can also add color labels to your layers, by Right-clicking on a layer and choosing a color from the bottom of the pop-up menu.

Step 16:

Now, back to our album page. Let's add a white stroke around the small photos. Click on the Couple Medium layer in the Layers palette to make it the active layer, then press-and-hold the Ctrl (Mac: Command) key and click on the layer's thumbnail. This puts a selection around whatever is on that layer. Click on the Create a New Layer icon at the top of the palette to create a new layer on top of this layer. From the Edit menu, choose **Stroke (Outline) Selection**. Set the Width to 3 px, the Color to white (click on the swatch), the Location to Inside, and click OK. Press Ctrl-D (Mac: Command-D) to Deselect and you'll see a white stroke around the photo. Go ahead and rename this stroke layer something descriptive, too.

Continued

Step 17:

Let's add the same stroke to the other square photo. Repeat the same steps: click on the layer, Ctrl-click on the layer thumbnail, add a new layer, then add your stroke. When the Stroke dialog opens, it should already have the correct settings, so just click OK. Now, deselect and rename your layer.

Step 18:

Next, let's add some simple colored rectangles to the background. Click on the background texture layer in the Layers palette to make it the active layer, then click on the Create a New Layer icon to add a new layer above the background texture, but below the large photo of the couple. Using the Rectangular Marquee tool, make a tall, thin selection to the right of the main couple photo. Click on the Foreground color swatch at the bottom of the Toolbox to open the Color Picker and set the color to R: 137, G: 160, B: 165. Click OK to close the Color Picker.

Step 19:
Now, press **Alt-Backspace (Mac: Option-Delete)** to fill that selection with the Foreground color, and then press Ctrl-D (Mac: Command-D) to Deselect. Since the color appears a little obtrusive as it is, let's make it a bit more subtle. At the top right of the Layers palette, reduce the Opacity setting of this layer to 50% (we did this earlier in the project with the texture background for the gradient layer we added below it).

Step 20:
Click on the Create a New Layer icon again to add one more new layer on top of the current rectangle layer. Then, create another thin rectangular selection (thinner than the first one and to its left) with the Rectangular Marquee tool. Press D, then **X** to set your Foreground color to white, and press Alt-Backspace (Mac: Option-Delete) to fill that selection with white. Deselect, reduce the layer's Opacity to 70%, and now you've got some extra color and a nice way to separate that large photo from the background.

Continued

Step 21:

Another task to do often is delete any layers that aren't needed or that you just don't like. For example, let's say you don't like the teal rectangle you added a few steps back. You could click on the little Eye icon to the left of the layer thumbnail to turn it off, but that still leaves the layer. To delete it permanently, click on that layer and drag it onto the Trash icon at the top right of the Layers palette (as shown here). Once you know you want something removed, deleting layers is a good habit to get into as you're working, because it helps keep file size to a minimum and Elements running faster overall. Plus, it cuts down on clutter in the Layers palette. I kinda like it with the teal rectangle, so I'm not going to delete it, but I wanted to show you how it's done.

Step 22:

Finally, I'd merge any layers that don't need to stay editable. You see, every layer you have in the Layers palette takes up space in your file and your computer's memory. Plus, too many layers are just plain hard to deal with. Who wants an image with 20, 30, or even more layers in it? So I merge (flatten) layers often when I know I don't need to change something. A great example here would be the small square photos and their stroke layers. To merge them, select both layers first (as seen here). Then from the Layers palette's flyout menu, choose **Merge Layers**. This squishes both layers into one. You won't be able to edit the stroke independently of the photo it was around anymore, but you probably don't care at this point (if you do care, just create a layer group for them instead—see the Tip a few pages back). That's it! The über layers project is complete. The only thing left to do is add some type with the Horizontal Type tool, and then save the image as a PSD file, so you can reopen it later and still edit all of the layers if you need to.

Blending layers is the next level of merging your images together. There are a lot of ways to blend layers together that go beyond simply changing the opacity. One of those ways is called blend modes. It's like opacity on steroids, and the effects you can get with blend modes are unlike any other effects you'll find in Elements. That said, I gotta tell ya, there are a lot of blend modes in Elements. My goal here is to show you only those you really need to know about. Most of the blend modes will probably never get used, so we're just going to concentrate on the ones that you're going to use often.

Layer Blend Modes for Photographers

Step One:
One of the first ways you'll see blend modes can help with photos is when you have a photo with a dark or underexposed area. In our example here, we have a really common problem with portraits taken outdoors. Sometimes the face (or the entire person, in this case) in a portrait will show up a little darker than we'd like. But the Screen blend mode comes in really handy and can fix that in no time flat.

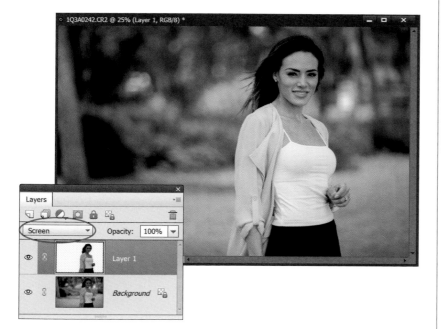

Step Two:
Grab the Lasso tool **(L)** or the Quick Selection tool **(A)** and make a quick selection of our model. Press **Ctrl-J (Mac: Command-J)** to duplicate the selection onto its own layer, so now you'll have two layers in the Layers palette. Then, at the top left of the palette, change the blend mode of the top layer to **Screen**. Because Screen is a lightening blend mode, it has the effect of lightening everything on that layer.

TIP: Use a Shortcut for Screen
You can use the keyboard shortcut **Alt-Shift-S (Mac: Option-Shift-S)** to switch to the Screen blend mode quickly.

Continued

Step Three:

Now, if your subject looks too bright for their surroundings, you could stop here if you wanted a good prank to play on a friend, but let's assume you want to move on. One option is to get the Eraser tool **(E)**, then click on the Brush thumbnail in the Tool Options Bar, and choose a small, soft-edged brush from the Brush Picker. Then, just click-and-drag to erase away any areas that don't need the lightening effect (any really bright spots on them). Also, try reducing the opacity of the layer to help it blend in better with the original layer below it, as I did here, but I only lowered it to 97%.

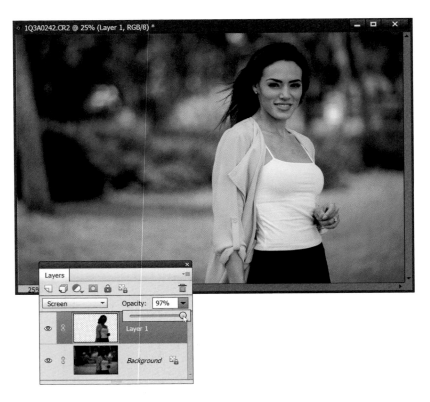

Step Four:

Another problem that blend modes can help with is when you have a bright, faded area in a photo. Here I've opened a travel photo where the sky looks good, but the mountains and foreground are a bit too bright and flat-looking. The first step is to duplicate the Background layer by pressing **Ctrl-J (Mac: Command-J)**.

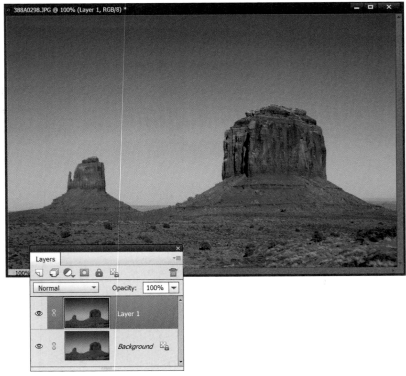

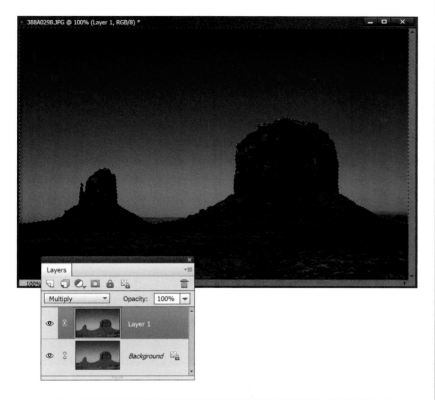

Step Five:
Change the blend mode of the duplicate layer to Multiply. Since Multiply is a darkening blend mode, this darkens everything in the photo. It may look just fine like that, so feel free to leave it alone. However, in this photo, it made the sky way too dark. So, get the Quick Selection Tool (press **A** until you have it) and paint over the sky to select it.

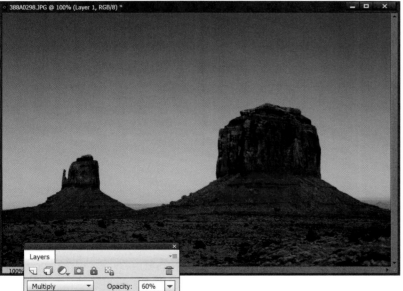

Step Six:
Press the **Backspace (Mac: Delete) key** to remove (or erase) the sky, then press **Ctrl-D (Mac: Command-D)** to Deselect. The darkening effect of the Multiply blend mode should now only affect the mountains and foreground, so they have a little more punch to them. Also, feel free to reduce the opacity of that top layer if the effect is too dark. Here, I reduced it to 60%.

Continued

Step Seven:

Here's another example of what Multiply can be used for: Open one of those cool, grungy black frame images, and you'll find most of them have white in the middle where a photo is supposed to go. To start, press **Ctrl-A (Mac: Command-A)** to put a selection around the entire frame image.

Step Eight:

Press **Ctrl-C (Mac: Command-C)** to Copy the frame, then open another image and press **Ctrl-V (Mac: Command-V)** to Paste it into that image. Press **Ctrl-T (Mac: Command-T)** if you need to resize it to fit the photo. Then, change the blend mode of the frame layer to Multiply, and Photoshop will automatically drop out the white and leave you with just the black frame around the photo. No selections, no nuthin'.

Step Nine:

As you'll see in Chapter 10, when you have a photo with a bright sky and a dark foreground, you can use a gradient to act like a graduated neutral density gradient filter. You simply change the gradient layer's blend mode to Overlay or Soft Light. Well, here's a totally different example to improve your photos with the Overlay or Soft Light blend mode: Open a photo and a texture image. It could be something you've downloaded or created in Elements, or you could just take a photo of a wall. Copy-and-paste the texture image into the photo. Change the texture layer to **Overlay** (or Soft Light), lower the Opacity (if needed), and it gives the photo a very rugged and faded style, as seen below.

The Power of Layer Masks

One of the things that Elements didn't have in the beginning that the full version of Photoshop did was layer masks. It was always one of the big features that people liked more about the full version of Photoshop. Well, after a while, Adobe decided to add layer masks to Elements. Yup, the same layer masks as Photoshop. These things are a huge help when it comes to working on your photos. Whether it's retouching, color correction, sharpening—you name it—layer masks play a key role. We'll give you a quick introduction here, but you'll see them pop up plenty of times throughout the book.

Step One:

In order to really take advantage of layer masks, you need to have at least two layers. So, go ahead and open two images that you'd like to combine in some way. In this example, we're going to put the photo of the football players into the computer screen and make it look like one of the players is coming out of the screen.

©ADOBESTOCK/DENNIS ROZHNOVSKY

Step Two:

Click on the photo of the players, press **Ctrl-A (Mac: Command-A)** to Select All, then press **Ctrl-C (Mac: Command-C)** to copy the photo. Switch over to the photo of the laptop, and press **Ctrl-V (Mac: Command-V)** to paste the players on top of the laptop screen on a separate layer. Press **Ctrl-T (Mac: Command-T)** to go into Free Transform (if you can't see the edges of the photo or the control handles, press **Ctrl-0** [zero; **Mac: Command-0**]). With the Constrain Proportions checkbox turned on in the Tool Options Bar, grab a corner handle and drag inward to make the image smaller, then move it so the bottom-right corner of the photo meets the white space at the bottom-right corner of the screen. Once you've got the players positioned like you see here, press **Enter (Mac: Return)** to lock in your changes, and close the original photo of them, so you're left with only the document with two layers.

Step Three:
There are two main ways to work with layer masks: selections and brushes. Let's look at selections first. Hide the top layer (the players) by clicking on the Eye icon to the left of it in the Layers palette (it's circled here in red), so you only see the laptop. Now, use the Rectangular Marquee tool **(M)** to make a selection of the white area inside the laptop screen.

Step Four:
Unhide the photo of the players by clicking on the Eye icon again, and just make sure that layer is active (highlighted). When working with layer masks, a selection tells Elements that you want to keep that portion of a layer and hide the rest of it. Notice I said hide, not delete. Give it a try. Click on the Add Layer Mask icon at the top of the Layers palette (shown circled here) and see what happens.

Continued

Step Five:

You should now see only the rectangular area (that was previously selected) of the photo. Again, when you have a selection active, a layer mask tells Elements that you want to keep the selected area visible and hide everything that isn't selected. In our case, a portion of the layer with the players on it was selected, so that stays visible. But part of the helmet was hidden (again, not deleted—just hidden for now).

Step Six:

Now take a look at the layer itself. Notice it has a black-and-white thumbnail next to the image thumbnail? That's the layer mask. The layer mask is the same size as the layer. The white part of the thumbnail corresponds to the rectangular portion of the photo (the players) that we see. The black part corresponds to the area we don't see. In other words, white shows you whatever is on the layer that the layer mask is attached to and black hides that part of the layer and shows you whatever is below it in the layer stack (in this case, the laptop).

Step Seven:

The biggest advantage of layer masks is that nothing is permanent. Even though it looks like we've deleted the top of the image, it's still there. Go ahead and look at the layer thumbnail (circled here) and you'll see it looks exactly the same. Nothing was deleted—just hidden. Layer masks are non-destructive and always give you a way out. Just to demonstrate really quickly, click once on the layer mask thumbnail (not the layer thumbnail) to select it. Then go under the Edit menu and choose **Fill Layer**. Set the Use pop-up menu to **White** and click OK to fill the whole mask with white again. Things are back to normal, as if nothing ever happened.

Step Eight:

Press **Ctrl-Z (Mac: Command-Z)** to undo that last step, so the black-and-white layer mask is back again. Let's take a look at the other main way to work with layer masks: adjusting them after the fact with brushes. In our example, the player's helmet is cut off. We can fine-tune the mask to show it, though. Remember, layer masks just care about one thing: black and white. It doesn't matter how black and white get there. Earlier, we did it with a selection, but you can also use a brush to get the ultimate flexibility and control over the mask. Click on the mask thumbnail, then get the Brush tool **(B)**, click on the Brush thumbnail in the Tool Options Bar and choose a small, soft-edged brush from the Brush Picker. Press **D** to set your Foreground color to white (remember, white allows us to keep whatever is on this layer visible) and paint over the top of the helmet. You'll see it reappear, because it wasn't permanently gone in the first place.

Continued

Step Nine:

Why all the trouble? If you're asking yourself, why not just erase away the unwanted areas instead of adding a layer mask, then read on. If not, skip to the next step. So, what would happen if we erased away the top of the image with the Eraser tool, and then we erased some more background? At some point, maybe we'd erase away part of the player's helmet. But then we'd continue to erase away the background until we got to the point where we were done, and we'd realize we'd erased some of the helmet. Well, each one of those clicks of the mouse when we erase is a history state. They build up, so we'd have to undo all the work we did to get back to the point where we inadvertently erased his head. Needless to say, that'd be a big pain in the neck. Plus, since layer masks are part of the layer, we can save our image as a PSD file and open it again tomorrow (or at some later date) and change it. Layer masks allow us to be non-destructive in our editing, so we can always come back and change something later if we need to.

Step 10:

You can see in Step Eight that I went a little overboard with the white brush and brought back parts of the background, too. No sweat. Remember that black and white thing? We were painting with white to bring areas back into view, so if we switch to black, the opposite will happen. Press the letter **X** on your keyboard to switch your Foreground color to black. Then, press **Ctrl-+ (Mac: Command-+)** to zoom in if you need to, and paint on the mask again to hide those areas and reveal the laptop and white background behind the helmet.

Final

Location: Trevi Fountain, Rome, Italy | Exposure: 154 sec | Focal Length: 17mm | Aperture Value: *f*/16

Problem Child
fixing common problems

This was kind of an obvious title, and I could have gone with "Modern Problems" instead, but I'm pretty sure I used that one in my Lightroom book, so "Problem Child" it is (the title is based on the 1990 movie from Universal Pictures, starring John Ritter, Amy Yasbeck, and Jack Warden). Now, why do we have so many problems with our photos? Well, it's not our fault. It's our camera's fault. You see, the camera doesn't really capture what it is we're seeing in front of us, and that's because as sophisticated as today's digital cameras are at capturing light, they are still way, way, way behind the tonal range of the human eye, so what we're seeing with our eyes is much better than what even the best crazy-high-megapixel camera can capture by a long shot. The human eye definitely is an amazing thing, but you might find it surprising to know that there is an animal species that can more accurately capture color and tonal changes, far beyond what the human eye can capture. And, as you might expect, the camera companies themselves have spent millions of dollars researching the eye structure of the Hispaniolan solenodon, which is only found on the island of Hispaniola. It is said that H. solenodon's eye will soon be the key to creating ultra-high-definition sensors that would completely negate ever having to shoot bracketed frames or create HDR images, because their tonal range perfectly exposes for indoors and outdoors at the same time, like the human eye does, but in a much more advanced way. Sony spent considerable time mapping H. solenodon's trabecular meshwork canal, but as Sony's own scientists were putting the finishing touches on a sensor that not only surpasses anything currently available, but that even surpasses the human eye, a group of researchers at Leica in Wetzlar, Germany, had a startling discovery. They revealed a working sensor prototype based on the anterior chamber of the eye of the tufted deer, found in damp forest areas of China. Then, and only then, a magical leprechaun appeared. You can take it from here, since I just made the whole thing up, so start with "…then, a magical leprechaun appeared" and throw in some fancy terms from an eye chart you can find on Google.

Adjusting Flesh Tones

So what do you do if someone in your photo has a red face? This is one of the most common people-photo problems out there. You can try this quick trick for getting your flesh tones in line by removing the excess red. This one small adjustment can make a world of difference.

Step One:
Open a photo that needs red removed from the flesh tones. If the whole image appears too red, skip this step and move on to Step Three. However, if just the flesh-tone areas appear too red, get the Quick Selection tool **(A)** and click on all the flesh-tone areas in your photo (press-and-hold the **Alt [Mac: Option] key** to remove any areas that were selected that shouldn't have been). Here, I selected her face, shoulders, ear, and hands.

Step Two:
Go under the Select menu and choose **Feather**. Enter a Feather Radius of about 8 pixels, then click OK. By adding this feather, you're softening the edges of your selection, preventing a hard, visible edge from appearing around your adjustments.

Step Three:
Click on the Create New Adjustment Layer icon at the top of the Layers palette, and choose **Hue/Saturation** from the pop-up menu. Then, in the Hue/Saturation adjustment palette, click on the Channel pop-up menu near the top and choose **Reds**, so you're only adjusting the reds in your photo (or in your selected areas if you put a selection around the flesh tones).

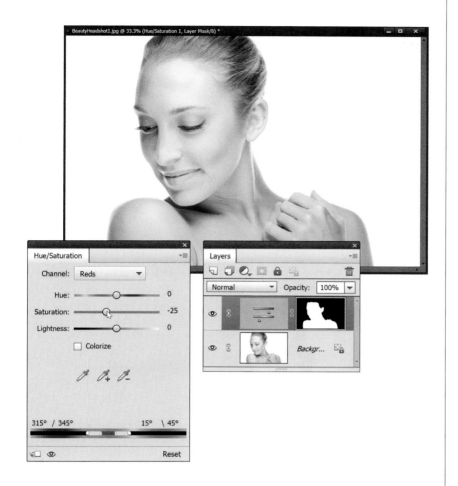

Step Four:

The rest is easy—you're simply going to reduce the amount of saturation, so the flesh tones appear more natural. Drag the Saturation slider to the left to reduce the amount of red (I moved mine to –25, but you may have to go farther to the left, or not as far, depending on how red your skin color is). The changes are live, so you'll be able to see the effect of reducing the red as you lower the Saturation slider. Also, if you made a selection of the flesh tone areas, once you create the adjustment layer, it will hide the selection border from view and create a layer mask with your selection. When the flesh tones look right, you're done.

Before

After

Smoothing Skin Like a Pro

Smoothing skin has always been tricky because not only has it traditionally been kind of complex, taking a lot of steps, but one of the biggest issues we've had is that the result of the smoothing often winds up making your subject's skin look plastic. Traditional smoothing techniques blurred the skin so much that you could often barely see any skin pores at all, but that's what's so great about this new type of skin smoothing in Elements—it maintains a lot of the skin pores and delivers a much more natural, realistic retouch, which is a great thing.

Step One:
In the Editor, open the photo where you want to retouch your subject's skin. Then, go under the Enhance menu and choose **Smooth Skin** (as shown here).

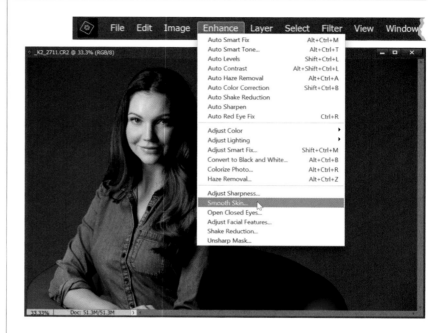

Step Two:
When the Smooth Skin dialog appears, I recommended zooming in to a 100% view (click the magnifying glass icon with the plus sign below your image a few times until it says 100%, as seen here). The blue circle around your subject's face lets you know that Elements is using facial recognition and that it recognizes your subject's face, so when you zoom in on the image, it automatically zooms right in on their face.

Step Three:

This retouch couldn't be simpler, because there's only one slider—the Smoothness slider. The farther you drag it to the right, the smoother it makes your subject's skin. It does a nice job of not totally obliterating your subject's pores, so the result doesn't make your subject's skin look plastic (which has been a pretty common issue in retouching skin over the years). There's a Before/After toggle switch below your image that lets you see a quick before/after. That's it—when you've got the amount of smoothing you want, click the OK button and you're done.

Step Four:

This really isn't a fourth step, but this same smoothing technology is built into the Perfect Portrait guided edit, as well. Click on Guided at the top of the window, then under Special Edits, click on Perfect Portrait. On the right, you'll see a Smooth Skin button. When you click it, it applies the Smooth Skin effect at a full 100% (that's different than the Expert version, where it doesn't apply any smoothing by default—you have to apply the amount). In this case, I felt full strength was too much, so I backed it off a bit by dragging the Strength slider to the left. Here's a before/after (I chose **Before & After – Horizontal** from the View pop-up menu at the top left of the window, then I used the Zoom slider to get it close enough to see the effects of the smoothing).

Using the Smart Brush Tool to Select and Enhance Skies at the Same Time

Photoshop Elements includes a brush tool that lets you fix problem areas (as well as create some pretty cool effects) with just a brush stroke. It's called the Smart Brush tool, and it helps keep you from making complicated selections and then having to fix them in a separate step. Instead, you choose which effect you want to apply and just brush away. Let's check it out.

Step One:

Open a photo that has an area you want to enhance or fix. There's actually a huge list of things you can do with this brush, but let's concentrate on one area for now—the sky. A big digital image problem is that the sky never seems to look as vibrant and dramatic as it does when we're there photographing it. Well, the Smart Brush tool has an option to help fix this, so go ahead and select it from the Toolbox (it's the large paint brush icon in the Enhance section) or just press the **F key**.

Step Two:

Once you select the tool, click on the thumbnail near the left side of the Tool Options Bar to open the Preset Picker. As you change the Presets pop-up menu and scroll through the Preset Picker, you'll see what I meant in Step One—there are indeed a bunch of things you can do here. Let's go ahead and choose **Nature** from the pop-up menu, though, to narrow it down. Then click on the thumbnail in the top left, which makes dull skies bluer.

Step Three:
Now the main thing to remember about this tool is that it is still a brush, which means it has settings just like all other brushes (size, hardness, spacing, etc.). So, using the Size slider in the Tool Options Bar, choose a size that'll help you paint over the area fairly quickly. In this example, I'm using a 400-pixel brush for the sky.

Step Four:
The rest is pretty simple—just click-and-drag on the sky to paint the effect on the photo. By the way, notice how Elements automatically started adding the Blue Skies effect to parts of the sky that you haven't even painted over yet? That's where the "smart" part of this brush comes into play. It automatically examines your photo for areas similar to what you have painted on and adds them to the selection.

Step Five:
Now, keep brushing on the sky to get the rest of it. Each time you click, you're adding to the selection, so there's no need to press-and-hold any keys or change tools to widen the effect to other parts of the photo.

Continued

Step Six:

Okay, this brush is pretty cool, right? But it's not perfect. There will inevitably come a time (probably sooner than later) where the "smartness" of the brush isn't as smart as it thinks it is, and it bleeds into a part of the photo you didn't want it to (like some of the mountain on the right, as seen in Step Five). When that happens, press-and-hold the **Alt (Mac: Option) key** to put the brush into subtract mode. Then paint over the areas you didn't want to apply the effect to (as shown here). Again, Elements will do a lot of the work for you and wipe away the areas, even if you don't paint directly on them. *Note:* Decrease the size of your brush and zoom in on the area, if needed, to help remove it from the selection.

Step Seven:

Here's another really cool thing about the Smart Brush tool: it's non-destructive to your photo. This means you can always go back and change (or even delete) the effects. You'll see this in two ways: First, you'll notice that the Smart Brush tool automatically adds a new adjustment layer to the Layers palette. If you ever find the effect is too harsh, you can always reduce the opacity of the layer to reduce the effect.

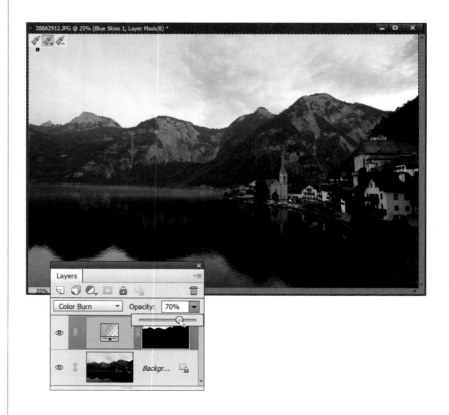

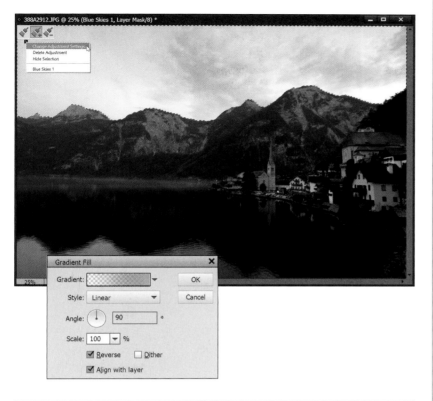

Step Eight:

Also, you may have noticed a tiny red box on your photo where you started to paint with the Smart Brush tool. This is the adjustment marker, letting you know you've applied a Smart Brush adjustment to the photo. If you Right-click on it, you'll see you can delete it if you want or you can change the adjustment settings. Choosing Delete Adjustment does just what you think it does—the adjustment will be removed totally. But try choosing **Change Adjustment Settings** instead. It brings up the adjustment palette or dialog with the controls for whatever adjustment Elements used to achieve your effect. If you're familiar with that adjustment palette or dialog, you can always try tweaking the settings. In this case, Gradient was used, so the Gradient Fill dialog appeared.

Step Nine:

You can also add multiple Smart Brush adjustments to different parts of the photo. If you notice, the sky looks a lot better, but now the mountains and town look a little flat in comparison. Press **Ctrl-D (Mac: Command-D)** to Deselect the current Smart Brush adjustment in the sky. Then, go to the Preset Picker in the Tool Options Bar and, under the Lighting presets in the pop-up menu, click on the second thumbnail in the top row, which intensifies contrast. Now, paint over the mountains and town to add some contrast to them. To bring some more color out in them, I Right-clicked on the adjustment marker for them and chose Change Adjustment Settings to get to the adjustment palette options that were used for the effect. It brought up the Brightness/Contrast controls, where I increased the Brightness to 12 and the Contrast to 65.

Continued

Step 10:

One more thing: the Smart Brush tool is so smart that you can not only change the adjustment settings, but you can also totally change the Smart Brush adjustment you've applied. For example, let's say we want to see what the Clouds adjustment looks like. Just click back on your Blue Skies layer in the Layers palette, then in the Preset Picker, click on the third thumbnail in the top row of the Nature presets and Elements will swap out the Blue Skies adjustment with the Clouds one. If you like it, then keep it (you can adjust the settings for the size of the clouds if needed); if not, then just click back on the first preset you chose or try a new one altogether. Once you're finished, just choose **Flatten Image** from the Layers palette's flyout menu.

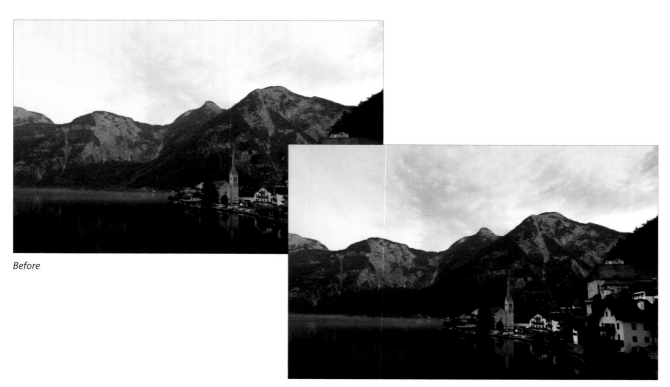

Before

After (with the Blue Skies preset)

Sometimes we don't get to shoot in perfect weather. Especially when you're traveling—you don't get to pick the day, time, or weather forecast. It has happened to me a hundred times. I get somewhere cool and I've got gray skies. Well, there's a sweet little adjustment in Elements that can take those gray skies and make them look pretty darn cool and dramatic. And more often than not, when you apply this and show it to people, they'll comment on how good the sky looks.

Adding Contrast and Drama to Cloudy Skies

Step One:
Open a photo where you've got some cloudy gray skies. Then, select the Smart Brush tool from the Toolbox (it's the large paint brush icon in the Enhance section) or just press the **F key**. (*Note:* For more on the Smart Brush tool, see the previous tutorial.)

Step Two:
Once you have the tool selected, click on the thumbnail on the left side of the Tool Options Bar to open the Preset Picker. From the Presets pop-up menu, choose **Nature**, and then click on the second thumbnail in the top row, which adds contrast to cloudy skies.

Continued

Step Three:

Now, choose a brush size using the Size slider (also in the Tool Options Bar), paint over the sky, and you'll start to see all the details that you knew were there when you took the photo start to come out.

Step Four:

Like most of the Smart Brush tool adjustments, sometimes the default adjustment is too strong. If that's the case, just go to the Layers palette and reduce the Opacity setting, depending on how strong you want it to look. Not bad, eh? It does a great job of taking an ordinary photo and turning it into something way more dramatic.

Before

After

Before you go any further, this is one of those circumstances mentioned in the beginning of the book, in the introduction on page xv. Remember the whole topic about how Elements has changed over the years, and the way we work on our photos is very different today than it was say, five years ago? This is a perfect example. Elements includes the hands-down best way to remove noise in your photos, but it's in Camera Raw (see Chapter 3). So, if you're thinking about using this filter, just know that there's a much better way to remove noise in Camera Raw. If you already have the photo open in the Editor and you're not in the mood to reopen it in Camera Raw, then this filter is an alternative (but not really a good one).

Removing Digital Noise

Step One:
Open the photo that was taken in low lighting (or using a high ISO setting) and has visible digital noise. This noise will be most obvious when viewed at a magnification of 100% or higher (noise appears on the side of the rock in this photo, although it's hard to see at the small size of the image here). *Note:* If you view your photos at smaller sizes, you may not notice the noise until you make your prints.

Step Two:
Go under the Filter menu, under Noise, and choose **Reduce Noise**. The default settings usually aren't too bad, but if you're having a lot of color aliasing (dots or splotchy areas of red, green, and blue), like we have here, drag the Reduce Color Noise slider to the right. If it still looks splotchy, try dragging the Preserve Details slider to the left.

Continued

Step Three:

One thing to watch out for when using this filter is that, although it can reduce noise, it can also make your photo a bit blurry, and the higher the Strength setting and amount of Reduce Color Noise, the blurrier your photo will become. If the noise is really bad, you may prefer a bit of blur to an incredibly noisy photo, so you'll have to make the call as to how much blurring is acceptable, but to reduce the amount of blur a bit, drag the Preserve Details slider to the right. Here, I thought it looked best set to 10%.

TIP: See a Before/After

To see an instant before/after of the Reduce Noise filter's effect on your photo without clicking the OK button or using the Preview checkbox, click your cursor within the Reduce Noise dialog's preview window. When you click-and-hold within that window, you'll see the before version without the filter (zoom in if you need to). When you release the mouse button, you'll see how the photo will look if you click the OK button.

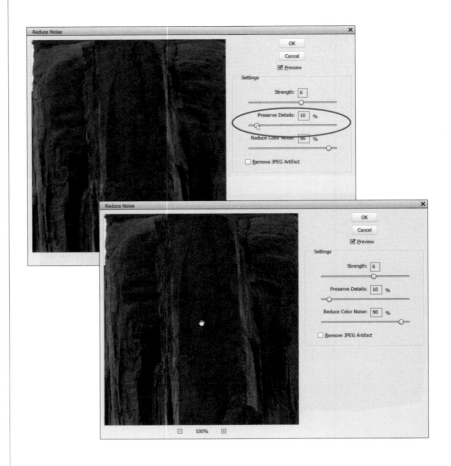

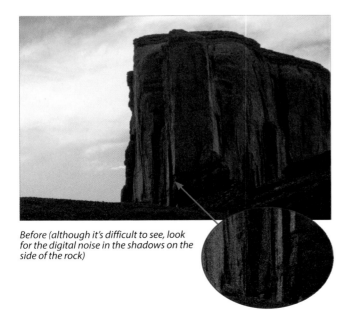

Before (although it's difficult to see, look for the digital noise in the shadows on the side of the rock)

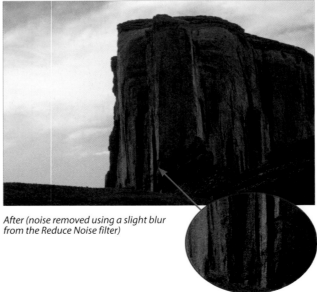

After (noise removed using a slight blur from the Reduce Noise filter)

I've got some bad news and some good news (don't you hate it when people start a conversation like that?). The bad news first (yeah, I like it that way, too): Elements' Dodge and Burn tools are kind of lame. The pros don't use them and, after you read this tutorial, I hope you won't either. The good news...there is a great method the pros do use to dodge and burn and it's totally non-destructive. It's flexible and really quite easy to use. See, isn't it better to end on a good note (with the good news, that is)?

Focusing Light with Dodging and Burning

Step One:
In this tutorial, we're going to dodge areas to add some highlights, then we're going to burn in some areas a bit to darken them. Start by opening the photo you want to dodge and burn.

Step Two:
Go to the Layers palette, click on the down-facing arrow at the top right, and from the flyout menu, choose **New Layer** (or just **Alt-click [Mac: Option-click]** on the Create a New Layer icon at the top of the palette). This accesses the New Layer dialog, which is needed for this technique to work.

Continued

Step Three:

In the New Layer dialog, change the Mode to **Overlay**, then right below that, turn on the checkbox for Fill with Overlay-Neutral Color (50% Gray). This is normally grayed out, but when you switch to Overlay mode, this choice becomes available. Click the checkbox to turn it on, then click OK.

Step Four:

This creates a new layer, filled with 50% gray, above your Background layer. (When you fill a layer with 50% gray and change the Mode to Overlay, Elements ignores the color. You'll see a gray thumbnail in the Layers palette, but the layer will appear transparent in your image window.)

Step Five:

Press **B** to switch to the Brush tool, and choose a medium, soft-edged brush from the Brush Picker (which opens when you click on the Brush thumbnail in the Tool Options Bar). While in the Tool Options Bar, lower the Opacity to approximately 30%.

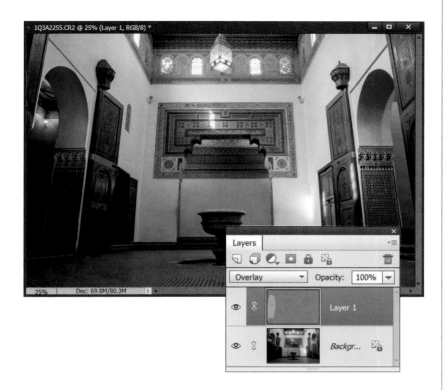

Step Six:
Press **D**, then **X** to set your Foreground color to white and begin painting over the areas that you want to highlight (dodge). As you paint (here, I'm painting the archway on the left), you'll see light gray strokes appear in the thumbnail of your gray transparent layer, and in the image window, you'll see soft highlights.

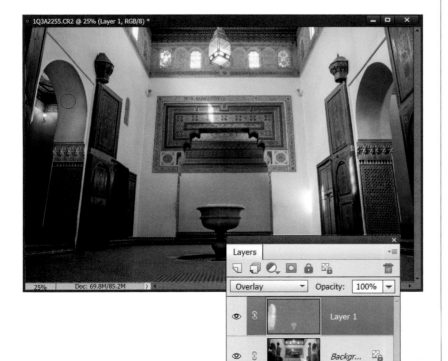

Step Seven:
If your first stab at dodging isn't as intense as you'd like, just release the mouse button, click again, and paint over the same area. Since you're dodging at a low opacity, the highlights will "build up" as you paint over previous strokes. If the highlights appear too intense, just go to the Layers palette and lower the Opacity setting of your gray layer until they blend in.

Continued

Step Eight:

If there are areas you want to darken (burn) so they're less prominent (such as the center ceiling area with the windows), just press **D** to switch your Foreground color to black and begin painting in those areas. Okay, ready for another dodging-and-burning method? Good, 'cause I've got a great one.

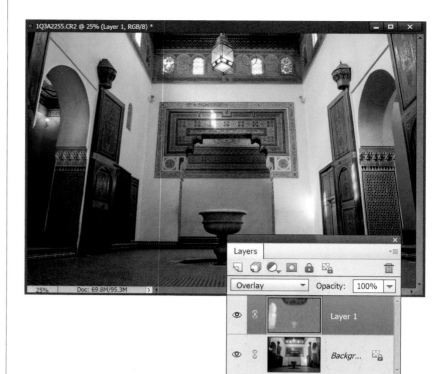

Alternate Technique:

Open the photo that you want to dodge and burn, then just click on the Create a New Layer icon in the Layers palette and change the blend mode to **Soft Light**. Now, set white as your Foreground color and you can dodge right on this layer using the Brush tool set to 30% Opacity. To burn, just as before, switch to black. The dodging and burning using this Soft Light layer appears a bit softer and milder than the previous technique, so you should definitely try both to see which one you prefer.

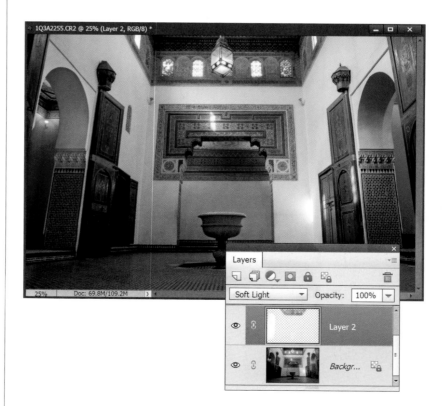

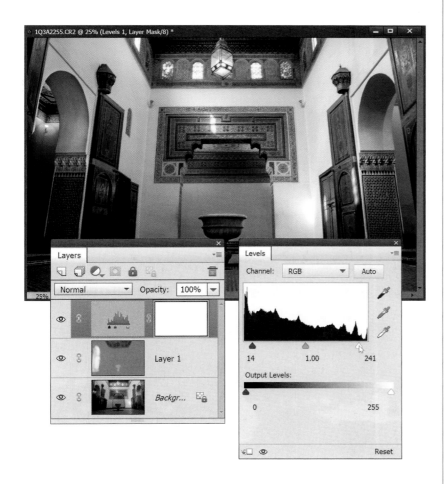

Step Nine:

Let's add some contrast to the image to finish things off here. Click on the Create New Adjustment Layer icon at the top of the Layers palette, and choose **Levels**. This will add a Levels adjustment layer to the top of the layer stack and open the Levels adjustment palette. Drag the far-left (dark gray) Input Levels slider (beneath the histogram) to the right a bit to bring out some detail in the shadows, and then drag the far-right (white) Input slider to the left to brighten the highlights. A before/after is shown below.

Before

After

Removing Haze from Your Photos

Here's a feature that's actually pretty darn slick. Anyone who shoots underwater photography, or takes a shot at an aquarium, or just shoots on foggy or hazy days will so love this. It cuts through haze amazingly well (and it doesn't just add the same ol' contrast, it's its own brand of contrast that works particularly well for this type of stuff).

Step One:

There are two ways to remove haze from your photos: automatically and manually. We'll start with the automatic way. Here, I've opened a photo I took in Venice on a hazy day. Instead of trying to add contrast ourselves to remove the haze, go under the Enhance menu and choose **Auto Haze Removal**.

Step Two:

Elements then analyzes your photo and applies the amount of haze removal it thinks your photo needs. In this case, it did a pretty good job, but if you think it is not enough or is too much, press **Ctrl-Z (Mac: Command-Z)** to Undo and try it manually (we'll cover that next).

Step Three:
Open another hazy photo, like this one, where you want to manually apply haze removal. This time, go under the Enhance menu and choose **Haze Removal** (or press **Ctrl-Alt-Z [Mac: Command-Option-Z]**).

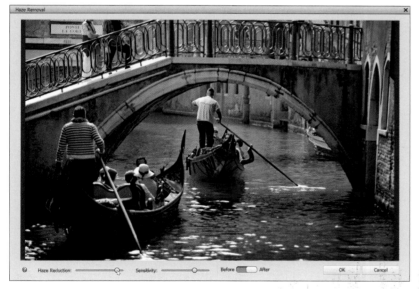

Step Four:
This opens the Haze Removal dialog. Elements will try to remove the haze, but you can click-and-drag the Haze Reduction and Sensitivity sliders back and forth until it looks good to you. To see the difference, simply click on the Before/After button at the bottom center of the dialog. Click OK when you're done.

Opening Up
Shadow Areas
That Are Too Dark

One of the most common problems you'll run into with your digital photos is that the shadow areas are too dark. Fortunately for you, since it is the most common problem, digital photo software like Elements has gotten really good at fixing this problem. Here's how it's done:

Step One:
Open the photo that needs to have its shadow areas opened up to reveal detail that was "lost in the shadows."

Step Two:
Once the photo is open, go under the Enhance menu, under Adjust Lighting, and choose **Shadows/Highlights**.

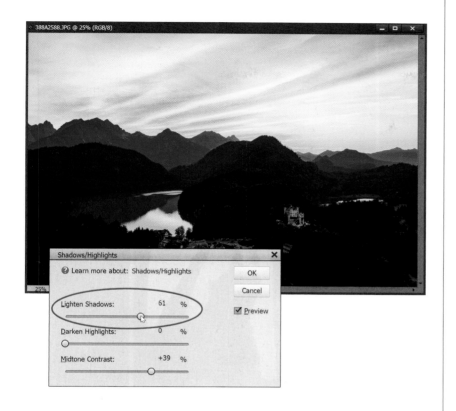

Step Three:

When the dialog appears, it already assumes you have a shadow problem (sadly, most people do but never admit it), so it automatically opens up the shadow areas in your document by 35% (you'll see that the Lighten Shadows slider is at 35% by default [0% is no lightening of the shadows]). If you want to open up the shadow areas even more, drag the Lighten Shadows slider to the right. If the shadows appear to be opened too much with the default 35% increase, drag the slider to the left to a setting below 35%. If your image begins to look flat, drag the Midtone Contrast slider to the right. When the shadows look right, click OK. Your repair is complete. Here, I dragged the Lighten Shadows slider to 61% and the Midtone Contrast slider to +39%.

Before

After

Fixing Areas That Are Too Bright

Although most of the lighting problems you'll encounter are in the shadow areas of your photos, you'll be surprised how many times there's an area that is too bright (perhaps an area that's lit with harsh, direct sunlight, or you exposed for the foreground but the background is now overexposed). Luckily, this is now an easy fix, too!

Step One:
Open the photo that has highlights that you want to tone down a bit. *Note:* If it's an individual area (like the sun shining directly on your subject's hair), you'll want to press the **L key** to switch to the Lasso tool and put a loose selection around that area. Then go under the Select menu and choose **Feather**. For low-res, 72-ppi images, enter 2 pixels and click OK. For high-res, 300-ppi images, try 8 pixels.

Step Two:
With the photo open, go under the Enhance menu, under Adjust Lighting, and choose **Shadows/Highlights**.

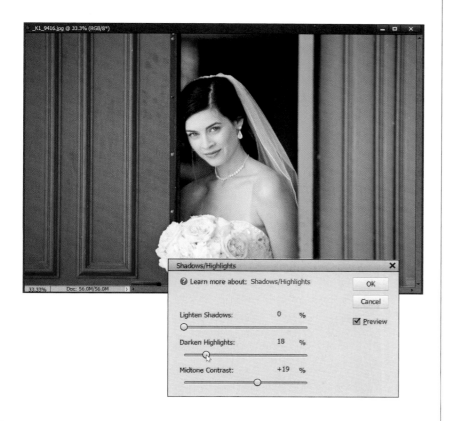

Step Three:
When the dialog appears, drag the Lighten Shadows slider to 0% and drag the Darken Highlights slider to the right, and as you do, the highlights will decrease, bringing back detail and balancing the overall tone of your (selected) highlights with the rest of your photo. (You'll mainly see it in the dress, veil, and flowers here. They have more detail now.) Sometimes, when you make adjustments to the highlights (or shadows), you can lose some of the contrast in the midtone areas (they can become muddy or flat looking, or they can become oversaturated). If that happens, drag the Midtone Contrast slider (at the bottom of the dialog) to the right to increase the amount of midtone contrast, or drag to the left to reduce it. Then click OK. *Note:* If you made a selection, you'll need to press **Ctrl-D (Mac: Command-D)** to Deselect when you're finished.

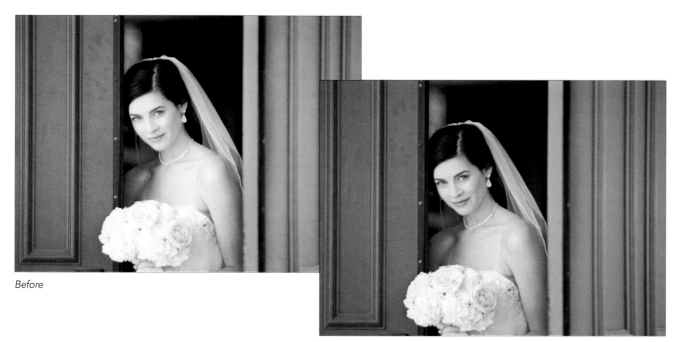

Before

After

When Your Subject Is Too Dark

Sometimes your subject is too dark and blends into the background—maybe there just wasn't enough light, or you forgot to use fill flash, or a host of other reasons that could have caused this. You could go and retake the photo if you realize it right away. However, you don't always realize it immediately, so you'll need to get Elements to help out. For those times, there's a really clever way in Elements to essentially paint your light onto the subject after the fact.

Step One:
Open a photo where the subject(s) of the image appears too dark.

Step Two:
Click on the Create New Adjustment Layer icon at the top of the Layers palette (shown circled here), and choose **Levels**. This will add a Levels adjustment layer above your Background layer, and open the Levels adjustment palette.

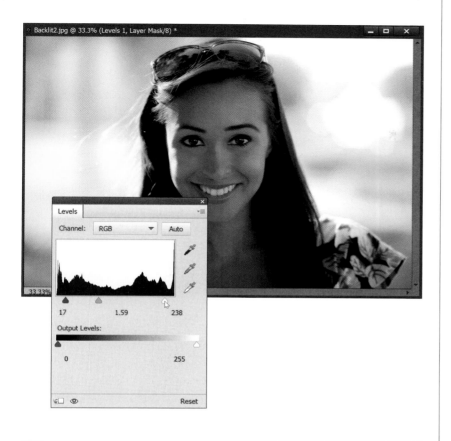

Step Three:

Drag the middle gray Input Levels slider (under the histogram) to the left until your subject(s) looks properly exposed. (*Note:* Don't worry about how the background looks—it will probably become completely blown out, but you'll fix that next—for now, just focus on making your subject look right.) If the midtones slider doesn't bring out the subject enough, you may have to increase the highlights as well, so drag the far-right (white) Input Levels slider to the left to increase the highlights (as shown here). She was looking kinda washed out, so I also dragged the far-left (dark gray) Input Levels slider to the right just a bit to increase the shadows.

Step Four:

When your subject looks properly exposed, press **D** to set your Foreground color to white and your Background color to black. Then press **Ctrl-Backspace (Mac: Command-Delete)** to fill the layer mask with black and remove the brightening of the photo. Press **B** to switch to the Brush tool and click on the Brush thumbnail in the Tool Options Bar to open the Brush Picker, where you'll choose a soft-edged brush. Now, you'll paint (on the layer mask) over the areas of the image that need a fill flash with your newly created "Fill Flash" brush. The areas you paint over will appear lighter, because you're "painting in" the lightening of your image on this layer.

Continued

Step Five:
Continue painting until it looks as if you had used a fill flash. If the effect appears too intense, just lower the opacity of the adjustment layer by dragging the Opacity slider to the left in the Layers palette (as shown here).

TIP: Try the Smart Brush Tool Instead
The Smart Brush tool (covered earlier in this chapter) has a Portrait preset called Lighten Skin Tones that also works pretty well in cases like this.

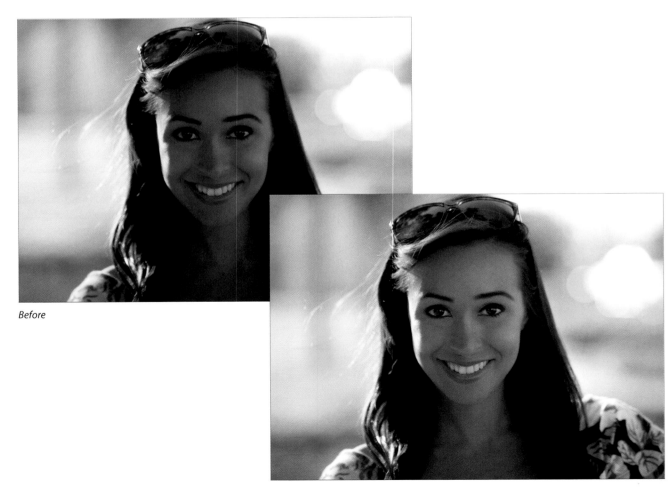

Before

After

Automatic Red-Eye Removal

If you just finished shooting an indoor event with lots of flash and low light, chances are you're going to have a ton of photos with red eyes. If you know this ahead of time, then the feature you're about to see comes in very handy. You can set up Elements to automatically remove red eye as your photos are being imported into the Organizer. No interaction by you is needed. Just let Elements do its work and by the time you see your photos onscreen, you'll never even know red eye existed.

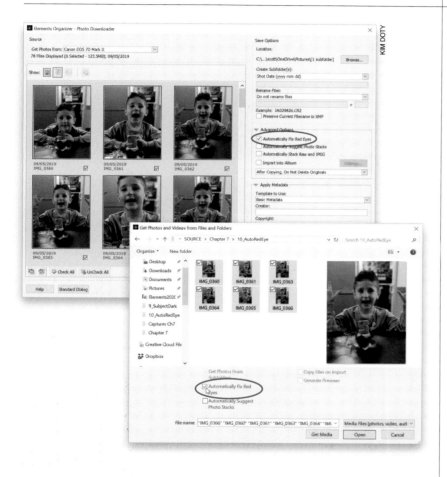

KIM DOTY

Step One:

First, we'll start with the fully automatic version, which you can use when you're importing photos into the Organizer. Here's how it works: When importing photos from your camera, the Elements Organizer – Photo Downloader dialog appears. On the right side of the dialog, in the Advanced Options section, there's a checkbox for Automatically Fix Red Eyes (if your dialog doesn't look like this, click on the Advanced Dialog button at the bottom). If you think some of the photos you're about to import will have red eye, just turn on this checkbox (shown circled here), and then click the Get Media button to start the importing and the red-eye correction. If you're importing photos already on your computer, you'll have the same option in the Get Photos and Videos from Files and Folders dialog.

Step Two:

Once you click the Get Media button, the Elements Organizer dialog will appear. In this dialog, there's a status bar indicating how many photos are being fixed. It also shows you a preview of each photo it's importing.

Continued

Step Three:

Once the process is complete, it automatically groups the original with the fixed version in a Version Set (you'll see an icon at the top right of the image thumbnail), so if you don't like the fix (for whatever reason), you still have the original. You can see both versions of the file by Right-clicking on the photo (in the Organizer) and in the pop-up menu, under Version Set, choosing **Expand Items in Version Set** (or by just clicking on the right-facing arrow to the right of the image thumbnail). *Note:* To expand your version sets, your thumbnail view must be set to Details (found on the View menu).

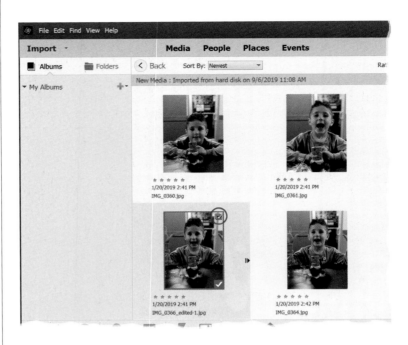

Step Four:

Here is one of the photos with red eye and with it automatically removed.

Step Five:

This really isn't a step; it's another way to get an auto red eye fix, and that's by opening an image in the Editor, in Expert mode or Quick mode, and then going under the Enhance menu and choosing **Auto Red Eye Fix**. You can also use the keyboard shortcut **Ctrl-R (Mac: Command-R)**. Either way, it senses where the red eye(s) is, removes it automatically, and life is good.

Instant Red-Eye Removal

When you use the flash on your digital point-and-shoot camera (or even the on-camera flash on a digital SLR), do you know what you're holding? It's called an A.R.E.M. (short for automated red-eye machine). Yep, that produces red eye like it's going out of style. Studios typically don't have this problem because of the equipment and positioning of the flashes, but sometimes you don't have a choice—it's either an on-camera flash or a really dark and blurry photo. In those cases, just accept the red eye. Become one with it and know that you can painlessly remove it with a couple of clicks in Elements.

Step One:
Open a photo where the subject has red eye.

Step Two:
Press **Z** to switch to the Zoom tool (it looks like a magnifying glass in the Toolbox) and drag out a selection around the eyes (this zooms you in on the eyes). Now, press the letter **Y** to switch to the Eye tool (its Toolbox icon looks like an eye with a tiny crosshair cursor in the left corner). There are two different ways to use this tool: click or click-and-drag. We'll start with the most precise, which is click. Take the Eye tool and click it once directly on the red area of the pupil. It will isolate the red in the pupil and replace it with a neutral color. Instead, you may now have "gray" eye, which doesn't look spectacular, but it's a heck of a lot better than red eye.

Continued

Step Three:

If the gray color that replaces the red seems too "gray," you can adjust the darkness of the replacement color by adjusting the Darken amount in the Tool Options Bar. To get better results, try adjusting the Pupil Radius setting so that the area affected by the tool matches the size of the pupil. Now, on to two other ways to use this tool (for really quick red-eye fixes).

Step Four:

If you have a lot of photos to fix, you may opt for this quicker red-eye fix—just click-and-drag the Eye tool over the eye area (putting a square selection around the entire eye). The tool will determine where the red eye is within your selected area (your cursor will change to a timer), and it removes the red. Use this "drag" method on one eye at a time for the best results. Or, you can just try clicking the Auto Correct button in the Tool Options Bar. This works pretty good, too.

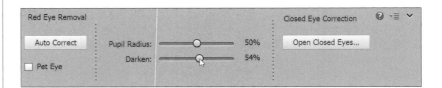

Before

After

Elements has a feature called Correct Camera Distortion that's made for problems that happen when we shoot with wide-angle lenses. We've all probably seen those super-wide photos that make it look like the buildings in a city are leaning over, or architecture where those perfect lines don't look like they do in real life. Well, that's exactly what this filter is for.

Fixing Problems Caused by Your Camera's Lens

Step One:

Open your photo, and then go under the Filter menu and choose **Correct Camera Distortion**. There are a few problems that this filter fixes, like distortion if you have curved surfaces in the photo. It's not quite as common as some of the other lens problems, and usually only rears its head if you're shooting with a fisheye lens or a lens that is really wide. But if you do have any distortion, like maybe a curved horizon line, you can use the Remove Distortion slider to fix it (as shown here). The little icons at either end of the slider show you which way you need to drag.

TIP: Use the Grid as Your Guide

If you need extra help lining things up, there is a Show Grid checkbox at the bottom of the dialog, as seen in the image above. It really helps you see whether or not crooked lines exist in your photo. It does get annoying, though, so you may want to turn it off if you don't need it.

Step Two:

The two sliders in the Vignette section remove any edge darkening in the photo. Again, this doesn't always happen and a lot of people actually like edge vignetting (it's an effect we often add to a photo). But, if it bugs you, you can remove it here by dragging the Amount slider toward the right (toward Lighten), and then adjusting the Midpoint slider so it is removed farther toward the middle or closer to the edges.

Continued

Step Three:

The next section is really where you'll probably spend most of your time—Perspective Control. And, usually, it will be lens distortion issues, like we have in this image. See how the building is bulging outward and is squashed on its right side?

Step Four:

Start by dragging the Remove Distortion slider to the right to get rid of the bulging. Then, drag the Vertical Perspective slider to the left to help straighten it. Depending on what lens you used, you may have to drag pretty far. Keep in mind, though, that when you do this, you're actually cropping away areas on the sides of your photo (Elements does this automatically). So if you go too far, you may cut out a key part of the photo. Personally, I always back off a little. If you're not an architectural photographer selling your images to clients, then nobody who sees your photos will care about the slightly leaning buildings. Why? Because the same problem happens to the rest of the world and they're used to it. :-)

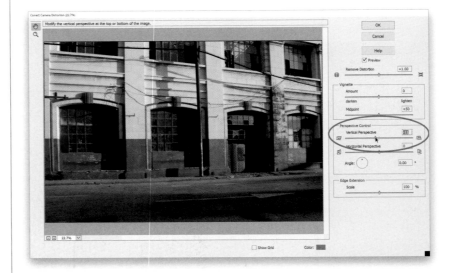

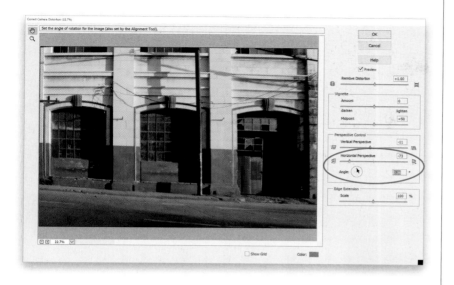

Step Five:

If you see any horizontal lines that aren't straight, then you can tweak a couple more settings. First, there is a Horizontal Perspective slider that may work. Usually, though, I try to get the vertical lines straight, and then I go to the Angle setting and rotate the image slightly to fix things (you can turn the Show Grid checkbox back on to help line things up). Also, if the Angle control moves in too-large increments, then click-and-drag directly on the word Angle. Keep in mind that when you do this, you may have to go back and fix the vertical setting a little, too. You'll find it's a constant push-and-pull here, but I don't mind a little bit of a tilt to the building so I'll leave it. When you're done, just click OK. You can see the before/after below.

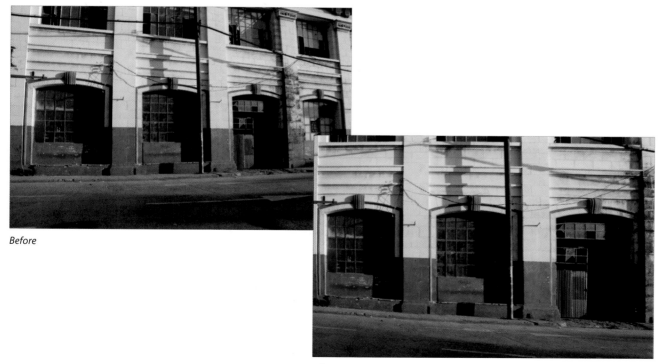

Before

After

Saving Blurry Photos Using the Shake Reduction Filter

If you have a shot you took handheld in low light (so the blurriness was caused by shooting with a slow shutter speed), or if your blurry shot came from a long lens, you may be in luck using a filter called Shake Reduction. It can greatly reduce the blur caused by shots where your camera moved a bit (it's not for shots where your subject is moving). This filter works best on images that don't have a lot of noise, have a pretty decent overall exposure, and where you didn't use flash. It doesn't work on every image, but when it does, it's pretty jaw-dropping.

Step One:

Here's a shot I took handheld in low light; it's a blurry mess, and this is exactly when you'd reach for the Shake Reduction filter (it's found under the Enhance menu).

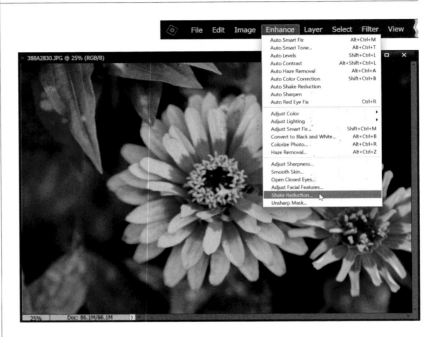

Step Two:

When the filter opens, it immediately starts analyzing the image, starting in the middle of that box (called a Shake Region) in the bottom-center of the preview area, and searching outward from there. You'll see a little progress bar appear (as it's thinking) inside that Shake Region. If you want to cancel the analyzing process, just click the little X in the top right of it. Once it's done doing the math, it shows you its automated blur correction (seen here), where I have to say, on this image, it did a pretty good job. It's not perfectly sharp, but the original was completely unusable. At least now, if I wanted to put it on Facebook or Twitter at web resolution, it would be totally passable, which I think is saying a lot. For most users, this is all you'll need to do: open the filter, let it do its thing, and you're done. However, if you're a "tweaker," then read on.

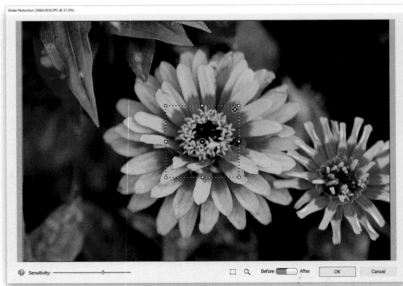

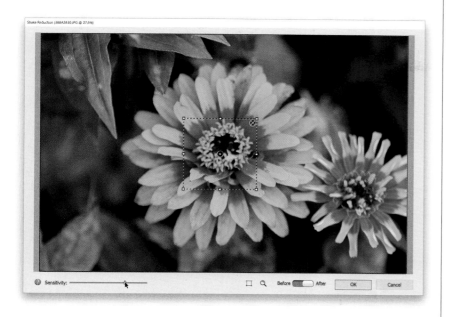

Step Three:

The filter automatically calculates what it thinks is the amount of camera shake based on how many pixels it thinks have moved, but if the auto method doesn't look good, it may be that it either needs to affect more or fewer pixels. That's what the Sensitivity slider is for. This slider controls how many pixels the filter affects (kind of like how the Tolerance slider for the Magic Wand tool determines how far out the tool selects). Dragging the slider to the left affects fewer pixels (so, if there's just a little blurring, it may need to affect fewer pixels) and dragging to the right affects more pixels. Its own estimation is pretty darn good but, again, you can override it (in this case, I only moved it a little).

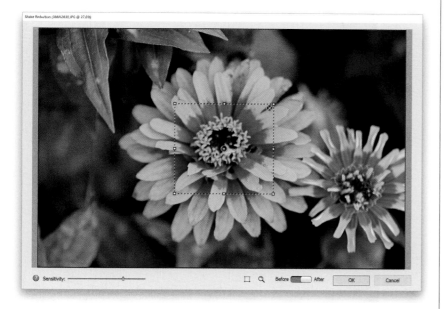

Step Four:

Now, what if you don't like where it placed the Shake Region, and think there's a better area for it to base its fix on? Just click on the dot in the center of the Shake Region and drag it where you want it. You can also click on one of the corner or side handles and resize the Shake Region (just like you would a Free Transform bounding box). Here, I made it into a larger square to include more of the flower.

Continued

Step Five:

So far, we've only used one area for Shake Reduction's calculations, but what if there's more than one place where you want the emphasis on camera shake reduction placed? Well, luckily, you can have multiple Shake Regions. To add a new Shake Region, either click-and-drag over the area you also want to emphasize, or click on the Add Another Shake Region icon below the center of the preview area, then move and resize it. Here, I added another Shake Region over the other flower.

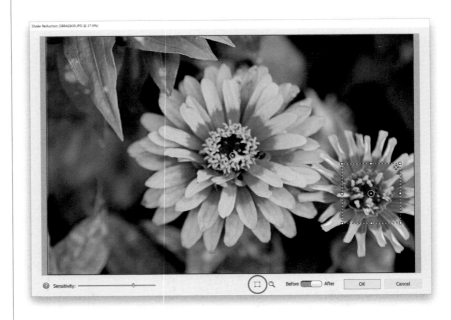

Step Six:

To see a zoomed-in view of your image (if you want a better idea of how well Elements is fixing an area), click on the Show Magnifier Window icon (it looks like a magnifying glass) below the preview area or press the letter **Q** on your keyboard. A floating magnifier window appears on your image that you can click-and-drag wherever you like. You can zoom in tighter by clicking the zoom amount buttons at the top right of the window. Press Q again to close it. If you click-and-hold inside the magnifier window, it gives you a quick "before" view of your image (before you removed the camera shake). When you release your mouse button, it brings you back to the edited "after" image.

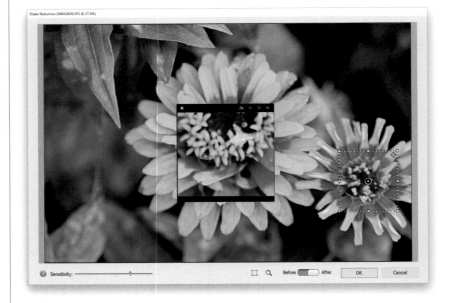

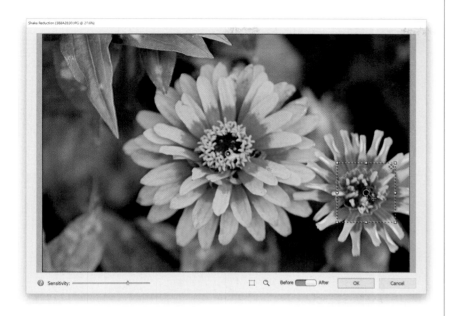

Step Seven:

If you've added a Shake Region and don't like the effect or want to see how the image would look without it, just click on the dot in the center of the Shake Region and it will turn solid gray (as shown here, in the Shake Region on the right). This means you've turned off that Shake Region. If you decide you want to keep it, click on the dot again. If you want to delete the Shake Region, click the X in the top-right corner. You can see the changes to the entire image by clicking on the Before/After toggle button to the left of the OK button.

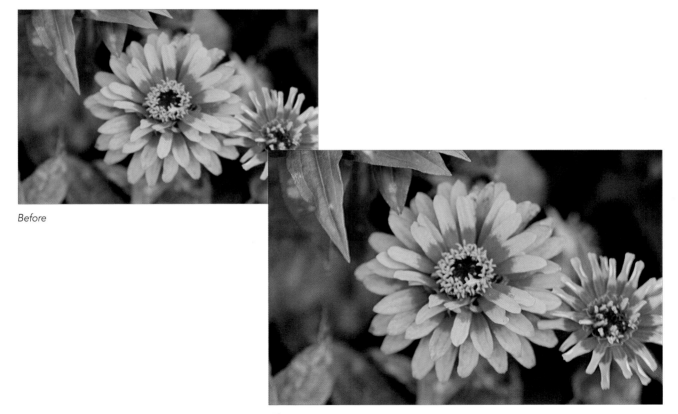

Before

After

Opening Closed Eyes

I don't know why it is, but when you're shooting a portrait, you can almost bank on the fact that when your subject has just the right pose, in just the right light, with just the right expression, they blink at just the wrong time and now their eyes are closed. This is such a common problem that I've banned blinking at my portrait shoots altogether. However, even with this strict ban in place, they somehow seem to slip one past the goalie every so often and I wind up with an eyes-closed shot. Luckily, since Elements can fix this problem for you automatically, I'm now thinking of lifting my blinking ban.

Step One:
In the Editor, open a photo where your subject's eyes are closed (as seen here, where my subject is clearly bored with our portrait shoot and may be fully asleep). *Note:* We used to fix this problem in Guided mode, using Photomerge Group Shot, but now that this feature has been added in Expert mode, we can do it right here much quicker and easier.

Step Two:
Go under the Enhance menu and choose **Open Closed Eyes** (as shown here).

Step Three:

This brings up the Open Closed Eyes dialog, and in the Eye Source section in the top right, you can find an image from that same shoot (or perhaps even a different shoot of that same person, or in a worst-case scenario, find somebody else's open eyes that look similar, but again, that's a worst-case-scenario type of thing. Adobe knows it might happen, so they put four sample portraits in the Try Sample Eyes section to choose from if you're really stuck). In my case, I was able to find another image from the same portrait session where my subject's eyes were open (it was actually just the next photo after the one where his eyes were closed). I clicked on the Organizer button, which opened the Add Photos dialog, and kept the Photos Currently in Browser radio button selected to see the images I already had open. But, you can choose another Open From option to help you search through your image files to find a suitable set of eyes. You can also choose to open more than just one image, in case you want to try out a few different sets of eyes. When you find one, turn on the checkbox to its left in the dialog's preview area (as seen here) and then click the Done button.

Step Four:

Now, any images you chose in the previous step will appear as thumbnails in the Click to Apply section. Here you can see the image I opened from the Organizer in there, and you can see my original closed-eyes image in the preview area. The blue circle around his face is letting you know that Elements is using facial recognition and it has recognized the area to be edited (the eyes) automatically. Now, click on one of those open-eyes images (well, in my case here, I only have one image to choose from) to apply the eyes from that image to the main image.

Continued

Step Five:

Once you click on that open-eyes thumbnail, you can see it's already working its magic, and the opened eyes from that image have been applied to your closed-eyes image. It does a pretty amazing job at it, I might add. If you have other images you had opened in the Click to Apply section, you can click on them to see if any of them look better to you.

Step Six:

When you're happy with how your open-eyes image looks, click the OK button and your final image appears in the Editor (as seen here). That's all there is to it. Pretty sweet, eh?

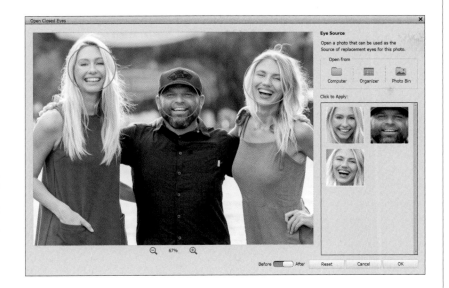

Step Seven:

If you have a group shot, no problem. You'll see a circle around each face that Elements recognizes using its built-in facial recognition. Just click on the person's face whose eyes are closed, and the circle around their face will turn blue to let you know that's the face you'll be editing. Now, open another image to use where your subject's eyes are open (I clicked on the Computer button this time and opened another group shot from that same shoot). It automatically recognizes that there are multiple faces in the image and it puts thumbnails of each person in the Click to Apply section (seen here).

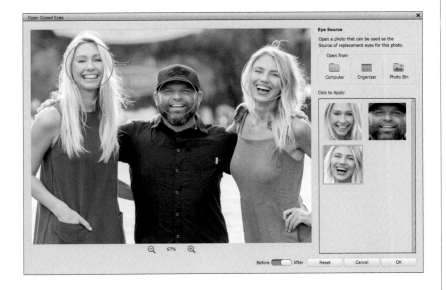

Step Eight:

Click on the thumbnail of the same person to use their open eyes in the shot (I guess you could choose someone else in the group shot and use their eyes instead, but ya know…that ain't right!) and it fixes the eyes (as seen here). She's laughing in the shot, so her eyes aren't as fully open as when she would not be laughing, but if you look closely and compare it to the image in Step Seven, you'll see that her eyes are at least open now.

Location: Lofoten, Norway | Exposure: 1/40 sec | Focal Length: 35mm | Aperture Value: ƒ/11

Natural Selection
selection techniques

Ladies and gentlemen, this year's nominee for the Chapter Title Hall of Fame is "Natural Selection," for its use as the title of a chapter on making selections [insert polite applause]. Can you imagine how thrilled I must have been when I typed the word "Selection" in the IMDb (Internet Movie Database) search field, and the 2016 movie *Natural Selection*, starring Anthony Michael Hall and Katherine McNamara, came up in the search results? Now, I didn't actually see the movie, because the tagline for the movie poster read: "Survive high school," so I figured it was not for my personal demographic, which is "people who skipped high school and went straight to NASA astronaut training school" (but that's another story, for another chapter intro). Anyway, I like Anthony Michael Hall (he was in the famous 1985 coming-of-age dramedy, *The Breakfast Club*), but the weird thing is he was playing a high school kid back then, and now it's 32 years later and he's still playing a high school kid. This has me thinking: I dunno, while it's a perfect title for a chapter on selections, there might be a casting issue here. I just looked it up and Anthony is 48 years old now, so I'm thinking there are other actors who could have just as easily, just as convincingly, played this role of the angst-ridden teenager. The first name that comes to mind? Dick Van Dyke (yes, he's still alive. Well, at least he was when I wrote this, but then so was Anthony Michael Hall), and between Anthony and Dick Van Dyke...I dunno, I think Dick has the edge. Did you see the way he danced in *Mary Poppins*? For goodness' sake, the guy was up on rooftops, and he's dancing around with chimney sweeps, and he's got soot all over his face—that guy could easily pass for an angsty-teen (well, a British one, who says realistic British phrases like, "Say no more, guv'nor" and "Grab the Lasso tool, 'ello, 'ello, 'ello!").

Selecting Square, Rectangular, or Round Areas

Selections are an incredibly important feature in Elements. They're how you tell Elements to affect only specific areas of your photos. Whether it's moving part of one photo into another or simply trying to draw more attention to or enhance part of a photo, you'll have so much more control if you know how to select things better. For starters, Elements includes quick and easy ways to make basic selections (square, round, rectangular). These are probably the ones you'll use most, so let's start here.

Step One:
To make a rectangular selection, choose (big surprise) the Rectangular Marquee tool by pressing the **M key**. Adobe's word for selection is "marquee." (Why? Because calling it a marquee makes it more complicated than calling it what it really is—a selection tool—and giving tools complicated names is what Adobe does for fun.)

Step Two:
We're going to start by selecting a rectangle shape, so click your cursor in the upper-left corner of the top-left tile and drag down and to the right until your selection covers the two top tiles, then release the mouse button. That's it! You've got a selection and anything you do now will affect only the selected rectangle (in other words, it will only affect those two top tiles).

Step Three:

To add another area to your current selection, just press-and-hold the Shift key, and then draw another rectangular selection. In our example here, let's go ahead and select the rest of the tiles. So press-and-hold the **Shift key**, drag out a rectangle around the tiles on the bottom, release the mouse button, and now all of the tiles are selected.

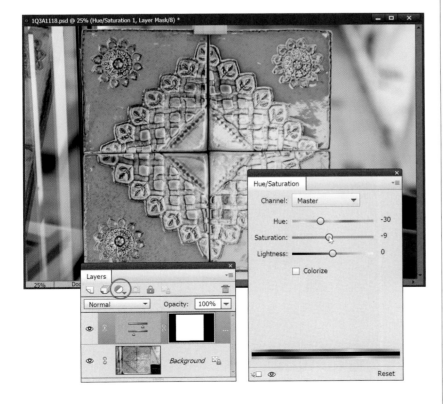

Step Four:

Now let's make an adjustment and you'll see that your adjustment will only affect your selected area. Click on the Create New Adjustment Layer icon at the top of the Layers palette, and choose **Hue/Saturation** from the pop-up menu. In the Hue/Saturation adjustment palette, drag the Hue slider to the left to change the color of the tiles to a red and green color. Notice how just the colors of the tiles are changing and nothing else in the image? This is why selections are so important—they are how you tell Elements you only want to adjust a specific area. You can also drag the Saturation or Lightness sliders, too, but I'm just going to move the Saturation to the left a little, here. Also, you'll notice your selection goes away when you add the adjustment layer, but if you ever want to deselect something, just press **Ctrl-D (Mac: Command-D)**.

Continued

Step Five:

Okay, you've got rectangles, but what if you want to make a perfectly square selection? It's easy—the tool works the same way, but before you drag out your selection, you'll want to press-and-hold the Shift key. Let's try it: open another image, get the Rectangular Marquee tool, press-and-hold the Shift key, and then draw a perfectly square selection (around the center area inside of this fake instant photo, in this case).

Step Six:

While your selection is still in place, open a photo that you'd like to appear inside your selected area and press **Ctrl-A (Mac: Command-A)**; this is the shortcut for Select All, which puts a selection around your entire photo at once. Then press **Ctrl-C (Mac: Command-C)** to copy that photo into Elements' memory.

Step Seven:

Switch back to the instant photo image, and you'll notice that your selection is still in place. Go under the Edit menu and choose **Paste Into Selection**. The image held in memory will appear pasted inside your square selection. If the photo is larger than the square you pasted it into, you can reposition the photo by just clicking-and-dragging it around inside your selected opening.

Step Eight:

You can also use Free Transform (press **Ctrl-T [Mac: Command-T]**) to scale the pasted photo in size. Just grab a corner point (press **Ctrl-0** [zero; **Mac: Command-0]** if you don't see them), press-and-hold the Shift key (or turn on the Constrain Proportions checkbox in the Tool Options Bar), and drag inward or outward. When the size looks right, press the **Enter (Mac: Return) key** and you're done. (Well, sort of—you'll need to press **Ctrl-D [Mac: Command-D]** to Deselect, but only do this once you're satisfied with your image, because once you deselect, Elements flattens your new image into your Background layer, meaning there's no easy way to adjust this image.) Now, on to oval and circular selections…

Step Nine:

Open an image with a circle shape you want to select (the green dish here), and then press **M** to switch to the Elliptical Marquee tool (pressing M toggles you between the Rectangular and Elliptical Marquee tools by default). Now, just click-and-drag a selection around your circle. Press-and-hold the Shift key as you drag to make your selection perfectly round. If your round selection doesn't fit exactly, you can reposition it by moving your cursor inside the border of your round selection and clicking-and-dragging to move it into position. You can also press-and-hold the Space-bar to move the selection as you're creating it. If you want to start over, just deselect, and then drag out a new selection. *Hint:* With circles, it helps if you start dragging before you reach the circle, so try starting about ¼" to the top left of the circle.

Continued

Step 10:

While we're at it, let's check out another little tip with selections. In our example, we've selected the green plate because it's simple and easy to select. But really, the background is the area we'd like to fix here. It's just a little bright and I think it'll look better if it's a bit darker. No sweat. Go under the Select menu, choose **Inverse**, and Elements will select everything else *but* what you put a selection around in the previous step. By the way, if there's anything in your selection that shouldn't be, get the Lasso **(L)** tool from the Toolbox, press-and-hold the **Alt (Mac: Option) key**, and then just select that area to deselect it.

Step 11:

Now let's adjust the area around the green plate. Click on the Create New Adjustment Layer icon and choose **Levels**. In the Levels adjustment palette, drag the black (shadows) slider beneath the histogram to the right to around 34, then drag the gray (midtones) slider to the right to around 0.82 to add more contrast to the background and the other plates. That's it. Remember, to simply make ovals or rectangles, just start dragging. However, if you need a perfect circle (or square), then press-and-hold the Shift key.

We make selections when we want to adjust one part of our image, rather than the entire image. For example, in the image I'm using here, I want to make the big rock formation in the front a bit brighter, but I don't want to adjust anything else in the image (I like the way the sky, sea, and the rock formations in the back look). This type of selection is a breeze now thanks to Auto Selection—you just make a very loose selection around what you want to adjust and it snaps a selection around the object inside your selected area. This will make a whole lot more sense once you try it, so…let's try it!

Auto Selecting Things in Your Image

Step One:
Here's the image, opened in the Editor, where there's just one part we want to adjust (rather than adjusting the entire image). Again, we only want to adjust that large rock formation in the front—it just looks a bit too dark. So, we're going to let Elements know that's the only thing we want to select, and it will do it for us. We'll do this using the Auto Selection tool (press **A** until you have it; its icon kind of looks like a sparkly magic wand). Once you have it, its options will appear down in the Tool Options Bar.

Step Two:
Now we just have to let Elements know which part of the image we want to select. There are four options you can choose from to draw your selection: the first one, Rectangle (the default choice), lets you take the Auto Selection tool and click-and-drag out a big rectanglular selection around what you want Elements to select for you (as shown here, where I dragged a large rectangular selection around the rock formation). The next one is Ellipse, which actually would have worked fine for encircling the rock. You can use the standard Lasso if a rectangle or oval won't work, and finally, there's the Polygon Lasso if the area you need to select needs straight lines (as you click with it, it draws a straight-line selection between your clicks).

Continued

Step Three:

When you let go of your mouse button, Elements looks at what's inside your selected area and creates a precise selection for you (as seen here, where it selected the rock formation perfectly for me). If it didn't do a perfect job (it either didn't fully select what you wanted, or it selected more than you wanted), you can tweak the results. For example, if it didn't select enough, you would make sure the Add icon (seen in the previous step) is selected in the Tool Options Bar. When you're in Add mode, any areas you click-and-drag over will be added to your original selection. If it selected too much, click the Subtract icon (it's to the right of the Add icon) to enter Subtract mode, then click-and-drag a selection over any areas you want to remove.

Step Four:

Once your selection is the way you want it (in my case, it did the whole thing for me, first time), any adjustments you make to your image will only affect that selected area. In this case, I wanted that rock formation a bit brighter, so I went under the Enhance menu, chose **Auto Smart Fix**, and that did the trick. It brightened the rock just enough so you can now clearly see its detail. When you're done, press **Ctrl-D (Mac: Command-D)** to Deselect.

If you've spent 15 or 20 minutes (or even longer) putting together an intricate selection, once you deselect it, it's gone. (Well, you might be able to get it back by choosing Reselect from the Select menu, as long as you haven't made any other selections in the meantime, but don't count on it. Ever.) Here's how to save your finely-honed selections and bring them back into place anytime you need them:

Saving Your Selections

Step One:
Open an image and then put a selection around an object in your photo using the tool of your choice. Here I used the Quick Selection tool **(A)** to select the sky, then went under the Select menu and chose **Inverse** to select the skyscrapers. Then, I zoomed in and clicked on any areas that I missed to add them to the selection. If you select too much, just press-and-hold the **Alt (Mac: Option) key** and click in the areas you want to deselect. To save your selection once it's in place (so you can use it again later), go under the Select menu and choose **Save Selection**. This brings up the Save Selection dialog. Enter a name in the Name field and click OK to save your selection.

Step Two:
Now you can get that selection back (known as "reloading" by Elements wizards) at any time by going to the Select menu and choosing **Load Selection**. If you've saved more than one selection, they'll be listed in the Selection pop-up menu—just choose which one you want to "load" and click OK. The saved selection will appear in your image.

Softening Those Harsh Edges

When you make an adjustment to a selected area in a photo, your adjustment stays completely inside the selected area. That's great in many cases, but when you deselect, you'll see a hard edge around the area you adjusted, making the change look fairly obvious. However, softening those hard edges (thereby "hiding your tracks") is easy—here's how:

Step One:

Let's say you want to darken the area around the teapot and sugar bowl, so it looks almost like you shined a soft spotlight on them. Start by drawing an oval selection around them using the Elliptical Marquee tool (press **M** until you have it). Make the selection big enough so the teapot, sugar bowl, and the surrounding area appear inside your selection. Now we're going to darken the area around them, so go under the Select menu and choose **Inverse**. This inverses the selection, so you'll have everything but the teapot and sugar bowl selected (you'll use this trick often).

Step Two:

Click on the Create New Adjustment Layer icon at the top of the Layers palette, and choose **Levels**. In the Levels adjustment palette, drag the gray (midtones) slider beneath the histogram to the right to about 0.50. You can see the harsh edges around the oval, and it looks nothing like a soft spotlight—it looks like a bright oval. That's why we need to soften the edges, so there's a smooth blend between the bright oval and the dark surroundings.

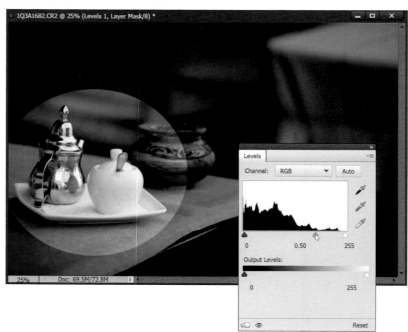

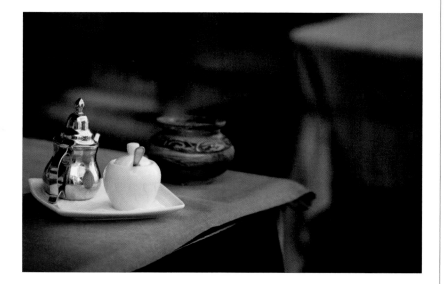

Step Three:

Press **Ctrl-Z (Mac: Command-Z)** three times so your photo looks like it did when you drew your selection in Step One (your selection should be in place—if not, drag out another oval). With your selection in place, go under the Select menu and choose **Feather**. When the Feather Selection dialog appears, enter 150 pixels (the higher the number, the more softening effect on the edges) and click OK. That's it—you've softened the edges. Now, let's see what a difference that makes.

Step Four:

Go under the Select menu and choose Inverse again. Add a Levels adjustment layer again, drag the midtones Input Levels slider to around 0.50, and you can see that the edges of the area you adjusted are soft and blending smoothly, so it looks more like a spotlight. Now, this comes in really handy when you're doing things like adjusting somebody with a face that's too red. Without feathering the edges, you'd see a hard line around the person's face where you made your adjustments, and it would be a dead giveaway that the photo had been adjusted. But add a little bit of feather (with a face, it might only take a Feather Radius of 2 or 3 pixels), and it will blend right in, hiding the fact that you made an adjustment at all.

Easier Selections with the Quick Selection Tool

This is another one of those tools in Photoshop Elements that makes you think, "What kind of math must be going on behind the scenes?" because this is some pretty potent mojo for selecting an object (or objects) within your photo. What makes this even more amazing is that I was able to inject the word "mojo" into this introduction, and you didn't blink an eye. You're one of "us" now….

Step One:
Open the photo that has an object you want to select (in this example, we want to select the mosque). Go to the Toolbox and choose the Quick Selection tool (or just press the **A**, for Awesome, **key**).

Step Two:
The Quick Selection tool has an Auto-Enhance checkbox down in the Tool Options Bar. By default, it's turned off. My line of thinking is this: when would I ever not want an enhanced (which in my book means better) selection from the Quick Selection tool? Seriously, would you ever make a selection and say, "Gosh, I wish this selection looked worse?" Probably not. So go ahead and turn on the Auto-Enhance checkbox, and leave it that way from now on.

Step Three:
Take the Quick Selection tool and simply paint squiggly brush strokes inside of what you want to select. You don't have to be precise, and that is what's so great about this tool—it digs squiggles. It longs for the squiggles. It needs the squiggles. So squiggle.

Step Four:
If the selection includes areas you don't want (like part of the sky, here), then try switching to the Refine Selection Brush (press **A** until you have it). This brush has some features that make it similar to the Refine Edge feature (which we'll look at in the next tutorial). One feature is the View option. When you click on this brush an overlay mask appears to help you refine your selection. You can change the color of the overlay, change it to a black or white mask, or reduce its opacity in the Tool Options Bar. The way the brush works is it automatically adds or subtracts from the selection based on where you place it. Go ahead and try it. Place the brush in the actual boundary of the selection and you'll see the center of the brush has a plus in it (as seen here). That means it's in Add mode. Then try placing it outside of the selection and it automatically has a minus sign in it, meaning it's in subtract mode.

Continued

Step Five:

In this example, we want to subtract areas from the outside, so move the brush to the outside of the selection. Take a look at the brush's three sliders in the Tool Options Bar. First, there's Size, which is the overall size of the brush. Brush size is important because it affects how closely the brush will work with the edges around it. Think of this brush as having two parts to it: the middle (dark gray) circle is what you put over the area you want to add to or subtract from your selection (the background, here), and the outer (light gray) circle is what you place over the area you want the edges of the selection to snap to (the mosque). Make sure the correct sign (plus or minus) is showing in the dark gray circle, and that it doesn't overlap anything you want in your selection. Next, you have Snap Strength, which I usually keep high. That means that Elements will tend to snap to edges more consistently than if the setting was lower. Finally, there's Selection Edge, which sets the selection edge radius. This slider moves when you set the Size of your brush, but you can also adjust it manually, making it a harder or softer edge radius. Click-and-nudge your selection edges inward until only the mosque is selected.

Step Six:

Now that we've got it selected, we might as well do something to it, eh? How about this: let's give it more contrast. Start by clicking back on the Quick Selection tool (so you see your image again without a mask). Then, click on the Create New Adjustment Layer icon at the top of the Layers palette and choose **Levels**. In the Levels adjustment palette, drag the black (shadows) slider (beneath the histogram) to the right to around 10, the gray (midtones) slider to the right to around 0.90, and then the white (highlights) slider to around 222. That's better.

Making Really Tricky Selections, Like Hair (and Some Cool Compositing Tricks, Too!)

Most of the selecting jobs you'll ever have to do in Elements are pretty easy, but the one that has always kicked our butts is when we have to select hair. Over the years we've come up with all sorts of tricks, but all these techniques kind of went right out the window when Adobe supercharged the Quick Selection tool in Elements with the Select Subject and Refine Edge features. Refine Edge is, hands down, one of the most useful, and most powerful, tools in all of Photoshop—and now we've got it in Elements.

Step One:
Start by opening an image that has a challenging area to select (like our subject's hair here). Before we dive into the selection process, your job of selecting someone off a background is much easier if you photograph them on a neutral background color, like gray or tan or beige, etc. Here, I used a roll of inexpensive white seamless paper for my background and I didn't light it, so it just became light gray, by default (a roll of 56" wide by 36" long white seamless paper goes for around $29.99 at B&H Photo). Of course, you could just buy light gray seamless paper, too, but any neutral solid wall in your house or office will do.

Step Two:
We want to select as much of our subject as we can, including her flyaway hair. We do this in two steps: (1) Get the Quick Selection tool **(A)** from the Toolbox, but don't actually use it. Instead, we're going to let Elements do the initial selection of our subject for us—stuff we used to have to use the Quick Selection tool to do manually (but now Elements will do this automatically using machine learning and AI to recognize our subject). Just go down to the Tool Options Bar and click on the Select Subject button (as shown here). That's all you have to do. Wait a few seconds and it will make the basic selection for you (as seen here). It doesn't include all those hard-to-select areas, like the outside edges of her hair, but that's okay—that's for the next step.

Continued

Step Three:

Okay, here comes a very important part of this stage of the process, and that is making sure that when her hair is selected, you don't have any background area with it. In other words, don't let there be any hair selected with gray background showing through. In fact, I basically follow the rule that I don't let the selection get too close to the outside edges of my subject's hair unless an area is pretty flat (in other words, no flyaway, tough-to-select hair in that area). You can see what I mean in the close-up here, where I used the Quick Selection tool to deselect the thinner edges of her hair (we'll let Elements select those hard parts using Refine Edge). Also, you can see where I stopped before some areas where the hair is finer. Again, we'll let Elements grab those parts later, but for now we're most concerned with deselecting areas where you can see gray background through her hair. If Select Subject selected an area with gaps, then just press-and-hold the Alt (Mac: Option) key, and paint over those gap areas to deselect them.

Step Four:

Once your basic selection in place, it's time to unlock the real selection power (Select Subject is just the warm-up act). Go down to the Tool Options Bar and click on the Refine Edge button (shown circled here). This is where the magic happens. In the Refine Edge dialog, you have a number of choices for how you can view your selected image (including the standard old marching ants), but for now, as part of our learning process, go ahead and choose **Black & White** from the View pop-up menu. This shows your selection as a standard layer mask. As you can see, Select Subject, by itself, isn't going to get the job done (the edges are jaggy and harsh, and there's no wispy hair selected at all). That's okay, though, because we're just gettin' started.

Step Five:

Next, turn on the Smart Radius checkbox (you won't see anything happen just yet). Smart Radius is the edge technology that knows the difference between a soft edge and a hard edge, so it can make a mask that includes both. This checkbox is so important that I leave it on all the time (if you want it always on, as well, just turn it on and then turn on the Remember Settings checkbox at the bottom of the dialog). Now, again, just for learning purposes, drag the Radius slider all the way over to the right (to 250), and all of her hair gets selected instantly (pretty amazing isn't it?). While it did a great job on her hair, there are parts of her (like the edges of her coat) that are being "over-selected." Those areas will wind up being transparent, and you don't want that, so we always have to back it way down. But, I just wanted you to see the incredible math at work.

Step Six:

Okay, drag the Radius slider down until those areas look more solid white. Here's how this works: We want our subject to be solid white and we want the background to be solid black. Anything that appears in gray will be semi-transparent. That's okay if this happens in her hair in wispy areas, but it's not good along the edges of her coat or anything that's supposed to have a well-defined hard edge. Otherwise, we'd leave the Radius at 250 and be done with it. But, there's more to most portraits than just hair, so we have to keep those other areas pretty much intact, too. Here, I rolled back the Radius to 50, but you might be able to bring it down a bit more, to 20, 30, or 40. It just depends on the complexity of the selection and the details around the person. For simple selections, leave the Radius amount down low. When you have a tricky selection, like fine hair, you'll have to increase it. So, just remember: trickier selections mean higher Radius amounts.

Continued

Step Seven:

Now, let's change the View to **Overlay** to see if there are any areas we missed. The parts that are selected appear in full color, and the parts that aren't appear in red. If you see the background color showing through (in our case, gray), you've got a problem (and we do here just a bit). You need to tell Elements exactly where the problem areas are, so it can better define those areas. You do that with the Refine Radius tool (**E**; shown circled here). Click on it (if it's not already active), then just take your cursor and simply paint over the areas where you see the background peeking through (as shown here), and it redefines those areas. This is what picks up that fine hair detail. I also ended up increasing the Radius amount a bit here.

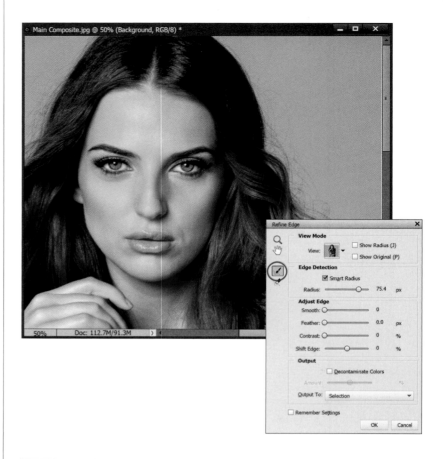

Step Eight:

As you look around her hair, if you see parts of it that are tinted red, those parts aren't selected. So, just paint a stroke or two over those areas, and they become full-color (letting you know they're added to your selection) as Elements refines those edge areas where you're painting. It'll look like it's painting the background sometimes (like you see here), but when you're done, it just redefines the area and tells Elements that this area needs some work, and it "redoes" its thing. Here, I've gone over some areas that were tinted red on her hair, and now those areas are appearing in color.

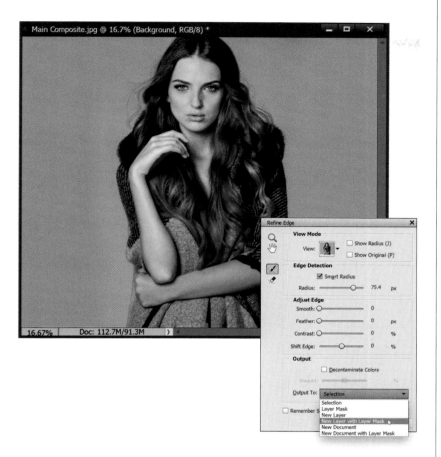

Step Nine:

I recommend avoiding the Adjust Edge section sliders in the center of the dialog altogether, because you'll spend too much time fussing with them, trying to make them work. (I figure you want me to tell you when to avoid stuff, too.) Down at the bottom of the dialog, there's a Decontaminate Colors checkbox, which basically desaturates the edge pixels a bit. So, when you place this image on a different background, the edge color doesn't give you away. Just below that, you get to choose what the result of all this will be: will your selected subject be sent over to a new blank document, or just a new layer in this document, or a new layer with a layer mask already attached, etc.? I always choose to make a new layer with a layer mask in the same document. That way, I can just grab the Brush tool and fix any areas that might have dropped out, which we're probably going to have to do next, so choose **New Layer with Layer Mask** and click OK.

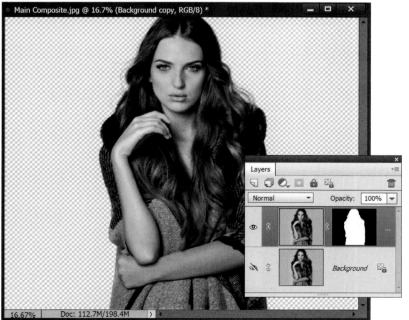

Step 10:

When you click OK, your image will now appear on a transparent layer (as seen here) and if you look in the Layers palette, you'll see a new layer with a layer mask attached (just what you asked for). You can also see it does a pretty amazing job. It won't get every little thin, wispy hair strand, but it gets most of the important ones. Also, I've got a trick or two coming up that will help a bit more, but first, let's do a quick check of that mask and fine-tune it just a bit before we put her over a different background (that's right, baby, we're doing some compositing!). Press-and-hold the Alt (Mac: Option) key and click directly on that layer mask thumb-nail in the Layers palette to see just the mask (you can see it in the next step).

Continued

Step 11:

Now, as you move around the mask, you may see some areas that aren't solid white (which means these areas will be semi-transparent and that's not what you want). You can see an area here on the side of her coat that needs a cleanup. So, get the Brush tool (**B**) and, with your Foreground color set to white, choose a small, hard-edged brush from the Brush Picker in the Tool Options Bar, and then paint along the grayish areas, to make them solid white. Next, press **X** to switch your Foreground color to black to clean up any places where the white has spilled over onto the black. It should be solid black in the background areas. For a little help cleaning up tricky areas, switch your Brush's blend mode to **Overlay**. That way, when you're painting with white, it automatically avoids painting over the color black (and vice versa).

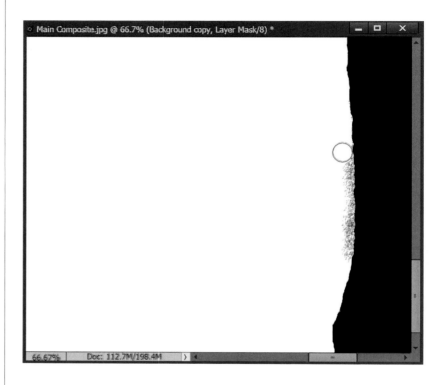

Step 12:

At this point, we're done with our mask, so you can apply it permanently to your image by clicking directly on the layer mask thumbnail (in the Layers palette) and dragging it onto the Trash icon at the top of the palette (as shown here) to delete it. When you do this, a warning dialog pops up asking if you want to "Apply mask to layer before removing?" You want to click Apply, and the masking you did is now applied to the layer (and the layer mask thumbnail is deleted). This just makes things a little easier from here on out.

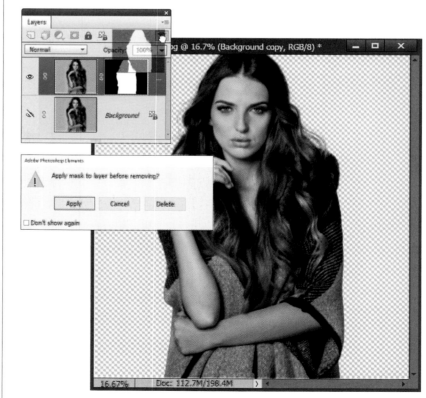

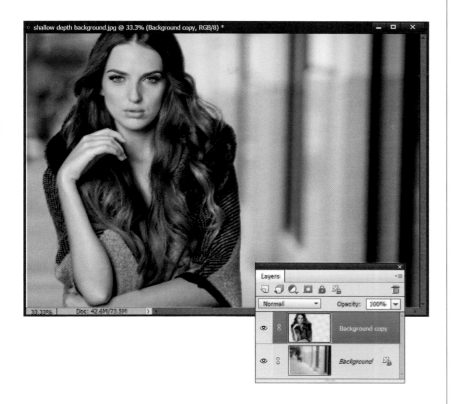

Step 13:

Next, open the background image you want to use in your composite. Get the Move tool **(V)**, then drag-and-drop your subject right onto this background image (as shown here). (*Note:* This is easier if you have all images onscreen. To float both images, press **Ctrl-K [Mac: Command-K]** to open the General Preferences, and turn on the Allow Floating Documents in Expert Mode checkbox. Then, you can go under the Window menu, under Images, and choose **Float All In Windows**. If all else fails, copy-and-paste it onto this background like we did in the chapter on layers; it will appear on its own layer.) If your subject is too big, press **Ctrl-T (Mac: Command-T)** to open Free Transform. Then, turn on the Constrain Proportions checkbox in the Tool Options Bar (if it's not already turned on), grab a corner handle, and drag inward until she is the right size for the background. Press **Enter (Mac: Return)** to lock in your changes.

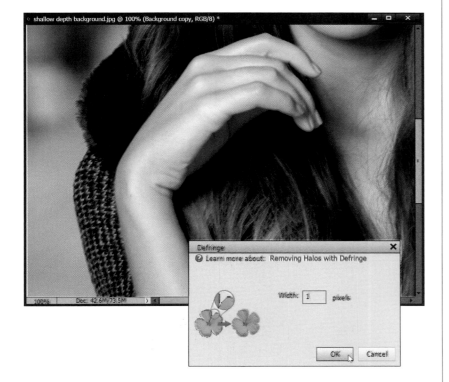

Step 14:

Depending on the background and your selection, you may see a gray fringe around your selected object. To remove the fringe, go under the Enhance menu, under Adjust Color, and choose **Defringe Layer**. When the Defringe dialog appears (shown here), enter 1 pixel (use 2 pixels for a higher-megapixel image), click OK, and that fringe is gone! (Elements basically replaces the outside edge pixels with a new set of pixels that is a combination of the background it's sitting on and your subject's edge, so the fringe goes away.)

Continued

Step 15:

Here's a trick that gives you more detail and brings back some of those lost wisps of hair by building up some pixels. It's going to sound really simple and it is. Just press **Ctrl-J (Mac: Command-J)** to duplicate your layer (the one with your subject). That's it. Just duplicate your subject layer, and it has a "building up" effect around the edges of her. Suddenly, it looks more defined, and it fills in some of the weaker wispy areas. If for any reason it looks like too much, at the top of the Layers palette, just lower the Opacity of this duplicate layer until it looks right (here, I lowered it to 80% and it looks about right). Next, merge this duplicate layer with your original subject layer by pressing **Ctrl-E (Mac: Command-E)**.

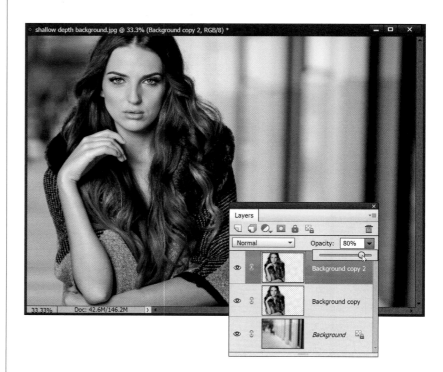

Step 16:

Now, she looks a little warm for the background, so let's desaturate her a little. Start by Ctrl-clicking (Mac: Command-clicking) on the layer thumbnail for her layer to put a selection around her again. Then, click on the Create New Adjustment Layer icon at the top of the Layers palette and choose **Hue/Saturation** from the pop-up menu. This adds a Hue/Saturation adjustment layer, but with your selection (our subject) already masked on the layer mask, so the adjustment will only affect what is inside the selection. In the Hue/Saturation adjustment palette, set the Channel pop-up menu to **Yellows** and drag the Saturation slider to the left a bit, until she blends with the background better (here, I dragged to –62). That's it.

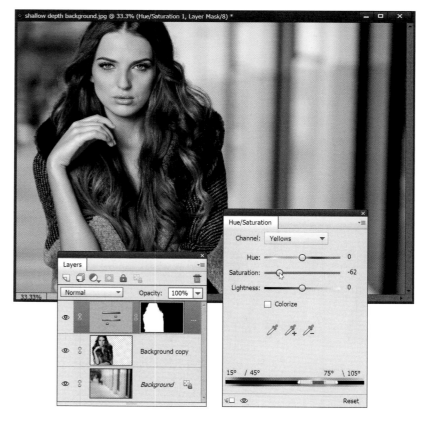

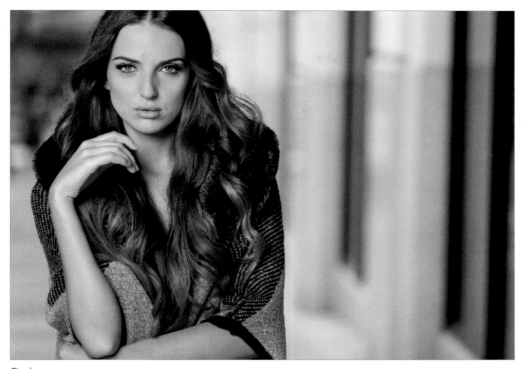

Final

Putting Your Subject on a New Background in Guided Mode

If you've ever wished your subject was photographed on a more interesting background than the one you originally shot them on, then this is for you. It lets you easily isolate your subject, and then it automatically places a new background of your choice behind them, and it even helps match the tone of your subject to the new background, so the end result looks realistic. Best of all? It's quicker and easier than you'd think.

Step One:
In the Editor, open the photo that has a background you want to replace with something more interesting. Click on Guided at the top of the window, then click on Special Edits near the top, and then click on Replace Background (as shown here). *Note:* In the previous technique, we looked at creating a more detailed composite that included a subject with a tricky hair selection. If your subject doesn't have that wispy, hard-to-select hair, then you could try creating a composite with this guided edit.

Step Two:
Our first step here is to make a selection of our subject. You can have Elements give it a shot first (I would—you'll be surprised at how often this works) by clicking the Select Subject button and it will use AI and machine learning to recognize your subject and put a selection around them automatically. Here it did a pretty darn good job, but it missed a little area on her shoulder on the left side of the image. So, we'll have to tweak it a bit in the next step.

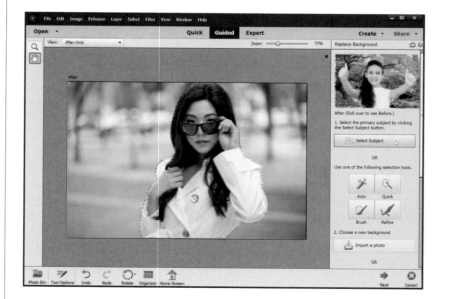

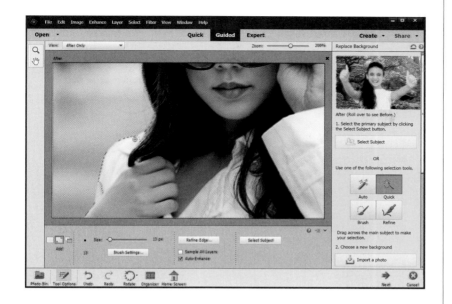

Step Three:
Click on the Quick button (it will be in Add mode by default, meaning that anything you paint over in your image will be added to your current selection. If it's not, for some reason, click on the Add icon down in the Tool Options Bar). Then, take the brush and paint over that little area it missed on her shoulder (as shown here—you can see the small circular brush cursor just above her hand. I zoomed in here by pressing **Ctrl-+** [plus sign; **Mac: Command-+**] and saw another little area on her coat that I needed to add to the selection, as well).

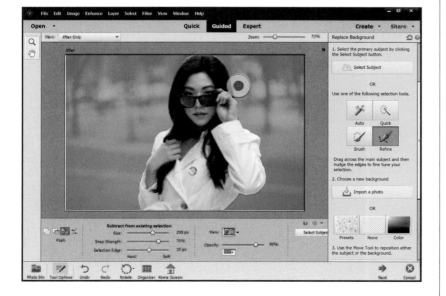

Step Four:
Now let's refine the edges of our subject so they will blend in nicely with the background and keep as much of the original subject as possible (like the edges of her hair). Click on the Refine button (your image will zoom back out, if you had zoomed in), and you'll see a see-through red tint appear over your image, showing the areas that are going to be covered by your new background. Take the Refine tool and follow along the edges of your subject's hair (as shown here). This recovers some of the edge hair that was lost in the original Select Subject selection.

Continued

Step Five:

Now that your image is fully selected, it's time to choose the image you want as your new background. Click on the Import a Photo button, and choose the image you want to use (here, I chose a shot from Miami Beach). When you click the Place button in the dialog, the background image is added behind your subject (as seen here).

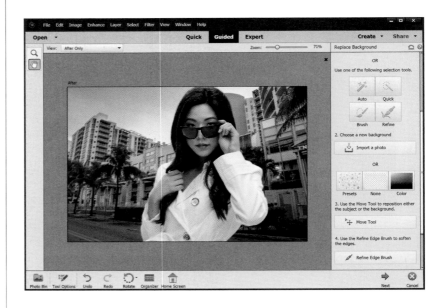

Step Six:

If you want to reposition the background image, click on the Move Tool button, then click-and-drag it to position it where you like it. If you need to clean up your subject selection a bit more, click on the Refine Edge Brush button, then use it to add or subtract from your selection. Finally, scroll down and click on the Auto Match Color Tone button. In a few seconds, it will apply a color to your subject that matches the new background color so the two images look unified color-wise.

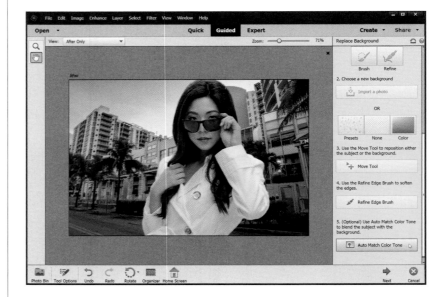

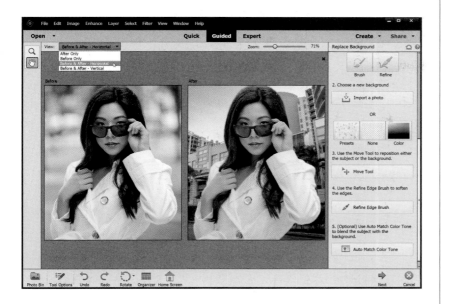

Step Seven:
To see a side-by-side of your original and the new image with your different background behind your subject, choose **Before & After - Horizontal** from the View pop-up menu near the top-left corner of the window. Finally, click the Next button at the bottom right and choose whether to save the final image, share it, or continue editing it.

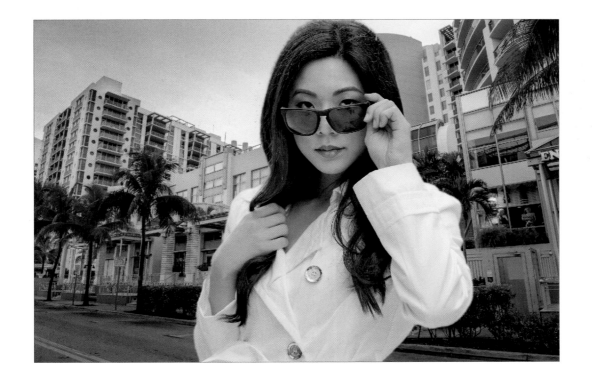

Location: Cannon Beach, Oregon | Exposure: 1/320 sec | Focal Length: 16mm | Aperture Value: *f*/11

Remove
removing unwanted objects

You know you're having a lucky day when you search the iTunes Store for the word "Remove," and you immediately find a band with that exact name. Remove. Now, I can't swear they're a band per se, because a band usually has some people in it, and their music (well, to be honest I just listened to one song—their song "Fallout," since it was the first search result to appear in iTunes), and I'm not 100% certain that those noises weren't actually produced and recorded by a half dozen Roomba® robot vacuums. Now, if I were a music critic for a big music magazine (like *Rolling Stone*, or…or…well, *Rolling Stone*), the way I would probably describe the genre the song "Fallout" would be categorized into would undoubtedly be "psychological torture music." It's the kind of music you'd expect to hear in a disturbing nightclub scene from a Liam Neeson movie, where he's going to lightly maim everybody in there about 30 seconds after he walks in, but in the meantime you hear this weird music that makes you think, "I hope he kills the bad guys fast, so they can switch to another scene in the movie where

they're not playing this Roomba music." So picture that, but with some flashing lights, and some bad guys that are probably bald. Now, how does all this relate to removing distracting objects in Elements you might ask? Well, I'm a little surprised you didn't see the direct correlation (it seems pretty obvious to me), but when Liam Neeson walks into that seedy nightclub, the first thing Liam would do (in real life anyway) is remove the most distracting objects in the scene, which in this case would have him headed straight to the DJ booth. Once there, he would immediately yank out every cable, cord, and wire connected to the nightclub's speaker system to make the psychological torture music stop. When he does this, the few scattered patrons in the club would start slowly clapping, and more and more patrons would join in, and pretty soon he'd be getting a standing ovation, but just then, the bad guy would burst into the nightclub, take out a pistol, aim it at the ceiling, fire off a couple of shots, then yell, "I'm missing half a dozen Roombas!" Oh, come on, tell me that couldn't happen!

Removing Spots and Other Artifacts

Elements has a tool, the Spot Healing Brush tool, which is just about perfect for getting rid of those tiny little spots and other artifacts. (By the way, the term "artifacts" is a fancy ten-dollar word for spots and other junk that wind up in your photos.)

Step One:
Open a photo that has spots (whether they're in the scene itself or are courtesy of specks or dust on either your lens or your camera's sensor). In the photo shown here, there are all sorts of distracting little spots in the sky (yes, I need to get my camera sensor cleaned). :-)

Step Two:
Press **Z** to get the Zoom tool and zoom in on an area with lots of spots (here, I zoomed in on the sky, which is typically where you'll see them the most). Now get the Spot Healing Brush tool from the Toolbox (or just press the letter **J** until you have it).

Step Three:
Position the Spot Healing Brush directly over the spot you want to remove and click once. That's it. You don't have to sample an area or Alt-click anywhere first—you just move it over the spot and click, and the spot is gone. (*Note:* If the fix doesn't look quite right, make sure Content Aware is chosen for Type in the Tool Options Bar.)

Step Four:
You remove other spots the same way— just position the Spot Healing Brush over them and click. I know it sounds too easy, but that's the way it works. So, just move around and start clicking away on the spots. Now you can "de-spot" any photo, getting a "spotless" version in about 30 seconds, thanks to the Spot Healing Brush.

Before

After

The Amazing (and Easiest) Way to Remove Distracting Stuff from Your Photos

When people talk about "Photoshop magic," the Clone Stamp Tool and Content-Aware options are some of those things they're talking about. Even after using them for years now to get rid of distracting things in my images, they still amaze me with the remarkable job they do. The fact that they're incredibly easy to use at the same time really makes them a powerful, and indispensable, tool for photographers. While the Spot Healing Brush in Elements has had a Content-Aware feature for a while now, back in Elements 13 they added Content-Aware Fill, which works a little differently. Most of the time, you'll end up using a combination of the two.

Step One:
In our natural-light portrait here, we want to get rid of the building on the right. The quickest way to do that is to put a Lasso selection around the entire building (railings and all) and then use Photoshop's Content-Aware Fill feature to remove it.

Step Two:
Get the Lasso tool **(L)**, or whichever selection tool you're most comfortable with (like maybe the Quick Selection tool), and draw a selection around the entire building (railings and all).

Step Three:

Next, go under the Edit menu and choose **Fill Selection** and choose **Content-Aware** from the Use pop-up menu (as seen here). Now, just click OK, sit back, and prepare to be amazed (I know—it's freaky). So, that pretty much got rid of the entire building (that's why it's called "Content-Aware" Fill. It's aware of what is around the object you're removing, and it does an intelligent filling in of what would normally just be a big white hole in your image), but it kind of trashed the railing in the process. What's weird is Content-Aware Fill usually does a pretty decent job replacing things like railings, but I think because the building behind it was so blurry, it kind of gave it fits. No problem—the Clone Stamp tool is perfect for fixes like this. Go ahead and deselect by pressing **Ctrl-D (Mac: Command-D)**.

Step Four:

Get the Clone Stamp tool **(S)** from the Toolbox, make your brush kinda small (you can change the brush size by pressing the **Left Bracket key** to make it smaller or the **Right Bracket key** to make it larger), and then Alt-click (Mac: Option-click) right along the edge of the top railing where it still looks nice and straight, and start painting (cloning) that part of the railing right over the missing part. Finish up by cloning that top railing to the bottom one, until it reaches the edge of the image. Now, you will fall deeply in love with Content-Aware Fill if you can come to peace with the fact that it won't work perfectly every time. But, if it does 70% or 80% of the work for me (in removing something), that means I only have to do the other 20%, and that makes it worth its weight in gold. If it does the entire job for me, and sometimes it does, then it's even better, right? Right. Also, it helps to know that the more random the background is behind the object you want to remove, the better job Content-Aware Fill generally does for you.

Continued

Step Five:

Content-Aware Fill is pretty amazing when it works, but like any other tool in Elements, it doesn't work 100% of the time on every single type of photo and every situation. When I use Content-Aware Fill, I usually wind up using the Spot Healing Brush along with it, because it has Content-Aware healing built in. Let's open another image (the shot here) and use these tools together to remove the trees in the top left, right, and bottom, along with the contrails on the right.

Step Six:

A lot of times, you don't have to do a really accurate selection. For the tree on the right, take the regular ol' Lasso tool (like we used for the building), draw a loose selection around it (as seen here), then go under the Edit menu and choose Fill Selection. When the Fill Layer dialog comes up, make sure Content-Aware is selected in the Use pop-up menu, then click OK, and press Ctrl-D (Mac: Command-D) to Deselect (you'll see in the next step that it's gone, and that I also removed the one at the top left). If part of its fix doesn't look great, simply select that area and try again.

Step Seven:

Take a look at where the trees used to be. They're outta there! Let's switch to the Spot Healing Brush tool **(J)** for the contrails on the right (make sure Type is set to Content Aware or Proximity Match in the Tool Options Bar). You literally just make your brush size a little bigger than the contrail, paint over it, and Elements uses the Content-Aware technology to remove it (when I release the mouse button, a second later that will be gone, too!). *Note:* The regular Healing Brush tool (the one where you have to choose the area to sample from by Alt-clicking [Mac: Option-clicking]) does not have the Content-Aware technology. Only the Spot Healing Brush tool has it.

Step Eight:

As you use the tools more, you'll start to get a feel for which one works better in which situation when it comes to the Content-Aware stuff. I usually use the Lasso tool and Content-Aware Fill for larger areas, like for the trees in this image, and the Spot Healing Brush with Content Aware turned on for smaller things that are touching an edge of something else, like the contrails. While sometimes they work the same, sometimes they also work differently, so it's always good to try both ways if you don't see the result you like right off the bat.

Continued

Step Nine:

Let's finish things off by using both tools to remove the trees at the bottom. They did a great job in this image—they filled them in almost perfectly, as if they were never there. You can see all the fixes in the Before and After images shown on the next page.

Before

After

Moving Things Without Leaving a Hole Using Content-Aware Move

This is another one of those tools that makes you just scratch your head at the math that must be going on to perform the mini-miracle of letting you select something, then move it someplace else in your image, and Elements automatically repairs the area where it used to be. This doesn't work for every image, every time, and it's one of those tools you won't be reaching for every day, but when you need it, and it does its thing perfectly, your jaw hits the floor. It can be finicky sometimes, but I'll show you a few things to help it help you.

Step One:

Here's the image we're going to work on, and in this one, we want to move the window to the right.

Step Two:

From the Toolbox, get the Content-Aware Move tool (or just press the letter **Q**). Now, draw a selection around the object(s) you want to move (in this case, the window). It doesn't have to be a perfect selection, but get fairly close.

TIP: Use Any Selection Tool

The Content-Aware Move tool works a lot like the Lasso tool. However, you could draw your selection with any selection tool you'd like, and then simply use the Content-Aware Move tool to move it just like we're about to do.

Step Three:
Next, click in your selection and drag it over to the part of the image you want to move it to. When you release the mouse button, the original will still be there in the same position until you click on the checkmark icon or press **Enter (Mac: Return)**. (*Note:* Turn off the Transform On Drop checkbox in the Tool Options Bar if you want it to just move.)

Step Four:
When you commit to the move, it's going to take a few moments for the magic to happen (depending on how large your file size is), but then you'll see that not only is your subject moved, but the hole that would normally have been left behind is instead totally patched and filled. However, don't deselect quite yet. Two things can happen after using this tool. First, the area that was filled in as you moved the selection away may not be perfect. Second, the selected area you moved may not fit nicely into its new background. If either happens, then leave your selection in place—especially if it didn't work well. While it's still selected, you can change how Elements creates the background texture that blends with your move. You do this using the Healing slider in the Tool Options Bar. You can choose a different healing amount and it will re-render your move. So, all you have to do is move the slider until you find a place that looks the best (again, I do this only if there's a problem). If you keep it to the left, it uses a strict healing amount that doesn't do as much healing between the two areas. This looks more realistic in some cases, but it can make the move look weird in others. You can also move it to the right (more healing), which forces Elements to really look around the selected-and-moved area and find other places to heal those holes with.

Continued

Step Five:

I'm not gonna lie to you here. As with many of the auto-fix tools in Elements, Content-Aware Move is not always perfect. Here, it did a pretty good job, but most of the time you're going to need to do some cleanup after. If that happens, try taking the Spot Healing Brush or the Clone Stamp tool and fixing it. Finally, just press **Ctrl-D (Mac: Command-D)** to Deselect.

Before

After

If you've ever tried to photograph a popular landmark or national monument, you'll know that it's pretty unlikely you'll be there alone. Unless you're willing to get up really early in the morning (when most people are still sleeping), you're bound to get a tourist or two (or 20) in your photos. In this tutorial, you'll learn a few tricks to help clean up those scenes and remove the tourists with just a few brush strokes.

Automatically Cleaning Up Your Scenes (a.k.a. The Tourist Remover)

Step One:

The first step starts in the camera. You'll need to take at least two shots of the same scene (but you can use up to 10 if you'd like). So, if you're in one of those situations where you just can't get a photo with no people in it, then take a few photos in the hope that the people move around a little (even if they don't ever exit the area completely).

Step Two:

Here, we have a couple shots that I took between two parked cars, along Ocean Drive on Miami's South Beach. The reason this house always draws a crowd is because it's actually the famous Villa Casa Casuarina (better known as the Versace mansion). Since we have this feature, though, getting rid of the people is an easy fix.

TIP: Keep Your Camera Steady

While I did shoot this on a tripod, Elements does a great job of auto-aligning photos. If you can't shoot on a tripod, the key is to try to be as steady as possible, so the actual photo doesn't change too much.

Continued

Step Three:

Go ahead and open the photos you've taken (remember, you'll need at least two but can use up to 10. In this example, I'm only using two) in the Elements Editor. Then select them down in the Photo Bin by clicking on the first one and Shift-clicking on the last one. Now, click on Guided at the top of the window. Click on Photomerge at the top right of the Guided window, and then click on **Photomerge Scene Cleaner**. This will take you into Photomerge.

ADVANCED TIP: Try the Advanced Options

Here's a follow-up to the previous tip. In fact, just file this tip away, because you may or may not need it. If you didn't shoot on a tripod, and you're not getting good results from Photomerge, then click on the Advanced Options button at the bottom of the Photomerge palette. Use the Alignment tool to place three markers in the Source window and three in the Final window, on similar places in the photos. Then click Align Photos, and Elements will do its best to align the photos based on those markers. This helps the Scene Cleaner give more predictable results. Again, give Step Three through Step Seven a try first and see how things work out. If everything looks good, then you don't need the Advanced Options.

Step Four:
The Source window on the left will auto-matically be populated with the first photo you chose. You'll need to create a Final photo though, so drag the other photo from the Photo Bin into the Final window on the right.

Step Five:
Now look over at the Source window and find the clean areas from this photo that you'd like copied over to the Final photo. In this example, we'll paint over clean areas where there aren't any people to remove them from the Final. You can use the Zoom tool (the one that looks like a magnifying glass in the Toolbox on the left) to zoom in to the area if you need to.

Continued

Step Six:
All right, let's start by getting rid of the woman on the steps. Click on the Pencil tool on the right side of the window because we're going to use this to paint on the Source image (left side). The way this works is you want to paint on an area from the Source image that you want copied over to the Final image. So, again, I'm going to paint where the woman is on the steps (as shown here). Remember, we're painting on a clean area that we want copied over to our Final image. Elements will only copy over the areas we paint over with the Pencil tool.

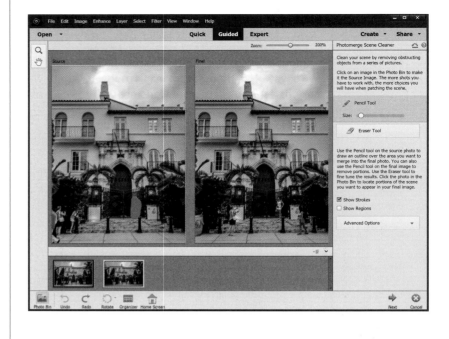

Step Seven:
When you release your mouse button, you'll see Scene Cleaner automatically removes her from the Final image. In this example, she goes away pretty quickly. To get rid of the other people, do the same thing—just paint over an area we want copied into the Final image. When you're done cleaning up the image, click the Next button and then choose what you'd like to do with the image. Here, we're going to continue editing it back in the Editor, so I'll click on the In Expert button.

TIP: Getting Rid of the Pencil Marks
If you move your mouse over the Final image, you'll see the yellow or blue pencil marks on it, too. If you want to see your Final image without the pencil marks over it, just move your mouse away from it and they'll disappear. If you want to see the Source image without the marks, then turn off the Show Strokes checkbox in the Photomerge palette on the right.

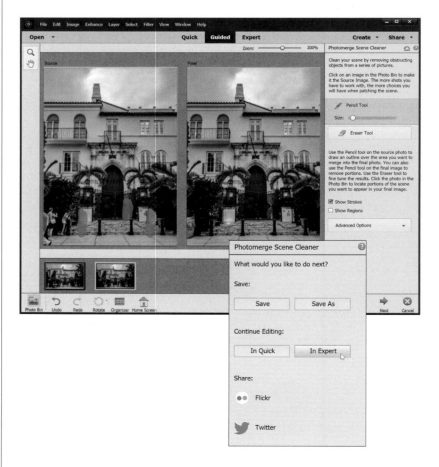

Step Eight:

If Photomerge left some extra white canvas around your final image, first flatten your image by choosing **Flatten Image** from the Layers palette's flyout menu, then just use the Crop tool **(C)** to remove the extra white canvas. The Before and After images are shown below. In the After image, I also ended up using some of the methods we used earlier in this chapter to remove a couple more people that Scene Cleaner couldn't remove.

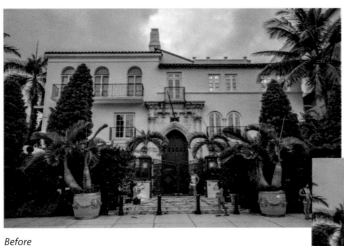

Before

After

Location: Rome, Italy | Exposure: 1/800 sec | Focal Length: 105mm | Aperture Value: ƒ/4

Special Edition
special effects for photographers

Didn't we already cover some special effects, back in one of the Camera Raw chapters and in the Editing chapter? Well, you're right. Thanks for catching that, so now there's no need for even more special effects. After all, who wants more cool stuff you can do to your photos, right? Good call. I'll drop it from the book. See, now don't you wish you hadn't been such a Mr. Smarty McNuggets Pants with your, "Oh, you've already done that!" and "This is redundant crapola" and "Where can I get 50% off a footlong sub?" Well, not so fancy now, are ya there, eh McNuggets? Okay, let's get back to the important stuff, which is how I came up with the name for this chapter title and, I have to tell ya, I kinda had to bend the sacred naming rules a little to get this one past the International Counsel for Extended Daytime-Teachers Educational Association (or ICED-TEA, for short). So, here's what I did: I couldn't find a movie named *Special Edition*, but there were a bunch of movies that had the term "Special Edition" added in rental or DVD releases and I figured that was close enough, so I went with it, and if you have a problem with that, take it up with the folks at ICED-TEA. I have to say, they're actually pretty open-minded folks over there (I've had to testify in my fair share of chapter naming fiasco cases, and it's not pretty). While the ICED-TEA folks are pretty lenient, you do not want to cross the folks at the Tonal Institute Geo Hyper Tech Association for Stable Shutterspeeds (I don't recommend using their acronym—they're really touchy about it). They act like they have a stick up their butt or something. Anyway, if you think they're bad (and trust me, they can be a pain in the Association for Stable Shutterspeeds), whatever you do, make nice with the folks over at the Association of Noise Gamma Ratio Yield Bracketing Over Watermark Export to Lightroom Studio group. They don't take this stuff sitting down, and if they catch you breaking the rules, they will drop all over you, and that really stinks.

Effects and Presets Galore in Quick Edit Mode

People love one-click effects. They're quick and simple to use, and they can help give your photos a new look that maybe you hadn't thought of. Plus, they really took the Quick edit mode effects up a notch by adding an auto feature, and now you've got a great group of presets that are really just a click away.

Step One:
Open a photo in the Editor, click on Quick at the top of the window, and then click on the Effects button at the bottom right. You'll see all of the possible effects listed in the panel on the right side of the screen.

TIP: Add Textures and Frames in Quick Edit Mode
Back in Chapter 5, we looked at making adjustments in Quick Edit mode, but you can also easily apply textures and frames here, as well. Just click on either of these buttons, at the bottom right of the window, to see these options.

Step Two:
Now, it couldn't be easier—just click on an effect, and it applies that effect to the photo you have open (here, I clicked on the second effect: Tint).

Step Three:

When you click on an effect, you'll see four other variations of the effect right below the main one. Some are just different levels of intensity of the main effect and some look way different. But it's easy to experiment by just clicking on them to see if you like what they do to your image. You can always click on another one to reverse the effect and see something else. Here, at the top, I clicked on the Vintage effect, and then at the bottom, I clicked on Faded Vintage (the first variation).

TIP: Apply One-Click Effects in Expert Mode

You'll find a bunch of built-in effects in Expert mode, as well, along with lots of cool filters, styles, and graphics (including backgrounds and frames). Some of the effects are even adjustable. Just click on the More button, at the bottom right in Expert mode, and then choose **Effects** to bring up these panels.

Step Four:

Finally, let's try the auto feature. Click on Smart Looks, at the top of the panel, and Elements will automatically apply five different effects to the image based on its color and lighting. Just click on the four other auto variations that appear to see what it came up with. Here, I clicked on the fourth variation, which applied a high-contrast effect to the image.

Creating a Picture Stack Effect

Picture Stack is one of my favorite Guided edits, because this one would seriously take a ton of time if you tried to do it manually. The idea is to take one photo and make it look like it was cut up into smaller photos with white borders stacked on top of each other. The effect looks pretty cool and is a fun way to show off your photos. Plus, it even goes so far as to add shadows under each photo, so it really looks like they're lying on top of each other.

Step One:
In the Editor, open the photo that you want to use for the Picture Stack effect. I usually find landscape and travel photos look good here. You can use photos of people, too, but sometimes Elements will cut the photo right in the middle of some-one's face, so you have to watch out when using these. Click on Guided at the top of the window and then, in the Guided window, under Fun Edits, click on Picture Stack (as shown here).

Step Two:
First, you'll choose how many pictures you want your photo to be chopped up into. My favorite is 8 Pictures. To me, 4 Pictures doesn't look like enough and 12 Pictures makes the photo look too busy. The good thing is that you don't really have to commit to too much at this point. So, click on the 8 Pictures button on the right and Elements will go to work. It takes a minute, but you'll eventually see your photo cut into smaller square/rectangular pieces.

Step Three:

If you want to see what it looks like using four or 12 pictures, then just click on one of those buttons and Elements will redo the stack. It's pretty easy to figure out which one looks best for your photo by just trying out each option.

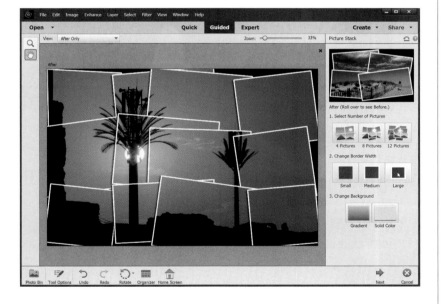

Step Four:

You'll notice that each photo has a white border around it and, in section 2, you can control the width of that border. I usually go with the Medium setting here—the Small setting is too thin, so I barely ever use it, but the Large setting isn't bad (sometimes it's a little over-powering, but sometimes it looks cool). Just like with selecting the number of pictures, this one is easy to experiment with, so click on the three border buttons to see which one you like better.

Continued

Step Five:

Lastly, you can change the background color and style (I switched back to eight photos with a medium border here). You have a choice between a gradient or just a simple solid-color background—I usually stick with a solid color. While the default black looks pretty cool, let's try a white background. Click on the Solid Color button and when the New Layer dialog appears, click OK. In the Color Picker, choose white and then click OK. I kinda like white, because it lets you see the shadows under the photos. It gives the image a little more depth, so each picture in the stack really looks like it's lying on the background.

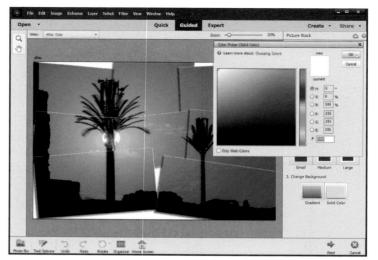

Step Six:

When you've settled on your background color, just click the Next button at the bottom of the Palette Bin, and then choose what you want to do next with the photo—save it, continue editing it, or share it.

TIP: Edit the Layers

If you choose to continue editing it in Expert mode and look in the Layers palette, you'll see the behind-the-scenes work that went on. Elements adds quite a few layers to your document. If you're brave enough, you can go into the separate layers and adjust them. The drop shadows, the outline around each photo—they each have their own layer, so if there's something you want to change, you can do so right on the layer.

You've seen this effect for years, and now there's a really easy way to pull it off yourself, using a Guided edit. Essentially, you only have two things to decide: which photo do you want to use, and what's the text going to say? Here's a tip, though: big, thick fonts seem to work best for this type of effect (if you use skinny letters, there will be gaps that can make it hard to figure out what the photo is inside the text).

Putting a Photo Inside Text

Step One:
In the Editor, open the photo you want to put inside some text (in this case, it's a photo taken in Rome). Click on Guided at the top of the window, then click on Fun Edits at the top, and then click on Photo Text.

TIP: Type in All CAPS!
This effect looks best when you see all caps, and as I mentioned in the intro, it helps to use a really think font. The font Impact works really well for text effects like these because the letters themselves are really thick, so it's easier to see what the photo is once you place it inside the text.

Step Two:
In the panel on the right, first click on the Type Tool button, then click once anywhere on your photo and type the word you want the photo to appear inside (in this case, it's the word "ROME." Kinda obvious, I know).

Continued

Step Three:

Click on the green checkmark beneath your text and your image now appears inside it. Now, there's a pretty good chance your text is way too small (well, probably way smaller than you envisioned it), so you're going to need to scale it up quite a bit, so you can see the photo inside of it. To get your font to a good size, in the second section on the right, you'll find two buttons that automatically scale up the size of your text so it either fits (proportionally; which is the only one I recommend, because it keeps the type looking good) or fills (which stretches the type to fill the image area, but distorts the font and well…it looks cheesy. Just sayin'). Below that are some choices for a background color behind your text (black, white, or transparent), and if you think the image would look better inside your text if it's cropped tighter, just click on the Crop Image button.

Step Four:

Lastly, if you want to add more definition to your text, there are one-click buttons to add a bevel, shadow, and stroke around it (worth a click to see if it looks better or worse). I can't tell you which one to choose, if any; it just depends on the photo and the word (here, I chose Medium). When you're done, click the Next button at the bottom right, and then choose what you want to do next with the photo.

TIP: Edit Your Bevel, Shadow, or Stroke

If you added an effect to your text, you can actually tweak those effects individually (rather than just using the default presets for them), by clicking on the Advanced button near the bottom of the Palette Bin, to bring up the Style Settings dialog. Here, you can edit the size of the stroke, angle, and opacity of the drop shadow, amount of bevel, and so on.

This is a really great way to add extra visual interest to an image by not only creating a multi-panel effect, but by adding color tint effects on top of that. The nice thing is, it looks like you did something really complicated, but because this is a Guided edit, it's super easy (plus, there are a number of different looks you can choose from, so although Elements is doing the heavy-lifting, you're still driving the creative train. Well, you know what I mean).

Creating an Effects Collage

Step One:
In the Editor, open a photo that you want to transform into a multi-panel effect collage. Click on Guided at the top of the window, then click on Fun Edits at the top, and then click on Effects College.

Step Two:
In the right side of the window, first choose how many sections you want in your collage—2, 3, or 4—then choose how you want them arranged from the menu below. Just click on the one that looks good to you (you can always change your mind later and try a different layout). Here, I'm going with a four-section horizontal collage.

Continued

Step Three:

Right below that is where the fun begins: this is where you choose the styles (mostly tints, with the occasional black-and-white or duotone style added to one or more panels), and there's a pretty decent thumbnail preview for each to give you an idea of how they will look. To try out one of these looks on your image, click on the little down-facing arrow to the right of the thumbnail to see them all, and just click on one. Some of these have textures applied as well, so it's worth trying out a few to see which one looks best with the particular image you're using. Here, I clicked on the sixth one from the top of the list.

Step Four:

Once you've applied a look, you can tone down the intensity (amount) of it using the Opacity slider at the bottom of the Palette Bin. The farther you drag that slider to the left, the less the "look" will appear on your image, so if you think a particular look is too much, use this slider to back it off a bit by dragging it to the left. When you're done, click the Next button, and choose what you want to do next with the photo—save it, continue editing it, or share it.

Depth of field is a great way to really make your subject stand out from the background by blurring it. Sure, we can do a lot of this work in-camera with our lens and f-stop choice, but sometimes the creative idea doesn't strike until the photo hits the computer. The Depth Of Field lens effect in Guided mode will help you fix that, though.

Enhancing Depth of Field (or Faking That 85mm f/1.4 Look)

Step One:
In the Editor, open a photo that has a busier background than you'd care for, or just one where you'd like to draw attention to a specific part of the image. Click on Guided at the top of the window, then click on Special Effects at the top, and then click on Depth Of Field.

Step Two:
In this example, we'll keep the woman and the motorbike in focus and blur the background. You'll see this effect has two modes: Simple and Custom. Let's start by clicking on the Simple button. Elements pretty much walks you through what to do in Simple mode. First, click the Add Blur button at the top to simply add some blur to the entire photo. At this point, you haven't defined the subject yet, so Elements will blur everything in the photo.

Continued

Step Three:

Next, you need to tell Elements what parts of the photo you want in focus. So, start by clicking on the Add Focus Area button in section 2, then click in the middle of whatever you want to be in focus and drag outward. The farther out from the center you drag, the smoother your sharp-to-blur transition will be. You can also click-and-drag more than once, as I did here, where I clicked-and-dragged around her head and body and most of the motorbike to get them in focus.

Step Four:

Once you've defined the part of the photo you want sharp, you can use the Blur slider to add more blur if you want. I dragged my slider to 10 to make the background even blurrier. Now, if you haven't realized it yet, the simple method is, well, simple, but it's limited because of the way it fades the blur away. Like most things in Elements, however, this effect gives you a simple way and a more custom way to do things. We'll take a look at the custom method next.

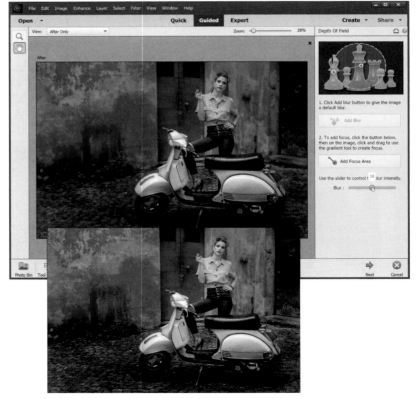

Before

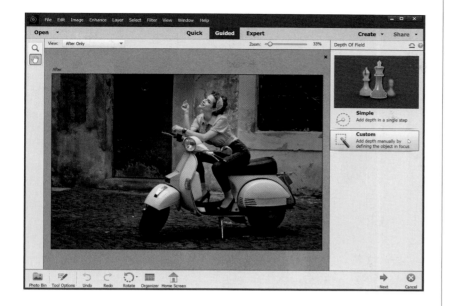

Step Five:

I've got another shot of the same model open here the Editor. We'll do the same thing here, keep her and some of the motorbike in focus and blur the background. So, once again, in the Guided options, go to the Special Effects, and click on Depth Of Field. This time, though, click on Custom.

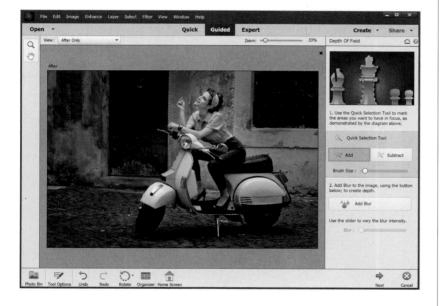

Step Six:

The first thing we'll do here is define our subject (the part of the photo that we don't want to blur). We did it before using a gradient tool, which didn't give us too much control, but in the Custom options, we get to make a selection. So, click on the Quick Selection Tool button (by the way, we covered this tool in greater detail back in Chapter 8), and then just start painting over the subject in the photo. Don't worry if you select parts of the background, though, because we'll take care of that in the next step.

Continued

Step Seven:

Chances are that you've probably selected something you didn't want to during your first pass with the Quick Selection tool. No sweat. Just press-and-hold the **Alt (Mac: Option) key** to put the tool into Subtract mode (or click on the Subtract button on the right) and click on any areas you didn't want selected.

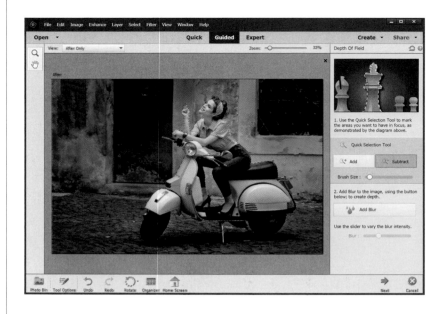

Step Eight:

The rest is a piece of cake. Just click on the Add Blur button in section 2 to blur everything that wasn't selected in the photo. Now the woman and the motorbike should stand out from the background a bit better. Just like before, if you want to add more blur to the background, just drag the Blur slider to the right some. If you find the blur is too intense (when using either the Simple or Custom method), click the Next button at the bottom right, then click the In Expert button to bring the photo back to Expert mode, and lower the blurred layer's opacity.

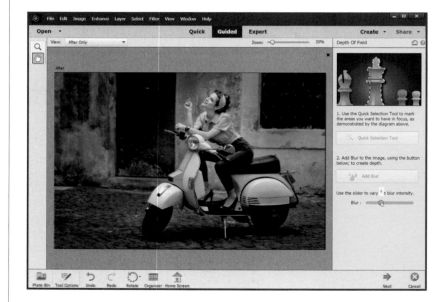

This is just about the hottest Photoshop portrait technique out there right now, and you see it popping up everywhere, from covers of magazines to CD covers, from print ads to Hollywood movie posters, and from editorial images to billboards. It seems right now everybody wants this effect (and you're about to be able to deliver it in roughly 60 seconds flat using the simplified method shown here!).

Trendy Desaturated Skin Look

Step One:
Open the photo you want to apply this trendy desaturated skin look to. Duplicate the Background layer by pressing **Ctrl-J (Mac: Command-J)**. Then duplicate this layer using the same shortcut (so you have three layers in all, which all look the same, as shown here).

Step Two:
In the Layers palette, click on the middle layer (Layer 1) to make it the active layer, then press **Ctrl-Shift-U (Mac: Command-Shift-U)** to desaturate and remove all the color from that layer. Now, lower the Opacity of this layer to 80%, so just a little color shows through. Of course, there's still a color photo on the top of the layer stack, so you won't see anything change onscreen (you'll still see your color photo), but if you look in the Layers palette, you'll see the thumbnail for the center layer is in black and white (as seen here).

Continued

Step Three:

In the Layers palette, click on the top layer in the stack (Layer 1 copy), then switch its layer blend mode from Normal to **Soft Light** (as shown here), which brings the effect into play. Now, Soft Light brings a very nice, subtle version of the effect, but if you want something a bit edgier with even more contrast, try using Overlay mode instead. If the Overlay version is a bit too intense, try lowering the Opacity of the layer a bit until it looks good to you, but honestly, I usually just go with Soft Light myself.

Step Four:

Our last step is to limit the effect to just our subject's skin (of course, you can leave it over the entire image if it looks good, but normally I just use this as a skin effect. So, if it looks good to you as is, you can skip this step). To limit it to just the skin, press **Ctrl-Alt-Shift-E (Mac: Command-Option-Shift-E)** to create a merged layer on top of the layer stack (a merged layer is a new layer that looks like you flattened the image). You don't need the two layers below it any longer, so you can hide them from view by clicking on the Eye icon to the left of each layer's thumbnail (like I did here), or you can just delete them altogether. Now, press-and-hold the Alt (Mac: Option) key and click on the Add Layer Mask icon at the top of the Layers palette to hide our desaturated layer behind a black mask. Press **D** to set your Foreground color to white, get the Brush tool **(B)**, choose a medium-sized, soft-edged brush from the Brush Picker in the Tool Options Bar, and just paint over his face and neck (any visible skin), as well as his hair, to complete the effect. If you think the effect is too intense, just lower the Opacity of this layer until it looks right to you. That's it!

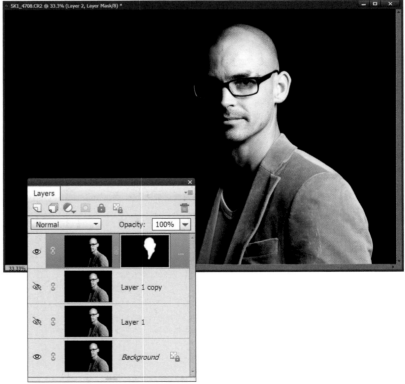

High-Contrast Portrait Look

The super-high-contrast look is incredibly popular right now, and while there are a number of plug-ins that can give you this look, I wanted to include this version, which I learned from German retoucher Calvin Hollywood, who shared this technique during a stint as my special guest blogger at my daily blog (www.scottkelby.com). The great thing about his version is you don't need to buy a third-party plug-in to get this look. My thanks to Calvin for sharing this technique with me, and now you.

Step One:
Open the image you want to apply a high-contrast look to.

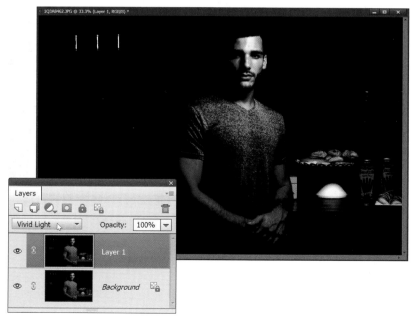

Step Two:
Make a copy of your Background layer by pressing **Ctrl-J (Mac: Command-J)**. Then, change the blend mode of this duplicate layer to **Vivid Light** (I know it doesn't look pretty now, but it'll get better in a few more moves).

Continued

Step Three:

Now press **Ctrl-I (Mac: Command-I)** to Invert the layer (it should look pretty gray at this point). Next, go under the Filter menu, under Blur, and choose **Surface Blur**. When the dialog appears, enter 40 for the Radius and 40 for the Threshold, and click OK (it takes a while for this particular filter to do its thing, so be patient. If you're running this on a 16-bit version of your photo, this wouldn't be a bad time to grab a cup of coffee. Maybe a sandwich, too).

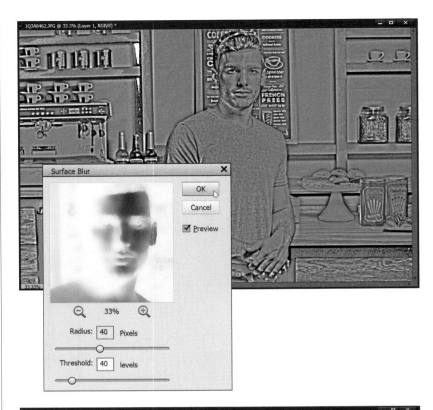

Step Four:

We need to change the layer's blend mode again, but we can't change this one from Vivid Light or it will mess up the effect, so instead we're going to create a new layer, on top of the stack, that looks like a flattened version of the image. That way, we can change its blend mode to get a different look. This is called "creating a merged layer," and you get this layer by pressing **Ctrl-Alt-Shift-E (Mac: Command-Option-Shift-E)**.

Step Five:

Now that you have this new merged layer, you need to delete the middle layer (the one you ran the Surface Blur upon), so drag it onto the Trash icon at the top of the Layers palette. Next, we have to deal with all the funky neon colors on this layer, and we do that by simply removing all the color. Click on your merged layer (Layer 2) to make it active again, then go under the Enhance menu, under Adjust Color, and choose **Remove Color**, so the layer only looks gray. Then, change the blend mode to **Overlay**, and now you can start to see the effect taking shape. You can stop right there (I usually do), but if you think you need an even stronger high-contrast effect (hey, it's possible. It just depends on the image, and how much texture and contrast you want it to have), you can continue on and crank your amp up to 11 (sorry for the lame *This Is Spinal Tap* movie reference).

Step Six:

Go under the Enhance menu again, under Adjust Lighting, and choose **Shadows/ Highlights**. When the dialog appears, drag the Lighten Shadows slider down to 0. Then, you're going to add what amounts to Camera Raw's Clarity by increasing the amount of Midtone Contrast on this Overlay layer. Go to the bottom of the dialog and drag the Midtone Contrast slider to the right, and watch how your image starts to get that crispy look (crispy, in a good way). Of course, the farther to the right you drag, the crispier it gets, so don't go too far, because you're still going to sharpen this image. Here, I dragged to +20%. Click OK. The next step is optional, so if you don't need it, go to the Layers palette's flyout menu and choose **Flatten Image**.

Continued

Step Seven:

Okay, this high-contrast look looks great on a lot of stuff, but one area where it doesn't look that good (and makes your image look obviously post-processed) is when you apply this to blurry, out-of-focus backgrounds, or ones that already have texture. So, I would only apply it to our subject and not the background. Here's how: Alt-click (Mac: Option-click) on the Add Layer Mask icon at the top of the Layers palette to hide the contrast layer behind a black mask (so the effect is hidden from view). With your Foreground color set to white, get the Brush tool **(B)**, choose a medium-sized, soft-edged brush from the Brush Picker in the Tool Options Bar, and paint over his face, neck, hair, arms, and hands to add the high-contrast effect there. Lower the brush's Opacity in the Tool Options Bar to 70% (so the effect isn't as intense), then paint over his t-shirt. This way, you avoid adding the contrast to the background altogether. Lastly, go to the Layers palette and lower the Opacity of this layer until it looks more natural, as shown here at 61%. Now you can flatten the layers and sharpen it using Unsharp Mask (see Chapter 11. Here, I used Amount: 120, Radius: 1, Threshold: 3) to finish off the effect.

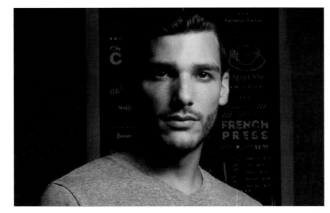

Before

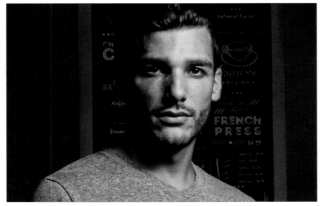

After

There are a few different ways to convert to black and white in Elements. You could simply use the Remove Color enhancement, but that leaves you with kind of a blah result—Elements simply removes the color from the photo and leaves a very bland looking image. Plus, you can't customize your black-and-white image in any way. We looked at my preferred method using Camera Raw's Profile Browser in Chapter 3, but here are two other techniques using the Editor that create a good looking black-and-white and give you plenty of control to really customize the way it looks:

Converting to Black and White

Step One:
The first technique is simple—pretty much one or two clicks and that's it. So, open the color photo you want to convert to black and white (yes, you need to start with a color photo), and then go under the Enhance menu and choose **Convert to Black and White** (as shown here).

Step Two:
When you choose Convert to Black and White, a dialog appears and your photo (behind the dialog) is converted to black and white on the spot (in other words, you get a live preview of your changes). At the top of the dialog is a before and after, showing your color photo on the left, and your black-and-white conversion on the right. Your first step is to choose which style of photo you're converting from the list of styles on the lower-left side of the dialog. These styles are really just preset starting points that are fairly well-suited to each type of photo. The default setting is Scenic Landscape, which is a fairly non-exciting setting. Since I'm generally looking to create high-contrast black-and-white photos with lots of depth, I recommend the Vivid Landscapes style, which is much punchier. Go ahead and choose that now, just so you can see the difference.

Continued

Step Three:

Whether you stay with the default Scenic Landscape, or try my suggested Vivid Landscapes (or any of the other styles to match the subject of your photo; here I ended up choosing Urban/Snapshots), these are just starting places—you'll need to tweak the settings to really match your photo, and that's done by dragging the four Adjust Intensity sliders that appear on the bottom-right side of the dialog. The top three (Red, Green, and Blue) let you tweak ranges of color in your photo. So, for example, if you'd like the skyline brighter, you'd drag the Red slider to the right. If you want the sky, which is mostly blue, darker you'd drag the Blue slider to the left. Here, I'm dragging the Green slider to the right to darken the sky and water a bit.

Step Four:

So, basically, you use those three sliders to come up with a mix that looks good to you. You don't have to use these sliders, but if you can't find one of the presets that looks good to you, find one that gets you close, and then use the Red, Green, and Blue sliders to tweak the settings. The fourth slider, Contrast, does just what you'd expect it would—if you drag to the right, it adds contrast (and to the left removes it). I'm very big on high-contrast black-and-white prints, so I wouldn't hesitate to drag this a little to the right just to create even more contrast (so, personally, I'm more likely to start with a preset, like Vivid Landscapes, and then use the Contrast slider, as shown here, than I am to spend much time fooling with the Red, Green, and Blue sliders. But hey, that's just me).

Step Five:

So, that technique isn't too bad and it's quick and easy. But, if you really want some control over creating a killer black-and-white, and have an extra minute or two, then give this second one a try: start by opening the color photo you want to convert to black and white, then press **D** to set your Foreground and Background colors to their defaults of black and white.

Step Six:

To really appreciate this technique, it wouldn't hurt if you went ahead and did a regular conversion to black and white, just so you can see how lame it is. So, go under the Image menu, under Mode, and choose **Grayscale**. When the Discard Color Information dialog appears, click OK, and behold the somewhat lame conversion. Now that we agree it looks pretty bland, press **Ctrl-Z (Mac: Command-Z)** to undo the conversion, so you can try something better.

Continued

Step Seven:

Go to the top of the Layers palette and choose **Levels** from the Create New Adjustment Layer pop-up menu (it's the half-blue/half-white circle icon). The Levels options will appear in the Adjustments palette and a new layer will be added to your Layers palette named "Levels 1." Press **X** to set your Foreground color to black, then go back to the top of the Layers palette and choose **Gradient Map** from the Create New Adjustment Layer pop-up menu. This brings up the Gradient Map options in the Adjustments palette and adds another layer to the Layers palette (above your Levels 1 layer) named "Gradient Map 1."

Step Eight:

Just choosing Gradient Map gives you a black-and-white image (and doing just this, this one little step alone, usually gives you a better black-and-white conversion than just choosing Grayscale from the Mode submenu. Freaky, I know). Now, if you don't get a black-to-white gradient, it's probably because your Foreground and Background colors were not set at their defaults of black and white. In that case, click-and-drag the Gradient Map and Levels adjustment layers onto the Trash icon at the top of the palette, press **D**, and then add both adjustment layers again.

Step Nine:

Now, in the Layers palette, click on the Levels 1 layer to bring up the Levels options again. From the Channel pop-up menu at the top of the palette, you can choose to edit individual color channels. So, choose the **Red** color channel.

Step 10:

You can now adjust the Red channel, and you'll see the adjustments live onscreen as you tweak your black-and-white photo. (It appears as a black-and-white photo because of the Gradient Map adjustment layer above the Levels 1 layer. Pretty sneaky, eh?) You can drag the middle gray midtone Input Levels slider to the right to darken the shadowy areas, as shown here. You can also try dragging the white highlight Input Levels slider to the left a little if you need to lighten things.

Continued

Step 11:

Now, switch to the **Green** channel in the Channel pop-up menu. You can make adjustments here, as well. Try increasing the midtones in the Green channel by dragging the same slider to the right, as shown here.

Step 12:

Next, choose the **Blue** channel from the pop-up menu, and try increasing the highlights and midtones quite a bit by dragging the Input Levels sliders (the ones that we've been using below the histogram). These adjustments are not standards or suggested settings for every photo; I just experimented by dragging the sliders, and when the photo looked better, I stopped dragging. When the black-and-white photo looks good to you (good contrast, and good shadow and highlight details), just stop dragging.

Step 13:

To complete your conversion, go to the Layers palette, click on the flyout menu at the top right, then choose **Flatten Image** to flatten the adjustment layers into the Background layer. Although your photo looks like a black-and-white photo, technically, it's still in RGB mode, so if you want a grayscale file, go under the Image menu, under Mode, and choose **Grayscale**.

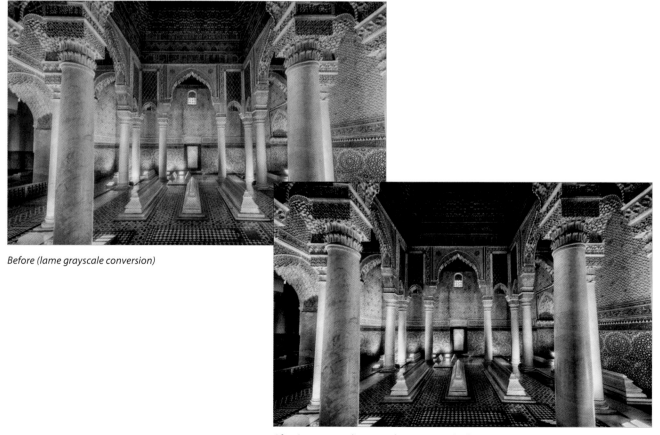

Before (lame grayscale conversion)

After (awesome adjustment layers conversion)

Panoramas Made Crazy Easy

Elements has had a feature to help you stitch multiple photos into a single panoramic photo for years now. As long as you did everything right in the camera (shooting on a tripod with just about every auto feature turned off), Photomerge worked pretty well. However, Photomerge is now so vastly improved that you can pretty much hand-hold your camera without regard to the auto settings, and Photomerge will not only perfectly align the photos, but now it will also seamlessly blend the pieces together, even if the exposure or white balance isn't "on the money." And, now that it's in Guided mode, it is even easier to use. This is very cool stuff.

Step One:

Before you create your pano, choose whether you want to edit it (stuff like exposure, highlights, etc.) now, in Camera Raw, while the individual images are still in 16-bit RAW format, or once it's a single 8-bit pano. (*Note:* Currently, you can only use 8-bit images in Photomerge Panorama on a Mac.) Your call, but I recommend tweaking them now in Camera Raw before you make your pano, so you get the advantages of working with RAW-quality images (if they're JPEGs, it doesn't matter when you edit them—I'd just wait until they're a pano). So, if you shot in RAW, Command-click (PC: Ctrl-click) to select all the pano images in the Organizer, and then click on the Editor button beneath the Media Browser (as shown here).

Step Two:

Since these are RAW files, they open in Camera Raw. Click the Select All button at the top of the filmstrip on the left to select all the images, so any changes you make are automatically applied to all the frames. Let's set the white and black points by pressing-and-holding the Shift key and double-clicking on the Whites and Blacks slider knobs. Decrease the Exposure (to −0.10) and increase the Contrast (to +45), pull back the Highlights to −67, and bump the Shadows up to +45 to see more detail. Then, let's crank the Clarity up to +40 to accentuate the texture, and the Vibrance to +25. When you're done, click the Open Images button.

Step Three:

This opens your images in the Editor. Click on Guided at the top of the window, then click on the Photomerge tab up top. Since your images were already opened, you'll see them in the Photo Bin at the bottom of the window. (*Note:* You can also open your images here right from the Organizer by going under the Edit menu, under Photomerge, and choosing Photomerge Panorama. Each will get you to the same place, but I prefer going directly from the RAW images.) Select your images down in the Photo Bin, and then click on Photomerge Panorama.

Step Four:

Now that this is a Guided edit, the process is simple. On the right, click on Settings, and you'll see a few options: Leave the Blend Images Together checkbox turned on. If you have lens vignetting (the edges of your images appear darkened), turn on Vignette Removal (as I did here; it will take longer to render your pano, but will try to remove the vignetting during the process). And, if you used a Nikon, Sigma, or Canon fisheye lens, turn on the Geometric Distortion Correction checkbox to correct the fisheye distortion. Click on the graphic above Settings and a pop-up menu appears (seen here). The default setting is Auto Panorama, and I recommend leaving it set to that to get the standard wide pano we're looking for. The five other choices all give you… well…funky looking panos (that's the best description I can give you)—they don't give you that nice wide pano most of us are looking for. So, let's stick with Auto Panorama.

Continued

Step Five:

Click the Create Panorama button at the bottom right, and within a few minutes (depending on how many photos you're using), your pano is seamlessly stitched together (as seen here). You'll see status bars that let you know Elements is aligning and blending your layers to make this mini-miracle happen, and in the Layers palette, you'll see all the masks it created.

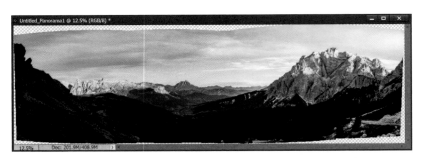

Step Six:

To make your pano fit perfectly together, Photomerge has to move and rearrange things in a way that will cause you to have some extra canvas around your final pano. That's why the Clean Edges dialog will pop up. With it, you can have Elements try to fill in the blank space based on the image—it does an amazingly good job, although you may have to continue editing in Expert mode and use the Clone Stamp tool (S) to finish it off. Or, you can click No, then click the In Expert button to go back to Expert mode, get the Crop tool (C), and drag out your cropping border (encompassing as much of the pano as possible without leaving any gaps).

Step Seven:
Now to finish it up. First, choose **Flatten Image** from the Layers palette's flyout menu, then sharpen it by going under the Enhance menu, and choosing **Unsharp Mask**. Pick some nice strong settings (here, I chose Amount: 120, Radius: 1.0, Threshold: 3), and click OK to finish the image (seen below).

Burned-In Edge Effect (Vignetting)

If you want to focus attention on something within your image, applying a wide vignette that acts like a soft light is a great way to do this (which is really just an alternative to the Vignette Effect in Guided mode). What you're doing is creating a dark border that will burn in the edges of your image. Here's how to do just that:

Step One:
Open the photo to which you want to apply a burned-in edge effect. Just so you know, what we're doing here is focusing attention through the use of light—we're burning in all the edges of the photo (not just the corners, like lens vignetting, which we learned how to fix in Chapter 7 and I usually try to avoid), leaving the visual focus in the center of the image.

Step Two:
Go under the Filter menu, and choose **Correct Camera Distortion**. When your image opens in the Correct Camera Distortion dialog, if it has an annoying grid over it, start by turning off the Show Grid checkbox beneath the bottom right of the preview area. In the Vignette section near the top, you're going to drag the Amount slider to the left, and as you drag left, you'll start to see vignetting appear in the corners of your photo. But since it's just in the corners, it looks like the bad kind of vignetting, not the good kind. You'll need to make the vignetting look more like a soft spotlight falling on your subject.

Step Three:
To do just that, drag the Midpoint slider quite a bit to the left, which increases the size of the vignetting and creates a soft, pleasing effect that is very popular in portraiture, or anywhere you want to draw attention to your subject. That's it!

Before

After

Creating the Selective Color Effect

Nothing says 1985 like selective color! I say that semi-jokingly in that it's one of those effects that some photographers are tired of. But, the rest of the world still loves it. It's basically a way to make part of a photo pop out by leaving it in color, while everything else is black and white. You'll find it in Guided mode, along with lots of other special effects. They all work pretty much the same, but we'll just go over the selective color one here.

Step One:
In the Editor, open a photo you'd like to apply the effect to, then click on Guided at the top of the window. At the top of the Guided window, click on Black & White, then click on B&W Selection.

Step Two:
In the Palette Bin, you'll see all of the settings you have control over for the effect. The way Guided edits usually work is you start from the top and work your way down, but you don't always have to use all of the settings there. For this one, click on the B&W Selection Brush button. Playing off the "Guided" name, you'll see that Elements pretty much guides you along the way.

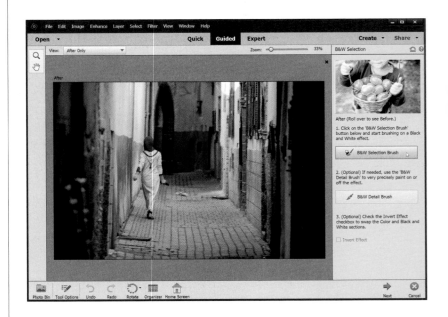

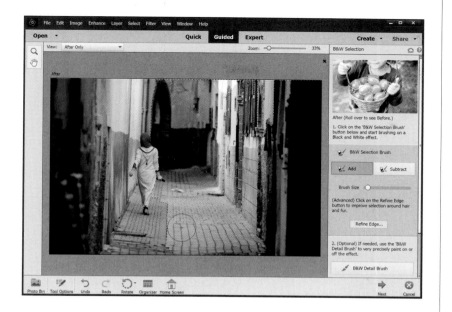

Step Three:

Here, you'll start off in Add mode. This means that wherever you paint on the photo, it'll be turned to black and white (as shown here). You even have a Brush Size option if you need a larger or smaller brush to paint with. Whatever you don't paint on remains in color. You'll also notice that it tends to snap to parts of your image. That's the Elements "smart" brush technology that helps make selections for you.

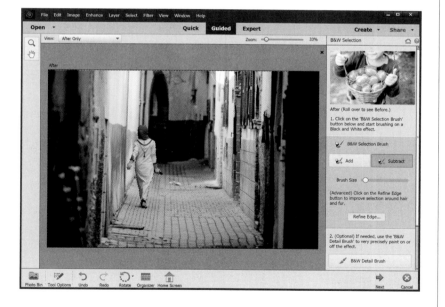

Step Four:

If you happen to paint over too much of the photo, or Elements doesn't automatically pick up an edge and turns it to black and white, then just click on the Subtract button and paint the color back in. In the previous step, I painted over her hand on the right, so I made my brush smaller, and painted the color back in there.

Continued

Step Five:

You can also click on the Refine Edge button (you can find out more about how Refine Edge works in Chapter 8), turn on the Smart Radius checkbox, and increase the Radius slider to help make the edges look more realistic and not so jaggy.

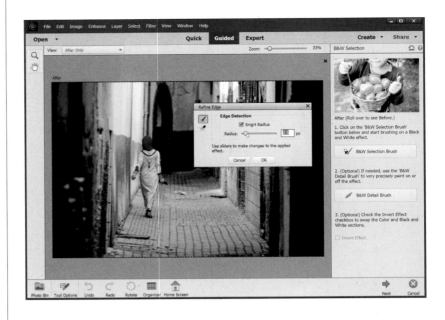

Step Six:

Finally, if you need to get really detailed, then click on the B&W Detail Brush option. This brush doesn't use any of Elements' selection technology, though. Instead, it works just like a regular brush and paints the effect in only the exact areas you paint on. Oh, and one last thing: if you want to see the reverse of everything you've done, then turn on the Invert Effect checkbox in the third section, and whatever was in color will now become black and white and whatever was black and white will be in color.

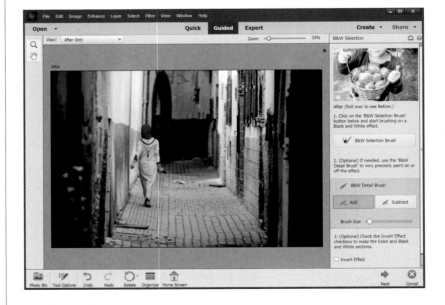

One of the most popular lens filters for outdoor photographers is the neutral density gradient filter, because often (especially when shooting scenery, like sunsets) you wind up with a bright sky and a dark foreground. A neutral density gradient lens filter reduces the exposure in the sky by a stop or two, while leaving the ground unchanged (the top of the filter is gray, and it graduates down to transparent at the bottom). Well, if you forgot to use your ND gradient filter when you took the shot, you can create your own ND gradient effect in Photoshop Elements.

Neutral Density Gradient Filter

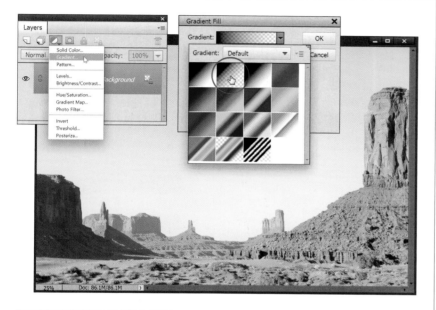

Step One:
Open the photo where you exposed for the ground, which left the sky too light. Press the letter **D** to set your Foreground color to black. Then, go to the Layers palette and choose **Gradient** from the Create New Adjustment Layer pop-up menu (it's the half-white/half-blue circle icon) at the top of the palette. When the Gradient Fill dialog appears, click on the little black downward-facing arrow to the right of the Gradient thumbnail to bring up the Gradient Picker. Double-click on the second gradient in the list, which is the gradient that goes from Foreground to Transparent. Don't click OK yet.

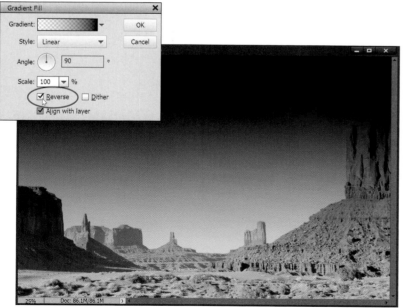

Step Two:
By default, this puts a dark area on the ground (rather than the sky), so turn on the Reverse checkbox to reverse the gradient, putting the dark area of your gradient over the sky and the transparent part over the land. Your image will look pretty awful at this point, but you'll fix that in the next step, so just click OK.

Continued

Step Three:

To make this gradient blend in with your photo, go to the Layers palette and change the blend mode of this adjustment layer from Normal to **Overlay**. This darkens the sky, but it gradually lightens until it reaches land, and then it slowly disappears. So, how does it know where the ground is? It doesn't. It puts a gradient across your entire photo, so in the next step, you'll basically show it where the ground is.

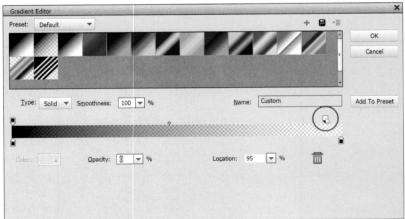

Step Four:

In the Layers palette, double-click on the thumbnail for the Gradient adjustment layer to bring up the Gradient Fill dialog again. To control how far down the darkening will extend from the top of your photo, just click once on the Gradient thumbnail at the top of the dialog. This brings up the Gradient Editor. Grab the top-right transparent Opacity stop above the gradient ramp near the center of the dialog and drag it to the left. The darkening will "roll up" from the bottom of your photo, so keep dragging to the left until only the sky and the taller rock formations (in this example) are affected, and then click OK in the Gradient Editor.

Step Five:

By default, the gradient you choose fills the entire image area, smoothly transitioning from a dark gray at the top center to transparent at the very bottom. It's a smooth, "soft-step" gradient. However, if you want a quicker change from black to transparent (a hard step between the two), you can lower the Scale amount in the Gradient Fill dialog.

Step Six:

Also, if the photo you're working on doesn't have a perfectly straight horizon line, you might have to use the Angle control by clicking on the line in the center of the Angle circle and dragging slowly in the direction that your horizon is tilted. This literally rotates your gradient, which enables you to have it easily match the angle of your horizon. When it looks good to you, click OK to complete the effect.

Before (exposing for the ground makes the sky and rock formations too light)

After (the ground is the same, but the sky is now bluer and the rock formations have more contrast)

Getting the Instagram Look

Here's a quick and easy way to get the wildly popular Instagram app look. Of course, there isn't just one "look," because Instagram has like over 20 different filters, so here we'll take a look at creating one based on the popular Clarendon filter. One more thing: I know you're thinking, "Do people really want to learn how to do phone app looks in Elements?" Yup. It's one of the most-requested effects people ask to learn (don't get me started). Luckily, it's easy, and the looks are actually based on classic darkroom effects, so that can't be a bad thing.

Step One:

Start by opening an image in Camera Raw. One of the trademark looks of the Instagram app is its square cropping ratio, so let's start there. Click-and-hold on the Crop tool in the toolbar at the top and a list of cropping ratios appears. Choose the 1 to 1 ratio (as shown here), which gives you a square crop.

Step Two:

Drag your cropping border out over the part of the image you want to have the effect (in this case, it's pretty obvious which part of the image we should keep). Once the crop is where you want it, just press the **Enter (Mac: Return) key** to lock in your square crop. From here on out, it's pretty darn easy—I'll give you some sliders to set, a couple of minor little moves, and you're there. Let's do it.

Step Three:

This look can easily be created using Levels. So, click on the Create New Adjustment Layer icon at the top of the Layers palette and choose **Levels**.

Step Four:

We're going to use some different settings in Levels than you may be used to. Under the Channel pop-up menu, you'll see you have the choice of adjusting the Red, Green, or Blue channels. Don't worry, though, even if you've never used Levels this way before, you'll absolutely be able to do this (I'll give you all the settings you'll need). So, first, from the Channel pop-up menu, choose **Red**. Then, click-and-drag the dark gray (shadows) Input Levels slider, beneath the histogram, to the right to 39, the middle gray (midtones) slider to the left to 1.15, and the white (highlights) slider to the left to 220. See, that was easy, eh?

Continued

Step Five:

Now that you've got the hang of adjusting the Levels this way, choose **Green** from the Channel pop-up menu. Again, starting on the left, beneath the histogram, this time drag the dark gray Input Levels slider to the right to 50, the middle gray slider to the left to 1.73, and the white slider to the left to 229.

TIP: Add Grain for a Film-Like Look

One of the trademarks of an Instagram effect is a grainy look, and you can always hop into Guided mode and apply the Old Fashioned Photo effect to the image. But, instead of using all of the settings, just click on the Add Texture button.

Step Six:

Next, choose **Blue** from the Channel pop-up menu. This time, drag the dark gray Input Levels slider to the right to 19, the middle gray slider to the left to 1.38, and the white slider to the left to 242.

Step Seven:
Finally, choose **RGB** from the Channel pop-up menu and let's add some contrast by dragging the dark gray Input Levels slider to the right to 13 and the middle gray slider to the right to 0.96. That's it.

Duotone Effect

The duotone tinting look is all the rage right now, but creating a real two-color duotone that will separate in just two colors on press is a bit of a chore. However, if you're outputting to an inkjet printer, or to a printing press as a full-color job, then you don't need all that complicated stuff—you can create a fake duotone that looks at least as good (if not better).

Step One:

Open the color or black-and-white RGB photo that you want to convert into a duotone (again, I'm calling it a duotone, but we're going to stay in RGB mode the whole time). Now, the hard part of this is choosing which color to make your duotone. I always see other people's duotones, and think, "Yeah, that's the color I want!" but when I click on the Foreground color swatch and try to create a similar color in the Color Picker, it's always hit or miss (usually miss). That's why you'll want to know this next trick.

Step Two:

If you can find another duotone photo that has a color you like, you're set. So, I usually go to a stock photo website (like Adobe Stock) and search for "duotones." When I find one I like, I return to Elements, press I to get the Color Picker tool, click-and-hold anywhere within my image area, and then (while keeping the mouse button held down) I drag my cursor outside Elements and onto the photo in my web browser to sample the color I want. Now, mind you, I did not and would not take a single pixel from someone else's photo—I'm just sampling a color.

©ADOBE STOCK/CHAT9780

Step Three:
Return to your image in Elements. Go to the Layers palette and click on the Create a New Layer icon at the top of the palette. Then, press **Alt-Backspace (Mac: Option-Delete)** to fill this new blank layer with your sampled color. The color will fill your image area, hiding your photo, but we'll fix that.

Step Four:
While still in the Layers palette, change the blend mode of this sampled color layer from Normal to **Color**.

Step Five:
If your duotone seems too dark, you can lessen the effect by clicking on the Background layer, and then going under the Enhance menu, under Adjust Color, and choosing **Remove Color**. This removes the color from your RGB photo without changing its color mode, while lightening the overall image (I didn't do that here, though, since I didn't think it looked too dark). Pretty sneaky, eh?

Double Exposure Effect

Although photographers have been doing double exposure effects since back in the film days, the double exposure look you can create in Elements is a particular look that's really popular right now. Because this is a Guided edit, it's really easy (and fun) to do, and there are lots of creative possibilities. So, let's get to it.

Step One:

In the Editor, open the main photo you want to use in your double exposure effect. Click on Guided at the top of the window, and then, in the Guided window, under Fun Edits, click on Double Exposure (as shown here).

Step Two:

This technique works best if your subject is in the center of the image, so first, click on the Crop Tool button (on the right). Move the cropping border over your subject, then click-and-drag its sides until your subject appears in the center. When it looks centered over your subject, click the green checkmark at the bottom-right corner of the cropping border (as shown here).

Step Three:

Next, you'll need to put a selection around your subject. You can use the Auto tool to drag out a selection around your subject and have it try to automatically select them, but I've had more luck using the Quick tool, so I'd go with that. You simply paint over your subject and it selects them for you. By default it uses a super-small brush size, but you can make the brush size bigger (which I recommend) using the Size slider down in the Tool Options Bar (here I increased the size of the brush quite a bit—you can see the outline of the brush in her hair on the right side).

Step Four:

To bring in the double exposure effect, you can either import one of your own photos to blend with your main image (by clicking on the Import a Photo button), or you can use one of the three sample images Adobe provided for you to use as the second image. Here, I went with one of their sample images (they picked some really ideal types of images for this effect, so if you want to use your own images, I would consider trying to find the same type of images that Adobe is using here—landscapes, cityscapes, clouds, etc.). I clicked on the City thumbnail and it masked the background away (so now it's solid white) and it blended this cityscape image with our main image (in this case, a portrait).

Continued

Step Five:

Once you've applied the double exposure image, you can control the amount that appears on your main image using the Intensity slider. Here, I lowered the Intensity amount of the cityscape image to 54, so you could see more of my portrait.

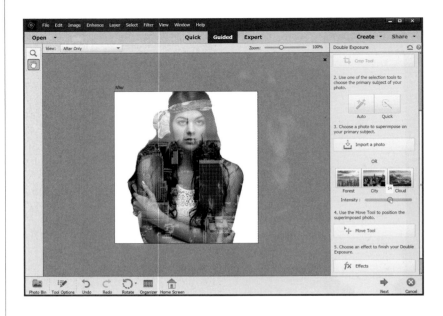

Step Six:

If you want to reposition the double exposure image, click on the Move Tool button, and then click-and-drag it within your image to position it where it makes the most sense with your main image. Once it's positioned where you want it (I left it where it was here), scroll down to Effects and click on the different thumbnails to apply different color effects to your image. Here, I clicked on the effect in the center, which puts a three-color gradient tint with added contrast over the image. If you think the color effect is too intense, lower the Intensity amount using the slider below the thumbnails. Now, click the Next button at the bottom right, and then choose what you want to do next with the photo.

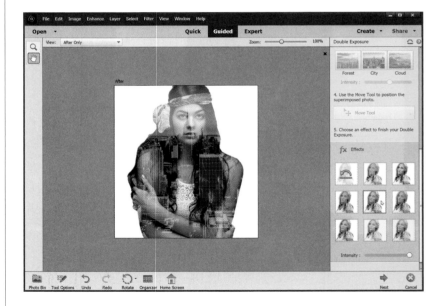

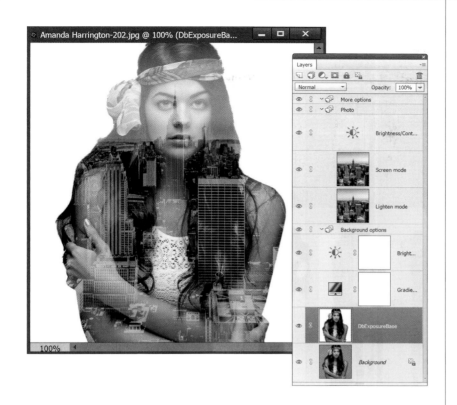

Step Seven:

I chose to open it back in Expert mode here, so you could see all the layers it took to create this effect from scratch (take a gander over in the Layers palette), and you can see why it's so nice to be able to do this technique as a Guided edit. While you can clearly do the whole thing by yourself in the Expert mode, the Guided method is so much faster, and easier, and it even provides sample images for you to use and practice with.

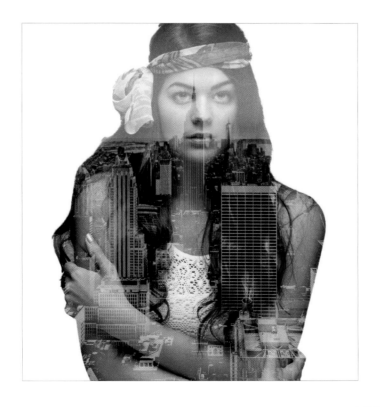

Colorizing Your Photos

This is one where all that AI, machine learning, and technology stolen from alien craft that's hidden at Area 51 really all comes together to create something amazing. This new feature is used for colorizing your old black-and-white photos, and I have to admit—it does a pretty amazing job on most photos. What's even better is that since Auto mode works so well, you'll rarely have to use Manual mode. But, even if you wind up having to use Manual mode, it still does a lot of the work for you.

Step One:

Open the black-and-white photo you want to colorize, then go under the Enhance menu and choose **Colorize Photo**. Now, as you look at this photo of me as a young man, you're probably thinking, "Man, Scott was such a cool dude back then." I know. Hard to believe the 16 years (ahem) since this photo was taken have flown by so quickly. This was taken for a set of publicity shots for the rock band I was playing in at the time called, The Edge. And, yes, we were awesome, and so was my 1980s attire, complete with rolled-up sleeves and skinny tie. Luckily, the "turn up your coat collar" phase had just passed, or you'd have seen that, too. So, what's changed clothes-wise for me since? I rolled the sleeves down and I don't wear a tie anymore. I might need to rethink my wardrobe. Moving on…

Step Two:

This brings up the Colorize Photo window in Auto mode, and it applies a colorization to your image (as seen here). It did a pretty darn good job, too. My jeans are blue, the skin tones look good, and the bushes behind me are green. All in all, a pretty decent job. On the right side of the window are three alternate versions, each with a different colorization applied in case you don't like the default. To switch to one of those, just click on a thumbnail. If you don't like any of them, then try Manual mode. You'd click the Reset button at the bottom of the window, then at the top, click the blue switch over to Manual. But, we're going to switch to a new photo for Manual mode here.

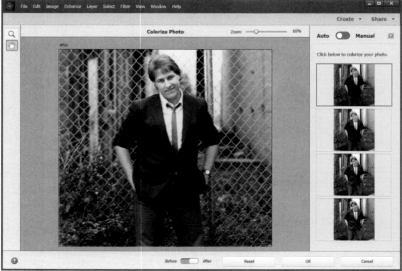

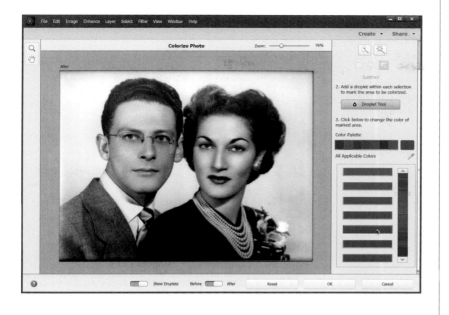

Step Three:
In Manual mode, start by selecting the first area you want to colorize. You can choose the Quick Selection tool or the Magic Wand tool, but the Quick Selection tool seems to work best here. So, click on its button (it's the one on the left) and paint over part of your image (as I did here, where I painted over my mom's hair to select that area). If it selects something you don't want selected (it also tried to select her ear here), click the Subtract button (just below the tools) and paint over that area to remove it from the selection. Now, click the Droplet Tool button, and then click it inside your selected area (you can see the little water drop icon where I clicked here). This creates a column of rectangular swatches for you based on what it thinks you'd need to colorize that area. If you don't like the colors in the column, you can have it generate a different set by clicking on the square Color Palette swatches just above it. Here, I clicked on a brown Color Palette swatch, so I'd have a choice of different shades of brown. Click on a swatch and it applies that color to your selected area.

Step Four:
Once you have a color you like for your first selected area, press **Ctrl-D (Mac: Command-D)** to Deselect that area, get the Quick Selection tool again, then select a different area of your image and do the same routine: Click the Droplet Tool inside your newly selected area. (*Tip:* To remove a droplet, click on it, and then click the Trash icon that appears beside it.) It creates a color palette based on where you clicked and it displays a column of colorization choices. Choose one of those, or change the selection by clicking one of the Color Palette swatches. Pretty soon you'll have a whole bunch of those droplet icons over all the areas you've colorized. If you find them distracting, turn off the Show Droplets button at the bottom of the window. When you're done, click OK and your colorization is applied.

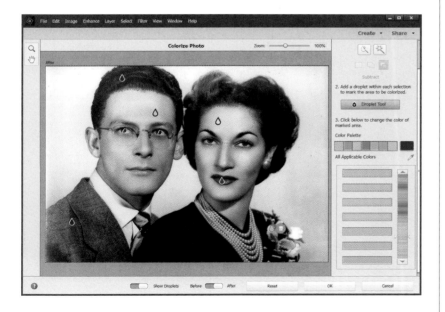

Location: Initiation Well at Guinta de Regaleira, Sintra, Portugal | Exposure: 1/50 sec | Focal Length: 14mm | Aperture Value: ƒ/2.8

Sharp Tale
sharpening techniques

Wait a minute. Wait a minute! Isn't it supposed to be *Shark Tale*, the DreamWorks animated movie with Will Smith and Renée Zellweger? Hey, look, typos happen. I see them in the *New York Times* and the *Wall Street Journal*, so it can surely happen here, even though we run an incredibly thorough process where teams of grammarsticians at university-level research labs in Gstaad, Geneva, Fresno, Bordeaux, and Osaka work night and day to ensure that every word (or at the very least, every third word) in this entire document has most of the components to form adequately spelled words, with just a hint of grammar and sentence form. And, we believe that the properly structured sentence is really a state of mind. A state of existential being where the letter and form congeal and become one. This frees us from the old-fashioned, outdated norms of what is and isn't acceptable in formal grammar and opens us to a world of discovery, experimentation, and speculative spelling and sentence structure that rewards those who can embrace this new wave of thinking and the profound changes it brings. Besides, all I can remember from *Shark Tale* is the cover of "Car Wash" by Christina Aguilera (which was not bad, but it's hard to beat the original). Okay, pop quiz: Who did the original sound track to *Car Wash*, including the title track? Was it (a) Bon Jovi, (b) Led Zepplin, (c) Rush, or (d) Rose Royce. If you said (a) Bon Jovi, you're right. (I love when you see them in concert, and Jon comes to center stage and he starts that "Clap. Clap. Clap-ca-clap, clap, clap!" and the place just goes crazy, and the rest of the band joins in, except Richie Sambora because he's not in the band anymore, which is sad because it was his clap on top of Jon's clap that really brought it together. And when Richie would come out front with Jon and they'd do "Rappers Delight," it was just magic. Every time Jon would belt out, "Now what you hear is not a test, I'm a rappin' to the beat…" and Tico Torres would kick in with record scratching. Man, those were the days.)

Basic Sharpening

After you've color corrected your photos and right before you save your files, you'll definitely want to sharpen them. I sharpen every digital camera photo I take, either to help bring back some of the original crispness that gets lost during the correction process, or to help fix a photo that's slightly out of focus. Either way, I haven't met a digital camera (or scanned) photo that didn't need a little sharpening. Here's a basic technique for sharpening the entire photo:

Step One:

Open the photo that you want to sharpen. Because Elements displays your photo in different ways at different magnifications, choosing the right magnification (also called the zoom amount) for sharpening is critical. Today's digital cameras produce such large-sized files that it's now pretty much generally accepted that the proper magnification to view your photos during sharpening is 50%. If you look up in your image window's title bar, or down in the bottom-left corner of the window, it displays the current percentage of zoom (shown circled here in red). The quickest way to get to a 50% magnification is to press **Ctrl-+** (plus sign; **Mac: Command-+**) or **Ctrl--** (minus sign; **Mac: Command--**) to zoom the magnification in or out.

Step Two:

Once you're viewing your photo at 50% size, go under the Enhance menu and choose **Unsharp Mask**. (If you're familiar with traditional darkroom techniques, you probably recognize the term "unsharp mask" from when you would make a blurred copy of the original photo and an "unsharp" version to use as a mask to create a new photo whose edges appeared sharper.)

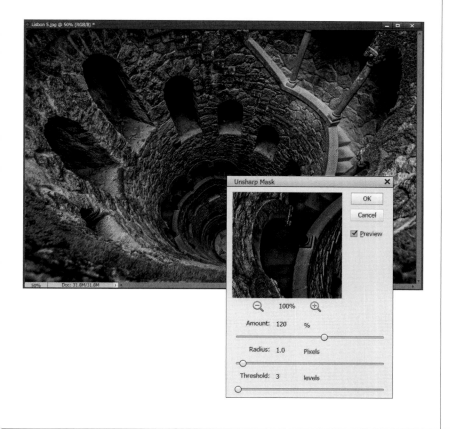

Step Three:

When the Unsharp Mask dialog appears, you'll see three sliders. The Amount slider determines the amount of sharpening applied to the photo; the Radius slider determines how many pixels out from the edge that the sharpening will affect; and the Threshold slider determines how different a pixel must be from the surrounding area before it's considered an edge pixel and sharpened by the filter. Threshold works the opposite of what you might think—the lower the number, the more intense the sharpening effect. So, what numbers do you enter? I'll give you some great starting points on the following pages, but for now, we'll just use these settings: Amount: 120%, Radius: 1, and Threshold: 3. Click OK and the sharpening is applied to the photo.

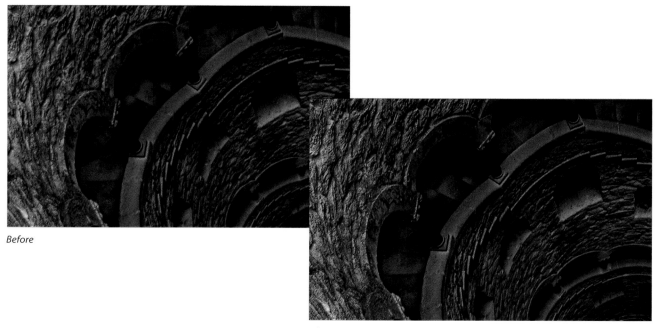

Before

After

Continued

Sharpening Soft Subjects:

Here are the Unsharp Mask settings—Amount: 120%, Radius: 1, Threshold: 10—that work well for images where the subject is of a softer nature (e.g., flowers, puppies, people, rainbows, etc.). It's a subtle application of sharpening that is very well suited to these types of subjects.

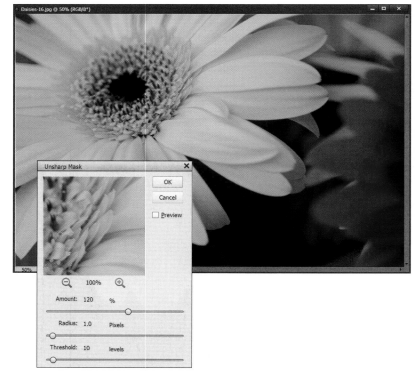

Sharpening Portraits:

If you're sharpening a close-up portrait (head-and-shoulders type of thing), try these settings—Amount: 75%, Radius: 2, Threshold: 3—which applies another form of subtle sharpening, but with enough punch to make eyes sparkle a little bit, and bring out highlights in your subject's hair.

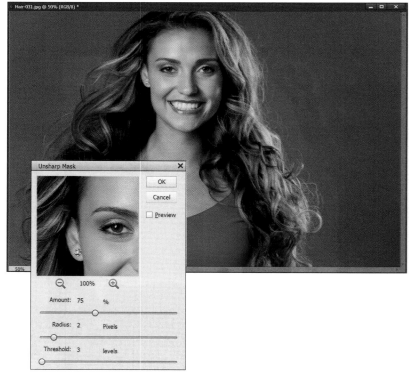

Moderate Sharpening:

This is a moderate amount of sharpening that works nicely on everything from product shots, to photos of home interiors and exteriors, to landscapes (and in this case, a lamp). If you're shooting along these lines, try applying these settings—Amount: 120%, Radius: 1, Threshold: 3—and see how you like it (my guess is you will). Take a look at how it added snap and detail to the edge of the lamp and the tassels.

Maximum Sharpening:

I use these settings—Amount: 65%, Radius: 4, Threshold: 3—in only two situations: (1) The photo is visibly out of focus and it needs a heavy application of sharpening to try to bring it back into focus; or (2) the photo contains lots of well-defined edges (e.g., buildings, coins, cars, machinery, etc.). In this photo, the heavy amount of sharpening really brings out the detail in the edges of these boats and the ropes.

Continued

All-Purpose Sharpening:

These are probably my all-around favorite sharpening settings—Amount: 85%, Radius: 1, Threshold: 4—and I use these most of the time. It's not a "knock-you-over-the-head" type of sharpening—maybe that's why I like it. It's subtle enough that you can apply it twice if your photo doesn't seem sharp enough after the first application (just press **Ctrl-F [Mac: Command-F]**), but once will usually do the trick.

Web Sharpening:

I use these settings—Amount: 200%, Radius: 0.3, Threshold: 0—for web graphics that look blurry. (When you drop the resolution from a high-res, 300-ppi photo down to 72 ppi for the web, the photo often gets a bit blurry and soft.) If the sharpening doesn't seem sharp enough, try increasing the Amount to 400%. I also use this same setting (Amount: 400%) on out-of-focus photos. It adds some noise, but I've seen it rescue photos that I would have otherwise thrown away.

Coming Up with Your Own Settings:

If you want to experiment and come up with your own custom blend of sharpening settings, I'll give you some typical ranges for each adjustment so you can find your own sharpening "sweet spot."

Amount

Typical ranges go anywhere from 50% to 150%. This isn't a rule that can't be broken. It's just a typical range for adjusting the Amount, where going below 50% won't have enough effect, and going above 150% might get you into sharpening trouble (depending on how you set the Radius and Threshold). You're fairly safe staying under 150%. (In the example here, I reset my Radius and Threshold to 1 and 2, respectively.)

Radius

Most of the time, you'll use just 1 pixel, but you can go as high as (get ready)—2. I gave you one setting earlier for extreme situations, where you can take the Radius as high as 4, but I wouldn't recommend it very often. I once heard a tale of a man in Cincinnati who used 5, but I'm not sure I believe it. (Incidentally, Adobe allows you to raise the Radius amount to [get this] 250! If you ask me, anyone caught using 250 as their Radius setting should be incarcerated for a period not to exceed one year and a penalty not to exceed $2,500.)

Continued

Threshold

A pretty safe range for the Threshold setting is anywhere from 3 to around 20 (3 being the most intense, and 20 being much more subtle. I know, shouldn't 3 be more subtle and 20 more intense? Don't get me started). If you really need to increase the intensity of your sharpening, you can lower the Threshold to 0, but keep a good eye on what you're doing (watch for noise appearing in your photo).

The Final Image

For the final sharpened image you see here, I used the Portraits sharpening settings I gave earlier (Amount: 75%, Radius: 2, Threshold: 3). If you're uncomfortable with creating your own custom Unsharp Mask settings, then start with this: pick a starting point (one of the set of settings I gave on the previous pages), and then just move the Amount slider and nothing else (so, don't touch the Radius and Threshold sliders). Try that for a while, and it won't be long before you'll find a situation where you ask yourself, "I wonder if lowering the Threshold would help?" and by then, you'll be perfectly comfortable with it.

Before

After

One of the problems we face when trying to make things really sharp is that things tend to look oversharpened, or worse yet, our photos get halos (tiny glowing lines around edges in our images). So, how do we get our images to appear really sharp without damaging them? With a trick, of course. Here's the one I use to make my photos look extraordinarily sharp without damaging the image:

Creating Extraordinary Sharpening

Step One:
Open your image, and then apply the Unsharp Mask filter (found under the Enhance menu) to your image, just as we've been doing all along. For this example, let's try these settings—Amount: 65%, Radius: 4, and Threshold: 3—which will provide a nice, solid amount of sharpening.

Step Two:
Press **Ctrl-J (Mac: Command-J)** to duplicate the Background layer. Because we're duplicating the Background layer, the layer will be already sharpened, but we're going to sharpen this duplicate layer even more in the next step.

Continued

Step Three:

Now apply the Unsharp Mask filter again, using the same settings, by pressing **Ctrl-F (Mac: Command-F)**. If you're really lucky, the second application of the filter will still look okay, but it's doubtful. Chances are that this second application of the filter will make your photo appear too sharp—you'll start to see halos or noise, or the photo will start looking artificial in a lot of areas. So, what we're going to do is hide this oversharpened layer, then selectively reveal this über-sharpening only in areas that can handle the extra sharpening (this will make sense in just a minute).

Step Four:

Go to the Layers palette, press-and-hold the Alt (Mac: Option) key, and click on the Add Layer Mask icon at the top of the palette (shown circled here in red). This hides your oversharpened layer behind a black layer mask (as seen here). *Note:* To learn more about layer masks, see Chapter 6.

Step Five:

Here's the fun part—the trick is to paint over just a few key areas, which fool the eye into thinking the entire photo is sharper than it is. Here's how: Press **B** to get the Brush tool, and in the Tool Options Bar, click on the Brush thumbnail to open the Brush Picker and choose a soft-edged brush. With your Foreground color set to white, and with the layer mask active in the Layers palette (you'll see a little blue frame around it), start painting on your image to reveal your sharpening. (*Note:* If you make a mistake, press **X** to switch your Foreground color to black and paint over the mistake.) Here, I painted over the candlesticks, the door and window frames, and the columns. Revealing these few sharper areas, which immediately draw the eye, makes the whole photo look sharper.

Before

After

Edge Sharpening Technique

This is a sharpening technique that doesn't use the Unsharp Mask filter, but still leaves you with a lot of control over the sharpening, even after it's applied. It's ideal to use when you have an image that can really hold a lot of sharpening (a photo with a lot of edges) or one that really needs a lot of sharpening.

Step One:
Open a photo that needs edge sharpening applied to it.

Step Two:
Duplicate the Background layer by going under the Layer menu, under New, and choosing **Layer via Copy** (or pressing **Ctrl-J [Mac: Command-J]**). This will duplicate the Background layer onto a new layer (Layer 1).

Step Three:

Go under the Filter menu, under Stylize, and choose **Emboss**. You're going to use the Emboss filter to accentuate the edges in the photo. You can leave the Angle and Amount settings at their defaults (135° and 100%), but if you want more intense sharpening, raise the Height amount from its default setting of 3 pixels to 5 or more pixels (in the example here, I raised it to 6). Click OK to apply the filter, and your photo will turn gray, with neon-colored highlights along the edges.

Step Four:

In the Layers palette, change the layer's blend mode from Normal to **Hard Light**. This removes the gray color from the layer, but leaves the edges accentuated, making the entire photo appear much sharper.

Continued

Step Five:

If the sharpening seems too intense, you can control the amount of the effect by simply lowering the Opacity of this top layer in the Layers palette.

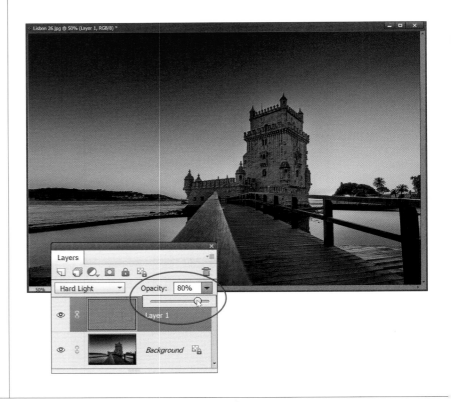

Before

After

We never used to use the Sharpen tool, until Adobe rewrote its underlying logic, taking it from its previous role as a "noise generator/pixel destroyer" to what Adobe Product Manager Bryan O'Neil Hughes has called "...the most advanced sharpening in any of our products." Here's how it works:

The Most Advanced Sharpening in Elements

Step One:
Start by applying your regular sharpening to the overall image using Unsharp Mask or Adjust Sharpness (more on this coming up next)—your choice. In this case, since this is a portrait of a woman, I'd use the portrait sharpening settings I gave you earlier in this chapter. Now, get the Sharpen tool (**R**; it's found nested beneath the Blur tool). Once you've got the tool, go to the Tool Options Bar and make sure the Protect Detail checkbox (shown circled here in red) is turned on (this is the checkbox that makes all the difference, as it turns on the advanced sharpening algorithm for this tool).

Step Two:
I recommend duplicating the Background layer at this point (by pressing **Ctrl-J** [**Mac: Command-J**]) and applying this extra level of sharpening to the duplicate layer. That way, if you think the sharpening looks too intense, you can just lower the amount of it by lowering the opacity of this layer. I also usually zoom in (by pressing **Ctrl-+** [plus sign; **Mac: Command-+**]) on a detail area (like her eyes), so I can really see the effects of the sharpening clearly (another benefit of applying the sharpening to a duplicate layer is that you can quickly see a before/after of all the sharpening by showing/hiding the layer).

Continued

Step Three:

Now, click on the Brush thumbnail in the Tool Options Bar, choose a medium-sized, soft-edged brush from the Brush Picker, and then simply take the Sharpen tool and paint over just the areas you want to appear sharp (this is really handy for portraits like this, because you can avoid areas you want to remain soft, like skin, but then super-sharpen areas you want to be really nice and crisp, like her irises and lips, like I'm doing here). Below is a before/after, after painting over areas that you'd normally sharpen, like her eyes, eyebrows, eyelashes, and lips, while avoiding all areas of flesh tone. One more thing: This technique is definitely not just for portraits. The Sharpen tool does a great job on anything metal or chrome, and it's wonderful on jewelry, or anything that needs that extra level of sharpening.

Before

After

Sometimes, I'll turn to the Adjust Sharpness control, instead of the Unsharp Mask filter, to sharpen my photos. Here's why: (1) it does a better job of avoiding those nasty color halos, so you can apply more sharpening without damaging your photo; (2) it lets you choose different styles of sharpening; (3) it has a much larger preview window, so you can see your sharpening more accurately; (4) it has a More Refined feature that applies multiple iterations of sharpening; and (5) it's just flat out easier to use.

Advanced Sharpening Using Adjust Sharpness

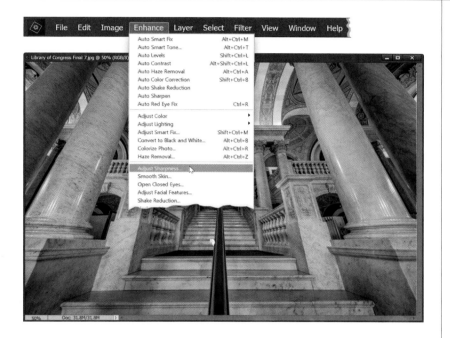

Step One:
Open the photo you want to sharpen using the Adjust Sharpness control. (By the way, although most of this chapter focuses on using the Unsharp Mask filter, I only do that because it's the current industry standard. If you find you prefer the Adjust Sharpness control, from here on out, when I say to apply the Unsharp Mask filter, you can substitute the Adjust Sharpness control instead. Don't worry, I won't tell anybody.) Go under the Enhance menu and choose **Adjust Sharpness**.

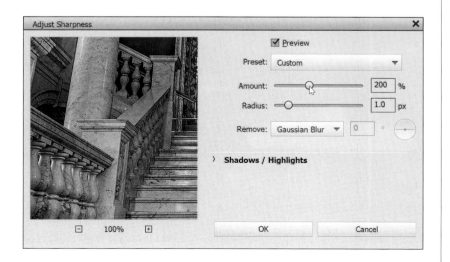

Step Two:
When the dialog opens, you'll notice there are only two sliders: Amount (which controls the amount of sharpening—sorry, my editors made me say that) and Radius (which determines how many pixels the sharpening will affect). I generally leave the Radius setting at 1 pixel, but if a photo is visibly blurry, I'll pump it up to 2. (Very rarely do I ever try to rescue an image that's so blurry that I have to use a 3- or 4-pixel setting.) Here, I increased the Amount to 200% and left the Radius set to 1 px.

Continued

Step Three:

Next is the Remove pop-up menu, which has three types of blurs you can reduce using Adjust Sharpness. Gaussian Blur (the default) applies a brand of sharpening that's pretty much like what you get using the regular Unsharp Mask filter. Motion Blur requires you to know the angle of blur that appears in your image, so it's tough to get really good results with this one. So, I recommend Lens Blur. It's better at detecting edges, so it creates fewer color halos than you'd get with the other choices, and overall I think it just gives you better sharpening for most images. The downside? Choosing Lens Blur causes the filter to take a little longer to "do its thing." A small price to pay for better-quality sharpening.

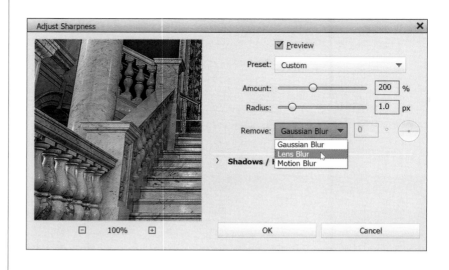

Step Four:

Below that is Shadows/Highlights. Just click on the little right-facing arrow to the left of it and these options appear. The Shadows sliders are for reducing sharpening in the shadow areas (I occasionally use these, but just on really noisy images—it allows you to reduce or turn off sharpening in the shadow areas where noise is usually most visible), and the Highlights sliders are used for reducing the amount of sharpening in the highlight areas (I never use those).

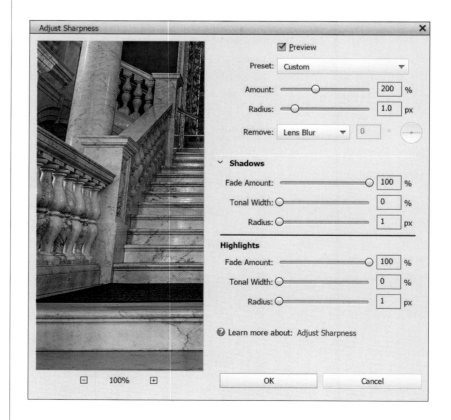

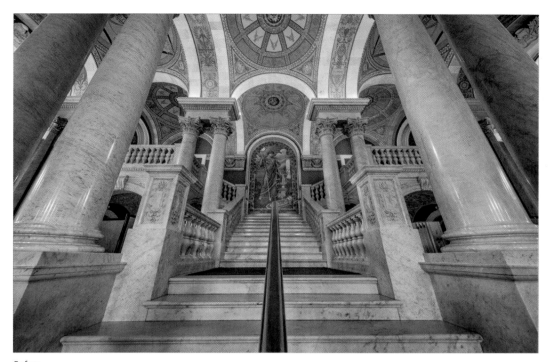

Before

After

Model: Hedy | Exposure: 1/100 sec | Focal Length: 130mm | Aperture Value: *f*/2.8

Print
printing, color management, and my Elements 2020 workflow

Oh sure, Scott, you want me to believe you found a song, TV show, or movie title simply named, *Print*. That's awfully convenient, dontcha think? Well, my cynical compatriot, it so happens it actually is a movie (one with an 8/10 star rating no less), released in 2008, starring Gabrielle Carteris and Will Rothhaar (just because you haven't heard of them, it doesn't make them any less real). While it is just the most perfect chapter name you could possibly come up with for a chapter on printing, the actual description of the film (from IMDb.com) is kinda creepy to say the least. Here's their description: "A psychological thriller about a troubled young man who decides to kill the best-selling author he is convinced stole his life story, only the author may not actually exist." Creepy, right? Now, I just want to say this to any of you out there reading this book: This book is absolutely *not* (I repeat, *not*) the story of your life, so there's no way I could have stolen it from you, and thus there's no reason for you to be troubled (especially if you're a young man), and decide to kill me. I know when you were reading some of the previous chapter openers the thought may have crossed your mind, but I assure you, this

is not an awesome idea. Here's why: I rented *Print* (which, by the way, was more a 6-star movie at best), and in the movie, the best-selling author (played by a devastatingly handsome photographer from Florida, who teaches people how to use Photoshop Elements 2020) actually winds up convincing the troubled young man to buy his new Elements book, and the young man is so elated at the magic in this book that unfolds for him, that instead of plotting to kill the author, he takes a second job as a master sommelier and sends every penny he earns directly to the author (118 Douglas Road E., Oldsmar, FL 34677) as his way of showing his undying gratitude for opening his eyes to a world of post-processing secrets that dare not speak their name. See? This is the kind of movie you can really get behind—one with life lessons that inspire people...well...like yourself who were once thinking of killing me, but then suddenly decided to send me all their money instead. Hey, now that I think of it, this movie easily should have won the Best Picture Oscar in 2008. They were robbed, I tell ya. Robbed!

Setting Up Your Color Management

Most of the color management decisions in Elements come in the printing process (well, if you actually print your photos), but even if you're not printing, there is one color management decision you need to make now. Luckily, it's a really easy one.

Step One:

In the Elements Editor, go under the Edit menu and choose **Color Settings** (or just press **Ctrl-Shift-K [Mac: Command-Shift-K]**).

Step Two:

This brings up the Color Settings dialog. By default, Elements is set to Always Optimize Colors for Computer Screens, which uses the sRGB color space. However, if you're going to be printing to your own color inkjet printer (like an Epson, HP, Canon, etc.), you'll want to choose Always Optimize for Printing, which sets your color space to the Adobe RGB color space (the most popular color space for photographers), and gives you the best printed results. Now just click OK, and you've done it—you've configured Elements' color space for the best results for printing. *Note:* You only want to make this change if your final prints will be output to your own color inkjet printer. If you're sending your images out to an outside lab for prints (or your final images will only be viewed onscreen), you should probably stay in sRGB, because most labs are set up to handle sRGB files. Your best bet: ask your lab which color space they prefer.

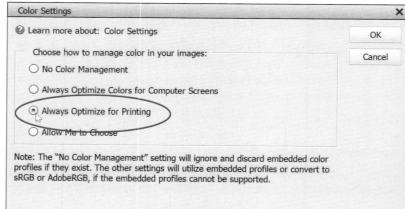

To get what comes out of your color inkjet printer to match what you see onscreen, you have to calibrate your monitor in one of two ways: (1) buy a hardware calibration sensor that calibrates your monitor precisely; or (2) use free software calibration, which is better than nothing, but not by much since you're just "eyeing" it. Hardware calibration is definitely the preferred method (in fact, I don't know of a single pro using freebie software). With hardware calibration, it's measuring your actual monitor and building an accurate profile for the exact monitor you're using, and yes—it makes that big a difference.

You Have to Calibrate Your Monitor Before You Go Any Further

Step One:
To find the free software that comes with Windows 10, in the Settings panel click on System, then click on Display, and go to the Advanced Display Settings. Click on the Display Adapter Properties for Display 1 link (the number may be different if you have multiple monitors set up), then click on the Color Management tab, and then click Color Management. Now, click on the Advanced tab, and then, finally, click on Calibrate Display. In Mac OS X, in the System Preferences dialog, click on Displays, then click on the Color tab to find it. I use Datacolor's Spyder5ELITE hardware color calibrator (around $200 street price), because it's simple, affordable, and a lot of the pros I know have moved over to it. So, I'm going to use it as an example here, but it's not necessary to get this same one, because they all work fairly similarly. You start by installing the software that comes with the Spyder5ELITE. Then, plug the Spyder5ELITE sensor into your computer's USB port and launch the software, which brings up the main window (seen here). You follow the "wizard," which asks you a couple of simple questions, and then it does the rest.

Step Two:
Start by clicking the Next button in the bottom right, and the window you see here will appear. If you're new to calibrating your monitor, I recommend using the Step-by-Step Assistant (which is already selected by default), so at this point just click the Next button again.

Continued

Step Three:

The next screen asks you which type of calibration you want to do. Are you going to update an older calibration you did previously with the Spyder5ELITE (then you would click the ReCAL radio button), or do you just want to check to see how accurate your current calibration is (Check-CAL), or are you doing this for the first time (which you are, so you'd click the FullCAL radio button, as shown here)? Then, just click the Next button, because you're going to leave all the pop-up menus here at their default recommended settings.

Step Four:

The next screen asks you to put the Spyder unit on your monitor, which means you drape the sensor over your monitor so it sits flat against it and the cord hangs over the back. It shows you exactly where to place it (the two blue arrows you see beside its outline actually flash on/off, so you can't possibly miss where it goes). The sensor comes with a counterweight you can attach to the cord, so you can position the sensor approximately in the center of your screen without it slipping down. Once the sensor is in position over your screen, click the Next button, sit back, and relax. You'll see the software conduct a series of onscreen tests, using gray, white, and various color swatches, as shown here.

Step Five:
This testing only goes on for a few minutes (at least, that's all it took for my desktop), and then it's done. It asks you to name your profile (it puts a default name in place for you), so enter a name, and then click the Save button. Below that is a pop-up menu where you can choose when you want an automatic reminder to "Recalibrate your monitor" to pop up on your screen. The default choice is 2 Weeks (so please don't tell anyone that I actually set mine to 1 Month). Make your choice and then click the Next button.

Step Six:
Now you get to see the usually shocking before/after. Click on the Switch button at the bottom right and you can switch back and forth between your now fully calibrated monitor and your uncalibrated monitor. It's at that moment you say, "Ohhhhhh…that's why my prints never match my screen." Well, it's certainly one part of the puzzle, but without this one critical piece in place, you don't have a chance with the rest, so you did the right thing. Click Next one last time, and then click the Quit button in the Profile Overview screen.

Getting Pro-Quality Prints That Match Your Screen

When you buy a color inkjet printer and install the printer driver that comes with it, it basically lets Elements know what kind of printer is being used, and that's about it. But to get pro-quality results, you need a profile for your printer based on the exact type of paper you'll be printing on. Most inkjet paper manufacturers now create custom profiles for their papers, and you can usually download them free from their websites. Does this really make that big a difference? Ask any pro. Here's how to find and install your custom profiles:

Step One:
Your first step is to go to the website of the company that makes the paper you're going to be printing on and search for their downloadable color profiles for your printer. I use the term "search" because they're usually not in a really obvious place. I use a Canon imagePROGRAF PRO-1000 printer and I generally print on Canon paper. When I installed the PRO-1000's printer driver, I was tickled to find that it also installed custom color profiles for all Canon papers, but some printers don't. So, if I needed to download them, the first stop would be Canon's website, where you'd click on the Drivers & Downloads link (as shown here). *Note:* Even if you're not a Canon user, still follow along (you'll see why).

Step Two:
Once you get to the support page, enter your printer model name/number, then click the Go button.

Step Three:

On the Drivers & Downloads page, click on the Software tab, then click on the Select button for imagePROGRAF PRO-1000 series ICC Profile for Supporting the Other Companies' Media (Windows), then click on Download. After they download onto your computer, just Right-click on the profile(s) for the paper(s) you use, choose **Install Profile**, and they're added to your list of profiles in Elements (I'll show how to choose them in the Print dialog a little later). On a Mac, go to your hard disk, in your Library folder, and in your ColorSync folder, to the Profiles folder. Just drag the file in there and you're set. You don't even have to restart Elements—it automatically updates. That's it—you download them, install them, and they'll be waiting for you in Elements' print dialog. Easy enough. But what if you're not using Canon paper? Or if you have a different printer, like an Epson or an HP?

Step Four:

We'll tackle the different paper issue first (because they're tied together). Say I wanted to print from my PRO-1000 using a different brand of paper other than Canon. For example, say I wanted to use Red River Paper's UltraPro Satin instead. So, even though I'm printing on a Canon printer, now I'd go to Red River Paper's site (www.redriverpaper.com) to find their color profiles for my PRO-1000. (Remember, profiles come from the company that makes the paper.) On the Red River Paper homepage, click on the Color Profiles link under Helpful Info on the left side of the page.

Continued

Step Five:

Under the section named Canon Pro Printers, there's a direct link to the ICC profiles for the PRO-1000 (as seen here), but did you also notice that there are ICC Color profiles for Epson and HP printers? The process is the same for other printers, but although HP and Canon now both make pro-quality photo printers, Epson had the pro market to itself for a while, so while Epson profiles are created by most major paper manufacturers, you may not always find paper profiles for HP and Canon printers. At Red River, they widely support Epson, and have a number of Canon profiles now, but there are only a few for HP. That doesn't mean this won't change, but as of the writing of this book, that's the reality.

Step Six:

Just like when you download Canon profiles, Red River (and many other paper manufacturers) provides the profile (shown here; some paper manufacturers provide an installer) and instructions, so you install it yourself. Again, on a PC, just Right-click on the profile and choose Install Profile. On a Mac, go to your hard disk, in your Library folder, and in your ColorSync folder, to the Profiles folder. Just drag the file in there and you're set.

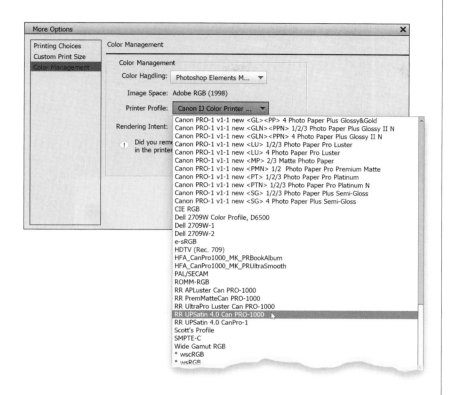

Step Seven:

You'll access your profile by choosing **Print** from Elements' File menu. In the Print dialog, click on the More Options button in the bottom left, then click on Color Management on the left of the dialog. Change the Color Handling pop-up menu to **Photoshop Elements Manages Color**, then click on the Printer Profile pop-up menu, and your new color profile(s) will appear. Here, I'm printing to a Canon PRO-1000 using Red River's UltraPro Satin paper, so that's what I'm choosing as my printer profile (it's named RR UPSatin 4.0 Can Pro-1000). That's it, but there's more on using these color profiles next in this chapter.

TIP: Custom Profiles for Your Printer

You can also pay an outside service to create a custom profile for your printer. You print a provided test sheet, overnight it to them, and they'll use an expensive colorimeter to measure your test print and create a custom profile, but it's only good for that printer, on that paper, with that ink. If anything changes, your profile is worthless. You could do your own personal printer profiling (using something like one of X-Rite's i1 Pro packages), so you can re-profile each time you change paper or inks. It's really just up to you.

Sharpening for Printing

When we apply sharpening, we apply it so it looks good on our computer screen, right? But when you actually make a print, a lot of that sharpening that looks fine on a 72- or 96-dpi computer screen gets lost on a high-resolution print at 240 ppi. Because the sharpening gets reduced when we make a print, we have to sharpen so our photo looks a bit too sharp onscreen, but then looks perfect when it prints. Here's how I apply sharpening for images I'm going to print:

Step One:

Start by doing a trick my buddy Shelly Katz shared with me: duplicate the Background layer (by pressing **Ctrl-J [Mac: Command-J]**) and do your print sharpening on this duplicate layer (that way, you don't mess with the already sharpened original image on the Background layer). Double-click on the new layer's name and rename it "Sharpened for Print," then go under the Enhance menu, and choose **Unsharp Mask**. For most 240 ppi images, I apply these settings: Amount 120; Radius 1; Threshold 3. Click OK.

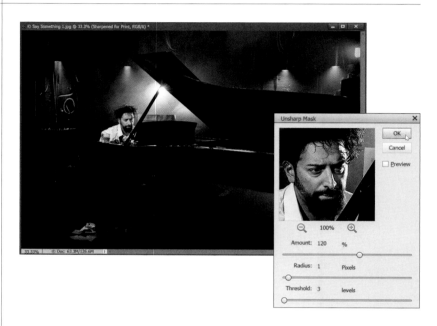

Step Two:

Next, reapply the Unsharp Mask filter with the same settings by pressing **Ctrl-F (Mac: Command-F)**. Then, at the top of the Layers palette, change the layer blend mode to **Luminosity** (so the sharpening is only applied to the detail of the photo, and not the color), and use the Opacity slider to control how much sharpening is applied. Start at 50% and see if it looks a little bit oversharpened. If it looks like a little bit too much, stop—you want it to look a little oversharpened. If you think it's way too much, lower the opacity to around 35% and re-evaluate. When it looks right (a little too sharp), make a test print. My guess is that you'll want to raise the opacity up a little higher, because it won't be as sharp as you thought.

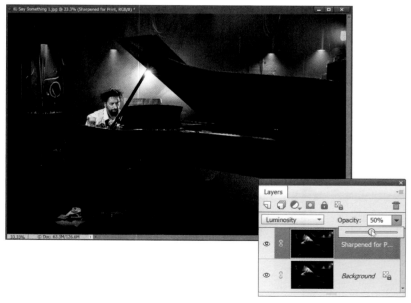

Okay, you've hardware calibrated your monitor (or at the very least—you "eyed it") and you've set up Elements' Color Management to use Adobe RGB (1998). You've even downloaded a printer profile for the exact printer model and type of paper you're printing on. In short, you're there. Luckily, you only have to do all that stuff once—now we can just sit back and print. Well, pretty much.

Making the Print

Step One:
Once you have an image all ready to go, just go under the Editor's File menu and choose **Print** (as shown here), or just press **Ctrl-P (Mac: Command-P)**.

Step Two:
When the Print dialog appears, let's choose your printer and paper size first. At the top right of the dialog, choose the exact printer you want to print to from the Select Printer pop-up menu (I'm printing to a Canon PRO-1000). Next, choose your paper size from the Select Paper Size pop-up menu (in this case, a 13x19" sheet), choose your page orientation beneath that menu, and then from the Select Print Size pop-up menu (on the bottom right), be sure that Actual Size is selected. In the middle of the Print dialog, you'll see a preview of how your photo will fit on the printed page, and at the bottom of the column on the right, there's an option for how many copies you want to print. If you want to print more than one photo, just click the Add button below the filmstrip on the left side of the dialog. This brings up the Add Photos dialog (similar to the one you get when using the Create Slide Show feature), where you can choose from your photos in the Organizer. Select the one(s) you want and click the Add Selected Photos button. To remove a photo from the filmstrip, click on it, then click the Remove button.

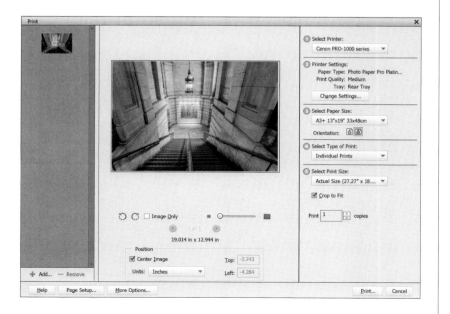

Continued

Step Three:

Click on the More Options button (at the bottom left) and then click on Custom Print Size on the left. Here you can choose how large the photo will appear on the page (if it's a photo that's too large to fit on the paper, just turn on the Scale to Fit Media checkbox, as I did here, and it will do the math for you, and scale the image down to fit).

Step Four:

Now click on Printing Choices at the top left of the More Options dialog. Here you can choose if you want to have your photo's filename appear on the page, or change the background color of the paper, or add a border, or have crop marks print, or other stuff like that—you have but only to turn the checkboxes on (you like that "you have but only to" phrase? I never use that in normal conversation, but somehow it sounded good here. Ya know, come to think of it— maybe not). Anyway, I don't use these Printing Choices at all, ever, but don't let that stop you—feel free to add distracting junk to your heart's content. Now, on to the meat of this process.

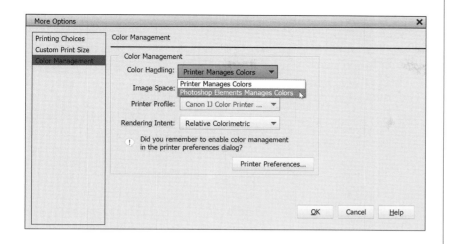

Step Five:

Click on Color Management on the left to get the all-important Color Management options. Here's the thing: by default, the Color Handling is set up to have your printer manage colors. You really only want to choose this if you weren't able to download the printer/paper profile for your printer. So, basically, this is your backup plan. It's not your first choice, but today's printers have gotten to the point that if you have to go with this, it still does a decent job. However, if you were able to download your printer/paper profile and you want pro-quality prints (and I imagine you do), then do this instead: choose **Photoshop Elements Manages Colors** from the Color Handling pop-up menu (as shown here), so you can make use of the color profile, which will give you the best possible color match.

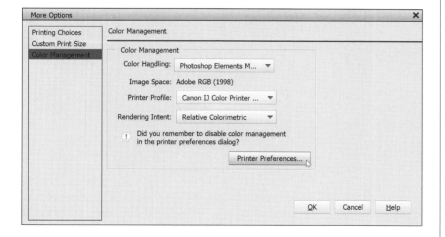

Step Six:

Below Rendering Intent, you'll see a warning asking if you remembered to disable your printer's color management. You haven't, so let's do that now. Click the Printer Preferences button that appears right below the warning (as shown here). (*Note:* On a Mac, once you click the Print button in the Elements Print dialog, the Mac OS X Print dialog will appear, where you can go under Printer Color Management and set it to Off [No Color Adjustment].)

Continued

Step Seven:

In your printer's Properties dialog (which may be different depending on your printer), you will turn off your printer's color management, but you have other stuff to do here, as well (on a Mac, you will do this in the OS X Print dialog, as mentioned in the previous step). First, choose the type of paper you'll be printing to (I'm printing to Canon Photo Paper Pro Luster). Find the Print Quality setting, choose **Custom**, click the Set button, then in the resulting dialog, drag the Quality slider at the top to the quality setting you want and click OK. If you have the option (usually found under Advanced Settings), be sure to set your printer options to **Off (No Color Adjustment).** Here, under Color/Intensity, I chose Manual, then clicked the Set button, and chose **None.** Click OK to save your changes and return to the More Options dialog.

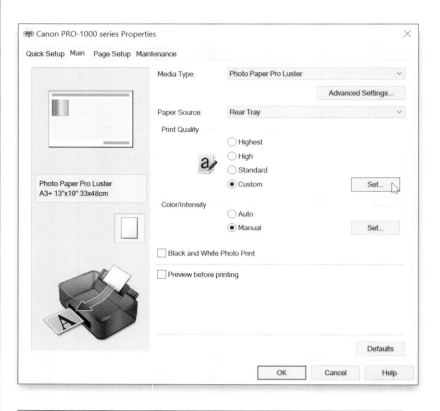

Step Eight:

After you've turned off your printer's color management (and chosen photo quality paper), you'll need to choose your color profile. Again, I'm going to be printing to a Canon PRO-1000 printer, using Canon's Photo Paper Pro Luster paper, so I'd choose that profile from the Printer Profile pop-up menu in the Color Management section. Doing this optimizes the color to give the best possible color print on that particular printer using that particular paper.

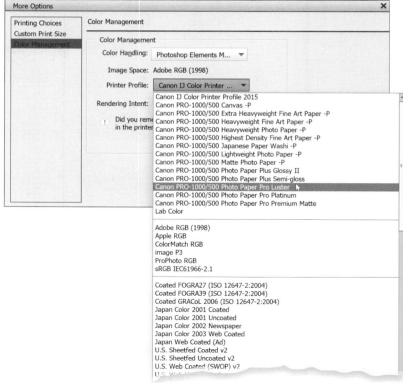

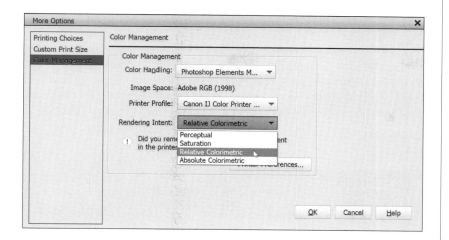

Step Nine:

Lastly, you'll need to choose the Rendering Intent. There are four choices here, but only two that I recommend—either Relative Colorimetric (which is the default setting) or Perceptual. Here's the thing: I've had printers where I got the best looking prints with my Rendering Intent set to Perceptual, but currently, on my Canon PRO-1000, I get better results when it's set to Relative Colorimetric. So, which one gives the best results for your printer? I recommend printing a photo once using Perceptual, then printing the same photo using Relative Colorimetric, and when you compare the two, you'll know. Just remember to add some text below the photo that tells you which one is which or you'll get the two confused. I learned this the hard way.

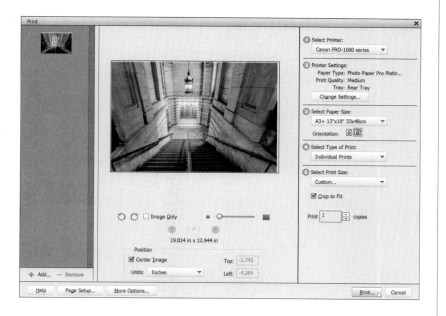

Step 10:

Now click the OK button, then click the Print button at the bottom of the Print dialog (this is where, on a Mac, you'll choose the options we talked about in Step Six and Step Seven).

What to Do If the Print Still Doesn't Match Your Screen

Okay, what do you do if you followed all these steps—you've hardware calibrated your monitor, you've got the right paper profiles, and color profiles, and profiles of profiles, and so on, and you've carefully turned on every checkbox, chosen all the right color profiles, and you've done everything right—but the print still doesn't match what you see onscreen? You know what we do? We fix it in Elements. That's right—we make some simple tweaks that get the image looking right fast.

Your Print Is Too Dark

This is one of the most common problems, and it's mostly because today's monitors are so much brighter (either that, or you're literally viewing your images in a room that's too dark). Luckily, this is an easy fix and here's what I do: Press **Ctrl-J (Mac: Command-J)** to duplicate the Background layer, then at the top of the Layers palette, change the layer blend mode to **Screen** to make everything much brighter. Now, lower the Opacity of this layer to 25% and (this is key here) make a test print. Next, look at the print, and see if it's a perfect match, or if it's still too dark. If it's still too dark, set the Opacity to 35% and make another test print. It'll probably take a few test prints to nail it, but once you do, your problem is solved.

Your Print Is Too Light

This is less likely, but just as easy to fix. Duplicate the Background layer, then change the layer blend mode to **Multiply** to make everything darker. Now, lower the Opacity of this layer to 20% and make a test print. Again, you may have to make a few test prints to get the right amount, but once you've got it, you've got it.

Your Print Is Too Red (Blue, etc.)

This is one you might run into if your print has some sort of color cast. First, before you mess with the image, press the **Tab key** on your keyboard to hide the Toolbox, palettes, and Tool Options Bar, and put a solid gray background behind your photo. Then, just look to see if the image onscreen actually has too much red. If it does, then click on the Create New Adjustment Layer icon (the half-white/half-blue circle) at the top of the palette, and choose **Hue/Saturation**. In the Hue/Saturation adjustment palette, from the Channel pop-up menu, choose **Reds** (or **Blues**, etc.), then lower the Saturation amount to –20, and then (you knew this was coming, right?) make a test print. You'll then know if –20 was too much, too little, or just right. You may have to make a few test prints before you nail it.

Your Print Has Visible Banding

The more you've tweaked an image, the more likely it is you'll run into this (where the colors have visible bands, rather than just smoothly graduating from color to color. It's most often seen in blue skies). Here's how to deal with this: Go under the Filter menu, under Noise, and choose **Add Noise**. In the dialog, set the Amount to 4%, click on the Gaussian radio button, and turn on the Monochromatic checkbox. You'll see the noise onscreen, but it disappears when you print the image (and usually, the banding disappears right along with it).

My Elements 2020 Photography Workflow

One of the questions I get asked the most is "What is your suggested digital workflow?" (Which actually means, "What order are you supposed to do all this in?" That's all "digital workflow" means.) I wrote this book in kind of a digital workflow order, starting with importing and organizing your photos, correcting them, sharpening them, and then at the end, printing. But I thought that seeing it all laid out in one place (well, in these six pages) might be really helpful, so here ya go.

Step One:

You start your workflow by importing your photos into the Organizer (we learned this in Chapter 1). While you're in the Photo Downloader (shown here), I recommend adding your metadata (your name and copyright info) during this import process. Also, while you're in the Photo Downloader, go ahead and rename your photos now, so if you ever have to search for them, you have a hope of finding them (searching for photos from your trip to Hawaii is pretty tough if you leave the files named the way your camera named them, which is something along the lines of "SK2_1751.JPG"). So give them a descriptive name while you import them. You'll thank me later.

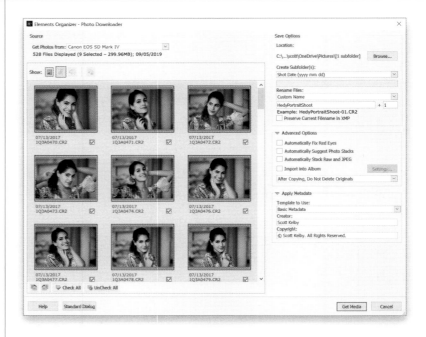

Step Two:

Once your photos appear in the Organizer, first take a quick look through them and go ahead and delete any photos that are hopelessly out of focus, were taken accidentally (like shots taken with the lens cap still on), or you can see with a quick glance are so messed up they're beyond repair. Get rid of these now, because there's no sense wasting time (tagging, sorting, etc.) and disk space on photos that you're going to wind up deleting later anyway, so make your job easier—do it now.

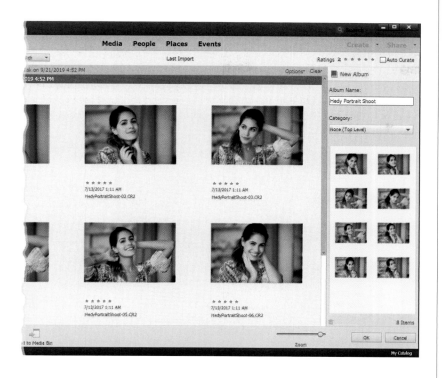

Step Three:

Once you've deleted the obviously bad ones, here's what I would do next: go through the photos one more time and then create an album of just your best images (see Chapter 1 for how to create an album). That way, you're now just one click away from the best photos from your shoot.

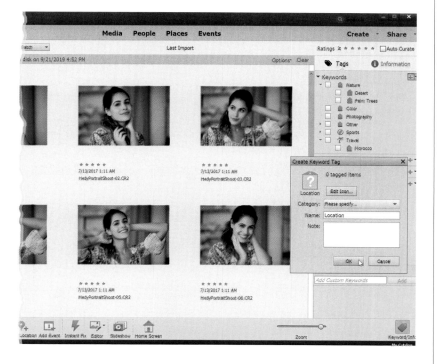

Step Four:

There's another big advantage to separating out your best images into their own separate album: now you're only going to tag and worry about color correcting and editing these photos—the best of your shoot. You're not going to waste time and energy on photos no one's going to see. So, click on the album, then go ahead and assign your keyword tags now (if you forgot how to tag, it's back in Chapter 1). If you take a few minutes to tag the images in your album now, it will save you literally hours down the road. This is a very important step in your workflow (even though it's not a fun step), so don't skip it—tag those images now!

Continued

Step Five:

Now it's time to start editing our location portrait shot. My workflow always begins in Camera Raw (whether I shot in JPEG, TIFF, or RAW. See Chapter 2 for more on working in Camera Raw), and the first thing I do at this point is figure out what needs to be done to get the image where I want it, so the question I ask myself is simple: "What do I wish were different?" Well, I wish I had composed the portrait a little tighter, cropping off the top 1/3 of her head to create a more intimate feel. I also don't like how bright the background is, so I'll need to pull that back. I need a bit more light on her face overall, and in particular her eyes. This was taken late in the day, but I might add a little cooler white balance, too.

Step Six:

Let's start with cropping the image while we're here in Camera Raw. Get the Crop tool (C) from the Toolbox and let's crop in quite a bit tighter, bringing the subject forward in the frame a bit. (We looked at cropping in Camera Raw in Chapter 3, as well as cropping in the Editor in Chapter 4.)

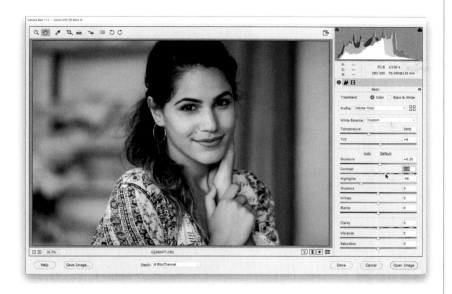

Step Seven:
To deal with that bright background, let's drag the Highlights slider to the left to lower the overall brightness. In this case, I dragged it over to −45, which was far enough for now (plus, sometimes if you go too far, really bright areas may turn gray). Next, the whole image looks a little dark, so I raised the overall exposure a bit by dragging the Exposure slider to the right to +0.20, and then I increased the Contrast to +19.

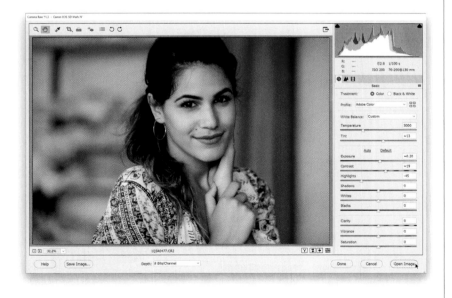

Step Eight:
Let's wrap things up here in Camera Raw by making the whole image just a tad cooler by dragging the Temperature slider over to +5000 (to add just a little more blue into the image). I also increased the Tint just a tiny bit to +13. Now, click the Open Image button to open the image in the Editor.

Continued

Step Nine:

Let's zoom in a bit (using the Zoom tool or by pressing **Ctrl-+** [plus sign; **Mac: Command-+**]), and then get the Spot Healing Brush tool **(J)** to remove a few little blemishes and stray hairs on her face. Make your brush size a little larger than the blemishes you want to remove, then move your cursor over each blemish and just click once to remove them. (See Chapter 9 for more on the Spot Healing Brush.) Remember, this is just a tweak, not an in-depth retouch, so don't spend too long on this step—a minute or two, tops.

Step 10:

Next, let's create an adjustment layer to add some highlights to her hair, eyes, and lips. So, click on the Create New Adjustment Layer icon, at the top of the Layers palette, and choose **Levels** (see Chapter 6 for more on Levels adjustment layers). In the Levels palette, drag the middle gray Input Levels slider (beneath the histogram) to the left to brighten the midtones, and then drag the far-right (white) Input Levels slider to the left just a bit to brighten the highlights. Now, press **Ctrl-I (Mac: Command-I)** to Invert the layer mask attached to this adjustment layer and hide those adjustments behind a black mask—that way, we can paint in the highlights where we want them. Get the Brush tool **(B)**, and with your Foreground color set to white, paint over the highlight areas in her hair, her eyes, and her lips to bring them out. Once you've painted them all in, at the top of the Layers palette, lower the Opacity of this adjustment layer until it looks realistic (here, I lowered it to 75%).

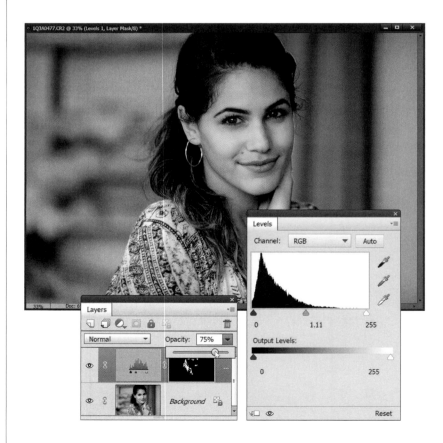

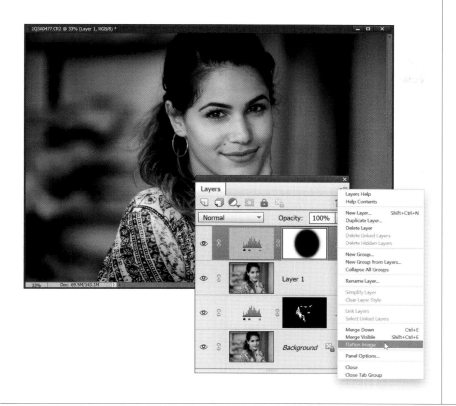

Step 11:

Our overall exposure is pretty good, but I'd like to add a soft spotlight to her to separate her from the background a bit. So, create a new merged layer at the top of the layer stack by pressing **Ctrl-Alt-Shift-E (Mac: Command-Option-Shift-E)**. Then, using the Elliptical Marquee tool, create a selection around her, invert and feather it, and add another Levels adjustment layer to add the spotlight effect (we learned how to do this back in Chapter 8). Now, choose **Flatten Image** from the Layers palette's flyout menu to merge all those layers down with the Background layer. That should wrap this up!. :)

Before

After

sorting photos, 12
special effects, 282–331
 black-and-white conversions, 301–307
 burned-in edge effect, 312–313
 colorizing photos, 330–331
 Depth Of Field effect, 291–294
 desaturated skin look, 295–296
 double exposure effect, 326–329
 duotone effect, 324–325
 effects collage, 289–290
 Guided mode, 146–149
 high-contrast portrait look, 297–300
 Instagram app look, 320–323
 neutral density gradient effect, 317–319
 panoramas, 308–311
 photo inside text, 287–288
 Picture Stack effect, 284–286
 Quick edit mode, 282–283
 selective color effect, 314–316
split-screen previews, 61
Spot Healing Brush tool
 blemish removal and, 374
 Content-Aware features and, 265, 268, 269
 spot/artifact removal and, 264–265
 unwanted object removal and, 268, 269
spot removal, 264–265
spotlight effect, 244, 245, 375
Spyder5ELITE calibrator, 355–357
square crop ratio, 320
square selections, 238–239
sRGB color space, 354
Stack icon, 39
stacking photos, 35, 39–40
standard photo sizes, 112–113
stock photo websites, 324
Straighten tool
 Camera Raw, 103
 Photoshop Elements, 125–126
straightening photos, 103, 125–126
Stroke dialog, 175, 176
strokes, 175–176
Style Settings dialog, 288
Subtract mode
 Auto Selection tool, 242
 B&W Selection Brush, 315
 Quick Selection tool, 247–248, 294
 Smart Brush tool, 198
Surface Blur filter, 298

T

tabbed viewing, 122
tagging photos. *See* keyword tags
Tags palette, 17, 21, 31
Temperature slider
 Camera Raw, 58, 60, 373
 Quick edit mode, 144
text
 photos inside, 287–288
 slide show, 38
textured backgrounds, 168, 169–170
themes for slide shows, 36–37
Threshold slider, Unsharp Mask, 335, 340
thumbnails
 layer mask, 186
 previewing selected, 10–11
 Profile Browser, 56
 Quick Edit mode, 142, 143
 sizing/resizing, 9, 168
TIFF images
 cropping in Camera Raw, 100, 102
 opening in Camera Raw, 49
Time Zone Adjust dialog, 13
Timeline, 14, 31
Tint slider
 Camera Raw, 60, 373
 Quick edit mode, 144
Toggle Film Strip button, 11
Tool Options Bar, 151
Top/Bottom previews, 62
touchscreen capabilities, 19, 140
tourist removal, 275–279
Trash icon, 178, 254
tripods, 275
Type Tool button, 287

U

UnCheck All button, 5
underexposed subjects, 216–218
Undo command, 63, 89, 187, 245
Unsharp Mask filter
 Adjust Sharpness control vs., 349
 basic sharpening and, 334–340
 downsized photos and, 131, 132
 extraordinary sharpening and, 341–342
 panorama creation and, 311
 print sharpening and, 362
 sample settings for, 335–340
 See also sharpening techniques
Unstack Photos command, 40

The power of small
Profoto B10

Can you spot our new light? It's in the middle just below the first camera. So yes, the Profoto B10 is small, yet it's more powerful than five speedlights and compatible with more than 120 light shaping tools - so it delivers beautiful light. This is small without compromise; and on-location - size matters.

Discover the B10 at profoto.com